£2

10

BEGIN WITH BAILEY

BEGIN WITH BAILEY

PHOTOGRAPHS BY DAVID BAILEY

TEXT BY GEORGE HUGHES

J. M. Dent & Sons Ltd
London Melbourne

The authors and publisher are grateful to Haymarket Publishing Ltd,
publishers of *Camera Weekly*, in which the material in this book
originally appeared.

This book is set in 9/10pt Photina
Printed in Great Britain by BAS Printers Ltd, Over Wallop, Hampshire for
J. M. Dent & Sons Ltd,
Aldine House, 33 Welbeck Street, London W1M 8LX

British Library Cataloguing in Publication Data
Bailey, David
 Begin with Bailey.
 1. Photography.
 I. Title
 770′.28 TR146
 ISBN 0-460-04621-7

Contents

Preface

Over the course of several years Bailey and I have had endless discussions about photography in general and the photographs in this volume in particular. Each photograph serves to highlight one broad area of technique, or of basic photographic awareness.

The material in this volume began as a series in *Camera Weekly*. It became obvious to us that we had hit upon a winning formula which would avoid all the pitfalls of so many textbooks – the heaviness, the stodginess, the indigestibility, and the ultimate confusion as the reader drowned in a sea of formulae, rules and obscure references to obscure photographic phenomena which have no place at all in the automated age of the 1980s.

Interestingly – and perhaps significantly too – as we were putting the finishing touches to this book, which has the same title as the series, there was much celebration in newspapers and magazines of the 350th anniversary of the birth of Samuel Pepys. He is recognised as one of the greatest diarists of all times: through his work it is possible for us to experience in part, life in seventeenth-century London. And the camera is surely the diary of today: at least, it seems to us that while there will always be writers and photographers and painters who reach real artist status, there are many thousands who set out in photography with the simple and honest desire to do no more than record for tomorrow the things and the events and the people around them. They want to steal a slice of time, and to preserve it. And since the camera designers are endlessly making it easier for beginners to master the technicalities, we feel it is only right to chip in with our contribution – sufficient simple and straightforward explanations, with actual pictures as examples, to help folk master the grammar and the techniques of photography.

Taking good pictures requires no mystical skill – any more than Samuel Pepys needed superhuman strength and insight to help him hand on to us a convincing picture of his times. It is, quite simply, everybody's right to be able to handle a camera – whether they do so for the delight of showing their grandchildren what was going on fifty years earlier, or whether they seek the warm winter glow of memories of summer holidays on an island in Greece, or the recollection of a friend from years ago.

Photography *is* powerful. More powerful by far, when well done, than the words Pepys used. Begin now, here, tasting and exercising that power with us. . . .

London
March 1983 George Hughes

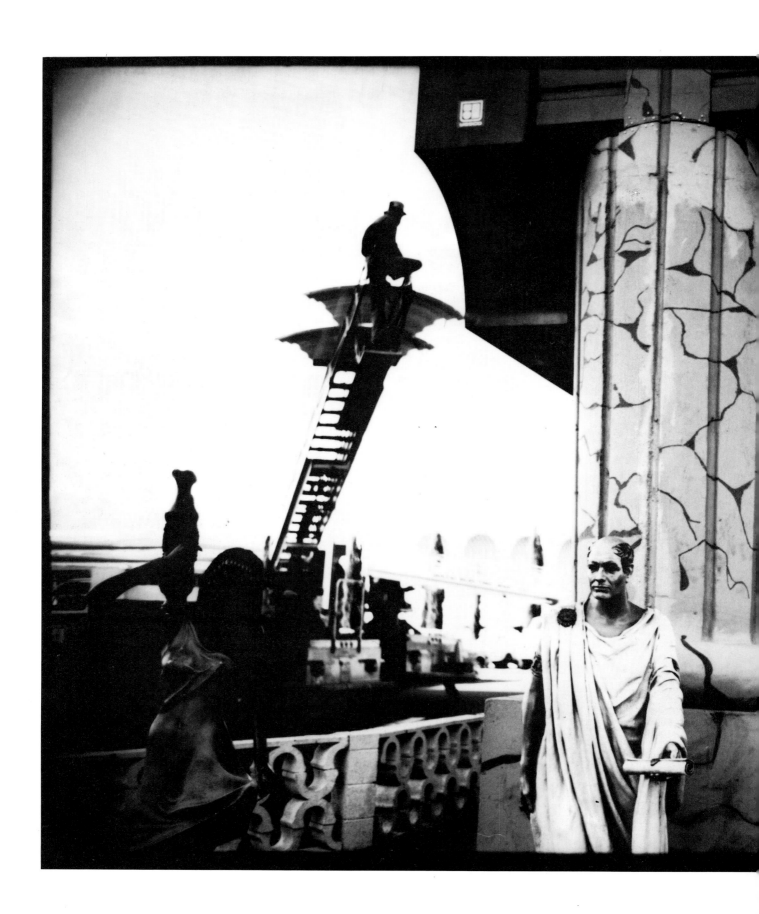

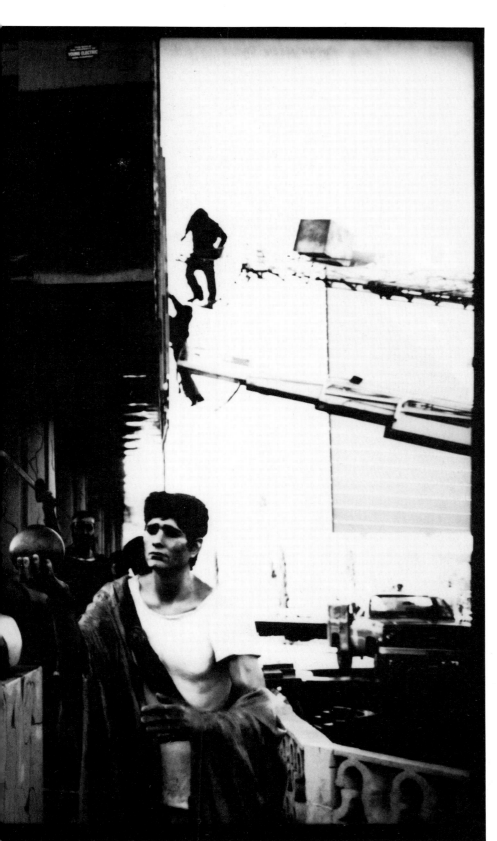

Subject
balance
camera position

The idea of symmetry is extremely important in design – and in photographic composition too. But thoughts about it are by no means unanimous!

For some, symmetry spells tranquillity and harmonious balance, while others find it boring beyond belief, insisting instead on a touch of off-balance tension in their designs/compositions.

Whatever your view, symmetry *is* powerful: if there's a hint of it before you, the mind can't escape it.

Here's a shot taken in Las Vegas, near the entrance to the fabulous Caesar's Palace. The arrangement of the elements of the picture, controlled of course by camera viewpoint, has a strong hint of symmetrical balance; yet the picture is just sufficiently 'off centre' to prevent that hint becoming so overwhelming as to obscure the rest of the picture-interest.

And that is important. For a picture should of course be good to look at from the point of view of design – but if it is nothing more than a sterile juxtaposition of shapes then it may well end up being merely a pretty pattern, with nothing else to stimulate the viewer's interest.

Here's a simple formula to help you avoid empty prettiness. First, establish what is to be the subject – and here the eye endlessly roams between these two Roman figures and the two repair men on ladders. Then, when you are very clear about what you are photographing, adjust your camera position for the most telling effect – and for the most graphic arrangement which doesn't diminish the importance of your chosen subject.

Now, that formula, when written down, seems like it might involve a lot of fidgeting about in front of the subject. It shouldn't! Subject recognition should be immediate: stop worrying about using too much film, and you'll find anything which causes you to take a second glance, or a lingering look, is actually also photographic subject material.

Subject choice
wide-angle shots
burning-in

Perhaps nothing confuses the enthusiastic beginner more than subject choice. He knows, with the certainty of a prophet, that if only he could trade up to a more expensive SLR he would get better pictures. But while he agonises over that misguided thought he positively drowns in the matter of subject choice.

Once, club photographers spent their days picturing wrought iron chairs and the elegant shadows thrown. And a later breed, inspired by the 135mm telephoto lens, discovered candid shooting and went all out to track down plump and picturesque ladies selling cabbages in the local market!

Faced with suchlike, no wonder the newcomers of the day trailed along and pictured the same fashionable subjects. Consequence – the eye was geared towards looking for quite distinct subject matter, but eye *and* mind ended up closed to other possible subjects along the way.

There are two ways to handle subject choice. The first is certainly to go for something *very* positive. Buy a ticket to a motor race and go along determined to come away with the very best action pictures you can get: take with you only the equipment to do that specific job – don't go with a gadget bag stuffed with bits and pieces 'just in case'.

The other approach is to free your mind of all preconceptions other than the need to find interesting graphic shapes. But don't go determined to ape fashion: look instead for shapes which are simple and direct.

The picture of this car, covered and parked in a quiet Paris street, began as a shape. It ends as an interesting snippet on how people feel about their cars.

This is a straightforward wide-angle shot, though burnt-in a bit in the darkroom; it's the kind of thing you might find on any afternoon stroll armed only with a simple 35mm compact.

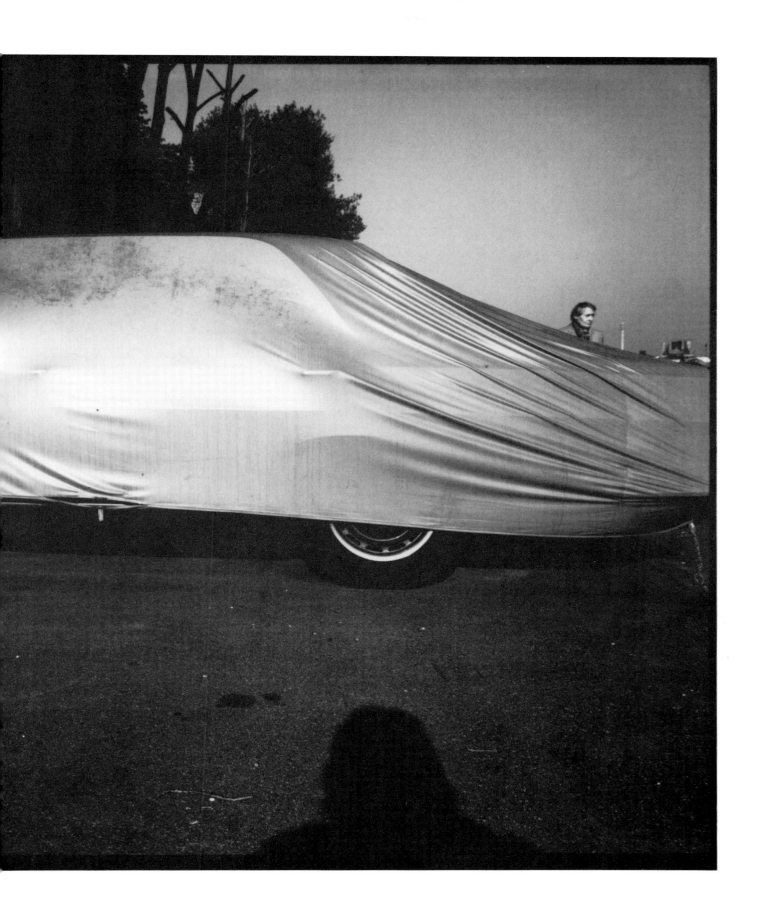

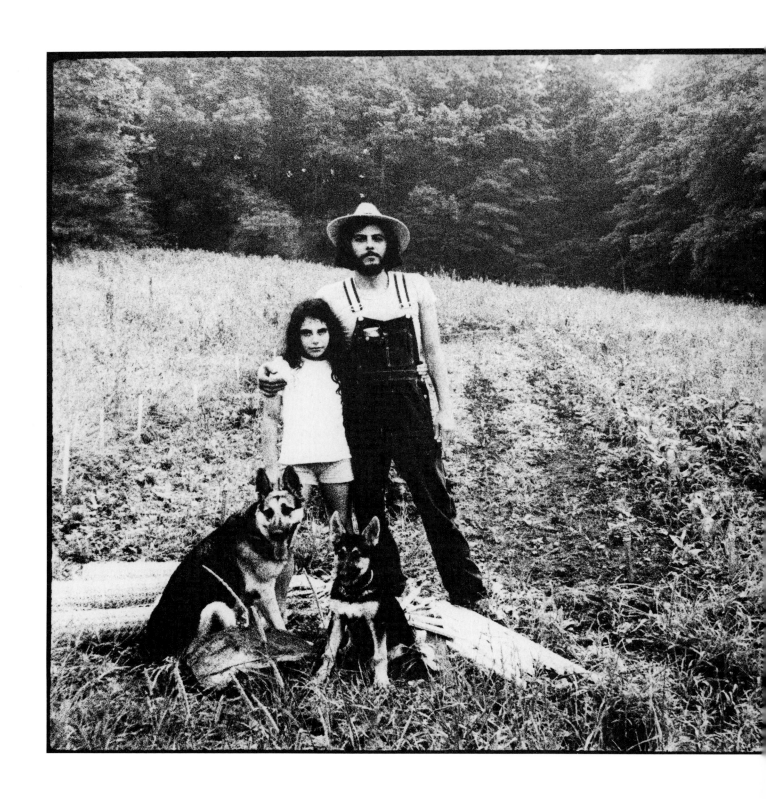

Composition
balance
tonal weight

If you've ever played darts you'll appreciate that with every throw you are looking at a big slab of darts board – but there's only one tiny area you're aiming for! Composing a picture in the camera is a bit like that too.

There before your eye is a space in the viewfinder, in the proportions of $1:1\frac{1}{2}$ where 35mm photography is concerned, but you can't just place the *main* subject interest anywhere. To create a harmonious balance there's a limited number of choices available.

Here's a relaxed portrait of Jordan Calfus, American producer. And he is placed well to one side of the picture area. That choice allows the picture to do more than simply provide a graphic rendition of the shape of Calfus. In fact the emphasis is now on atmosphere, and a sense of the open air life in the country pervades every corner of the frame.

But does such 'off balance' placing of the main subject always introduce a certain atmosphere? Well, it is true, of course, that the more information you include within a picture the more material you have available to create an impression. But this is *not* an unbalanced picture.

The difference between balance and imbalance is very subtle: it is much more a feeling than it is a set of rules.

At the right hand side of this picture there is a greater weight of tone evident than there is in the trees and field at left – though Calfus and companions provide a 'heavy' area there. There is no one area which, screaming for attention, uncomfortably draws the eye – because the picture is predominant in either light or dark areas.

But cover up the right hand half of the picture and you will see how quickly Calfus and Co dominate. They offer variety of shape, of tone – and they become the *centre* of interest. Now examine again the entire picture. Without doubt the surroundings of the little group of people and animals *are* of interest, and have an effect on the impression conveyed to you.

Imagine the effect you'd experience if the group was arranged at the right hand side of the frame instead of on the left. Then, the major areas of heavy tone – the black bits – would all be in one place, and at the left hand side there would be an uninteresting desert of very lightweight tone. That *would* be imbalance!

And how conscious is all this decision making – as to whether what you see in your viewfinder is or isn't balanced? Well, to repeat what's above, it's more a feeling than a set of rules. But it is a feeling made very much more tangible once you begin to appreciate light, and the way light and photographic film work together. In the viewfinder when this picture was taken it was obvious that area at top right was not black: it looked full of detail, but it *was* murky – very much in shadow. And it was obvious that the film in the camera, if exposed to give reasonable detail in the figures, would record that shadowy area as black.

Finally, it was – and always is – very much in mind that strength of tone could be adjusted to a certain degree in the darkroom. Any area of this picture could be made more heavy than it is by the simple act of burning in – that is, allowing more light to fall on that area when printing, so that it becomes darker in comparison with the rest of the print. That's part of the value of darkroom work.

Visualising the final impression of your pictures is not some kind of intellectual exercise: it is the practice of the craft of photography. And the best advice anyone can give to beginners who wish to go far beyond holiday snaps is this: stop at once being miserly about film – get out there and shoot pictures under *every* variety of lighting. Study the results (have contact sheets made) as you would read a practical manual. You'll learn more that way than from a hundred leaflets stuffed with specifications of new cameras.

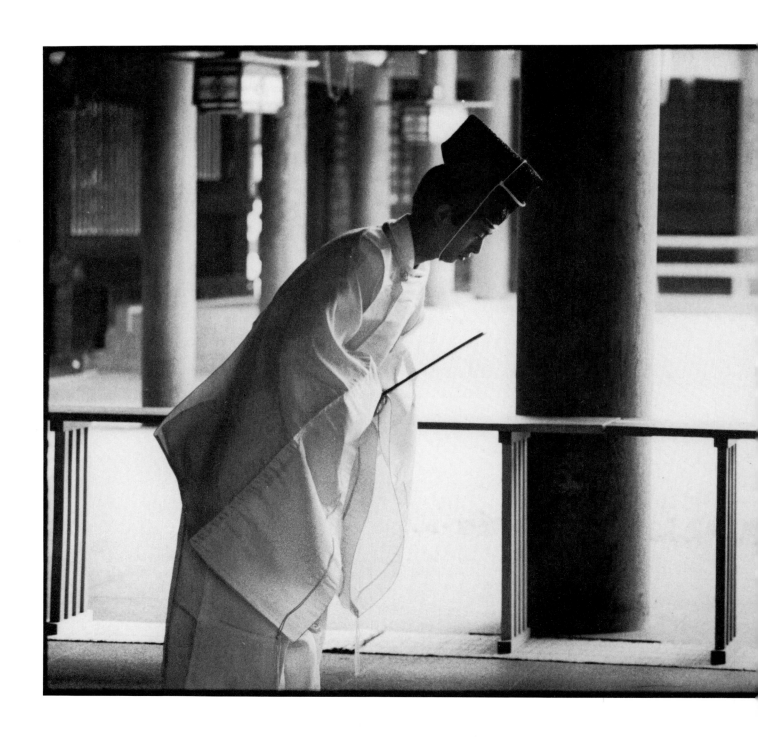

Composition
balance
viewfinder use

When just about every hobbyist who tried colour photography loaded his camera with colour reversal film, to produce transparencies for projection on a screen, there was one warning the pundits always offered him. It had to do with composition. 'Fill the frame', they would say: 'Create your picture in the camera, for once you have your processed transparencies there is nothing you can do about bad composition.'

Then the market changed. The emphasis was gradually taken away from colour reversal, and the public was progressively sold on colour prints. The enthusiasts followed the snapshot crowd, for home colour printing has blossomed mightily, and it's now just about as easy to do as black and white printing. But the majority who shoot colour do so in exactly the same way that colour reversal users once did. That is, when the camera shutter is fired that tends to be that. Off goes the film to a processing house, and soon the enprints are back – with all their moment-of-shooting faults faithfully preserved. Probably not one in a hundred people think any further.

And unless our enthusiast is converted to doing his own printing he winds up with no more say in the subsequent treatment of his pictures than did his slide-shooting forerunners. So, composition is important, and greatly so. Indeed, today it is much more important even than getting the right exposure. This is because colour negative photography will stand considerable abuse, since exposure error and colour drift can be put right automatically by the sophisticated printing machinery used by the big processors.

Trouble is, composition is such an off-putting concept! But here we shall concentrate on how it affects the balance of a picture. And it is actually no more complex than choosing your wallpaper – it simply has to do with how pleasing or otherwise are the effects you produce.

From a series on a Japanese temple comes this picture of a priest, who was bowing before his version of our altar. And the picture is divided decisively into two parts by that great pillar just beyond the priest. The right hand side is a geometric maze of lines horizontal and vertical. In fact, there are two pictures in one. Cover up the left side and you have an arrangement a bit like one of those paintings by Mondrian; cover the right side and you have – a priest bowing. So, *could* the picture exist without its right hand side? Of course, but it then has an anxious and crowded air about it. It needs that space to the right in which to breathe.

And much the same is true of any picture in which people play a large part. Go in too close, crop too tight around the face or body, and you create what can't help but be an intimate portrait, with the person claiming all of your attention. But leave some space around them (and it usually works better if the space is in front rather than behind) and you produce something over which the eye can comfortably wander.

Don't, though, confuse the issue by taking in more than one subject in a picture. Here it is quite plain the priest is the main point of the picture, for almost everything else is rendered slightly out of focus – so that most attention automatically falls on him. If the quite interesting geometric arrangement *had* been treated as the main subject that would be very much sharper, and the priest would have been left out altogether.

Give each separate subject its proper attention, and concentrate hard on arranging that in your viewfinder *exactly* as you want it to look on the enprints you'll eventually get back from your processor. Remember, always, that your viewfinder is actually a preview screen – and you are the first of the audience...

Composition
format
contrast

John Lennon, who as one of the incredible Beatles helped rock the music world with compositions unexpected and truly brilliant, lost his head when sitting for this studio portrait!

But isn't chopping off the subject's head one of the major faults against which beginners are always being warned? It is – if it's done by accident. The trouble with an accident is that you can't visualise the outcome of it! What, though, is a fault? A simple answer is that it's the error resulting from not sticking to the rules. And there we move into an area knee deep in confusion. It's all to do with that idea of rules.

Staying with the simple definition of fault, you can see that the most beautiful copperplate writing would be a fault, since it doesn't stick to the rules laid down by teachers instructing schoolchildren in handwriting! But that is nonsense. Everyone would agree copperplate writing is elegant, and much more attractive than a childish scrawl of 'the cat sat on the mat' variety.

Photography is, when you first begin to explore it, full of rules. And composition, the assembling of the shapes which make up a picture, is more full of rules than most other areas of photography. Here, the rules have to do with balance. A good composition is harmonious, they say, and full of balance. Trouble is, there are as many arrangements of balance as there are atoms in the universe! And as for harmonious – millions found the songs of the Beatles harmonious, and millions didn't! The point is that nothing, not rules and not technique, should ever come between you and what it is you set out to do with a photograph.

This portrait of Lennon appears high in contrast: that helps to prevent attention wandering over different textures and details, by simplifying the image down to one simple strong shape. And Lennon's head goes out of the picture. Why? Because it isn't needed! The viewer's eye will rove up to that expression and those powerful eyes and will stop there. If the picture demonstrates anything it is use of economy in putting across the message. There's economy of image, and of tone. The result is unfussy and straight to the point.

Composition is much influenced by the film format a photographer uses. Perhaps it shouldn't be, for all negatives can be cropped to varied proportions when they are being printed. But if you have any awareness of quality you will want to use all – or as much as possible – of your negative area. Now we've added another variable to balance, for a 35mm negative certainly provides a different shape to one of $2\frac{1}{4}$ square. What you see in the camera's

viewfinder will often be so powerful and persuasive in itself that you may find yourself in danger of letting the camera do the composing for you. Resist it! Never forget the camera is merely a tool.

It's not too far fetched to suggest (in portraiture at least) that you should actually take your picture in your mind's eye before ever you lay hands on the camera! Look, look again, and keep on looking and thinking until you decide just what it is you want to show. That decision will tell you which format to use, which technique, how close to go, whether to use a telephoto lens or not, whether to go for high contrast.

In this portrait the square shape lends an air of strength to the solidity and simplicity the high contrast brings. The eyes are high in the frame, and there's a sense of dignity.

Had a suggestion of elegance been required it would have been better to use 35mm – the long slender shape of the negative is very graceful. But here, use of the 35mm format would have meant either making Lennon's face smaller in the picture, or lengthening the dark shape of his body. And the effect just would not have been the same.

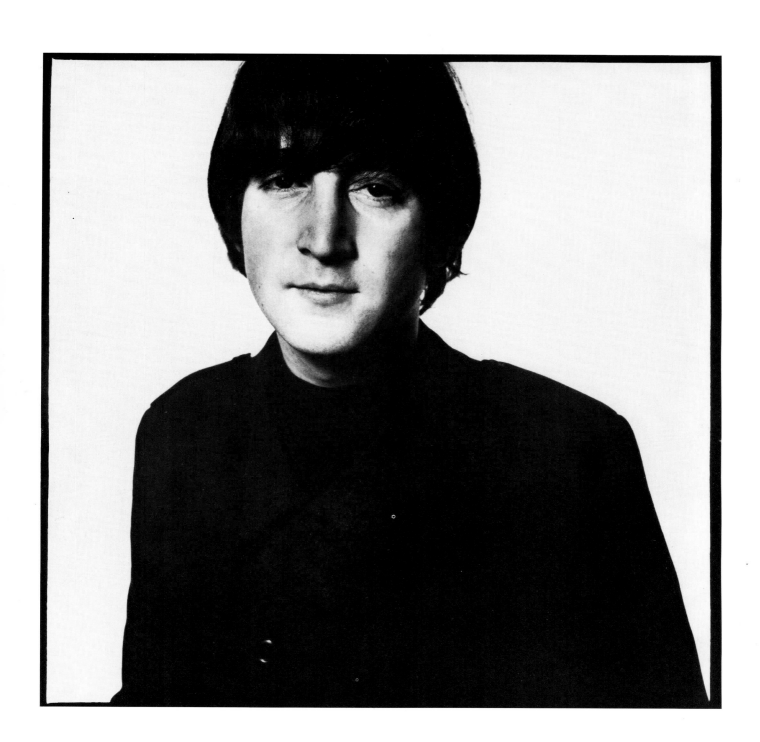

Composition
subject placing
compacts

On a street in New York a busker blows his trumpet: from all sorts of angles he'd make an interesting picture. But nobody is ever the centre of attraction all by himself. Though buskers are common enough there's always somebody around showing a bit of reaction; sure enough, three yards away here stands a man in bemused contemplation.

The picture underlines the opportunities to be had in reaction. Wherever something is going on there is always somebody reacting. More than anything else, this sort of picture suits the quickfire technique made so simple with the pocketable little 35mm compacts which can go anywhere and everywhere with you and will deliver, consistently, high quality images. In the quality stakes they beat the other pocketable contenders, the 110s. in all departments.

Incongruity, odd juxtapositions, will rarely let you down. If something strikes you as odd it's a fair bet those who see your pictures will sense the oddity too. And again the 35mm compact is an advantage. With its relatively wide-angle lens and extensive depth of field it will let you quickly and surely compose a view in which all the elements are together. Isolated, this trumpeter would tell a story quite different from the one he now tells with his audience included in the picture area.

The picture makes another point too, and it concerns subject placing. Camera makers have, and with reason, come to the conclusion that the *main* subject is very often placed in the centre of the frame: in consequence they have arranged built-in exposure systems to read from the central subject area; but here the centre of the scene is apparently empty! The main subject influences lie at the edges of the picture. Yet that empty central area is also subject, and is important – it establishes the relationship between the figures. So forget subject placing *within* a picture – the entire area should be subject...

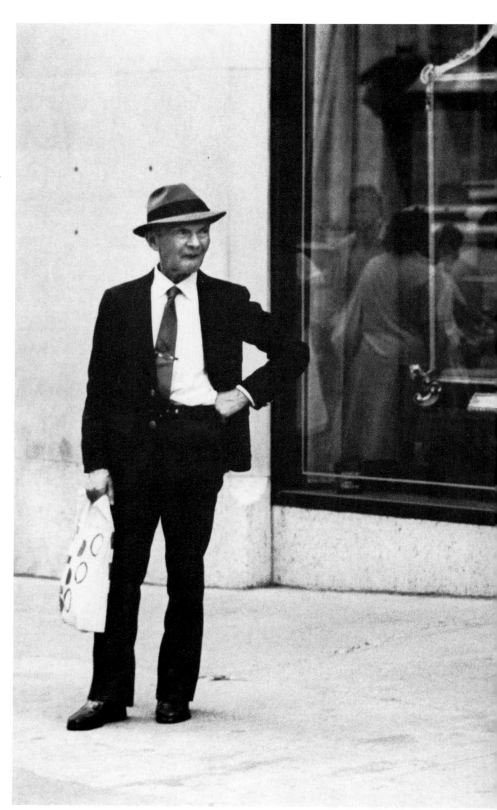

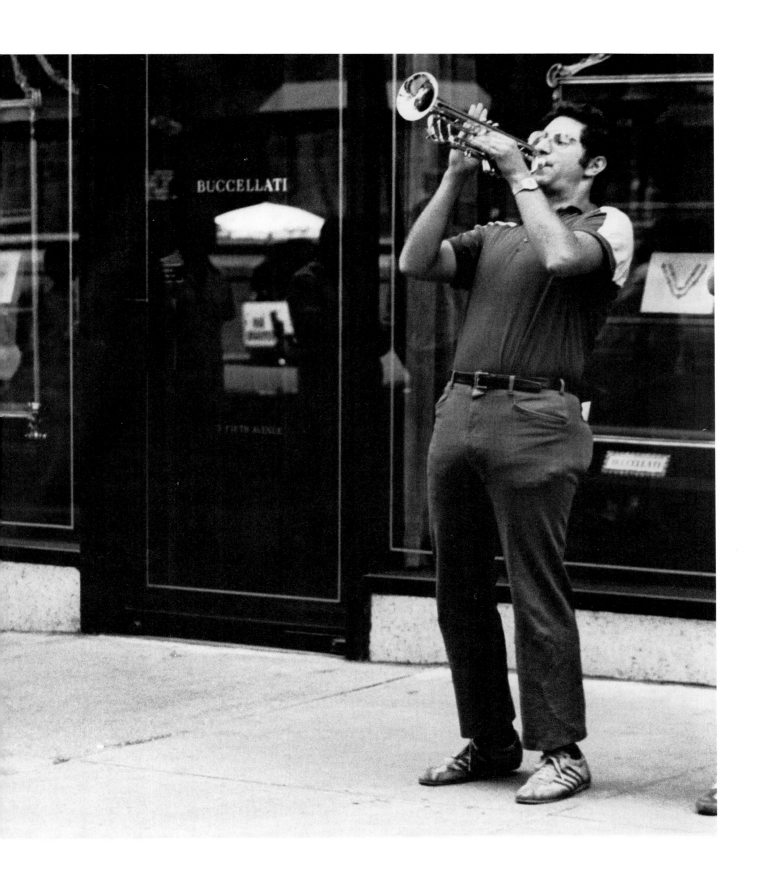

Composition
depth of field
contrast

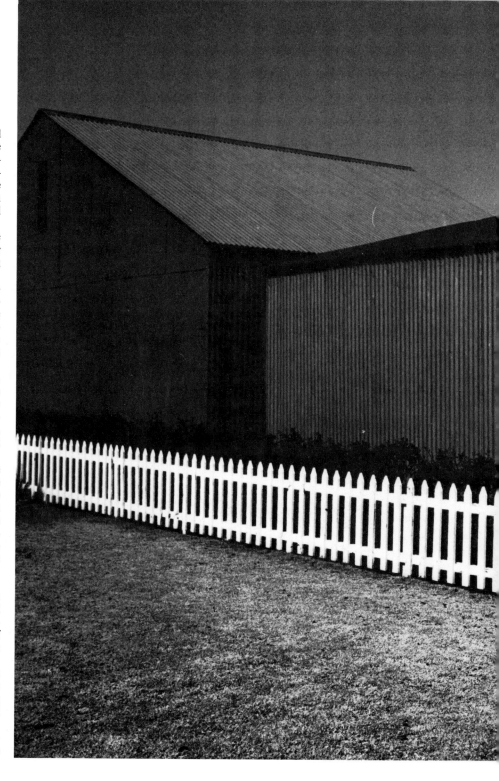

If you were to travel from the East End of London across to Surrey, and from there north through Birmingham and Newcastle, and on to Inverness, what a lot of dialects you'd come across. And it's for sure that if you examined the work of half a dozen dedicated photographers you would come across as many different styles.

Styles? Well, subject preferences may be a better description: you might find your half dozen different photographers showing you pictures of *very* different subjects.

Point is, before you can claim total involvement in, and sympathy with, photography you have to come to terms with the fact that you will often be looking at pictures which may be a million miles away from your own subject preferences. But *that should not cause you to scorn them.*

We are here treading a precarious path. In conventional fine art there are things we all understand – like a good nude by Rubens, and there are things thought obscure by the majority – some abstract work, for example. Much in photography might be thought abstract and obscure.

Open up your newspaper, look at the sports pages: there is Kevin Keegan in the act of slamming one into the back of the net; and turn to the front page and you know that's the way such and such a train ended up after de-railing just south of Potter's Bar. But dip into a book of 'art photography' and you may wonder what on earth such as Paul Strand are up to.

Paul Strand – who's he?

He was quite a big wheel in American photo-art circles, and was much involved in documentary photography and in pictures which made much of pure design of everyday objects – fences, houses. His work covered a wide range.

Here is a South African scene, which echoes Strand's design pictures; the white fence is particularly thought of as being 'his' subject, but he explored forms and rhythms endlessly.

But why should anyone set out to emulate pictures by such as Strand – or anyone else, come to that?

Simply because in doing something you experience the problems involved, and in solving those problems you appreciate other photographer's work – and perhaps extend your own capabilities too.

For example, let your eye roam across this picture and then ask yourself what problems might have been involved...

Here, there would have been two major problems to solve – getting the contrast sufficiently high for the fence to stand out as it does, and ensuring that depth of field was sufficient to make both fence and background as sharp as they are.

Solving such problems can *never* be a matter of theory alone. Nobody could give you a recipe which would enable you to go out and duplicate this picture. The steps you'd take would be dictated by the lighting on the subject, and by the subject's colours.

Here, all the shadows indicate there was a bright light falling on the subject. But was it sunlight, or moonlight? Moonlight *could* have created this effect, with the fence bathed in electronic flashlight to boost contrast. And sunlight could, too, have brought this result, with filters (red or orange) controlling the colour of the sky and the buildings, and a degree of holding back in the darkroom being used to separate fence from background.

So, whatever the lighting was at the time would have dictated the shutter speed to be used: for the requirement of great depth of field would already have demonstrated use of a small lens aperture. And use of filters, or slow speed film, would bring further influences. A tripod would have been necessary under very low light.

Remember, even low light casts shadows. When reading the work of other photographers concern yourself with examining contrast levels and depth of field.

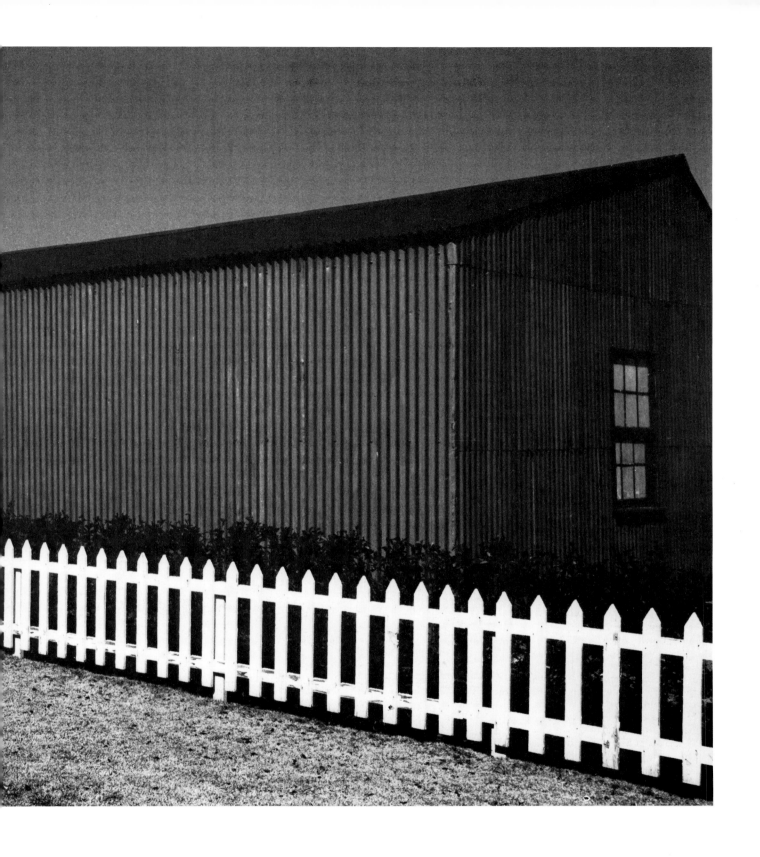

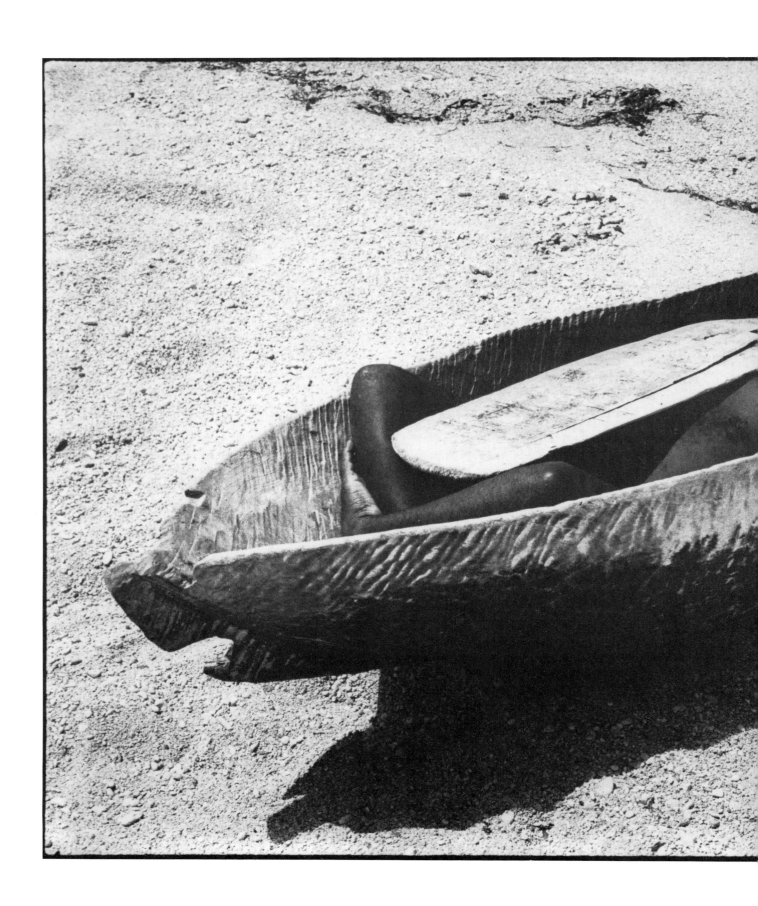

Composition
diagonals
subject arrangement

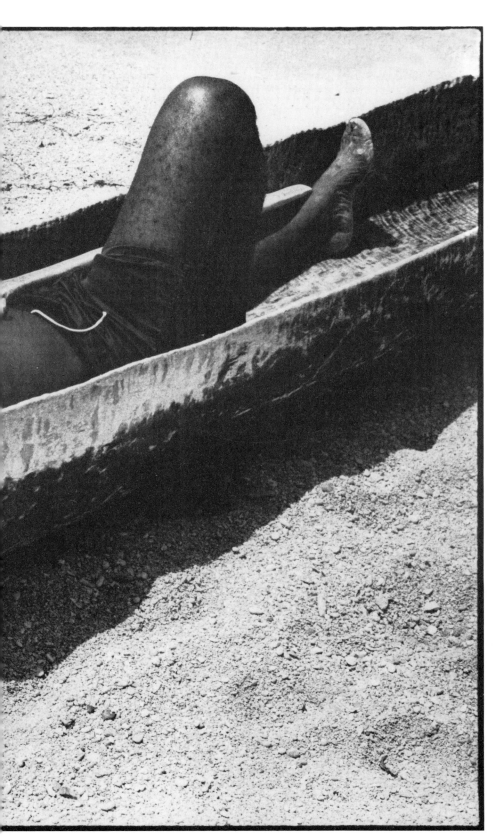

Let's get one thing absolutely straight: nobody can give you a recipe which will endlessly lead to perfection. There is no one set of precepts which will guarantee, under every circumstance, that you will deliver a masterpiece. Whatever else holds in photography this remains – that in the final analysis it is the mind which perceives and arranges and shoots any scene which is the ultimate factor.

All of that is but to set the scene. It is there to warn you against a too lavish adherence to advice. Yet, there is some advice which just goes on being justified...

It has to do with diagonal lines in a picture. And photographic lore tells us that use of strong diagonals leads to a powerful picture. And photographic lore, ninety times out of a hundred, is dead right!

Here is a picture made up entirely of diagonals – lines, slabs of tone. The pattern is broken only by the man's knee, and his left forearm: and both of those tell us instantly that he is sprawling luxuriously.

So, the picture shows a man at rest, in his dug-out canoe. An exotic subject, yes; one you won't find in the local high street. Thus, subject matter adds as much as does composition to the impact of this particular image. But consider in how many ways you could shoot a picture like this.

One very obvious way is to walk around to the front of the canoe and shoot so that the figure appears full length; the thinking there being that you might as well get all of him in the picture while you're at it! But now visualise the photographic effect of such an approach. You'd have a more or less vertical arrangement – though with the right lens and the right viewpoint that could be dramatic.

But vertical arrangements are notoriously unstable: they lack what photographers refer to as dynamism. The image itself then seems indeterminate, and the whole effect must rely very heavily on subject appeal.

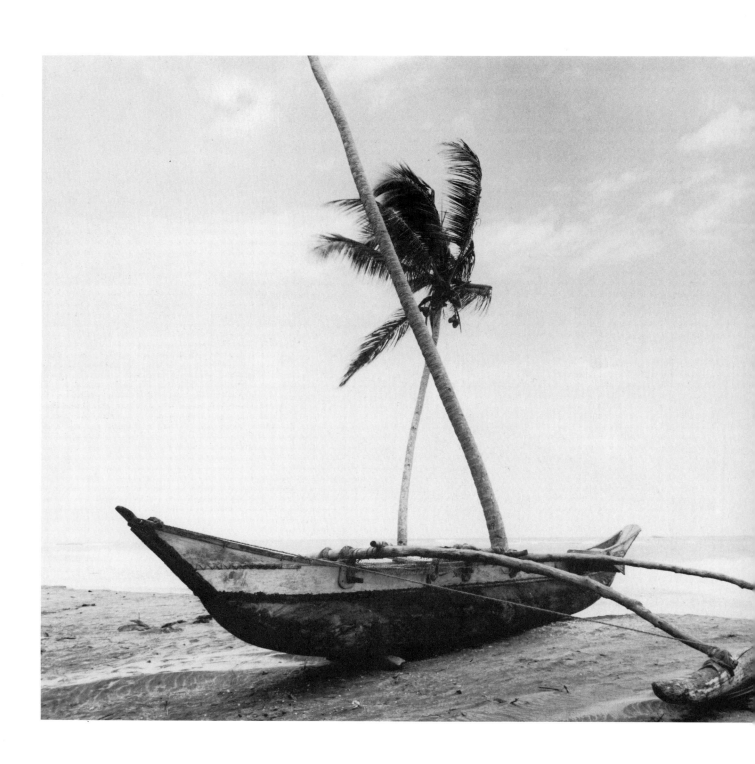

On a Pacific beach an outrigger canoe lies drawn up on the sand. Beyond, a palm tree soars upwards, out of the frame; more distant still, another palm spreads its fronds to the wind.

This is a wide-angle lens shot, and everything in it is crisp, full of detail, easy to examine. Even the clouds yield an impression; the picture plainly shows them drawn out, moving steadily across the sky.

But for the elements of palm trees and canoes, this is an empty place, so there is little competition for attention: the eye may leisurely take in all there is to take in.

And what is there to take in, apart from the detail, the clustered coconuts on the palm, the curious construction of the canoe, the various textures?

What more do you want!

There should be an assault on the idea that the newcomer to 'serious' hobby photography must go out deliberately seeking scenes which he can turn into works of art. Much more important is that he should go out prepared to shoot pictures of whatever interests him or her. In that way, the gradual build-up of pictures of interest will begin to yield some pattern. And that pattern should in its turn begin to yield some evidence of a style.

Art is not often successful if it is self-consciously worked at. And art for art's sake hasn't a lot going for it at all. It is a tricky subject altogether where photography is concerned, for each photograph has two values – three if you include the actual technical quality of the print, which really ought to be taken for granted.

The two major values are the interest inherent in the subject itself (and that interest may be captured just as easily by a child as by a mature expert), and the general arrangement of the picture – its composition, its sharpness and clarity through crisp focusing and adequate contrast.

Those two values may be quite independently satisfying. Thus the vintage tennis pictures of Jacques-Henri Lartigue may delight fans of the sport alone, because of the famous and legendary figures of tennis shown: but they may also delight photographers because of their arrangement, their sense of action, their pure pictorial appeal. When both values appeal to the same person, then you have a picture which is quite extraordinary, and may certainly be said to be art – or very close to it.

Of all the millions of exposures which have been made at major events only a very tiny minority live on as lasting documents, and mostly that is because the pictures display those two major values in some abundance. Many a sporting gem is still admired; but, showing nobody famous, it is condemned to reappear from time to time only in photographic coffee table books.

The truth of it all is that great pictures emerge from a combination of recognition of significant subject matter and from almost automatic response in arranging how it should be photographed. And by that yardstick there are relatively few great pictures. That is a fact, not a slab of 'wet-blanket put-down'! And recognising that fact should free the aspiring photographer from a depressing sense of inadequacy if he doesn't set the world alight each time he squeezes the camera's shutter release.

Armed with a new camera, bristling with controls, it is perhaps only natural that the beginner should feel ready to take on the world, convinced that his first set of pictures will contain at least a couple of masterpieces.

But masterpieces by whose standards? That will be his dilemma. Much better if he goes out instead with an eye open for shapes which interest him – shapes, rather than subjects. Looking for quite particular subjects is, to begin with, a bit like looking beyond the trees to that perhaps non-existent forest ...

Composition
shock effect
telephoto lens

It's just possible that nobody would know the names Salvador Dali and Pablo Picasso had those two incredible dream merchants decided to play things entirely straight. And maybe Alice in Wonderland would be less wonderful if Alice had avoided talking rabbits and spiteful queens. The ordinary somehow remains just ordinary, no matter how hard you try to convince people it's really extraordinary. The simple fact is, odd is in!

It always has been, truth to tell. And life is riddled with legends born of the strange and the weird. So we've begun here on a bit of a zany note – but zany equals impact, at least if you think of zany as ridiculous, and of ridiculous as being far from the norm.

Trouble is, photography is the last stronghold of the normal in the communications business – or the art business. The photographer is, more times than not, an altogether accurate portrayal of reality; it's a normal view of a normal event or scene before the lens. But as this book continually points out, the photographer has many tricks and techniques available to him.

What's wrong with the ordinary? Not much; can't be, since most of us spend most of our time doing ordinary things in ordinary surroundings. But where the ordinary, in photographic terms, is merely a statement of the obvious then it can be a bit superfluous. And if an ordinary photo is used in an otherwise dramatic story in a magazine then somebody is wasting somebody else's time! But it is important to get this into perspective.

What is ordinary and commonplace in one location may be earth-shattering in another. The photographer on the spot who decides that a certain ordinary event in the lives of war-ravaged people in some obscure town will make magazine readers in comfortable, peaceful civilisation realise with shock just what is going on elsewhere is transposing the ordinary, and in the process is making it dramatic. Heaven forbid that pure murder should ever be commonplace, but it is an accompaniment to war, and when *Daily Express* photographer Bill Lovelace photographed a mass bayoneting in Dacca some years ago he shocked a nation – by picturing an event which actually drew crowds!

The photographer who is also a storyteller is referred to as a photojournalist; he brings back pictures which are so descriptive they don't necessarily rely on reams of words to fill in their meaning. Of course, he may go to exotic spots with a writer, and the writer may construct the most elegant prose, but the photographer will, if he's good, do much more than just illustrate the words; he will create the images which stick in the mind.

What has all that got to do with photography as a hobby? Plenty! For every time you show your pictures to other people you're being a bit of a photojournalist yourself: you are, surely, trying to make them aware of some experience you've known – even if it may seem quite ordinary, like an autumn evening in the Chilterns. Most people have appreciated fine landscapes themselves, and most people have marvelled at a beautiful sunset. And to show them those things may be sufficient to evoke a response. *But maybe not:* the temptation is always there to assume that because you felt something fine at the time it will automatically show in your pictures. The scene you can show (and make sure you get the exposure right for the mood of the place), but the time and occasion are not so easy. And that's why it's always a good idea to look for the remarkable – for something just a little out of the ordinary to grip attention.

Here's a picture taken in a street in India. It shows a child in the arms of his parent. And the child is swaddled and looks secure enough in the arms of his parent. But when talking of a child in the arms of his parent we tend automatically to think of that parent as the mother. Here, the child is held by a man. And whatever the feminist movement may say, that is a circumstance bound to provoke a reaction. When the scene was observed in India, a poor society, a certain pathos is added. What has happened to the mother? Well, maybe she's simply too busy at home cooking the rice; but nothing can stem that sneaking feeling that in this case child and the man are everything to each other. You see? It's all a question of circumstance, and of a picture being capable of making the people who see it ask questions about it. And here we all are assuming the man is the child's father. Nobody can be sure, but the suggestion is strong. And because of it, the picture moves away from the ordinary.

So how do you impart the extraordinary to, let's say, that evening view in the Chilterns? One way, and a very easy way it is too, is by using a telephoto lens – and make it a long one, of at least 300mm. If you own a telephoto lens much shorter than that then put a 2 × converter between it and the camera, so doubling the focal length of the lens.

What a telephoto lens does is to pick out a narrow slice of the scene before you, and spread it across the same area of film as is covered by a standard lens. This little bit of trickery does strange things to scale, and it makes distant objects look huge in comparison with those nearer the camera. And if you use your long lens to photograph a sunset you will get a most impressive sun, looming very large in the picture. If you silhouette a tree (or a church steeple, or even a person) against the sun, the impression will be positively spectacular – and surreal.

That sunset effect is best when the sun is hazy, slightly covered by mist or wispy cloud. But if the sun is bright – as it might be on a cold and clear afternoon at the end of the year – don't view it directly through a telephoto lens. That *could* damage your eyes. Make sure you stop the lens down a good deal before lining up, or else fit a neutral density filter. But a weak sun is best of all – it won't do you any harm, and it will look more red.

It's always worthwhile looking at what the masters have done, to see whether you can identify the tricks they use, and to consider whether such tricks could serve you. For example, Bill Brandt – and there's a master for you – has created some very remarkable portraits, working outdoors in dull weather, using flash. The results force the viewer to concentrate on the portrait subject while the remainder of the picture presents a strange and unreal background.

The technique involves underexposing the background by, say, three stops, so that skies become moody and clouds look dense and trees are in silhouette; but the portrait subject is lit by a small flash unit. Obviously, the technique would not work in brilliant sunlight; all you would get would be a rather poor example of fill-in flash – since the brightness of sunlight equals that of any small electronic flash. But on dull days – or late in the afternoon or evening – the balance is right.

Using that technique above is a good example of presenting an extraordinary image, for the viewer expects to see people outdoors lit at the same level as their surroundings. But photography is full of ways of forcing attention by unconventional means.

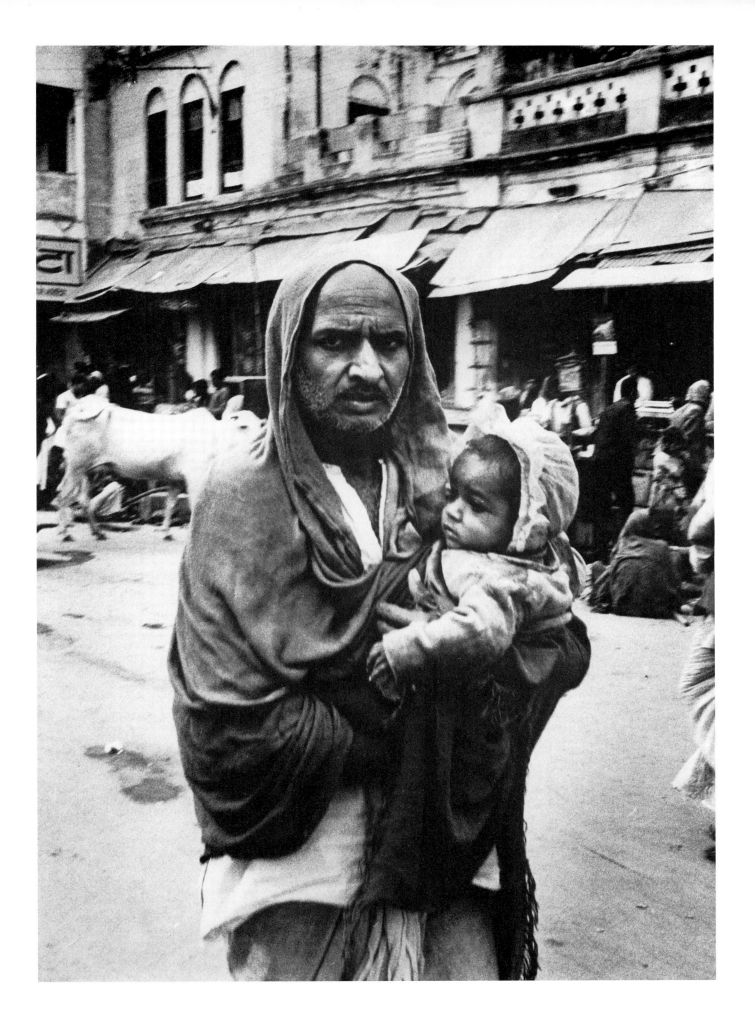

Formats
cameras

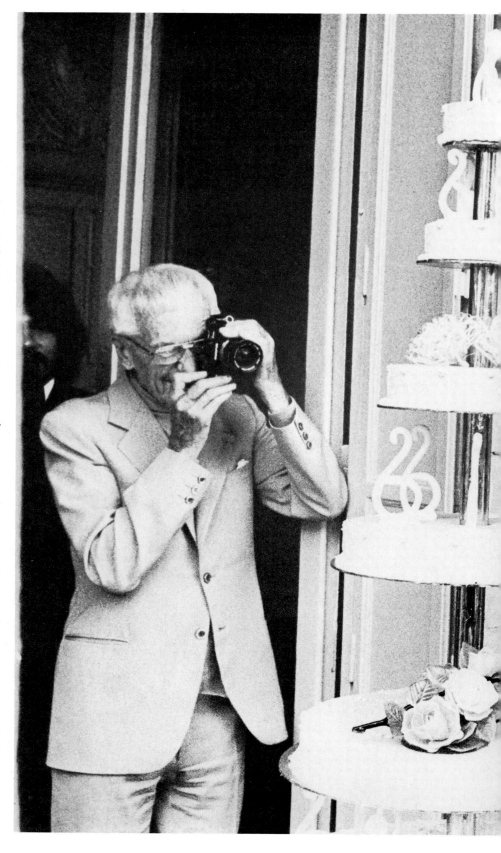

Here's a happy occasion, featuring Jacques Henri Lartigue at left, and Charlotte Rampling and Jean Michel Jarre at right, cutting the cake. And the picture has a brief lesson to yield, in the matter of film formats and composition.

This shot was taken with the camera held 'right way round', with the base of the machine parallel with the ground. But Lartigue is using his SLR on its side. No problem there, for one shot was taken to get in three people, somewhat widely spaced, while the other is more concerned with only two – and in a very close grouping at that.

It is obvious that a 35mm frame turned on its short end – that is upright, or in what is commonly referred to as portrait format – will include a greater height of subject matter than a negative on its long side. When the camera is held the right way up it is being used to produce what's known as landscape format, and the $1\frac{1}{2}$ inch *length* of the negative covers more of the subject, from side to side, than the 1 inch side does when the camera is on its side. That supposes that the same focal length lens is used in both cases, of course.

Photographers who work with square negatives have no such distinction to bother with: they may compose their pictures with the camera held perfectly naturally, safe in the knowledge that they may crop however they please in the darkroom to achieve any print shape they wish. That freedom has long been appreciated by wedding photographers particularly, and by press photographers too – though it is true to say that more and more newspapermen are now using 35mm cameras.

So, is there a difference in approach between use of a twin lens reflex camera and a single lens reflex model (or a 35mm compact, come to that)? Obviously there is – or ought to be. For picture shape matters a great deal when it comes to the effect created by the final print. Apart from the fact that you will occasionally be *forced* to turn your 35mm camera on its side, in order to get in all of the subject, there is the matter of overall impression – and a print which is wider than it is high tends towards a more gentle air than one which is tall and relatively narrow. Something to do with the way the eye feels when scanning from side to side, no doubt.

But if that impression is already there, in the physical dimensions of the print, then it makes sense to capitalise upon it, and to make the inherent impression act as a boost to whatever mood you set out to portray.

Suppose you are photographing a friend seated before you. With your camera held on its side you might very well end up with a picture full of lines going all over the place, and a mass of tones competing for attention. That would be all very well, if your aim was for a lively vigorous attention-grabbing picture. But turn your camera back onto its base, observe all the space you now introduce around your friend (though you may have to move back a bit to accommodate him within your viewfinder) and see how relaxed the impression now is. And adjust your composition so that he is not plumb in the centre, but over a bit to one side – perhaps leaning towards the centre, his elbow on a table – and you begin to create a quite distinct mood.

You may easily prove all these effect-inducing manoeuvres to yourself. Simply shoot one picture of each subject with your

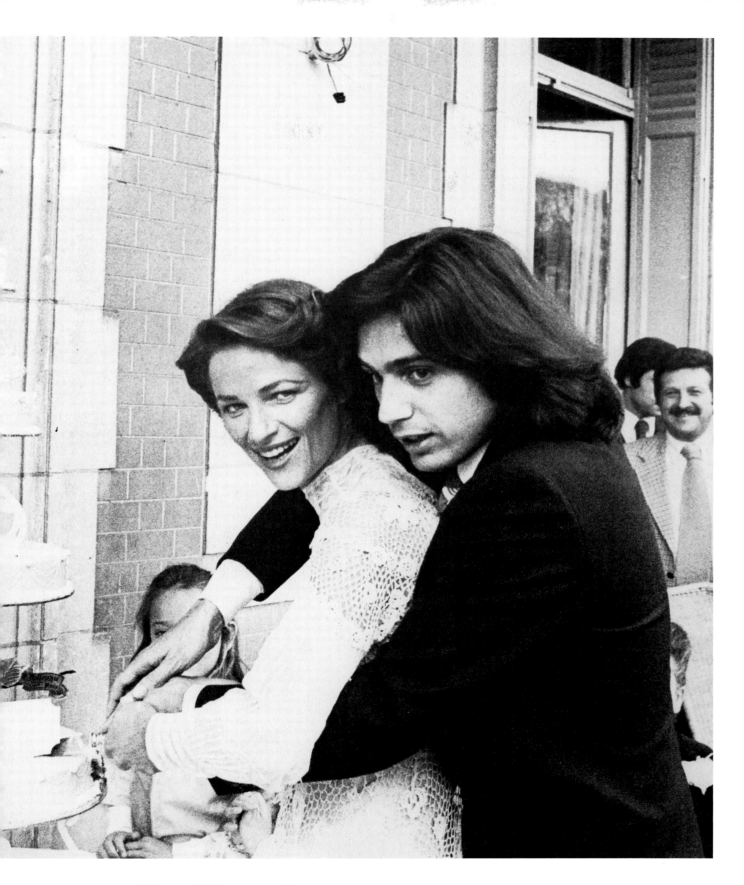

camera upright, one with the camera on its side, when you load your next film; then, at leisure, compare the results – and try the effects on others too.

You will be surprised at just how effective a control you have at your fingertips; all you have to do is turn your camera through ninety degrees!

Exposure
EV system
ASA rating

How odd it is that the Exposure Value system remains such a mystery. It probably has to do with the fact that there are already sufficient numbers and fractions in photography, and one more set may seem just about as welcome as a hole in the head.

It's possible photography was set back a good hundred years or so before it even got going – just by all the mystical mumbo jumbo the few knowledgeable experts of the day used to preserve their precious black art. Today, electronics and automation have brought relief and delight to millions, who now don't need to understand a lot about what the camera is doing. But in a way, that very proliferation of aid can be a bar to further understanding of how the camera/film combination works – which understanding in turn leads to very much more control and very much better pictures.

Here is a picture, taken in Milan, which might offer a number of impressions if treated in different ways. A slow shutter speed would give a great depth of field, because that would necessarily require a small lens aperture – assuming the film in the camera wasn't ultra slow. And a large lens aperture could throw all that busy background out of focus while keeping the foreground action crisp, where those men are fiddling with the toys. A particular treatment might make all the pigeons into blurred and swirling shapes as they lift off, and an extension of that treatment might turn all those folks into soft and slightly blurred 'ghosts', with the buildings crisp.

The point of the Exposure Value system is to help the photographer realise all those options, and to put them quickly and effectively into action.

An Exposure Value, commonly written as EV, is a number which actually represents a wide range of shutter speed/lens aperture combinations. And it is arrived at by allocating a number to each individual shutter speed setting and to each lens aperture. At aperture f/1.4 the number is 1; and it is 2 at f/2; 3 at f/2.8; 4 at f/4; 5 at f/5.6; 6 at f/8, and so on: at a shutter speed of 1/2sec the number is 1, at 1/4sec it is 2, it's 3 at 1/8sec, 4 at 1/15sec, 5 at 1/30sec, 6 at 1/60sec, and so on. Added together, the number for aperture and shutter provide the EV.

Thus, an EV of 9 represents camera settings of 1/30sec and f/4. But also of 1/15sec at f/5.6. And of 1/125sec at f/2, and 1/4sec at f/11 – and of any other combination which allows the numbers allocated to shutter and aperture setting to add up to 9.

How beautifully simple! Just one number, the EV, can indicate a whole range of possible exposure settings. In everyday photography EVs from 2 to 18 serve to describe just about every exposure combination the hobbyist is likely to come across. It is a very logical system. Taken further, an EV range from 16 to 22, which encompasses less than forty EV numbers, is actually sufficient to indicate every photographic exposure from dead-of-night conditions to shots during ultra-high-speed-flash-burst photography!

Many a professional exposure meter is calibrated in EV, but Hasselblad cameras are about the only contemporary models to feature the system in a mechanical linkage between lens and shutter settings: it is understood by professionals, and its efficiency is much appreciated, for it allows rapid switching from, say, a small lens aperture to a large aperture, in order to control depth of field – while the photographer remains confident that his reliance upon EV means that the right shutter speed is automatically set to compensate.

It is important to comprehend that EV is affected by the ASA rating of the film in use. EV is *not* a measure of light level, *it is an indication of exposure setting alternatives available with a particular film at a particular light level.*

There is nothing tricky about that: a higher ASA rating brings with it a higher EV, that's all. If at 100ASA the EV is, say, 12 (which is about right for a reasonably bright day), then you could shoot at a good all-purpose exposure of f/8 and 1/60sec. Changing to a 200ASA film means a one stop less exposure, and loading with 400ASA means two stops less. In other words, instead of f/8 and 1/60sec you could shoot at f/16 and 1/60sec on 400ASA: and since f/16 is represented by the number 8 while 1/60sec is represented by 6, the EV at 400ASA is now 14.

While EV is not a measure of light level, it is none the less quite reasonable that those familiar with it should soon equate the exposure alternatives it suggests with a particular level of light. Obviously, an EV of only 2, which indicates a possible exposure of 1/2sec at f/1.4 (amongst other alternatives, remember), relates to a low light level; any photographer with even only modest experience is also aware that those two exposure settings mean low light – even if he has never heard of EV!

The real value of EV is that the photographer can use it quickly to convert his camera settings to suit particular subject needs, while very speedily being able to assess which setting of shutter or lens is necessary to keep the exposure correct according to his original exposure reading.

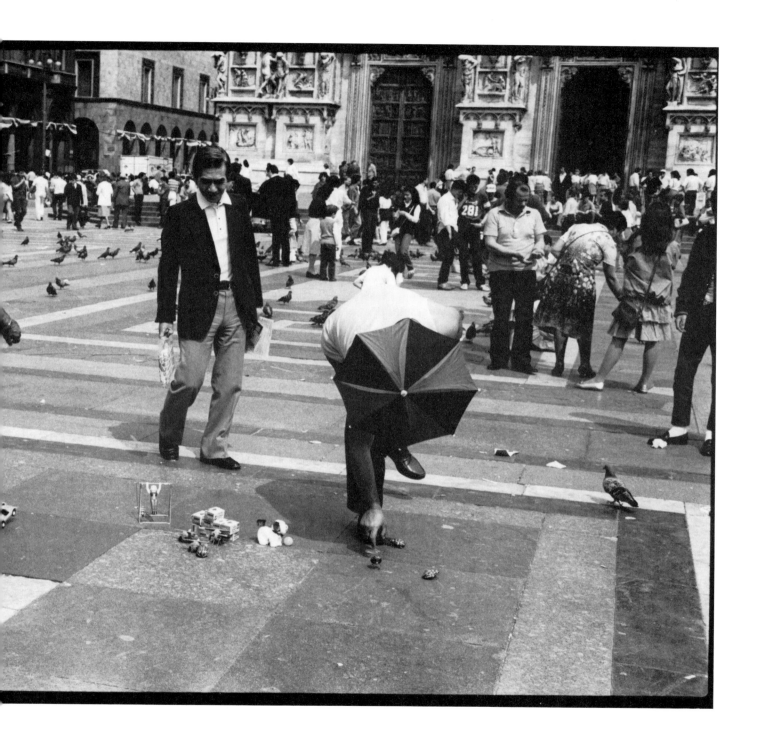

Contrast
overexposure
underdeveloping

In the beginning, any new hobbyist's preoccupation with cameras tends to obscure the fact that the machine is a mere 25 per cent of the picture-taking process.

In fact, the camera is second in the chain of the four elements which go to make up the picture. First comes the photographer's decision (what to shoot and how, from where, and at which precise moment) and then comes the camera (and its ability to cope with whatever has been decided upon); next comes the film – it receives the image, imparts its own texture and granularity, its own perception of fine detail and its inherent handling of contrast. Then comes the final element – which can in itself be a series of mini-elements like film processing, printing, choice of paper.

For many hobbyists the final link in the chain is forged by one processing laboratory which takes the film into its care and disgorges a handful of finished colour prints. Those who sally further into the hobby may take full control and process the film themselves – which gives much opportunity for adjustment – and may also claim even greater control by printing too.

The film is, of all four links in the chain, by no means least important. Each film has its own specifications: each has what is known as a characteristic curve, that will tell a potential user much about the eventual density of the film under varied circumstances of exposure (of *exposure* – not subject), while further graphs can be constructed to show effects with various developers, and with varying times of development.

To put it very simply, a film is not a construction of inert chemicals and chemistry, designed to produce one effect only: just as you can improve (or ruin, depending on your taste) a pot of tea by adjusting the brewing time, so too can you vary what a film will do.

That is complicated by the fact that different films begin life with differing sensitivity to light and with inherently differing degrees of contrast built in, and by the additional fact that different films will often behave differently in different brands of developer.

Essentially, black and white films offer the hobbyist the greatest opportunity to interfere with their behaviour. Colour films *can* be pushed to higher ASA sensitivity – easier and more controllable with colour reversal than colour print – but black and white offers much more scope for tampering.

Here is artist John Piper, in surroundings which could send the auto-metering system of an average SLR round the bend!

Piper is seen amidst brilliant white snow: he, and the tree, provide a very small presence of dark tone, and an automatic metering camera would very likely close down the lens aperture so far that detail would be quite absent from the artist's face. He would be in silhouette, though there would almost certainly be detail in the tree, and in the mounds and hillocks and drifts of snow.

The automatic camera, fed the information concerning the sensitivity (ASA rating) of the film, would adjust lens and/or shutter to a 'correct' exposure – on the assumption that the scene before the lens is more or less evenly divided into dark and light tones, or highlights and shadows. The camera's meter averages the extremes: you can see that here the camera would be fooled by the excess of brightness, and would assume the scene to be, overall, very bright indeed. This scene *is* bright – but Piper's face isn't! So, the photographer must, at times like this, step in and impose his will – either by switching to manual operation, by using the camera's over or under exposure control, or by outwitting the metering mechanism by adjusting the ASA setting.

But no matter what advice is given in photography, it is never too wise to say 'This is the only way'. Plainly, there is in this picture a high degree of contrast between the brilliance of the snow and the shadowed areas of the subject's face and clothing. It would be possible to render Piper in silhouette, or to expose in such a way that he would become a welter of detail. Such differences would be brought about by, basically, adjusting the camera controls. But for maximum detail, overall, in a scene like this it would be as well to bear in mind the limitations of whatever film is being used. For example: for full detail in both main subject and snow it would perhaps be advisable to reduce the film's ASA rating (or arranging for your processor to reduce it), which can be done by the simple trick of underdeveloping (film, not print, since an underdeveloped print is usually no more than a mess of grey tones).

Underdeveloping and overexposure go hand in hand. The overexposure puts onto the film detail from every corner of the scene; the underdevelopment merely prevents well-detailed areas of the scene from blocking up – thus obliterating detail through the difficulty in printing it (ultra long exposure times).

If you are, or are about to be, much involved in black and white shooting, and in subsequent home processing, here's a simple experiment which could teach you volumes about the behaviour of film developing combinations.

Take three films – one very slow, another medium, and one fast in terms of ASA rating. Expose them all at the same ASA value – say, 200. Adjust, or have adjusted, the developing times to suit. Then, a leisurely examination of the negatives will reveal to you that you have interfered with the contrast (and thus detail) handling capacities of your films quite substantially.

In fact, choice of printing paper is an important part of all this; for by selecting a hard or soft, or normal, paper, you can also do much to control contrast. So, consider that by choice of film, choice of exposure, deliberate control of processing, and finally by choice of paper, you can greatly influence the appearance of the final result – and you will soon begin to appreciate the great seduction that having a home darkroom may work upon those who wish to control precisely the results they produce.

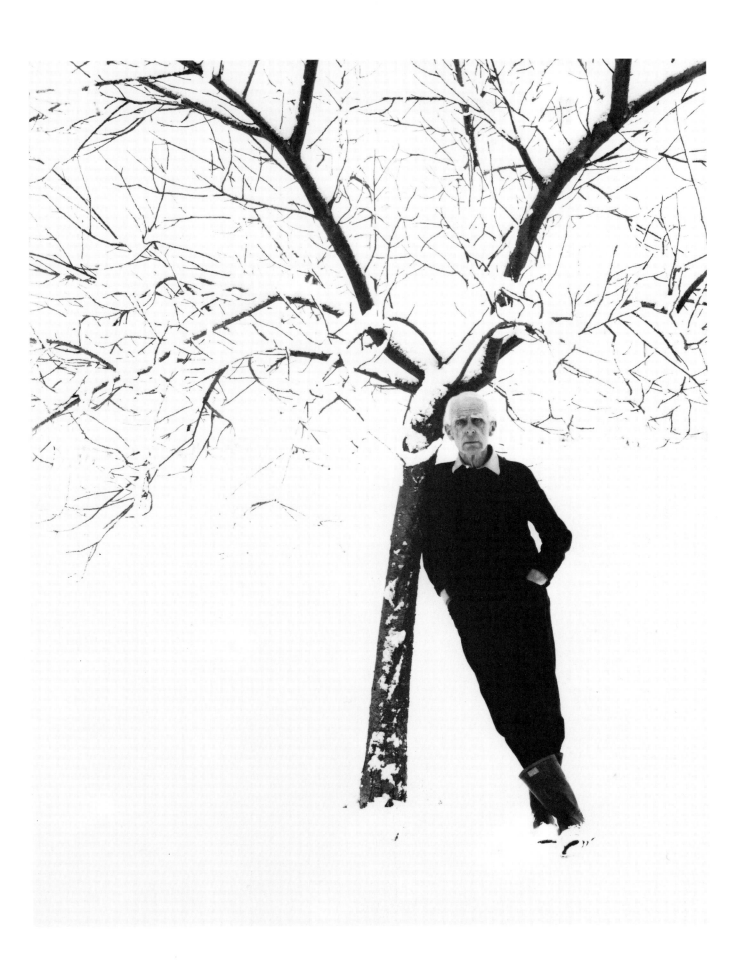

Contrast
detail
filters

What is detail, and how important is it? Detail is whatever you most want to draw attention to – and it is so important that if you fail to draw attention to it then you've fluffed your picture!

Here, a row of trees stretches away from the camera, trunks standing like ancient pillars. Each tree is, almost, a piece of abstract art: lichens dot the trunk in haphazard fashion, suggesting age and serenity. Without crisp definition of the lichens the picture would lose its point.

Thus, the subject dictated the technique – a small lens aperture in order to make depth of field stretch sufficiently to cover the subject from front to back.

In this picture, contrast is reasonably high. Not only does this high contrast help emphasise detail by its separation of tones, but it can make the most of a duff lens – bringing a very crisp appearance.

To ensure snappy contrast keep your exposures niggardly. Err towards underexposure rather than overexposure: in black and white photography you will produce areas of solid juicy black, in colour (transparency films) you will step up the colour saturation.

Ultimately, a result which is exactly what you want will have very little to do with the quality of the lens on your camera and everything to do with the way you arrange your subject.

In terms of emphasising detail the world of filters is, latterly, being ignored. Though the new breed of special effects filters does certainly provide a fair amount of fun, it is enlightening to go back to beginnings and use (with black and white film) green filters, red and orange and yellow filters. Each will exaggerate its opposing colour while subduing its own colour. Thus, a red filter will lighten red and reddish objects, while darkening green objects.

Detail is never – or never should be – accidental. Think of it as the 'punchline' and you'll never underestimate how hard you should work to make it significant.

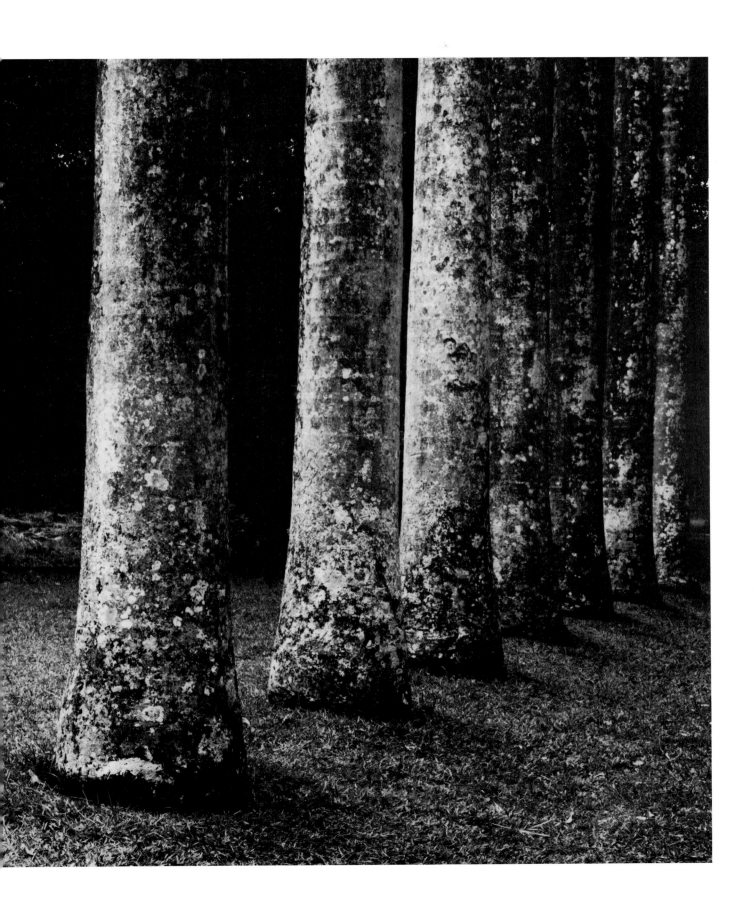

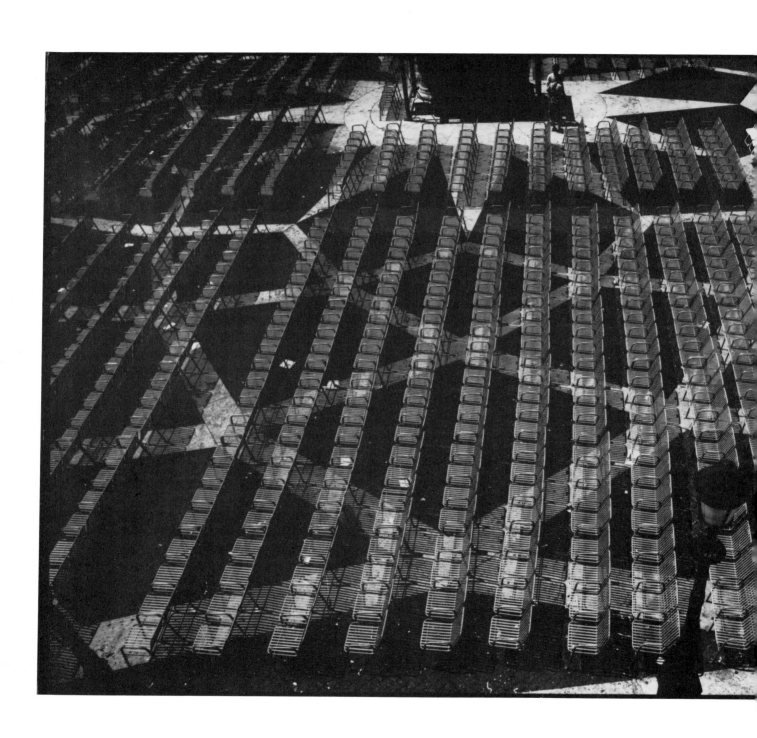

Nothing demonstrates more convincingly than does the business of contrast just how wide may be the gap between what the eye sees and what the camera sees. Or rather what the film sees – for any lens, given sufficient time, can cope with any lighting conditions on earth.

Contrast refers to differences of brightness between varying parts of a scene. It might be extremely high, as it often is in brilliant sunlight or under blazing studio lights or flash; and it might be very low indeed, as it certainly would be at twilight, or on a grey winter's day. Snow, however, because of its blinding brilliance, is a bringer of high contrast if there are also shadowed areas in the same photograph.

The eye can easily take in great differences of brightness, and if you were to switch your gaze suddenly from the dark alleyways of a little Spanish street to the glaring white sunlit walls you'd still perceive detail in each. Film would be very much less efficient – and it has to take in all brightness ranges in one go, whereas your eye may swivel from one area to another, with time for adjustment to the variations.

Black and white film can handle a scene in which the brightest part is about 10,000 times brighter than the darkest part, but colour film is not yet that flexible, managing a ratio of something like 125 to 1 only. The eye is streets ahead of both.

But what do those ratio figures mean? Well, black and white can handle a range of about 10 f stops, colour about 7, though the most modern colour negative films might manage 8, and quality is improving all the time.

That business of stops can be seen 'in action' by a simple experiment. Take an exposure meter up close to the very brightest part of a scene, and note which lens aperture is registered; now take a reading from very close to the darkest part, and check what lens aperture would now be required – assuming the same shutter speed, which you must maintain by whatever means your TTL camera or exposure meter allows. You will find that a dullish outdoor scene might register a mere three or four stops variance: obviously, that is well within the capabilities of both colour and black and white film. But a very bright sunlit scene showing a variance of 10 stops is beginning to get tricky, and would cause problems for colour film.

This photograph shows high contrast very graphically, the brightness ranging from those vividly lit and highly reflective seats at right, to the shadowed areas beneath *all* the chairs. Certainly there is less brilliance at left, but it is very important to realise that beneath the seats at right

it's just as dull as anywhere else: dullness, or darkness, or lack of brightness, is absence of light. Though this picture was taken in very bright sunlight, the black and white film has handled things reasonably well – since not too much detail was required at right. But colour would have fallen down here.

Contrast is product of light and lack of it, but certain steps may be taken to diminish its harsh effect on film. You could overexpose and underdevelop, you could use a reflector to throw some light into the darker areas of the subject, and you could use fill-in flash. Those last two methods work well by simply adding light where there was little, thus reducing the ratio between the brightest and least bright areas.

Don't lose sight of the fact that bright light by itself does *not* create contrast: it is obstacles in the way which cause shadows to obscure detail – that's the bugbear! In fact, a blazingly bright desert under a sorching sky, no matter how bright, could yield a perfectly well detailed picture, simply because the exposure could be arranged to cope with blazing light. But bright light and shadows *together* must have you on your guard...

Contrast
light
film

In light like this the choice is simple – underexpose or overexpose! Something has to go. And here it was the shadows, for that sandy arena would have looked very washed out indeed had the exposure been arranged to put detail into the faces of the audience and the flanks of the bull.

Every single sparklet of light which hurtles out from the sun starts life like every other sparklet – but how things change by the time light collides with earth. The character of light beneath the tree canopy of the jungle is very different from that in the mountains.

Trees will infuse a gentle green into light, but there are other changes which affect colour too: sundown certainly does, and light bouncing from any surface will take on *some* of its coloration.

Colour does not affect contrast though. It is unhindered light which sends contrast soaring: the dissipating effect of cloud cover breaks the headlong journey of light and bounces it in all directions.

Bounced light is soft light – at least when it is bounced in so many directions as to be *thoroughly* diffused: here, there is just too much strength in the light on the sand and too little in that reflected from the shadowed side of the bull.

Colour film is much less tolerant of high contrast that black and white film, and a colour picture such as this would be a complete wash out. That's what is behind the frequent advice to avoid taking colour pictures in harsh sunlight. And it *is* true that it's better by far to shoot when the light is gentle – early or late in the day – and when there is just enough cloud for a gentle overcast day.

When contrast is levelled *all* colours will appear more saturated, whereas in bright light some will wash out, some will underexpose. Don't imagine the sun is a liability though – but it's less kind to photographers than rumour has it!

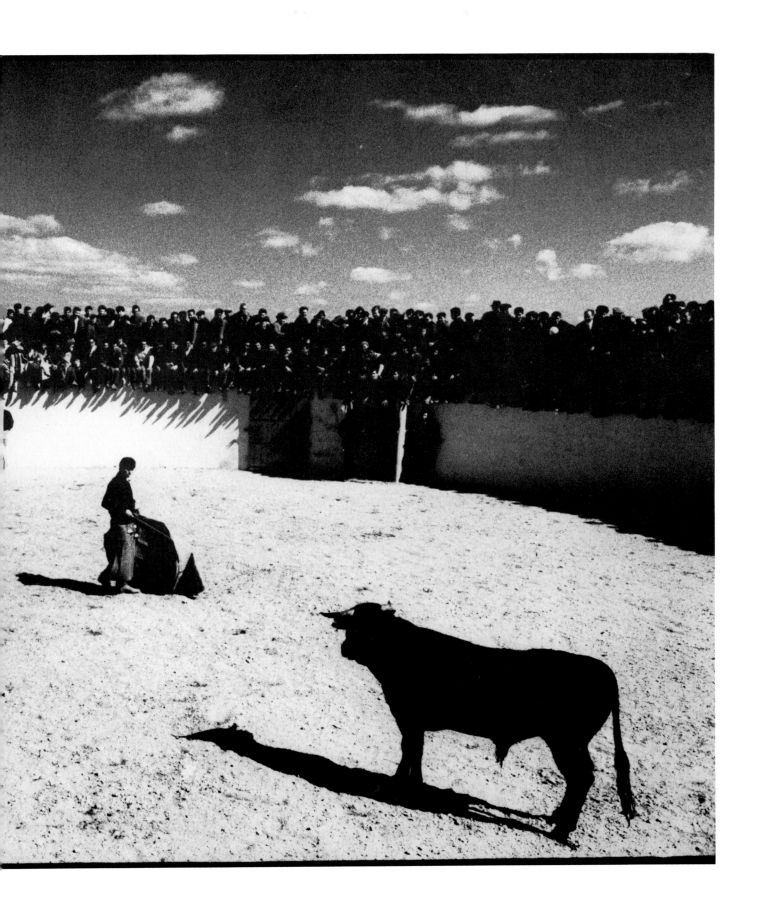

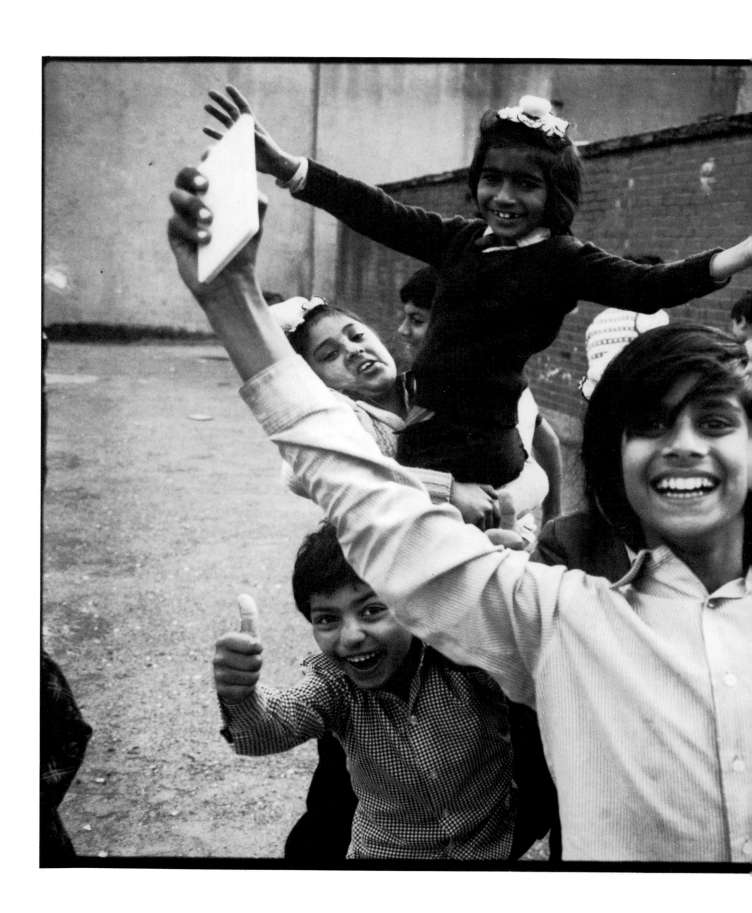

An exuberant group of young Sikhs, as yet un-turbanned though already wearing the hair tied in a knot, here help to demonstrate the characteristics of the wide-angle lens.

When photographing people, lenses of 35mm and lesser focal lengths force the photographer to move close to his subject – to within six feet – if he wishes to maintain anything like a full size or a head and shoulders rendition. At the widest – 21 or 24mm – he'd be as close as three feet. At which point distortion is likely.

But it is very important to understand what kind of distortion: it won't *automatically* make a face look comical or gruesome.

In fact, provided the subject is contained within one plane which is parallel to the film plane, little distortion will be evident. It is where a close subject has considerable depth, extending through many planes, that distortion shows – then it is distortion of relative image sizes. As parts of the subject are further from the camera they appear to diminish in size much more dramatically than is evident to the eye, or to a standard lens or tele-lens.

There is apparently great difference between the apparent sizes of these young lads, so much as to begin to persuade you that the *actual* sizes are very different too, and that the one in the dark pullover is really quite a midget. But common sense tells you that they are all pretty much the same size, and that they are grouped quite closely together – see how the chap at left is crouching to look under his pal's upflung arm.

This apparent distortion of perspective is a product of viewpoint, not of the lens at all. The only thing the wide-angle lens does which the standard doesn't is to take in a much wider angle of view, and to do that it has to diminish the image size – make things seem smaller. That in turn introduces the temptation to move closer, in order to step up image size.

Candid shots
camera position
composition

This is one of those pictures which used to be referred to as 'candid'. Well, it is that to be sure, for it shows a group of ladies sitting in a park taking their ease, unaware (or are they?) they are being photographed. But to label the picture in that way is to limit the exploration of it, so that it doesn't then yield up all the points of interest within it.

Candid photography suggests the surreptitious. And the more we think of that the more we find our minds full of thoughts of hiding the camera, of making ourselves unobtrusive, of catching our subjects unawares. One of these ladies is actually eyeing the camera: so, is the shot a failure? Now some will argue yes and some will insist it isn't – and both factions will, simply because they have categorised the picture as candid, miss the point!

A quick examination will tell you the camera was not at conventional eye level here. But it is not the camera's actual height which matters – much more important is its position in relation to the line of ladies.

Imagine this scene viewed from above, as if you were hovering in mid-air. The bench forms a straight line: at one end two ladies huddle together, while the third sits apart, at the far end of the bench. Now pinpoint the camera position. It was closer by far to the lady in white, yet not so close as to make her ridiculously large in the frame – as would have happened with a wide-angle lens of, say, 24mm used in such a way as to produce an image of her as large as here. It matters little whether this was taken with a standard 50mm lens or one of modest wide angle, such as would be fitted to a 35mm compact camera: what matters, and what produces the particular effect, is the camera position and the relationship of the subject parts to each other.

Imagine the effect which would have been produced had the camera been fired from a position between the two major parts of the subject – the single lady and the pair of ladies. The impression conveyed then would be similar to here, but more geometric – more dependent on balance of lines and shapes and tonal masses. That, you will see, adds up to an altogether different exercise!

Here the subject is neither two women nor one woman – and it certainly isn't three women! The subject is the relationship. And it is that subtle point which would have been lost had the camera been used from such a position as to give equal prominence to all three people. The curious lady in the foreground isn't exactly sinister (her white clothing combats that) but she certainly has an air of separateness about her – you might even call her mysterious,

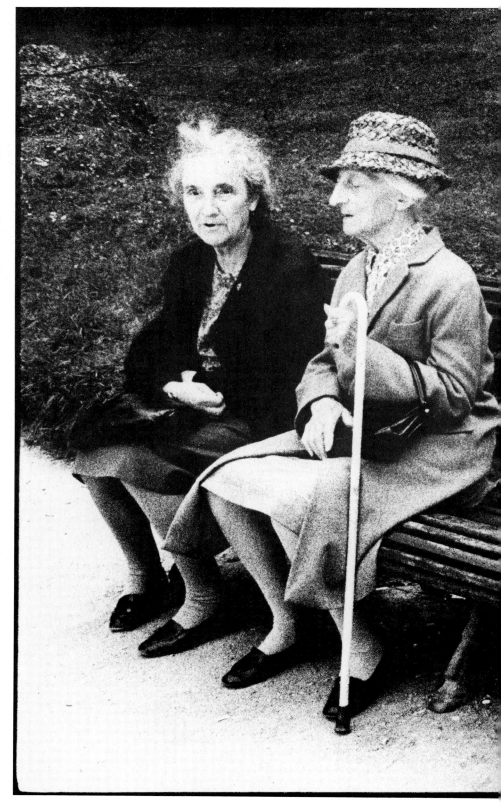

with those dark glasses being worn on a day which is not awash in sunlight!

No matter how long you look at the picture it is that foreground figure to which the eye returns; effectively, she has been thrust into the prominence her appearance immediately suggested when spotted 'in the flesh'. And it is making decisions about your subject which matters much more than category, or grain, film used, or focal length of the lens. Camera viewpoint is your most sensitive choice.

Candid portraits
low light
exposure

Here is one of the world's most humorous and sharp-witted men, the American S. J. Perelman. Maker of movies, writer of books; here he sits, in a restaurant – fuelling the mind which brought the world a million chuckles.

Outside his own studio a photographer, no matter how celebrated, has no advantages over any other. And this is a picture grabbed in the relatively low lighting which restaurant owners arrange for their customers' comfort, but certainly not for elegant portrait effects!

It has, though, worked well enough to suggest a hint of the restless animation of Perelman. And in that, the picture is a piece of praise for the concept of 'have a go'.

Of course, a technically perfect photograph is well exposed, crystal clear and bitingly sharp; the subject is well lit and probably sensibly posed. But such a picture may also be sterile in terms of pure interest. Only may, mind you. The point is, no amount of attention to technical matters will guarantee success unless the subject is right.

But the subject is right more often than are the other circumstances. That is what is behind the steady advance of automatic cameras: the makers aim to equip us with machinery which will handle any subject fast, without fiddling, so that we may catch any subject speedily, shooting almost as a reflex action.

Most of the big manufacturers have now included in their ranges cameras which feature programmed aperture and shutter control – a mode scorned by the greybeards of the hobby (and by many professionals too) only a few years ago. The thinking of the diehards was, and is, that if you can't do it all yourself then it's not worth doing. And it is just such an attitude which has scared off thousands, leaving them quaking with fear.

Today, nothing could be more unfortunate. Of course a professional studio is still stuffed to the rafters with highly sophisticated gear and lights and exposure meters. But even a simple 35mm compact camera will produce the goods some of the time, and even most of the time.

Let your eye roam across this picture. Register the fact that some areas are in deep shadow (or appear to be) and other areas are burnt white by light too bright to allow the film to record detail there. Indeed, Perelman's face shows both deep shadow and burnt out highlights.

In *any* location where there is bright light (house lamps, table lamps, street lamps, candles) some of that light will record on photographic film. It is simply a matter of waiting until the light is where you want it, and then shooting quickly. Imagine the

effect here if Perelman's head had been turned the other way, perhaps his face inclined down towards the table. Obviously, there would not have been sufficient light on the face and we'd have ended with a murky blob.

Alongside the advances in automation have come cameras which 'talk' to us. At least, in the viewfinder there is an increasingly large amount of information. Particularly common is that little light (usually red) which glows to tell us we're in danger of underexposure, and we really should switch to flash. Slavishly nod your head in agreement and fit your flash: you'll get your picture, but it may be a little harsh, and without atmosphere.

Suppose you were to shoot anyway, in spite of the winking red light which is insisting you shouldn't. You'd still get your picture – provided your subject was lit roughly as seen here. You'd get lots of shadows, yes, but some parts would be right.

Automation is fine, but it is geared to solving generalised problems and offering generalised solutions. And auto exposure metering (in simple cameras at least) measures the entire subject area, to arrive at an estimate of the average quantity of light on your subject. The system is nowhere near sophisticated enough to tell you 'Perelman's face is fine for an exposure, but his jacket will be a bit shadowy down there by his right pocket'. But your mind can give you that sort of information – and you should be ready to have a go. If you don't try, you definitely won't produce pictures.

Some cameras don't allow you to argue with them! Some will lock when the light is too low for a reasonably good *overall* exposure. What then? There is a solution – but remember we are still talking only of subjects in an unevenly lit environment, in which some parts of the subject (important parts, faces) *could* still yield a satisfactory image. The solution is to adjust the camera's ASA setting. Go higher: turn the setting up to 400 or even 800ASA. That will fool the built-in exposure meter into believing there is a fast film in the camera – and it will probably then agree that there might well be sufficient light for a picture.

Be warned – you will have some flops. Everybody does when working in tricky light. But the more you dare to have a go in difficult lighting the less tricky the lighting seems next time – and you begin to understand it all very much better. Do not, ever, let your camera dictate to you.

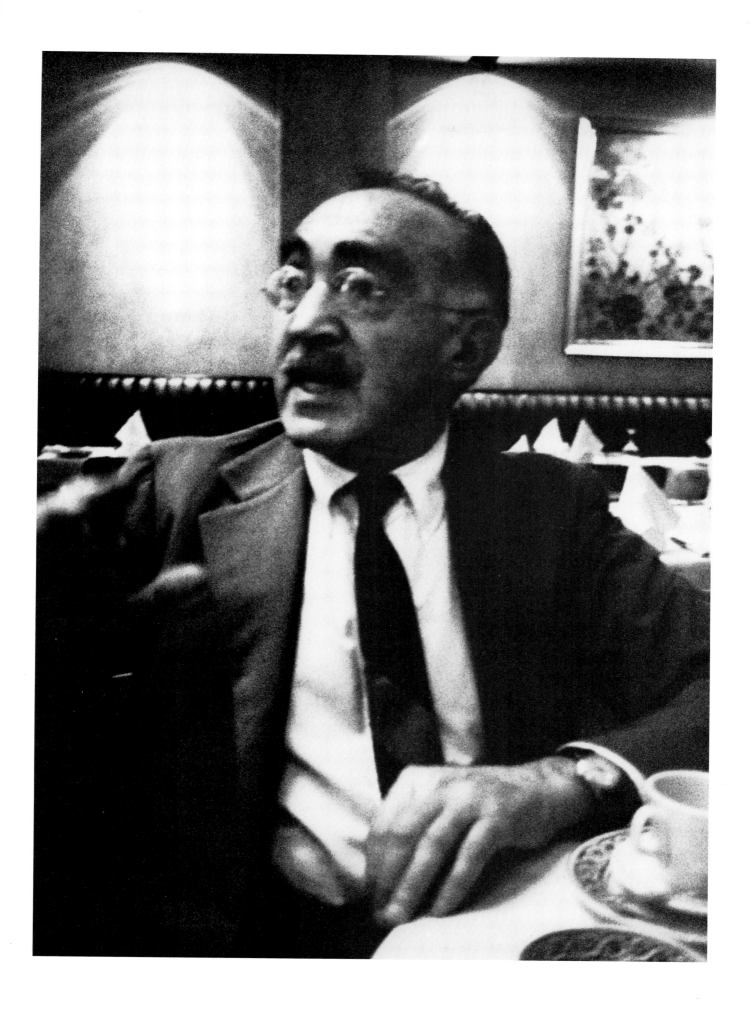

Portraits
subject choice
posing

Here's a face well known to the fashion conscious cognoscenti of the eighties. It belongs to Steve Strange, singer, club owner, and setter of trends which might give your grandma (or even your mum, depending on how switched on she is!) very severe heart problems...

Not everybody accepts the way things are today, and no doubt many a young lad has hit trouble with his family for sporting a ring in his ear, wearing make-up, and dressing with much more flamboyance than his dad ever did. So, what has changed! D.A. haircuts and beetle crusher shoes and slim Jim ties and Teddyboy suits caused the same problems, and the fashions of the nineties will no doubt create some too.

Here's a suggestion which might help widen your understanding of photography just a little bit more: take a trip to your nearest portrait gallery and go round leisurely, examining the many pictures of people of the past. Note how different they appear, even when painted within a relatively short time of each other.

The Victorians differed from the Edwardians, and the nobility of two centuries ago were hugely at variance with either. Styles changed immensely; but the painters got stuck in and recorded all the frills and the lace and the gilt and the jewellery – in the process creating a very accurate view of how things were in their own times. And look at the lighting in which the old painters portrayed their subjects: sympathetic, arranged to complement the image, actually adding much to the information on the canvas.

The point is made? It should be! A photographer with access to subjects representative of today should get on and picture them as is! And most young photographers surely are surrounded by dozens of friends who wear clothes of today, the current hairstyles, the faces of the minute.

There isn't here the intention to persuade you that all portraits should be precious social documents; but it is true that the minute you start letting any strong views of your own creep in you stand in danger of destroying the honesty of your portraits. Now that is a tricky area, and some truly great portraits have been made only because the photographer *did* overlay a personal view: Arnold Newman pictured arms manufacturer Krupp in a very sinister way, by considered application of unusual lighting, and Bill Brandt's portraits are always beyond the obvious. But to make a portrait great because of your own point of view, then that point of view has to be simple, punchy, easily understood.

There is nothing wrong with a straightforward, perhaps even simplistic (in lighting and background, that is) approach to your portraits. Simplicity is often the order of the day when it comes to exploring any new subject area.

Like most of photography's great themes, portraiture is a complicated one. It may be said to stretch from being a mirror of reality, as it is here, to being photojournalism. It isn't what you shoot – it's how you shoot it! What that means is that you should always ask yourself to consider why you are shooting such and such a subject in such and such a way: if you find it difficult to answer, then find another way...

Aimless shooting will of course afflict just about every beginner – it's a natural desire to want to try out new equipment, to live in expectation that the next shot will be a masterpiece. But quickly, very quickly indeed, get over that – and start developing very sound reasons for every approach. It pays to have some sort of motivating force.

And one good reason for portraying your friends could be that they are representative of the times they live in – a reason which is as good as any other. Don't be dramatic and don't be over heavy on comment – just shoot straight pictures.

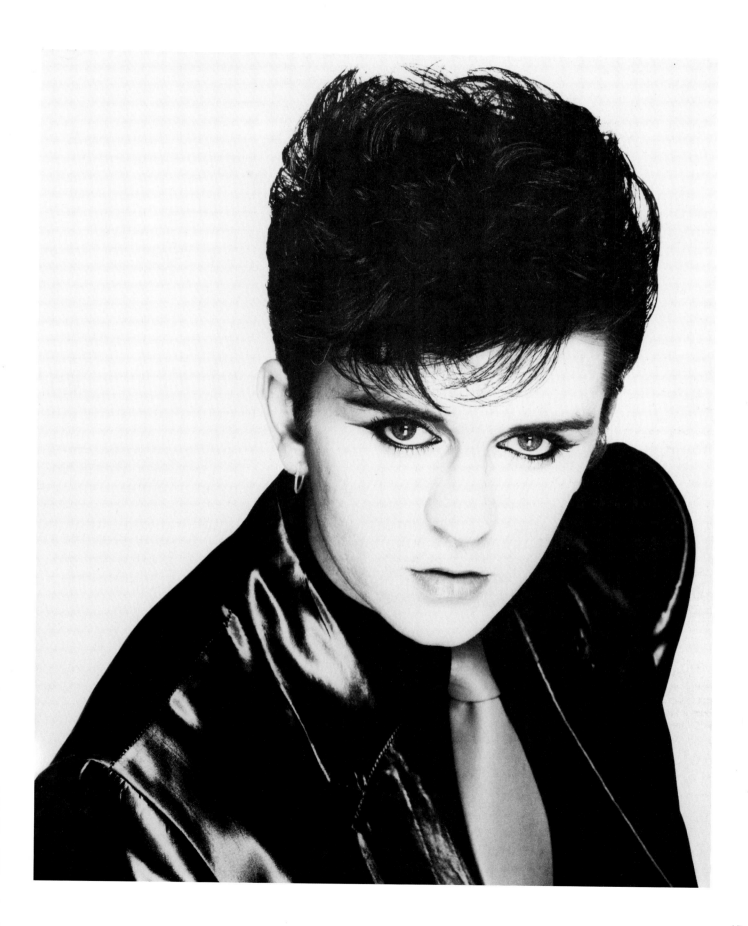

Portraits
composition
zoom lens

Sir Frederick Ashton, man of the arts, peers through a decorative hole in a decorative wall. And with his exotic hat and determined pose he makes of this portrait a decorative picture. But the significance here for us will be the use of that arch, that framework, not the fact of the portrait itself.

Out there in the world upon which the sun seems rarely to shine – in Britain at least – bald and empty skies must be numbered high in the list of public enemies. At any rate, an empty sky, featureless, without tone or clouds, is a terribly uninspiring framework for fine buildings and sweeping landscapes.

And photographers have long been aware of the decorative qualities of arches of stone, of trees, of gates, to 'fill in the empty spaces' and hold the picture together.

The idea is that something dark, heavy, solid, around the edges of the picture will remove that sense of emptiness, and will effectively keep the eye involved with the main subject, focusing attention there. And it does work. Even after you've looked at this picture of Sir Frederick for a couple of minutes, chances are it is his eyes and his hat, his well worn face, which you will recall – and you won't at all have been distracted by that surround of complex masonry.

Here, of course, both Sir Frederick and surrounding stone are in the same plane: and the comparative sizes of each remain, in the picture, as they were in reality. And common sense and judgement tell us this stone arch is little more than three feet high. Yet, that is quite high enough to provide a perfectly attractive framework for something as massive as, say, Nelson's Column.

It all depends upon the relative distances from the camera of framework and of subject, and upon the focal length of the lens in use.

In fact, in Paris there are bridges with 'holes' in their stonework which are mere inches high, but which can beautifully frame the distant Paris architecture if you move in very close and shoot through them with a wide angle lens. On the other hand, shoot through the Arc de Triomphe, using a telephoto lens from a great distance, and the mighty arch can be made to shrink to such proportions that it will form a pleasing frame for the scene beyond.

This scale-adjusting quality of the focal lengths of lenses is, or ought to be, considered every bit as valuable as the facility of putting a bigger/smaller image of the main subject onto film. But, never forget that perspective – the relationship between sizes of different objects – varies with the distance from which those objects are observed: focal length of the lens doesn't affect that one jot. When you have moved yourself into such a position that any two objects seem in pleasing harmony with each other – then is the time to think about the focal length of your lens. And if you have only a fixed focal length lens then you are stuck with making do with whatever image size it records. Perhaps you can enlarge a section of the picture later – and with the fine-grained films now available to us that is a perfectly reasonable option. But the man who shoots on colour negative material for enprints only, or on transparency material, may not have that luxury available to him.

His salvation will lie in the use of a zoom lens. And if he is off to shoot pictures in some holiday city stuffed with fine buildings and pleasing views around every corner, then his choice of zoom should sensibly be something going from wide angle to modest telephoto.

So equipped, he can move in close to even quite small bushes and shrubs, stretching their dimensions to make them frame the most grand buildings and vistas. And moving back from doorway-sized arches he will pleasingly frame quite distant sights.

New owners of zooms may be forgiven for not being completely aware of this magical quality of their lenses – since so much time is spent selling zooms for sports photography alone, or for getting close to distant subjects. But that ignorance can soon be put right: take your zoom out into the streets and select two significant subjects, some distance apart. Start by viewing them from close to, and then walk away, stopping for another look through the zoom every ten paces, but adjusting the zoom to keep the nearest object the same size. Immediately you will see – and understand – what control of perspective really means, and how much it can be at your command.

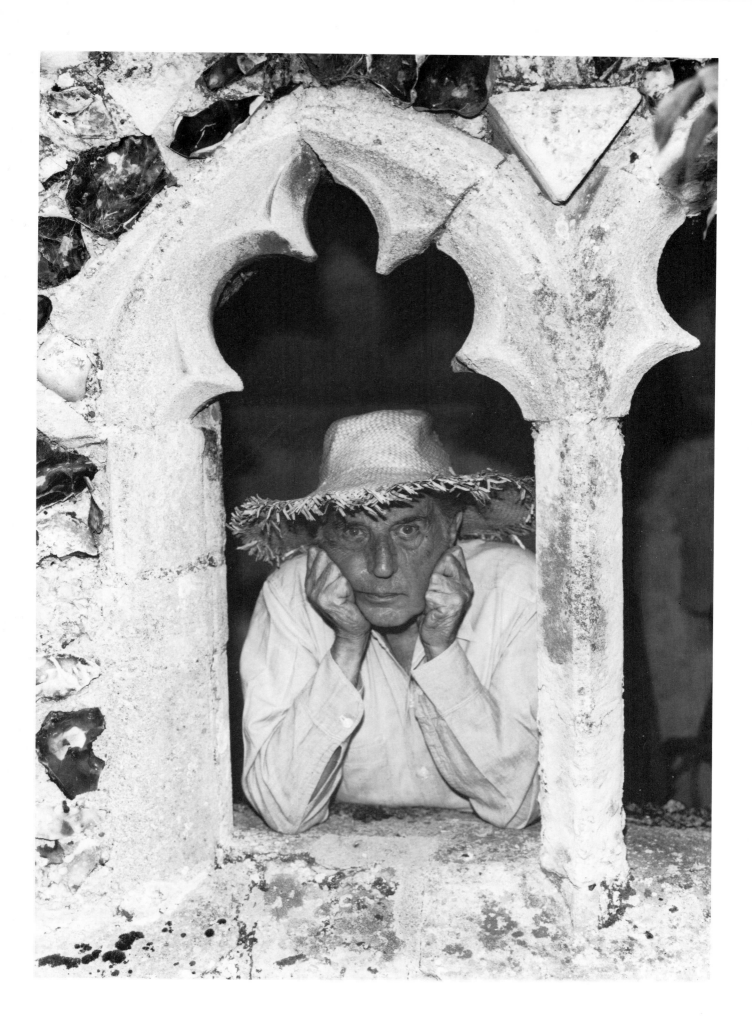

Portraits
composition
simplicity

For some strange reason (perhaps by osmosis!) photography has been littered with fads and fancies – periods of abundance of one special style.

And one such style which has enjoyed a popularity beyond what it truly deserves is that of surrounding portrait subjects with the paraphernalia of their calling. In particular, artists were to be seen surrounded by canvases, peering through holes in sculptures. The point of it all was actually quite valid, but the style suffered from attempts to cram too much information into the pictures – and so too often it would be information so subtle that not one in a hundred would grasp its significance.

Example? Well, imagine trying to portray Lowry, painter of Northern cityscapes and much skilled in suggesting population by dotting his pictures with matchstick people. To suggest that, a photographer might very well have portrayed Lowry (perhaps with a wide-angle lens, perhaps by printing trickery) as an elongated character. But that would have little or nothing to do with reality; it would be a visual pun.

Puns, visual and otherwise, can work – and immensely well. But their seductive power far outweighs their actual value. The object of a portrait is never to show how clever you are, rather to interest and inform the viewer.

The man portrayed here is a Kabuki actor – certainly an artist, in Japanese culture at least. He is seen here in the process of making up for his part. There is just sufficient in the picture to suggest that and no more. But the sparse quality of the picture also suggests something of all Japanese life, with its simplicity of décor.

The face of the actor is hugely dominant, and not even those blazing lights can distract. Cover up the right hand side of the picture and you still have a powerful design, though now even more simple. But whatever you do there is nothing to detract from that riveting face. Portraits, to succeed, need power.

Portraits
background exposure

Here's Frenchman Jacques Demy, who is a film director. And he is seen here against a background of what? Nothing! Nothing, that is, except a couple of boats floating out there on some non-existent sea behind him.

At least, the photograph suggests there's nothing behind Demy other than those boats; but that is plainly impossible. Boats don't float in thin air, so the intellect comes to the rescue and assures us there's a sea-scape out there beyond the main subject – and it tells us that the sea is sparkling in brilliant sunlight. The shape of the picture and the attitude of the figure tell us that Demy is walking away from the beach.

The absence of detail behind the subject is nothing but a photographic phenomenon. Under other circumstances – with a different exposure – it would have been perfectly easy to show a great deal of detail in the distance. But that would have meant sacrificing detail in Demy's face and figure – unless a powerful dose of fill-in flash had been fired at him.

Very early on in one's appreciation of photography it is important to come to terms with the simple fact that the amount of detail which eventually appears on a photograph does not necessarily bear any relation to the amount of detail you are able to perceive with your eyes. The amount of detail which shows in a picture is dependent upon just how much of the light reflected from the subject (or background) is allowed to pass through the camera's lens and onto the film. And that, in turn, is determined by the photographer's treatment of what he considers to be the most important bit of the picture. Obviously, Demy's face is the significant area here. And the background influence is there (the boats and the suggestion of searingly brilliant sun add to the effect), but is far from overwhelming.

Imagine this picture with an alternative background. Let's say Demy had been walking along a sunlit street, the light slanting in diagonally, one side of the street bright, the other in shadow.

With the shadowed side beyond the figure the entire effect would be quite the opposite of this picture. Instead of white beyond Demy there would be dense black, and the exposure which has held detail here would hold detail in the street scene too – detail in the face, that is.

Problem: cameras which deliver an averaged exposure reading might not deliver exactly the same exposure in those two quite different picture taking situations (the subject is the same, the situation is different).

With an average meter reading the camera would convert extremes of light and of shade to one brightness level and Demy would end up either under or overexposed. Now you can see the value of spot metering?

Of course, many cameras don't have the luxury of spot metering – but many provide some method of avoiding the blind insistence of average meter reading.

If you have an over/underexposure setting on your camera (usually close to the film speed dial) then spend hours and hours getting to know how to use it. For this is the commonsense control – the one which defies unthinking mechanisation and provides an effect that's precisely what you want. If you don't have such a control on your camera you can achieve the same effect by adjusting the film speed setting: for an over bright background adjust the ASA rating downwards, and adjust it upwards for a very dark background. How much?

Take this picture as an example: an averaged reading would probably have underexposed Demy's face by about two or three stops – so the ASA rating should have been downrated to a quarter its actual value. That is, a 400ASA film should have been set on the film speed dial as if it were actually 100ASA.

A lot of fiddling? Not really; certainly not more than is involved in changing your car's gears. Practise it and practise it – and it becomes second nature.

Portraits
lighting
exposure

Could you imagine actor Donald Pleasance any other way than he is shown here? Probably not – for Pleasance is the archetypal man of menace. And so it seemed perfectly right to photograph him in this way.

The shape of his face and his piercing eyes add up to an overall effect which has chilled cinema audiences everywhere – and those in front of TV sets – for he is an internationally recognised presence. And it is his presence we are discussing here. The arrangement of light and shadow in this picture is tailormade to enhance it.

Yet this is not a particularly tricky effect. There is hardly a modern SLR which couldn't handle it – most of the 35mm compacts would do a fair job of it too.

The point is, there's more than enough light here, where it matters – right on the face of the subject. And even a match or a candle is capable of delivering sufficient brilliance to illuminate certain subjects in certain circumstances. Remember that absence of light is as important as its presence – and the blackness surrounding the central figure in this picture adds as much to the impression as does the gradation of the greys on the face.

Look carefully, though, and you will see that this picture was not actually taken *solely* by the light of the oil lamp Pleasance is holding: that little tinge of light on the base of the oil lamp tells you that, and the window frame behind the actor would obviously have spilt some light into the room too. However, neither of those has affected the picture – the light from the oil lamp's wick dictates all.

Now imagine the scene at the time the picture was taken. Remember that the human eye and photographic film do not perceive things in exactly the same way. Film will deliver large slabs of jet black into your pictures where the eye will perfectly easily see detail. It was therefore necessary here to imagine the eventual effect required, and to shorten the exposure to achieve that. For the effect required was to be, above all, sinister: lighting Pleasance more conventionally would have destroyed that.

Light directed upwards onto a face has a very dramatic effect – making the face seem devilish. But a presence such as that would here have been just too overwhelming, for the arresting thing about Pleasance is those cold eyes. It did, though, perfectly suit armament maker Alfred Krupp, at least according to Arnold Newman, well-known portrait photographer. Newman is particularly known for his attention to details of lighting, and when he pictured Krupp the lamps went below and on either side of the face – creating a genuinely devilish effect which Krupp didn't appreciate!

Light shapes a face – a fact exploited by fashion photographers who frequently exaggerate delicate cheekbones by placing the lamps very high. But it is important, if you are to progress in portrait shooting, to stop thinking of carefully placed studio lighting as being the only way to get results. There was once a cigarette commercial on TV ('You're never alone with a Strand') in which the 'romantic' mood was greatly heightened by having an actor strike a match to light his cigarette; and matchlight could be used just as readily as any studio lighting for a portrait. It will of course impose an effect on your picture, which is all very well if it's the effect you're after.

What all this adds up to is simple. We see our way around the world by light, and by light of great variety – fluorescent tubes, street lamps, car headlamps, torches, twilight, the first glimmer of dawn...

And *all* of those lighting circumstances are actually tools for you to use, for different impressions.

Photographers refer to such lighting as available light – by which they mean it is light not augmented by deliberately placed lamps or electronic flash. But by placing your portrait subjects just where you want them, and by adjusting your camera's lens and shutter settings and thoughtful choice of film, you can retain just as much control in available light shooting as is yours in studio lighting. For example, by positioning Donald Pleasance close to a street lamp it would have been possible to produce an effect similar to what you see here.

Never forget that successful portraiture is not a matter of chance, but of control.

Portraits
lighting
flash

Please, on a quiet weekend, spend a little time polishing up your portrait skills!

Portrait skills – does the phrase put you off? It shouldn't do, for it doesn't at all refer to some complicated magic with a camera.

Here's a very simple portrait indeed, of a very young Mick Jagger. It was taken in 1964 – when the Rolling Stones were a very different bunch from those gyrating and not so young sex symbols, later widely photographed (and televised) on a triumphant US tour.

Primarily, what will attract most people is the simple fact that this is a portrait of Mick Jagger, for he is endlessly interesting.

But of much interest too will be the fact that it shows Mick almost twenty years ago. And in that, the picture will spark off so many memories – automatically, people will recall their own youth, and their perhaps frenzied following of the early Stones.

Pictures have that sort of power.

And yet, this is such a simple portrait. The singer stands there, wearing the gear of the sixties and a direct gaze, and he is lit in simple fashion, from one side. The background is perfectly plain – though a little tone creeps in where light has spilled.

You could go for his kind of effect anywhere around the house where there is a blank wall and a window – in the hallway perhaps. No window? Then use bounced flash – its effect is very similar to daylight provided the location isn't too cramped, in which case there won't be sufficient room for the light to spread adequately to cover a whole figure.

The thing to watch out for is clowning brought on by embarrassment! Jagger has by now been pictured heaven knows how many times: even in his twenties he was front page news, and embarrassment has long since gone – if it ever existed. But people unused to being photographed do tend to play up a bit – making funny faces and camp poses.

Just sometimes such carrying on will make a very successful and amusing picture, but that is really a matter of luck, since the photographer is then not fully in control of what's going on. Better by far to approach the whole thing calmly; get friend or relative away on their own for a quiet moment – then take your picture without any fuss. Don't give in to anybody who wants to dash upstairs first to 'powder my nose' or 'put my hair straight'. Go for a simple and honest record of whoever is standing there in front of you – and before you know it you will be confidently taking portraits which work, and work well.

It's a great pity the Victorians did such awful things to family portraits, with all those starchy and over-grand poses, making the family album something of a study in self-consciousness. Today, we are all much more relaxed, much less concerned with putting on a face. And since first class quality is within everybody's reach – with automatic exposure, auto-flash and very good lenses on even inexpensive cameras – the family pictures we take today ought to be much more satisfying to look at in the years to come.

Each time you point your lens at granny or the little brother you are in fact about to create a little piece of family history: it makes sense to get the facts right...

Portraits
lighting

Irish writer Edna O'Brien is a very romantic lady. Her writings are full of vivid images, and full too of poetic words. In *Johnny I hardly knew you* she puts this piece of musing: 'I liken love to a great house, a mansion that once you go in, the big door shuts behind you and you have no idea, no premonition where it will all lead to. Chambers, vaults, confounded mazes, ladders, scaffolding, into darkness, out of darkness – anything.'

And here, in this portrait in which she is seen as though coming forward out of darkness, is an indication of how the photographer may use light and shade; just as craftsmen or women in other fields use words and musical notes, or chisel and stone, to make their images take on atmosphere.

Light has to be understood before you can begin to truly control the end result in your photography; but it must be understood in relation to what it will do to film.

A quick check will show that here the face was lit from high up, almost directly in front. And a very generous exposure has limited detail in the face, while recording the texture of fur, dark leather, and scarf. By itself, this control has forced attention onto the expression in the eyes – too much facial detail could easily diminish them.

But behind the writer is a brilliant halo of white, which, commonsense tells us, must be obscuring a fair degree of outline detail.

How, though, can light obscure anything? Isn't the major characteristic of light that it illuminates and reveals? To the eye it reveals, yes – but even so it can occasionally obscure, as when you squint into vividly brilliant sunlight. And, since film is nowhere near as accommodating as the eye, it happens that film will actually quite often find itself thoroughly unable to deal with a very bright light – and so there will be obscurity. Obviously, light has here streaked from behind Edna O'Brien in such abundance that whatever detail was in its path has simply been obliterated.

But in these particular circumstances a very specific quality of light has contributed much to the effect...

Light travels in a straight line. Well, it does so through spaces. But when it encounters something it changes course. If it hits a brick wall it bounces off it. Thus, if you're on the other side of the wall all you see is darkness, because the light has changed course and bounced off away from you, to where it cannot stimulate your eyes.

But if light strikes glass or water, or anything else transparent or translucent, it falters but doesn't actually stop. It changes course a little, through refraction. Translucent objects interfere more than transparent objects: within them, the light is bounced all over the place, only some of it escaping to carry on its way.

What happens to the rest? Here's an easy way to find out. Pull a hair from your head and examine it through a very powerful magnifying glass, with a bright light beyond – a table lamp will do. Suddenly your hair isn't the sleek brunette strand you thought it was: it's aglow with light. What has happened is that light striking the hair has bounced here and there inside, lighting up the entire strand – just like fibre optics. And blonde hair will light up even more brilliantly.

Obviously, a head of hair tightly packed close to the skull is a bit too dense for any light to penetrate. But where stray hairs and thinner curls and waves fly loose, there is inviting territory for light. There, light can streak in and bounce around and light up the area like a patch of gold. And that's just what has happened here. The bright area around Edna O'Brien's head is no longer hair and fur – it is pure light, strong light, overwhelming detail, since light streaks in all directions.

A weaker spotlight behind a portrait head will lessen the effect; a very strong light will exaggerate it. Thus, by the strength of the light you elect to use, you can control the effect.

But remember, what your eye sees is not necessarily exactly what will appear on film. Your eye can perceive detail where a film will be unable to do so. Half close your eyes when examining *any* lighting effect: that will take what you see much nearer to what your film will record.

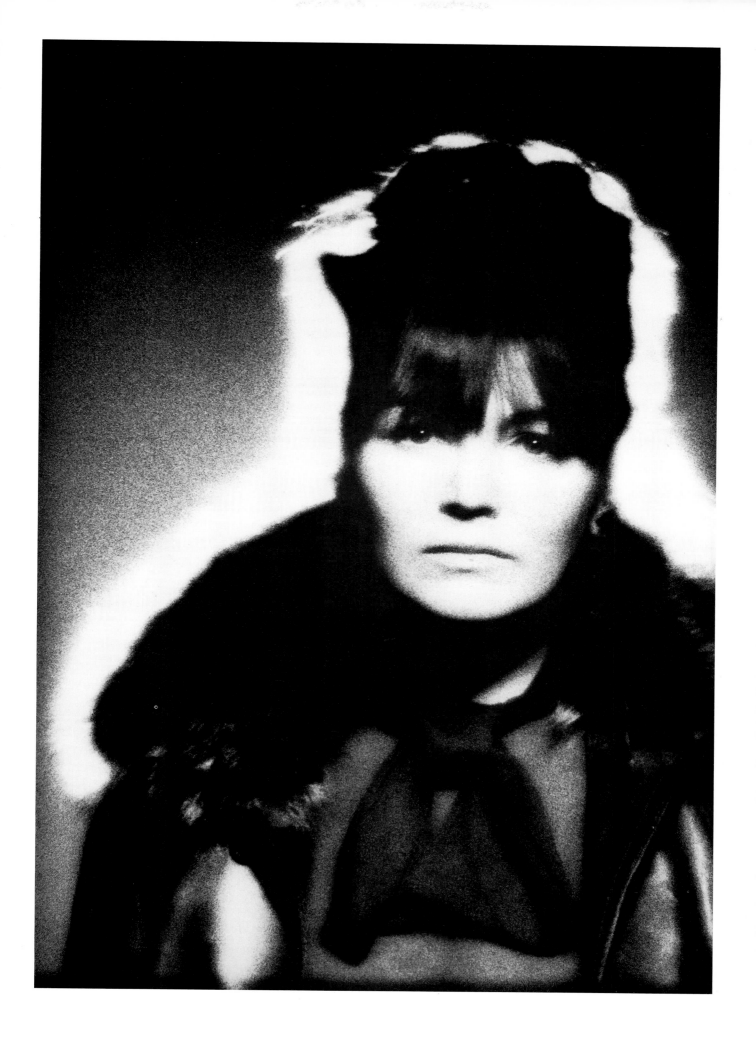

Portraits
posing

Don McCullin is a war photographer, and a much respected one too, though he does photograph more peaceful subjects as often as he can. But it's war that has made the McCullin name.

There is, though, another important observation which can be sparked off by the photography of such as McCullin, and that is that it's perfectly possible for some cameramen to go through life as observers, recording what they see but taking no part in it at all beyond firing the shutter. It's even possible, though unlikely, that a photographer could shoot for a lifetime without ever actually speaking to any of his subjects. You can see what would happen: without contact, without directing, the photographer would be stuck with whatever formation and whatever postures the panorama of people passing before his lens fell into.

Reporters like McCullin have the skill to select the telling postures and actions of course, and their pictures are great documents of reality. But photography cannot always be about people in poverty or pain, any more than language should be concerned only with obituaries and sermons. Great slabs of photography are about situations in which both photographer and subject are not only aware of each other, but are actually near oblivious to all else.

Fashion photography is, of course, one area in which photographer and subject operate as a unit. Many a model has a repertoire of poses she can move through automatically, and you'll see girls doing just that at those gatherings of photographers organised by clubs, when a score of more cameras are clicking away at the same girl at the same time. But getting another human being into just the shape (and that includes facial expression) you want is not a matter of luck, and shouldn't be treated so.

The model in this picture – she is Susan Hess – has been very much controlled. The idea was to make her reminiscent of a puppet. And even the base she's standing on highlights that impression. Of course, professional models can do this kind of thing without the selfconsciousness that exaggerated posing brings to most people, but even an obviously exaggerated picture like this needed something extra. Hence the enlarged shadow, created by using a tiny light source in front of the girl (try a small pocket flash unit if you want to experiment with the effect); and to underscore the unreality of the picture a very powerful spotlight blasted onto the background killed the lower part of the shadow – result, a model who is a puppet, with a genie for a companion.

Posing is not always this dramatic. More often you'll have to cope with it only to make sure that portraits of friends and family look like portraits and not like prison mug shots!

All hobbies and professions have their own jargon, which tends to sound off-putting and elitist, but which actually merely describes straightforward goings-on. And posing is the word all photographers use for what they get folks to do in front of the camera's lens. But, and this is important, sympathetic but firm direction of subject by the photographer can make all the difference between success and failure. And a touch of flair and imagination in arranging unusual poses can make a genius of you.

The simplest photo you can take – in the portrait sense – would be of someone standing rigidly still in front of the camera. And all too often people actually do freeze; there is something about the lens which brings out inhibitions and idiocy, and an attack of self-consciousness. Your job is to combat all that. How do you do it?

The first and most obvious thing is to ooze awareness – and really look and act as if you know what you're doing. That means knowing your camera backwards: never fiddle with it during a shooting session – load it, focus it, fire it, but never fiddle. And get your background sorted out well before it's time to press the shutter. Choose where you're going to do your portrait shooting, and place your subject firmly there without dithering.

Lighting? Same things apply, with one proviso: get it sorted out in advance, but don't be afraid to make a minor adjustment, or move your subject a little in pursuit of the most pleasing effect. Be positive in everything.

It's no good saying every portrait subject should be relaxed. Some will actually provide a far more fascinating picture if they're tense, and adopting an interesting posture while looking intently – or even aggressively! – at the camera. But shape is the first requirement. You must talk your subject out of awkwardness – which always attacks those with little experience of being photographed.

Particularly bad are hands and legs. People just don't seem to know what to do with them! But why not have the hands thrust deep into the pockets, or the arms folded, or hands holding something (even a newspaper), or your subject leaning on the back of a chair, or even holding a pair of specs as if they're about to be placed on the face? Get the hands doing *something*. But make it plain what's happening: if your picture is of granny twisting her apron-strings (that's not a bad idea!) make sure your photograph shows clearly what she's doing: hands or arms in strange positions will make your portrait subjects look like they're disabled unless the photo plainly shows good reason for the distortion.

Unless your subject is a gorgeous young thing in a fashionable skirt or a bikini you'll find legs are not only difficult to handle but actually unattractive too – especially when they're standing stiffly and are draped in baggy trousers. Legs crossed?

Yes, that works, and often very well: a city-gent type leaning on a brolly, *Times* under his arm, one hand in pocket, legs crossed – and there you have a nice study which says something about his jaunty personality. And a schoolboy, catapult dangling, arms folded, legs crossed, will be alive with mischievous pride. You could, though, shoot a side view portrait, with your subject leaning forward to stroke a pet cat or dog – possibly looking at the camera, but not necessarily – which would automatically attract a major slice of the attention anyone would give the picture.

An easy remedy is to leave out the legs altogether – chopping off your portrait at the waist. But that's flunking the challenge. Better instead to be aware that real gems have been produced, and there's no reason why you shouldn't succeed too.

One last word: it is not necessary to have portrait subjects sit, or stand, rock still. Let them act normally – if they don't then they *must* look abnormal! Using flash, or high shutter speeds outdoors with fast film of, say, 400 ASA, you'll be able to let your subjects get on with normal fidgeting and breathing and twitching. Just arrange the shape, the general composition, and then wait like a cat for the expression to look as you want it. When it does – pounce! And do talk to your subjects.

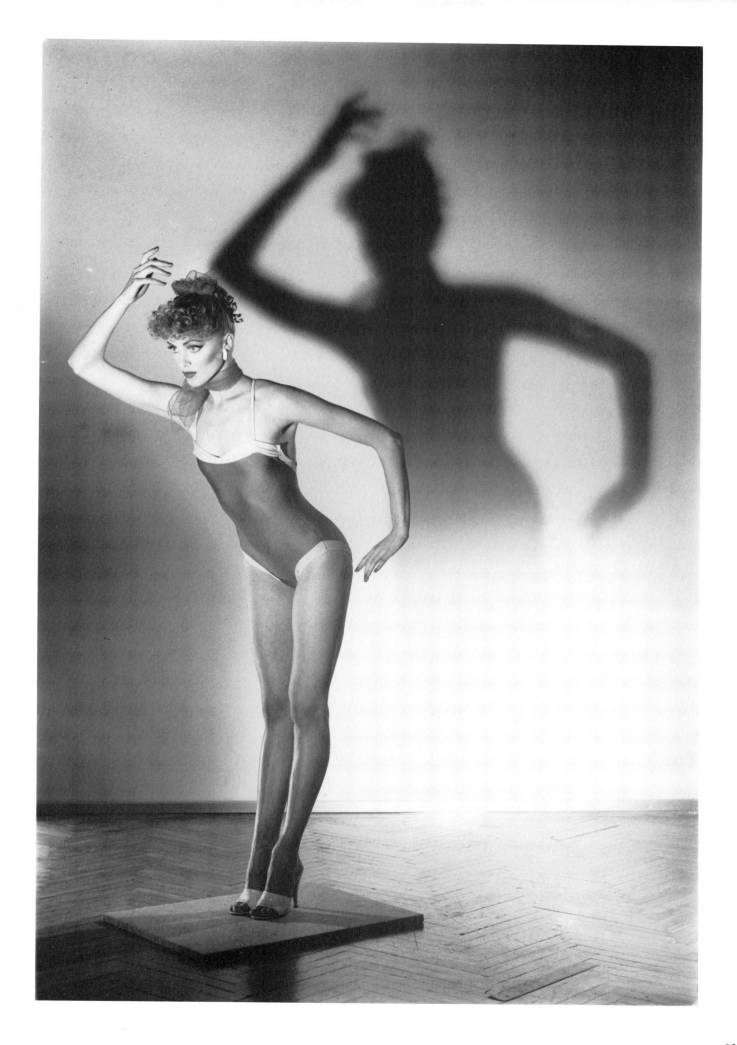

Portraits

posing
expression

Remember those 'What the butler saw' machines, the things on the pier with a series of still pictures inside, which flip-flopped rapidly on top of each other to give a sense of motion?

The two children here will, if flip-flopped in similar fashion, help set us off on a discussion about the most compelling subject, the human face.

First cover up the face of the child at the bottom: put your palm over the picture, thumb towards the bottom of the page. Now flip your palm upwards, to reveal the lower face and obscure the upper face. The children are remarkably similar, but what a difference in their expressions – the smile contrasting greatly with the suspicious stare. Obvious this may be, but let's reiterate: the expressions are *so* different that they would leave quite conflicting impressions if photographed separately. On the one hand, an obviously happy youngster: on the other hand a picture of sadness and deprivation – strongly reinforced by the lower child's hands. Of course we know that it is merely curiosity, and perhaps a tinge of suspicion, which makes the little soul *appear* so much in need of sympathy: fact is, in spite of her frugal dress and surroundings she is as capable of a happy smile as her brother. And two smiles would have made a very different picture.

The point is as plain as, well, the nose on your face. It is just this: the photographer of people will be fully aware of the mood of his sitter, through the atmosphere and the conversation at the time of shooting – but the viewer of the finished picture has to depend very largely on the expression for *his* impression.

It is long standing practice to make a sitter say 'cheese' – at least in popular fiction it is! In fact, photographers do make their sitters and models say many things – not all of them as palatable as cheese. But that isn't enough; and anyway, the real aim is to shape the face, to induce a kind of pout when the mouth shapes the words, not to suddenly infuse character and expression into a face. The chances of your producing a winner of your granny just because she's saying 'gorgonzola' are – nil!

So how then does anybody influence expression? In the answer, whatever it is, lies the reason why some photographers succeed and some don't. You *can*, of course, influence expression, and greatly – assuming your sitter is a lively personality and normally does assume a range of expressions. That particular skill matters a darned sight more than the LPM rating of your lens.

Conversation is one way, but you need a lengthy session to hit the right level. An easy manner is an immediate winner, and a good ambience is a near necessity. But ultimately, all will revolve around your subject responding to you, not your camera – even if that response is a stare right through your lens.

You must look closely at the eyes and observe the moment that guarded look (the lower child here shows it) drops.

That guarded look *may* in itself be the picture on some occasions: certainly it could be here, if that little girl had been pictured alone; and covering up part of the page will speedily demonstrate that.

But there is no reason whatsoever why either a guarded look or an inane 'cheese' grin should appear in portraits taken for fun. You must aim at conducting the session at a leisurely pace, and getting rid of any stuffiness or embarrassment (which, remember, is a natural reaction from the majority of people when faced with a camera). Work hard at getting the expression out of the run – make the eyes sparkle, twinkle, react – and *then* concern yourself with the shape of your picture, and you are home and dry.

Sounds simple, even over-simple? That's because we're used to people reacting naturally enough when in face to face conversation; before a camera they become very conscious of their appearance, unlike children. Your job is to defuse that concern with the instrument, and focus the concentration on something else – as the upper child is here concerned with something outside the picture frame.

The best trick of all is to get your sitter as apparently interested in your camera lens (nice direct gaze) as this child is interested in that compelling something over to the left of camera. What it was that interested him matters little – it was not part of the intention to show anything other than what is on this page . . .

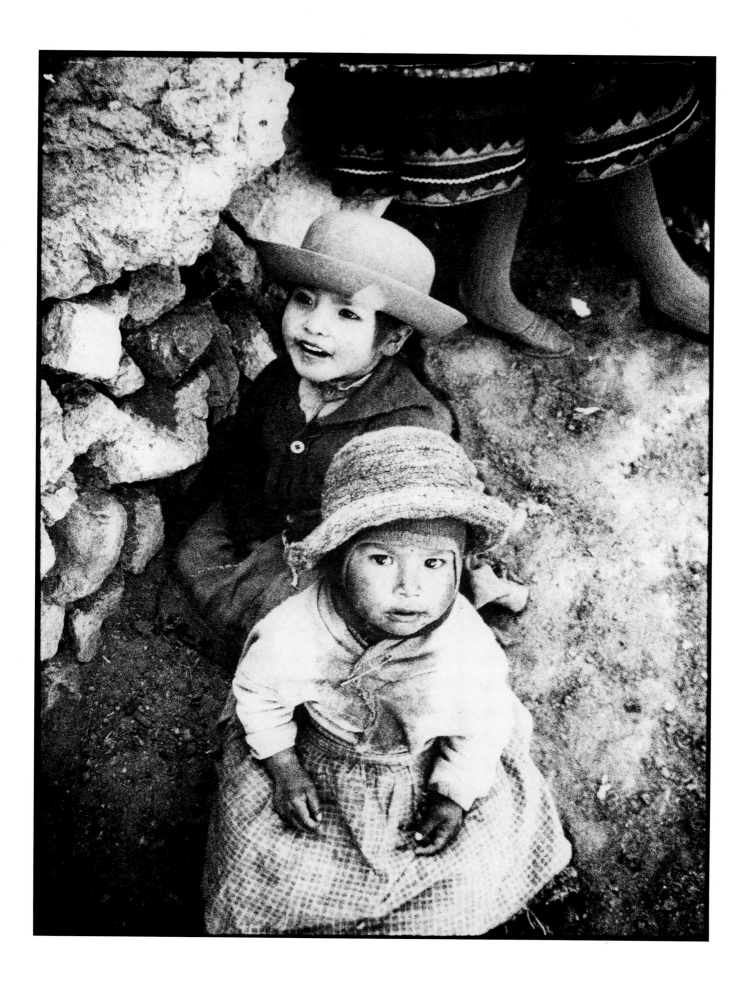

Portraits
posing
camera position

Imagine one of those dandelion clocks – the things you puff on to tell the time by, sending the seeds floating into the air.

From the centre of the plant those seeds radiate in every direction. And from you, from anybody, lines also radiate. But they are imaginary lines. And at the end of any one of them there might be positioned a camera.

It is easy to think of all portraiture as being done with the camera at eye level, the axis through its lens horizontal, parallel with the ground. The whole thing all square and head on, in fact. But there are many ways of tackling portraiture, and adopting a less than normal viewpoint is only one way of introducing variation.

Of course, if you thought too hard about the dandelion clock analogy you might end up shooting the top of someone's head and nothing else. Silly? On the face of it, yes; but even that might work – if your subject was a man particularly famed for his baldness, like Telly Savalas or Yul Brynner!

In photography, nothing is so outrageous as to be entirely useless, and extraordinary portraits which make even an obscure point, which is more close to caricature than anything else, may be thoroughly valid.

But let's remain here at least within a reasonable range of the normal viewpoint.

Here's Yoko Ono; and she's without all that hair she was so widely reported as having shorn off to mark the anniversary of John Lennon's death.

She is seen from a fairly low viewpoint, the camera certainly below her chin level. With the eyes placed so high in the frame (though that's a function of cropping in the camera, not of the viewpoint) an air of strong character is introduced.

The picture was taken some time ago, in 1974. Since then, as the world knows, tragedy has entered her life, and she would probably not be portrayed today as the confident and aloof lady you see here. By switching the camera viewpoint, to somewhere just above her head, and arranging her in the lower part of the picture, a very different impression could be introduced. To begin with, the eyes would be given much more prominence: they would appear larger, Yoko would look much more wide eyed – and vulnerable.

It's true, a simple switch of camera position will make a world of difference to the impression you put across to those who look at your pictures.

Here, the strong jaw and the relaxed eyes tell the tale. And you may take it for granted that in all newspaper offices there are piles of photographs of the headline personalities, each showing different faces, some with a smile, some with a scowl, others pondering and some with the calm confidence Yoko here displays. Part of the picture editor's art is in selecting just the right picture from his files to match the news story he is illustrating; and it is obviously unthinkable that such a calm air as this would have been used by any newspaper to illustrate the headlines at the time of John Lennon's death.

Portraiture is not, never was, and never will be, a matter of chance. It is as descriptive an art as the most finely polished prose, the most delicately scored music. And changing your viewpoint to alter the emphasis is but one key.

Try it on your friends. But watch out that your experiments don't spill over into ridicule! Shoot from too low when picturing a friend with a double chin and you'll give him a face like the rolling Cotswolds, and go too high with a pal who's going thin on top and you will end up with a picture of an egg equipped with eyes.

The opposites are true: shoot from lowdown with your bald friend and you can disguise his thinning thatch, and raise your camera a few inches to trim away a double chin.

Use portraiture: use your camera viewpoint to emphasise, and to clarify your intent. Don't give the wrong idea by shooting from the wrong place...

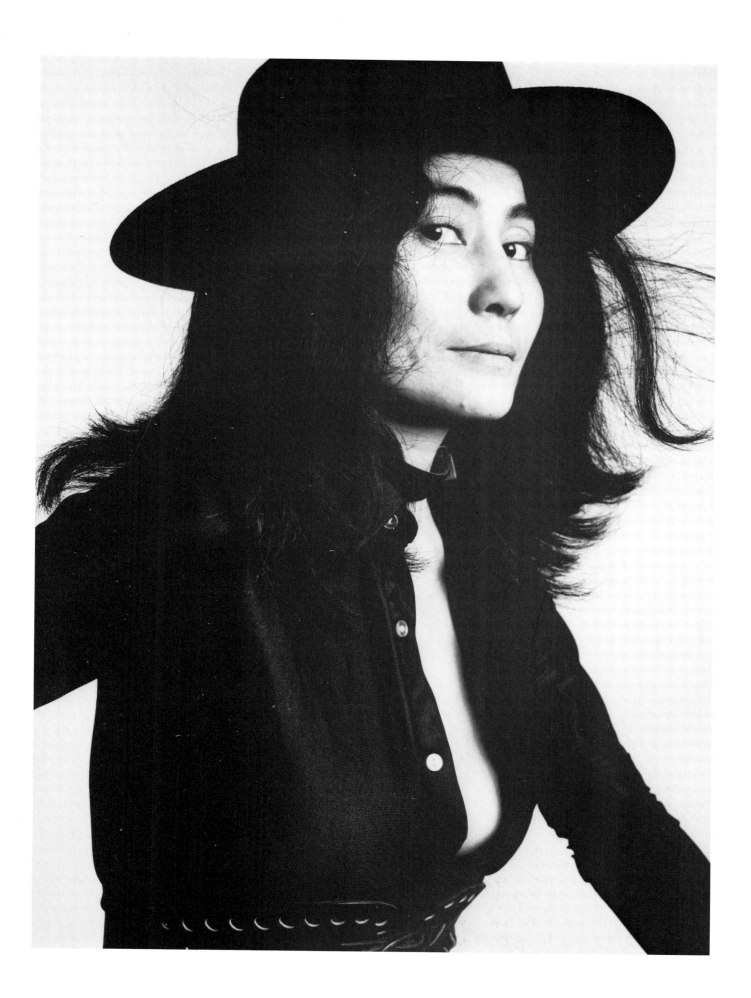

Portraits
expression
lighting

Of course this is a thoroughly professional picture (it appears here courtesy of Condé Nast Publications Ltd, having been shot for *Vogue*) and naturally it was shot in a studio full of the right equipment. But there isn't a single element of the portrait so complex as to make it impossible for any moderately knowledgeable hobbyist to produce a similar result.

This shows the very well-known character actor Hugh Griffith – a naturally interesting subject. But imagine how much more satisfactory could be your pictures of father or grandfather – pictures full of character, instead of those indistinct little snapshots with a self-conscious figure standing in the middle of the cabbage patch!

It is misleading to suggest that the elements of a picture can always be taken apart, analysed, and put together by somebody else to give the same result. For successful photography includes one very important element which *can't* be duplicated: that is the decision-making process within the photographer. Shooting a portrait is not a mechanical operation, it is an appreciation of one instant when all the elements come together in just the right way.

Having put it that way now let's put it another way – in an earnest attempt to steer you towards that appreciation of that one instant...

And we can go some way towards that by considering the elements of this portrait. There are six points which prove interesting.

First, it is a full length portrait. And if you examine the picture carefully for a moment you will see that to move in close for a head-and-shoulders only would have taken something away. Everything about Griffith adds up to a kind of aggressive bulldog air – the head thrust forward, the stocky build, and those feet planted fairly and squarely apart. The view of the man is tempered by every inch of him from head to toe. Much is said about the need for a portrait to probe the inner man – but you must agree that here the soles are more effective than the soul!

Most people have a quite characteristic way of standing or sitting, though it may vary with their mood. Exploit that.

Second, Griffith is posed before a plain background. That allows all the attention to be concentrated on the figure – the full figure. Sometimes background detail is valuable, and often it may be unavoidable. But try to find the plainest possible background if you really want to sharpen up your portrait perception. Studios have rolls of plain paper hung from a large framework, but you could tack paper up on the wall at home – or use a bedsheet.

Next element is the obvious evidence that Griffith had apparently just arrived in the studio – or was just about to leave. That's made plain by the coat and hat and gloves, and by the stick he carries. It all adds up to the suggestion that something is going on, and he isn't just standing there waiting for next Friday! It introduces a kind of tension, an awareness that this is just a fleeting glimpse of the actor pausing in his busy life. That impression is so powerful that it overwhelms any air of the static which the studio surroundings might have introduced.

Was Griffith actually arriving or leaving, or was it a conscious decision to have him pick up his outdoor clothes while posing? The answer to that question would throw no light at all on this discussion. For it is part of that ultimate element – the high speed decision-making process of the photographer at the time of shooting, and the great concentration he must bring to every shooting session. But a good piece of advice is this: follow your instincts.

If your portrait subject looks right at any time, then shoot – even if you have something more complex and 'arranged' planned for later on. Follow your decisions through, and then carry on anyway with what you had planned. The 35mm camera gives you the opportunity to experiment 36 times with each cassette of film. Exploit that too.

The cigarette, that's our next element. Griffith holds his in a very positive way, reflecting years of habit: there's nothing of the poseur about the way he stands, nothing delicate and affected, no long cigarette holder. This man smokes and to blazes with government health warnings! It matters not a jot whether or not you approve of smoking – that's the way this particular subject is.

And that same conversation could be re-run in relation to any other habit. Why begin to photograph your punk son and then scream at him to go and comb his hair first! That *is* done, endlessly, by parents who shy away from photographing their children before the hair is slicked down, the Sunday-best clothes put on, the face carefully scrubbed. Nothing is made much of here concerning Griffith's cigarette – but its presence adds to the overall impression of the man. In fact, students of *Homo sapiens* might even be the more able to picture the real live Griffith in motion, just from his appearance here.

If habits are to be changed then change your own – don't demand that your portrait subjects become what they plainly are not.

Now, expression. This one indicates a very positive reaction to photographer and camera. And through the lens the actor appears to be very much involved with the viewer too. There is a time for going for the soft and the moody and romantic – perhaps when photographing some dreamy young girl – but here the presence before the camera is certainly very much a character and very male. Belligerent almost, hmm? That has been allowed to show through, quite clearly. And, as with all the other elements, it slots into place as a constructive part of the overall view. A sickly and self-conscious smile would have been a nonsense...

Finally, lighting. Obviously, there's lots of it! To Griffith's right a big and soft light source splashes him all over, accentuating his shape by creating shadows on face and clothes. In front of him, and fairly high, a less intense and even softer light applies gentle fill-in, though not sufficient to destroy those important shadows. You could approximate this effect with any of the multi-head flash outfits on the hobby market. But you could also get close to it by working by light from a large window.

The old portrait painters knew a thing or two, and early photographers copied their ways. The north light, flowing in through a big studio window, was thought ideal – more soft by far than the harsh directional light from the south, where the movement of the sun dictates directional effect and intensity.

Soft light! But shouldn't male portrait subjects always be pictured by something more harsh? Ah, now you're looking for answers which, again, won't help – for the most important element remains that decision-making process, quickly switched into gear when the subject is actually standing there in front of your lens and you can begin to see what your picture *should* be all about...

Some elements are there to be studied – but the most important one is inside you.

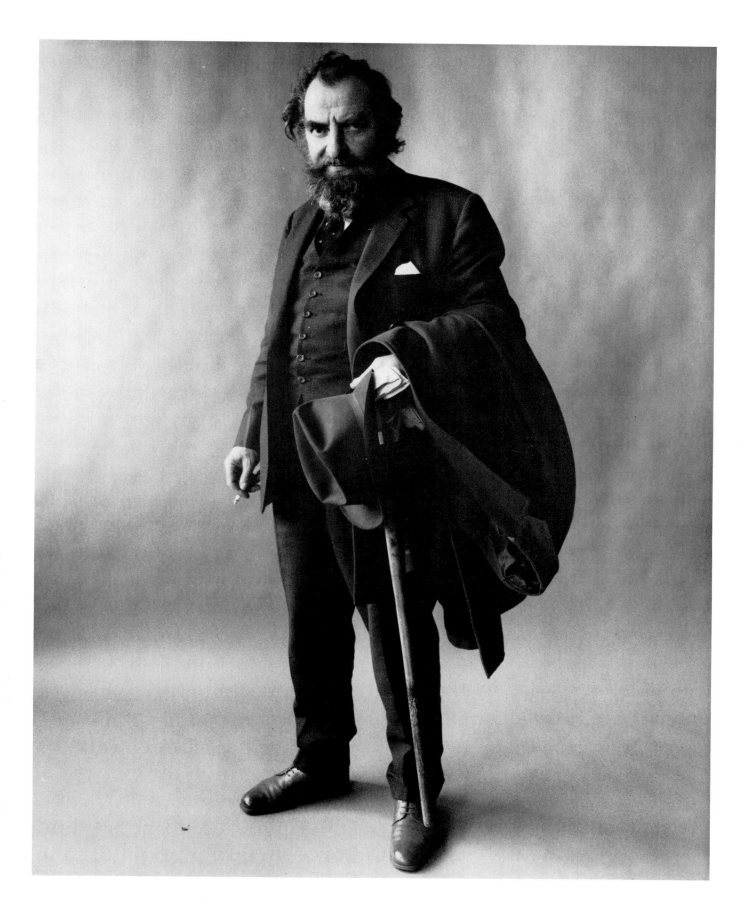

Portraits
expression
lighting

This is a very visual age, what with television, cinema, magazines, posters, newspapers. And what that means is that any photographer presenting a famous face is up against a lot of competition.

Whatever he shows will be competing with hundreds of other impressions. Take this portrait of Meryl Streep: how much it differs from images you may have seen in movie magazines and gossip columns, and perhaps in the cinema too, where she played in *The French Lieutenant's Woman* – acting out a part in which she was both a romantic and tragic figure. Then, too, she was in a tearjerker of a movie called *Kramer v Kramer*; and also in *The Deerhunter*.

She is an actress of considerable talent, of course, and her profession requires that she adapt her mannerisms and appearance, and her presence, to each part she plays. No doubt she could readily become some gin-soaked harridan for a film set in city slums!

But, essentially, her big parts have seen her in tragic and perhaps romantic roles. Faced with that, what's a photographer to do? Photograph her as cinema fans see her? No – unless, that is, he has been expressly asked to do so for, say, a magazine feature. He *could* go for shock value: here, Meryl could have been dressed up and made up as, say, a clown – though that particular approach can very easily augment the impression of a tragic figure, thanks to the universal awareness of Pagliacci.

In fact, the most honest kind of portraiture, and almost invariably the most successful, is that which involves working with the material before the camera, uninfluenced by other impressions.

That material before the camera – in this case Meryl Streep – has been before cinema lenses too, and before the eyes of casting directors. And it's entirely likely her looks and her slightly 'faraway' expression persuaded the casting people she was right for certain parts – as those aspects have come through in this portrait.

The often expressed need to capture character in a portrait has surely perplexed endless numbers of enthusiasts – and must have led to horrific concoctions of elaborate lighting, and the use of extraordinary props. Yet if there is one approach more successful than any other it is that of simplicity. And it has been demonstrated in this book so many times – simplicity to an extreme degree, even to the extent of the perfectly plain background.

If simplicity is a desirable aim then so too is naturalness. Here, Meryl tousles her hair in a way to drive hairdressers mad. An elaborate sleek hairdo is never an essential, and fussy mums who insist on brushing the locks of their children for pictures are usually doing nothing but destroying a natural look.

Lighting is simple here too: one lamp, not too soft, and high up in front of the subject. The high angle throws the light down in such a way as to emphasise those fine cheekbones, and the hair swept away from the forehead leaves the eyes free of shadow.

Posing a portrait sitter is actually quite an active affair – not at all a question of telling the sitter to sit there rock steady. Use your eyes and watch the effect as he or she moves: watch particularly the effect of light and shadow on the face, with the head at various angles – and don't be at all shy of yelling out 'Hold it there' when what you see is just right.

So, forget preconceived notions of your sitters – and of portraiture altogether, come to that. Work with what's before you, and keep it simple. Let your sitter move naturally: if you use flash you are not going to get blur through subject movement. Most important, observe the play of light across the face – for it can change the effect just as dramatically as clouds scudding across the sky can send different patterns of light and shade onto the landscape.

Portraits
spectacles
posing

In the annals of portrait photography much has been done that might be described as torture! In the early days the sitter's head was pressed against a clamp behind his head, to limit movement during the very long exposure times. He was made to stand stiffly and still, avoiding swaying outside the depth of field of the long portrait lenses then in use, and he never seemed to be allowed even the ghost of a smile.

What an ordeal! And you'd think the artificiality of it all so horrific as to be now long gone. Mostly it is; but there are still tales of portrait photographers who whisk off the glasses from the sitter's nose and replace them with frames which have no lenses – to avoid reflections!

True it is that light is pretty volatile stuff, bouncing off all shiny surfaces and clouding detail with a bright glare. But in these days of the single lens reflex, using glassless specs ought not to be necessary, as the viewfinder shows exactly the effect being transmitted onto film. And in any case, light travels in straight, and therefore predictable, lines.

Here is broadcasting journalist Janet Street-Porter, in a lively portrait which has all her 'trade marks' – and those very big specs are very much a part of Janet's persona.

She is pictured here sitting in what is usually referred to as threequarters profile; her face is not head on to the camera, but is turned away obliquely.

What that does is turn the plane of the spectacle lenses sufficiently to avoid light bouncing into the camera – reflected beams from the studio lights, via the specs. At least that's what you might think, and that is the glib explanation so often trotted out; but offered as any kind of a rule, it's a bit short on commonsense.

Quite simply, the extent of glare from any shiny surface depends on the angle created by the line of direction of light falling on that surface with the line of direction of reflection *from* the surface. And if the camera is on the axis of that line of reflected light coming from the shiny surface? Well, you will end up with a certain amount of glare whichever way a spectacle-wearing sitter is posed. Remember, light reflects away from a smooth surface at an angle equal to that at which it strikes.

Conquering reflection is (apart from trying to control it with a polarising filter) much more a matter of positioning the light sensibly than of moving the sitter – just as is the case when dealing with ugly shadows.

Examine this portrait and you will see that the light was high, and to the right of the camera – though only just to the right. So, light reflected from those spec-tacles would obviously shoot off in a direction well away from the lens – down towards the studio floor, to camera left. Result, not a trace of glare is visible in this photograph.

As mentioned before, use of an SLR should prevent glare problems anyway, but it is actually remarkably easy to overlook small potential distractions (a strong reason for great discipline in examining the viewfinder image very thoroughly). And especially you should take very great care in portraying bespectacled sitters in locations where there is more than one light source: it is no good working out a suitable position for your photo lights or flash if a nearby window then casts a milky glare over the specs and ruins the result.

Having said all that, there is actually nothing intrinsically wrong with glare, as long as it is where you want it, and doesn't interfere with important bits of the picture, and eyes usually are of paramount importance in portraiture. Glass is reflective, and there is nothing wrong with a touch of glare showing: in a portrait of an old craftsman it might even add to the atmosphere if there was just a touch of light on, say, the bottom part of his spectacle lenses. But it should be under your control.

Control, in so much of photography, is the operative word. And the time to remove blemishes (if you consider glare a blemish, which most do, if it obscures the eyes) is before you shoot. There's very little you can do about it afterwards ...

Portraits
skin tones
ring flash

At the present state of development of photography as a hobby (as opposed to a business) it's reckoned that about 85 per cent of enthusiasts have a distinct preference for seeing their end results in the form of colour prints. Fair enough: that would certainly encompass all of those who want to do no more than press the button on an appealing scene and then sit back and wait for the results.

Nothing wrong with that at all and it still leaves 15 per cent who explore colour transparency and black and white neg/pos shooting. That 15 per cent is more than adequate to ensure that there will always be sufficient photographers out there to prove new techniques, to polish up printing skills, and in general to advance the capabilities of photography as a craft.

But the trouble with the relatively limited involvement of the colour-print-only enthusiast is that he or she never gets a chance to understand at first hand the staggering variety of changes which may be wrought upon an image between firing the camera and seeing the ultimate result.

Take such a simple matter as skin tones, which phrase is actually very frequent in the conversation of that 15 per cent mentioned earlier – and for chat about which, this portrait of the vivacious Tina Chow will nicely serve as basis.

This is a Hasselblad portrait, shot with a 150mm lens – and being about twice the focal length of a 2¼in square standard that lens has rendered perspective very pleasing (for the simple reason that it allowed a more distant shooting position than an 80mm lens for an image size large enough to show such quality). The shadows all round Tina indicate the lighting – ring flash.

But on to skin tones – the way the colour and the texture of the skin appears in a finished picture.

Here, the picture emphasises one of the virtues of black and white material for portraiture – and especially of ladies. It is that large areas of the skin may be allowed to appear on the print just as pale as you like. Tina's skin is actually paper-base white in some spots – the arms, forehead, cheeks. This gives a light and pleasant effect, one easily obtained by generous exposure at the shooting stage, and use of a good snappy printing paper grade, say three or four. Note, this is nowhere near such a dramatic treatment as what is known as soot and whitewash photography, where contrast is deliberately engineered to a very high level so that the finished print has black and white as its basis, with few greys evident.

So, why can't this technique be transferred to colour? Well it can at a pinch, but it needs great control indeed – over the exposure, over the lighting. If it happens in a haphazard way it looks awful! Paper white skin simply looks washed out when other areas in the picture show a fine tan, or strong lipstick colour. Few portraitists – and Tony Snowdon is one of them – can successfully produce a very high key colour print portrait which doesn't look like a great mistake.

In colour transparency shooting the difficulty is great too, for entirely clear film, which would lead to a glaring white on-screen when projected, simply makes the colour around it look patchy – and grainy, since such a washed-out effect generally comes from gross overexposure of the transparency.

Commercial developing and processing laboratories – terrific though they be for mass popularity of the hobby – actually work against the colour print photographer who may be tempted to do something a bit unusual with his portraits (and, for that matter, against the fans of graduated filters too!). The filtration and all the colour correction methods of the d & p houses are geared up to producing what they see as proper skin tones: and in their book proper skin tones sure as blazes aren't stark white – so they work hard at giving every face in a picture a nice colourful complexion.

And if that means printing your favourite girlfriend in such a way that all her spots show – too bad! However, colour printing is not that much more difficult than black and white, and home darkroom fans should be able to improve their portraits greatly.

Portraits
groups
lighting

Ask any wedding photographer what is the most difficult part of his job and he'll tell you it's organising groups of people. First it's very time consuming; secondly, most of the wedding guests will have had a few to steady their nerves and will be a bit boisterous; thirdly, groups of people are disastrous when it comes to creating an aesthetic shape within the picture. There's no hope at all of aesthetics when the group is really large – remember those awful school photographs?

Fortunately, the studio photographer has things a little easier. To begin with, the people who come to him specially to be pictured will readily cooperate with whatever arrangements he suggests (well, mostly!). In a studio environment it is relatively easy to arrange a suitable setting, and a few simple props such as chairs or chaise longue, even a high stool, will mostly be great aids to composition. But it must be said that props can get out of control. Once you begin placing bits and pieces here and there the temptation to go on is powerful. Chair? Yes, and now a table, next some flowers – and so on...

Simplicity scores time and time again: subjects can always be asked to sit or kneel, to avoid the repetitious arrangement of having them standing in a row. For photographing Wings the ingredients were as simple as they could be – the group themselves, background paper, one bounced flash head.

The background was sprayed with aerosol colouring, to provide a varied tone. If you try this make sure you hold the spray can some distance from the paper (or hardboard) and build up the pattern bit by bit. You must avoid hard edges, and it is very well worthwhile pausing to check the effect with your camera. To do that, view at small apertures, such as you might use when lighting your set by flash. This really is important, for even a small group arranged in anything other than a straight row will have some considerable depth, and will take up a large proportion of a small studio.

The subjects will then have to be quite close to the background, and that will make any marks behind them more likely to be sharply rendered. Look closely here and you'll see that Wings were close to the paper – as is made evident by Paul McCartney's shadow. But the shadow has been partly obliterated by burning in during printing.

Paul's shadow also tells you a good deal about the lighting. It was high, but not so high that it would case unpleasantly long shadows under the noses, or make deep sockets of the eyes of Linda and Denny Laine.

It's never a good idea to go in for complex lighting when shooting portraits – and it is positively suicidal when shooting portrait groups. It can't be said often enough that each light casts its own shadows, and the more lamps in action the more shadows there will be. Confusion! Far more controllable is a reflector, to bounce light into shadows. A projection screen will do the trick nicely.

Balance and harmony should be second only to aesthetic shape in group portraits – indeed, you could say they are the same thing. But lighting and tonal weight need balancing too: had flash been bounced or reflected into the shadows here, it would have lightened the group, and that would not have been in keeping with the rather mysterious air of the picture induced by that 'cloudy' background.

The pyramid arrangement formed by the trio is a great standby for small groups. It particularly suits Wings, since it makes Paul the dominant element of the composition, as he is in the band. When the Beatles entered public awareness they created headaches. But one memorable solution to the four-strong grouping was to have them look around a door, heads piled above one another. There's always a solution...

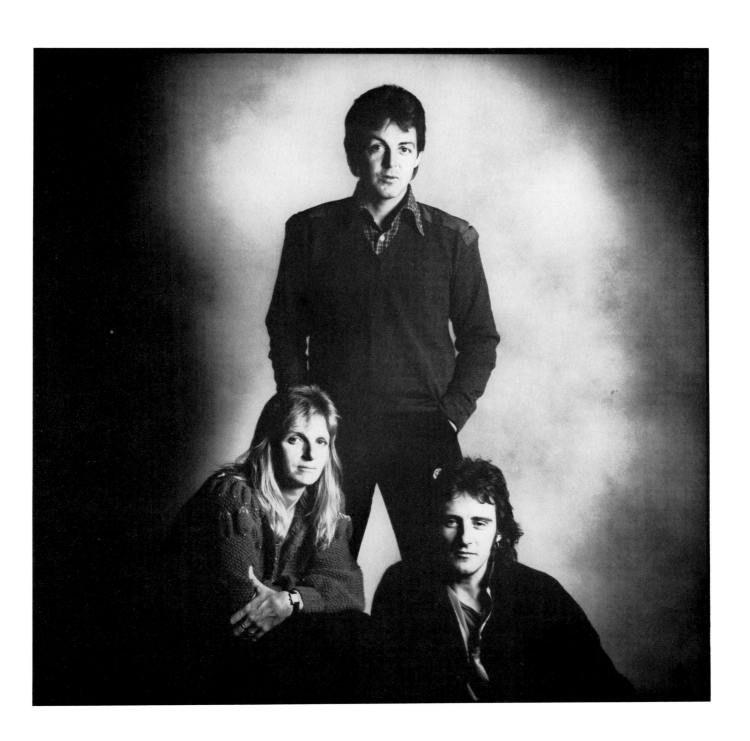

Portraits
groups
exposure

Just listen to any really involved photographer: when he's wound down and taking his ease he will be forever ready to talk equipment, discussing the merits of this or that lens and by how many stops you can push a certain film.

But when he's at full gallop, fresh from the chase or still alive with the memories of it, he'll talk about light. Tricky light and low light, sun scorching down so bright he couldn't see into the shadows, the strange half light of dawn and dusk, the mystery of fog and distant haze – all of those he'll dwell on with relish. Just now and again he may cuss of course, for with the light against him a photographer *is* in deep trouble; but mostly, light is the love of them all. You can't even begin to think about being a photographer unless you are sensitive to light and its ways!

Light, by itself, will often tell the whole story. Look at the way the harsh shadows and the near burnt-out background here suggest blistering heat; you can almost feel the warmth on your skin, the smell of dust in your nose. But light extracts a price for its co-operation! And that is that you should know how to handle its excesses, and how it will react with your film.

Against this blazing bright backdrop these dark skins positively cajoled light into a mood of excess. To expect any film to handle brightness ranges as high as that between the faces and the background would have been naive. Even with the 400ASA films, especially good for their ability to render detail in both shadowed and brilliantly lit areas, you could not encompass such a range as is here. So – problem!

In a situation such as this something has to go – unless you decide to use a synchro-sunlight or fill-in flash technique. But for the moment we're discussing understanding and handling light, not supplementing it, so flash is out. The warning signals should always ring in your brain in very bright light, but especially in really harsh sunlight – where the ratio of 1:4 (darkness:brightness), which can be comfortably handled *throughout* the photographic process, is certain to be exceeded.

The particular choice for this family group, a low shooting angle to isolate the three, has partly helped. The background now consists mostly of sky. The tree, as you can see, had to be allowed to take its chances. The prime need was to record detail in the dark skinned faces and bodies, and so exposure had to be carefully chosen for *that* purpose alone. That required opening up the lens: but too much was obviously going to bleach out the areas of the faces on which sunlight does fall. In the end, the compromise just worked:

you can see by that area at bottom left that any less exposure would have failed to hold detail.

The question is, how do you meter for circumstances as difficult as these? With care! Especially, it's important to decide which area of the picture is most important, and to base exposure assessment on that. So, you must know your camera's metering.

When exposure was a relatively simple affair photographers worked in one of two ways. The hobbyist would point his meter at his subject, being careful to prevent undue influence by bright sky (he'd point his meter slightly downwards, so that it actually read a greater area of foreground than would appear in the picture, and then simply transfer the readings to his camera). In the studio, the professional would take individual readings (still does) from important areas, and then work out whether his film would cope with the brightness range: if it wouldn't, he'd adjust his lights to even up the balance. Sometimes the professional prefers incident light reading – that is, he moves to the subject position and points the meter towards the camera, with a special attachment – the invercone for Weston meters is particularly well known – on the meter. Incident light reading is particularly successful, but it only *reads* – it does not affect the brilliance ratio, and that must always be the responsibility of the photographer.

Through-the-lens-metering mushroomed into popularity around 15 years ago, and now there's hardly a 35mm SLR without it. But the way of reading varies.

Some internal exposure metering systems are centre weighted: they take more account of the central area of the scene being photographed than they do of the edges. And sometimes the central area measured is very small – so that the meter can be thought of as a spot meter. With that, it is possible to take a number of very precise readings, and estimate what the result will look like with a high degree of accuracy. Other metering systems are weighted in a different fashion, and it's very important to ascertain how your equipment behaves; *read the instruction book!*

Many cameras are equipped with what's known as an 'averaging' metering system. The meter reads from the entire scene and then computes the best exposure settings for the total brightness level – but such systems, while satisfactory most of the time, can be fooled by large areas of particularly bright sky or deep shadow. It is then you should be prudent and bracket your exposures: fire one or two shots at the meter's suggested reading, and then fire more, at one stop above and one stop lower. If the

shot is very important it is wise to be even more generous, and shoot at half stop intervals across a range of one and a half over to one and a half under.

Finally, when buying a new camera check whether the meter reading can be held. It can be quite an advantage.

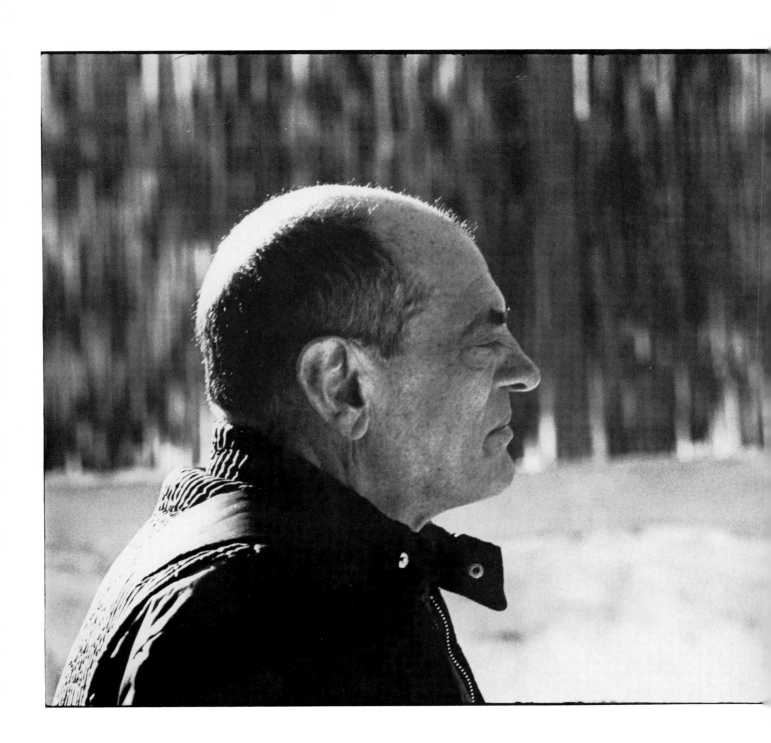

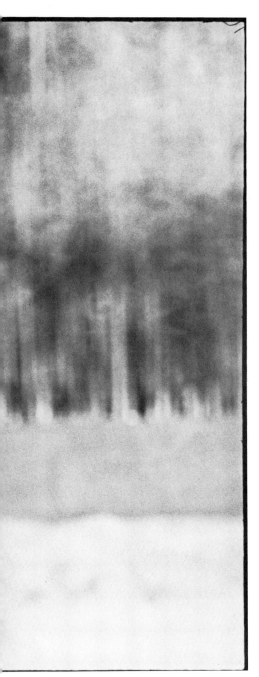

The man in the vivid sunlight is Spanish movie director Buñuel. He is shown here with all the classic effects of the simple technique known as backlighting, or contrejour. The head is rimmed with brilliant light. But the background – that part in full sunlight – is burnt out, and the shadowed side of the subject's face holds much more detail than would have been possible without use of the technique.

The majority of automatic light metering systems work on the 'average' principle. That is, the meter is designed to assume all scenes it measures will be made up of light and shadow in fairly equal proportions; and it takes into account the extremes, arriving at an average reading for the entire scene. In practice, that works perfectly satisfactorily more often than not – but you can see that there is no such thing as 'perfect exposure' in which one click of the shutter encompasses every level of brightness before the camera.

Advanced metering systems will incorporate spot measurement – the reading will be taken from a tiny area of the subject. With spot metering the photographer may decide exactly which tiny area of his subject is to be precisely exposed. And many professionals use a separate meter, of the spot measuring kind, rather than rely on the possible idiosyncrasies of a built-in system.

You can over-ride an averaging system to make allowances for unusual lighting – which is precisely what backlighting is. Unusual, in that it is contrary to the common advice to shoot with the sun behind your shoulder. But it is also a very attractive technique and makes the subject stand out boldly from the surroundings.

The control which over-rides the camera's meter is usually referred to as backlight control or exposure compensation control. It allows you to impose under or overexposure usually to the extent of $1\frac{1}{2}$ stops, sometimes more. In backlighting, as seen here, you would reproduce a similar effect through overexposing by about $1\frac{1}{2}$ stops, thus holding all that facial detail – which would otherwise vanish in a murky blob as the meter averaged itself out to handle the brilliant background.

SLRs almost invariably offer exposure compensation, and so do a few compacts – there's a little lever on the base of the Olympus XA which automatically offers a $1\frac{1}{2}$ stop adjustment. But you can compensate by adjusting the film speed too. Instead of 100ASA set your ASA dial to 50 and you will introduce a one stop overexposure. Don't forget to reset the dial for normal conditions, though.

An especially valuable feature on those compacts without exposure compensation is a light lock. With that facility you can take your exposure measurement from a very close range (here, it would be right up against Buñuel's cheek), lock the reading and then move back to the shooting position. The meter will have sent 'instructions' to the heart of the system that the subject is in shadow, and the lens will be opened up – giving you a picture taking full advantage of the pleasing backlight effect.

Portraits
exposure
backlighting

Portraits
exposure programming

At first glance this chap might look like a Pacific island warrior, all painted up for action. In fact he is a baker, from Sri Lanka; and what seems like war paint is actually flour.

Whether or not colour photography would have made that any more clear is not relevant, since here we are going to discuss exposure. But there is a point to be made concerning the use of colour reversal film: it would have had a tricky job in handling the high degree of contrast the high and strong sun has introduced. Both colour print film and black and white are less troubled by contrast extremes, as both are much more tolerant of exposure error.

And in a scene like this there must be exposure error. Why so? Because the difference between the whitened shoulders of the baker and the darkened doorway behind him is so great that there is no film made which could satisfactorily record detail in both areas. So, the exposure here is right for the shoulders, 'wrong' for the doorway. At least, wrong for the doorway if one wants to see detail there; but the man is the important element of the picture, and the 'error' which has created the darkened background also becomes a valuable element – in that it prevents the picture from becoming too cluttered with detail, and thus concentrates attention on the figure.

All exposure is a compromise. Hence the great care with which studio photographers approach lighting and exposure metering. By adjusting the lights it is possible to bring various elements of the scene up to just the right brightness to give the right depth of tone with a specific exposure – that exposure being calculated to record properly the main subject or most important bit of the picture. Compromise *will* have to be made, but as long as it concerns relatively unimportant bits it doesn't matter.

Basically, the big attraction of a manual camera is that the photographer may control the exposure setting himself, and with some degree of precision: *but he needs that only if he has identified some part of the subject which requires special treatment – which needs to be rendered out of focus, or which needs to show great detail, or which will be allowed to go very dark, to quote just a few examples.* If there is no such requirement, and if the light is fairly even (as it might be on a slightly overcast day) then perfectly satisfactory exposures will be delivered by even a fully programmed compact. And it is important to understand just what fully programmed means, before any beginners run away with the idea that a camera featuring it is going to guarantee super pictures whatever happens.

It is sad but true that any mention of automatic or programmed has folks believing there are no decisions left to be made! Nothing will ever replace the need to decide on suitable point of view, and suitable composition: all that is up to the photographer.

There are, essentially, two kinds of exposure control – adjustable, and non-adjustable. Neither is intrinsically better, though control introduces much greater flexibility for special treatments.

But modern programmed compacts, especially if the camera settings go from (say) f/2.8 to f/16 and from (again, say) 1/30sec to 1/500sec in stepless fashion, are for most subjects very precise little instruments indeed.

Stepless means a smooth transition from one setting to another; going from 1/30sec to 1/60sec also takes in *every little fraction* between them. There is no jump from one to the other. Thus, the camera adjusts itself very accurately to whatever part of the subject is the most influential in terms of brightness. So much has full programming proved itself that it is now built into some highly sophisticated SLRs too.

The one drawback (if it can be called that in view of the other advantages of accuracy and simplicity) of full programming is that the camera decides for you which pairings of settings you will use. If you want to shoot at a higher shutter speed and a wide open lens aperture, forget it! Programming provides, almost invariably, a maximum exposure capability of 1/30sec at f/2.8, going up to 1/500sec at f/16. And that means that in order to use a very high shutter speed the photographer just has no option but to work in brilliant sunlight (though using the fastest possible film is a help). Equally, he must work in the dullest light if he wants to get that lens wide open to f/2.8.

Fully programmed cameras take away the problems of deciding upon exact exposure – but they also take away some options.

Portraits
flash
shadows

The first spark from the first flint stone ever struck must have been quite a revelation. Suddenly, though for a very brief period, there was a little burst of light – caused quite independently of the elements.

Flash is now so common that we seldom stop to consider the marvel of it. But without any problems at all we can put light just where we want it. And how we put it where we do affects greatly the appearance of our pictures.

Straightforward flash units are a dime a dozen: you buy one, stick it on top of your camera, and there is light. Of course you can go on and experiment, bouncing the flash and doing all sorts of things with it. Shadows will appear, or not, depending on how you use the flash unit. For shadows and light go very much hand in hand.

Have you noticed something odd about the shadows outlining Frank Muir in this portrait? They were caused by a fascinating bit of equipment known as a ring-flash unit.

Ring flash resulted from experiments in medical photography, aimed at producing a shadowless light on close-up subjects for dentists, and doctors comparing their diagnoses of, say, skin problems. They needed a form of lighting which did not throw any shadows at all on *very close-up* subjects.

Ring flash is just what it says. It consists of an electronic flash tube wrapped around the camera's lens barrel, to deliver light from an ultra bright circular source. At very close quarters the light strikes the subject evenly from all directions. But move the subject away and the shadows begin to appear as the light falls off in strength.

Photographers soon discovered uses other than medical, and ring-flash is common now in natural history photography when the subject is quite small – an insect, or a plant. But since light is the most basic of photography's tools *any* source of it was bound to be subjected to experiments. So here we have portraiture by ring flash.

The effect is quite different from that coming from any other source. But particularly evident is that biting rendition of texture – even on Frank Muir's rugged face! The catch light in the eyes is, too, characteristic.

The most vital point to remember about electronic flash is that it is all over in one ultra-brief burst: a very powerful unit might emit a flash as brief as $1/100,000$th of a second! What that means is when ambient light is low the electronic blast of light is not only illuminating the subject but is dictating the effective shutter speed as well. Consequently – little or no chance of camera shake.

More traditional sources of light, such as studio photofloods, are not as powerful as flash and are more likely to lead to a blurred effect through too slow a shutter speed – or a too quickly moving subject.

Flash can be used in so many ways. It does not have to be fired from one position only. There is a night-shooting technique known as painting with flash, which requires a number of bursts of light from different spots around the subject. It is necessary to keep the camera on a tripod, and to lock the camera shutter open on B, using a locking cable release. The flash is used without connection to the camera – being fired by its own test button. The effect then, if sufficient bursts are fired, is an overall even lighting; alternatively, the various bursts may be used only to light different parts of the subject – the technique is often used for studies of large buildings or industrial locations.

Painting with flash relies for its success on delivering light from a number of different positions – which is exactly what ring flash does, and all in one go.

Portraits
flash
reflector

At one time there was a special person in portrait photographers' studios, charged with the very important duty of putting a sparkle into the eyes of the sitters. With a very sharp blade this person would gently scrape away tiny pieces of the picture, to put a white catchlight in each eye; sometimes, the job would be done with a paintbrush and white paint instead. The effect was the same, more or less: it would enliven the picture and make the eyes look more bright.

That was in the days of somewhat formal portraiture, when photographers would have nothing else but 'glamour lighting' – with a delicate little shadow falling across the sitter's upper lip, the shadow caused by the nose. And the lights, photofloods, would be moved with infinite care and patience to get that shadow just right. The style is sometimes referred to as Hollywood lighting – especially when combined with a soft focus appearance.

Nowadays, the tendency is to use flash, most often bounced, and to have the main light pretty weak and in front of the portrait sitter, instead of away to one side. So, often there is only one light – an electronic flash unit being directed into a brolly, so that a soft and diffused light is bounced back onto the subject. And that typical nose shadow is today no longer thought as desirable as it once was.

If you look very carerfully at a portrait shot you will be able to tell much about the lighting under which it was taken, just from the reflections in the eyes.

This is Tracy Taylor, pictured under very soft bounced light. You can see a square of white reflected in Tracy's eyes: it was caused by a large diffuser over the Bowens electronic flash 'bank' directly in front of her. But you'd see a similar effect if you bounced a fairly powerful electronic unit off a sheet of white card.

The shape of your reflector – your white card – could be varied: you could even cut out a big star shape. The eyes really are very important, and in recent years photographers have begun to do all sorts of extraordinary things with them – to further heighten their natural impact.

Red-eye – a common flash fault – is so dramatic it never fails to draw a comment; and in some of the more outrageous fashion pictures you may have seen the effect simulated, the vivid red being added with bright ink or paint. Even more remarkable in appearance, though, is a picture in which the eyes have been obliterated altogether – either by paint or by trickery try a double exposure, or a very slow exposure in which the eyes are open for a moment then closed, so that the eyeball appears faintly, the eyelid strongly.

And why shouldn't you experiment with one of those starburst filters everybody seems to be using nowadays: the effect could be sensational, if that sparkle in the eyes is strong enough in the first place. There's a real lighting challenge for you!

Whatever else you do, make sure the eyes are sharp in your portrait pictures: if they're not, the dissatisfaction your pictures will cause could be great – probably out of all proportion to the relatively minor technical error of bad focusing. And do aim to get a catchlight in the eyes every time – blank dark pools just aren't as lively as eyes flecked with that all-important sparkle of light.

Portraits

filters
film

How do you turn sparkling blue eyes into balls of coal – and how could you make them pale as straw? And how do you exaggerate freckles? What's the best way to make a mouth luscious and full of tone and texture? How do you soften the already translucent look of delicate skin?

You could hire a very skilled and probably expensive make-up artist, or you could opt for the simpler method – using filters.

The female face – this one belongs to the bubbling Twiggy – is actually a very colourful area: and you surely appreciate what filters can do to colour, since they have been very much in vogue in the past year or two.

The past year or two! Filters have been in vogue for ever. Even astronomers used them, before photography came along.

If, heaven forbid, you'd never seen a picture of Twiggy, you might assume this to be a shot of just another pretty girl. But the eyes of this lady have peeped out from endless magazine covers, and everyone knows they are predominantly grey: depending on the colour photography and printing treatment they may end up tinged with either blue or green. Yet here she is with smouldering dark orbs.

Using filters for portraiture is not a common idea, but it's certainly not a rarity amongst those who shoot faces for a living.

Of course, filters are commonly used for landscapes in black and white photography, but there's no reason why they shouldn't be used for portraits in either colour or mono. It's important, though, to understand the essential differences.

Filters for colour are basically of two types – either correction, or the more dramatic special effects variety now often sold in kits, with special holders to mount on the front of the lens.

Correction filters will have an effect on the quality of the light by which your subject is lit, and will actually do little more than bring the finished result more clearly into line with what your eyes perceived at the time of the session. Unless, that is, you deliberately set out to experiment with the colour temperature of light – in which case you can actually shoot outdoors with special tungsten light film and make your portrait shots look as though they were taken by romantic moonlight.

The special effects filters will show immediate and dramatic differences (in colour). But they are mostly designed for landscape shooting, and you are hardly likely to want to shoot portraits with a graduated filter.

Though you can adjust the effect of colour temperature of light when black and white shooting, it is nevertheless true that filters for black and white photography are mainly of the contrast variety. They impose their effect by subduing some colours, exaggerating others – effectively heightening or lowering contrast, depending on the colours in the original scene.

Obviously, green, red, yellow and blue contrast filters could all be used to adjust the tone of one or more parts of a portrait face: in particular, green and blue are reliable ones, since they can darken lips, and may put more apparent colour into slightly pale cheeks. But think of *all* the effects of contrast filters, and don't hesitate to experiment with them. Just remember that each filter will, in black and white photography, lighten its own colour and will darken its complementary colour – green will lighten green but darken red, yellow will lighten yellow (say, flaxen hair) and will darken blue, and so on.

In the early days, portraitists had many problems, since the orthochromatic film of the day was a little weak on sensitivity to red (lips would be weak and, worse still, the film would be very slow in artificial light which was very strong in red content). Now life is easier, since modern film is panchromatic – sensitive to all colours of the spectrum.

In fact, that orthochromatic film of old may really be thought of as just another form of filtration: now that we no longer suffer from its defects we are free to introduce any other defects we may wish in pursuit of whatever effects of our own we want to introduce.

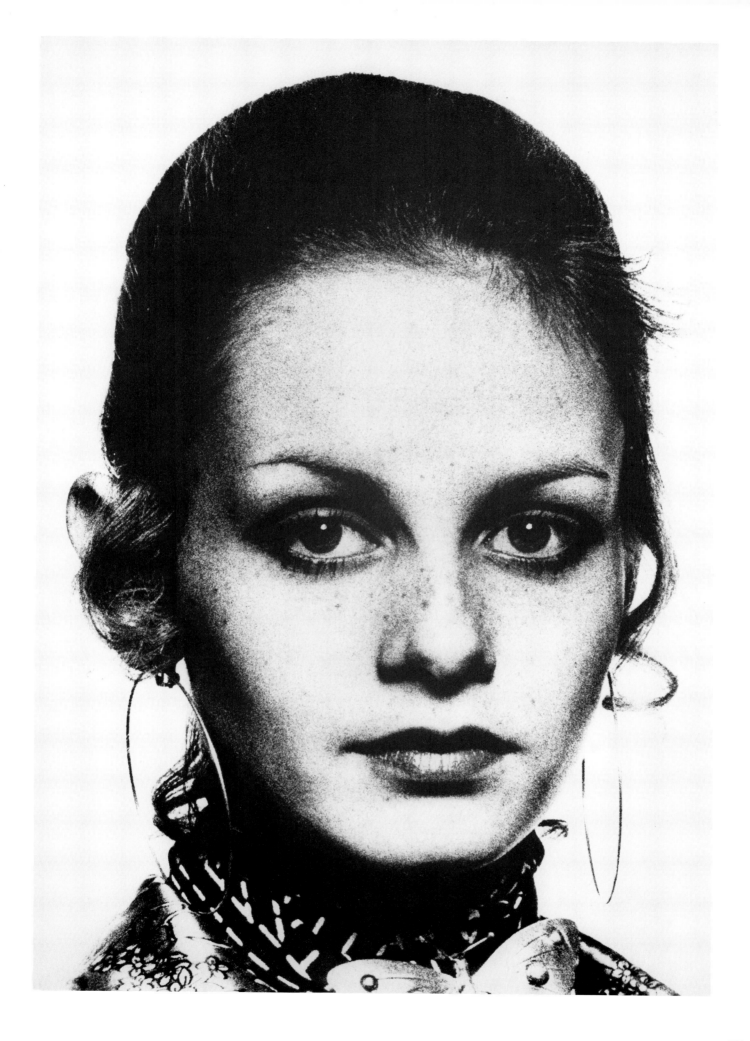

Portraits
bas-relief

When you send a roll of film to be processed what comes back is a set of pictures of more or less exactly what was in front of the camera when you pressed the button. And the prints will be of a quality determined not by yourself but by the processing laboratory – transparencies are, on the whole, returned in pretty satisfactory condition, and don't suffer from the same horrendous colour and contrast deficiencies which plague enprints.

Making your own prints does away with disappointments. And, perhaps even more important, doing it yourself opens up a fantastic box of tricks. There are so many techniques to be explored that you could easily spend a night a week in your home darkroom for the rest of your days trying something different each time.

Opposite is a portrait of singer Cat Stevens (remember his beautiful song *Morning has broken?*) who has latterly considerably changed his life-style. You will see in the picture a strange effect, which softens the outlines; it gives the picture a quality of depth and relief rather in the manner of a shallow sculpted plaque. In photography, the effect is known as bas-relief.

Before we go on to find out how this particular technique is produced, let's consider why anyone should wish to embroider a straightforward photographic image. There are times when a special technique – imposed in the camera or in the darkroom – may introduce some extra element which helps add to what the picture is saying.

Probably the commonest way of influencing the impression a picture gives is by controlling the grain – that is, the structure of the actual image, the tiny clumps of silver which build it up – and the way it records detail. When photographing a beautiful girl in a romantic setting a commercial photographer will often enhance the dreamy atmosphere by obscuring some detail, and blending pastel colours together. He will put this soft focus technique into action by using a special filter which diffuses the light rays from his subject, but he can also do it by shooting through cellophane or through Vaseline smeared on his lens. The misty effect obtained equates perfectly with the warm thoughts the picture is intended to produce.

On the other hand, there are many who will exaggerate their film's grain structure, either by special development or by enlarging a tiny area of it. Grain, when exaggerated, also obliterates detail, but with a different end result. Combined with pastel colouring it can create an exotic and romantic image too, but when used in conjunction with deep colour, or stark black and white, it introduces an effect of excitement, of action, of something going on. You'll often see it used in sports photography.

Other techniques introduce other impressions: the important thing to remember is that the photographer can influence the images he produces at two stages: first, when actually shooting, and secondly when he is creating the finished picture in his darkroom.

What of the bas-relief technique? What can it do for a picture? Several things. It can emphasise detail, by making it more eye-catching due to that relief effect, and it can help separate a subject from its background. It can too create subtle suggestions in the viewer's mind – suggestions of dual personality, of the subject being surrounded by a halo, even of the image being a little three dimensional.

Bas-relief is a technique with more than one end result. Indeed, the two major variable elements within it combine to make the outcome entirely individual.

You begin by selecting a thinnish negative to work from. And it should be of a subject which is relatively simple and bold in outline and tone. Too many tones and shapes within the picture will lead to a confusing jumble more like op-art than subtle suggestion.

Having chosen your negative (and the ideal should be soft in contrast as well as a little thin) you must now make a positive of it, by contact printing onto sheet film. In effect, you must make a transparency (the positive) exactly matching the size of your negative. And make the positive a little on the thin side too, thinner than the negative.

The relationship between the densities and the contrasts of the negative and the positive is what makes one of the major variable elements mentioned earlier. Now here comes the other!

Sandwich both negative and positive together, but just out of register. How much out of register? That's the variable, and the degree of displacement will affect your end product. The tiniest overlap will give you an effect which is actually little more than apparently increased sharpness of the original image, and a great separation will produce an exaggerated effect – sort of double vision.

In practice, you should displace the negative and positive along an axis which matches the direction of the light falling on your subject, but there you come upon yet another variable. The real guide is your own appreciation of how the end result appears. And you can happily experiment with half a dozen different versions.

Bas-relief is not exactly a rarity, but it's far from being a common technique these days. Its heyday was back in the pictorialism period, when enthusiastic hobbyists would spend ages doing anything and everything to an image which might render it even marginally less than straightforward. But since then we have been through an age of realism, and are emerging onto what could be described as a new plateau of expression.

Television imagery – electronic colour shifting, and image splitting – has helped bring us onto this new plateau, and so has the astonishing stuff produced for record covers and pop posters. What it all boils down to is that today's photographer is screaming for attention in an image-laden world – just as the writers of newspapers must resort to screaming abbreviations of banner headlines to help them cope with TV newscasts. To keep pace with the needs for immediate impact the photographer will doctor many a picture.

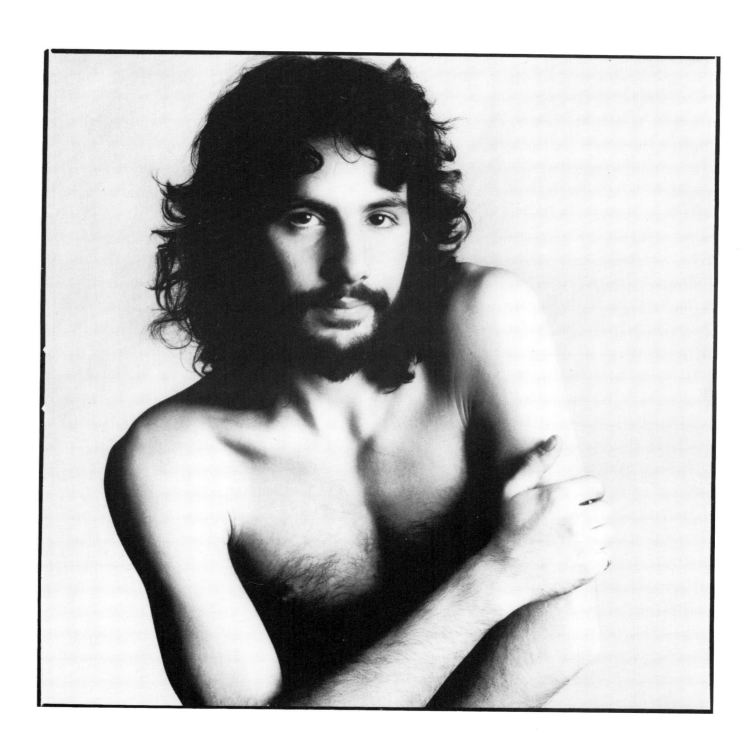

Portraits

grain
light level

This is Sarah Moon, very well known for her quite individual style – subjugation of detail through chunky grain-filled images, and almost monochromatic coloration.

A Moon image sets out to set a mood. It conveys information not through any story-telling effect gradually built up by detail after detail – the effect is a raw assault on the emotions.

Rarely, though, does Sarah Moon shoot the face in quite such prominence as here. Mostly, the viewer is invited to peek into a private world, in which Moon's models are going about some quite languid business of their own, and are perhaps even being a bit eccentric, or are reminiscent of period days.

So, here is Sarah Moon portrayed in *something* after the fashion in which she herself works. It is a way of portraying personalities which is frequently adopted – though it is often wildly overdone, as when artists are pictured surrounded, even swamped, by the paraphernalia of their studio existence.

However, the significant point here does not relate to the extent you need to go in order to build up a picture of a person's lifestyle or character: it has to do instead with economy.

In strict fact there's hardly a grey in this portrait. It is of black and white, stark and simple. The grain is hugely evident, so much so that it's easy to perceive the black individuality of each clump. This is almost a 'dot' picture – stippled as in French impressionism. Tones are few to say the least, the impression of grey coming only from those clumps of grain – which shape the picture where it is necessary.

And there are very few props: a cigarette, a hat, some rings.

Economy in the extreme. Yet, overall, the impression is of a somewhat romantic lady in a somewhat romantic setting.

For all that, amongst photo hobbyists who should know better, obsession persists with marginal differences in lens performance. An image such as this – and a hundred thousand other images too – could have been shot with virtually any camera.

Two things are important. First, detail is valuable only if it significantly aids the impression you are trying to put across: if it doesn't do that then it stands a very good chance of doing nothing more than confusing the message. Example? A perfectly plain background will often succeed where a carefully arranged setting may flop.

Second point of importance: you must have complete confidence that your camera (and the way you set its controls) and the film in it are capable of recording just those bits of the subject you want recorded.

Here, the oval-shaped face and the particular tilt of the hand are the picture – and the cigarette is but a suggestion. But suppose the exposure had been such as to guarantee a perfectly exposed cigarette; what then? Disaster elsewhere, that's what. The face and hand would have been too dark, and contrast would have been lowered to such an extent as to remove any sparkle the picture has.

What makes this picture is the light level! More or less exactly the same picture could have been taken with a very limited camera – providing the light level had been high enough. Even a simple 110 camera with an exposure setting of, say, 1/100sec at f11, could capture an image like this – if all the right bits were lit to the right level (a much higher level of course, than would be required by a good quality compact operating at 1/30sec and f2.8 with 400ASA film in the camera).

Imagine one of those dimmer switches in action – the sort of thing you twiddle to turn the room lighting higher or lower. And consider that every little twiddle actually represents a different camera exposure. With the lights turned down low you can still get a certain picture with a wide aperture lens, a slow shutter speed, a very sensitive film; turn the lights up high (remember – light level alters, not the position of the light) and you can set to and reproduce a similar effect with the simplest box camera.

Other matters come into all this, such as the characteristic of films which makes them react somewhat differently in ultra low light to the way they do in bright light: but the important thing to dwell upon is that each shutter speed/lens aperture/film combination is capable of a certain effect in specific lighting conditions which it will not reproduce in other lighting conditions.

Thus, there's really a great deal more value in learning how to comprehend light (the way it affects film) than there is in busting your bank balance for a few more lines per millimetre in the performance of your lens. And a thoroughly good way to begin understanding light is to shoot one subject at every single exposure combination your camera's lens and shutter will allow.

Very rarely will you find one exposure perfectly right for every corner of your picture area, but quite often you will find the most extraordinary exposure right for a *certain part* of your subject. And if that part is truly significant then you have begun to shoot successful pictures.

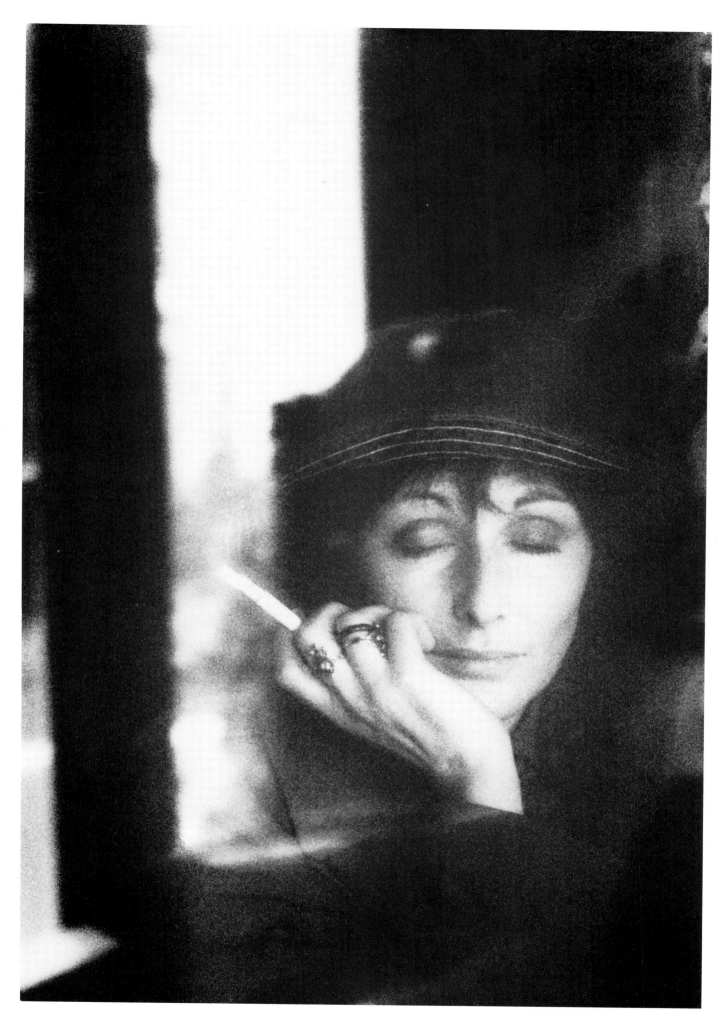

Portraits

formats
shutter speeds

Here's a portrait of Dirk Bogarde. It's a thoroughly relaxed and informal picture, one in which the famous actor is seen entirely at ease. A portrait it is – but this one is a long way from the studio set-up in which everything is under the photographer's control.

And yet, such a picture as this *is* under the photographer's control. In the sense, that is, that he has the ability to decide whether or not to shoot at all: either he produces a picture or he doesn't.

There is, it seems, a great reluctance to accept that all cameras are basically similar, the refinements being there essentially as problem solvers. But you need a problem solver only when you have a problem.

Here, in the shade, though with light sneaking in from various directions and in varying strengths, there wasn't really a problem, so there was no reason to refrain from shooting. Some of course will object to that, and will say the picture has been taken from too close. The implication of that is that there is something wrong with whipping out a camera and shooting a picture while you are chatting to someone. What rubbish!

Where there is light, and where there is a subject, there too is a picture! And the great charm of the contemporary 35mm compact is that it goes wherever you go, into whatever interesting situations arise; and provided you have a reasonably sensitive film (400ASA is pretty good as an all-purpose tool) and a camera capable of reasonably low light shooting (say, 1/30sec at f/3.5 or f/2.8) you can come away with a satisfactory picture.

Of course, at close quarters an SLR will be an even better bet when lens apertures begin to move as wide as f/2.8 – the accuracy of focusing will prevent unsharpness on the all-important area of the eyes.

It is enormously important to acquire the confidence to shoot in whatever situation you find yourself. Nobody will deny the suitability of a lengthy lens (100mm or so on 35mm format) and a clean background and well-positioned lighting for first class portraits: *but only a fool will insist they are the essentials of portrait shooting.*

Essentials? If there are any at all why not insist on a studio, and on a background paper of a certain colour; why not plump inflexibly for 6 × 6cm format, and refuse to work unless you have brolly flash and a make-up expert standing by; why not refuse to shoot unless your camera is loaded with colour film...

Without doubt the inventiveness of the camera companies has given us a breed of compact cameras which are capable of just about anything. And should you find yourself sitting there in conversation with a friend then you are also in a perfectly adequate position to shoot a portrait of him, or her.

Format is much discussed – and today, with disc, 110, 35mm and 120 film, there is indeed a good deal to discuss. But format means the shape of the negative too, as much as its actual area. And camera designers give much thought to that. Until you get into the *very* sophisticated cameras the assumption seems to be that the majority, if not all, will use their cameras in just the way they are built – that is with the camera square, not tilted.

A 35mm camera used in its 'designed' position will give you a negative of proportions wider than they are tall: the 36 × 24 negative will then be in what is known as landscape format. Turn the camera up on its side and you have a tall and relatively narrow negative, in what is now known as portrait format. And though it isn't at all the only way, that format is nicely suitable for portrait shooting – it gives you a nice deep picture in which the face occupies the important area at the top, still leaving plenty of space for you to utilise in the important business of hands and arms and upper torso. In this picture, Bogarde's cigarette, and even his 'sporty' shirt, add a bit extra to the overall portrait.

Portraiture – at least, portraiture this close – is unfortunately relatively rare. But there's no reason why it should be so. Using a camera this way up, in the portrait format, will give you a good sized image, even with a compact 35mm model – which will probably have a modest wide angle lens.

One tip: use your camera with the right hand edge at bottom when shooting in the portrait format. That way, you will be perfectly able to reach the shutter release button while propping both elbows firmly upon the table, thus forming a solidly based triangle – which will give you sufficient support to help avoid over-obvious camera shake, even at shutter speeds of down to 1/8sec or 1/15sec.

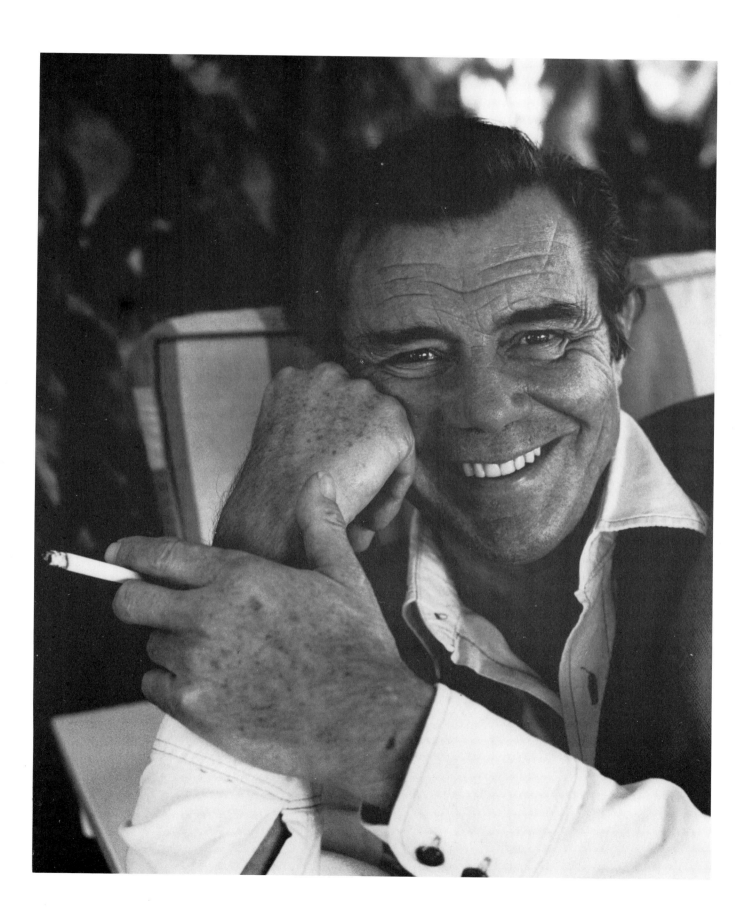

Portraits
negative area
grain

Sting, of The Police, is blessed with 64 eyelashes along the lower lid of his left eye. That information won't change the world, but it does have a photographic significance which just might gently nudge your way of thinking.

This portrait of Sting – in which the eyelashes can be counted – was taken on 10×8 film, and the picture is stuffed with detail. At least, it is in the plane which is in sharp focus; but look closely and you'll see the crispness falling off around the hair, the hands, and shoulders.

Obviously, the eyes presented the important target on which to focus for this shot, and it is there you can see most detail. It has to be admitted that 10×8 is a little outside the budget of even the most avid hobbyist. But big format photography is, in landscape and still life photography particularly, capable of stunning sharp detail from foreground to horizon; and there are negative sizes larger than 35mm which are more readily available to the hobbyist than is 10×8.

No, this is *not* the beginning of an assault on 35mm photography – it is a brief discussion about pure image quality. And what you see here is more or less a contact print.

Grain exists in every negative. It has to, otherwise there's no image. Yet no matter how large you make this shot of Sting it will always contain more detail than any 35mm negative could yield.

Grain is image; the image is made up of grain clumps. Look through a powerful magnifying glass at any black and white print and you will see the uneven arrangement clearly: and the more you enlarge your picture the more that arrangement of clumps of grain becomes plain to the naked eye.

Since grain represents the building bricks of the image, there is a great relationship between it and the ability of any picture to hold detail.

Frequently a photographer may not wish to hold detail. He is as free as any artist to choose his medium, Artists work with chalk, water colours, ink, oil paint, lithographs – all of which render detail in different ways and in different degrees. In photography, a grainy image subjugates detail for atmosphere and impression. And heavy grain is deliberately induced, by very generous development of the film, by overexposure, and by great enlargement of small areas of the negative.

Detail and grain are inextricably linked, just as detail and negative size are. And there's another factor in these relationships: that is that fast film of conventional type begins life, before development, as a compound of larger silver halide particles than does slow film.

Now let's see what all that means in practice. A 10×8 negative has more than fifty times the area of the $1 \times 1\frac{1}{2}$ inches of a 35mm negative. Imagine the 10×8 as a football field, and the 35mm as a proportionately smaller piece of turf, and imagine both crammed with footballs. The balls are our particles of silver halides, assuming both negative sizes are coated with the same kind of film emulsion.

When, first, light and then development affects a film emulsion what happens is that some of the particles are turned to black metallic silver. Not grey, black.

Where much light has struck the film there will be a concentration of blackened particles, and there will be few blackened particles where only a little light has struck. The resulting negative is a reversed image of reality. When it is printed onto photographic paper the process begins again. Where little light fell on the negative, resulting in only a scattered few blackened particles, the enlarger's light will pass through more or less clear film, and will be free to heavily affect the photographic paper, now creating an area of *greatly* blackened particles – and recreating those dark areas which were in the original subject.

Exactly as in a newspaper illustration the picture is made up of black and white, the detail being created by the density or lack of it with which all the blackened particles clump together. In large white areas there are very few particles: in dense black areas, someone's hair perhaps, there is a great profusion of particles clumped closely together.

Let's return to those footballs. And let's suppose we are about to paint some of them black, in order to create a pattern which might represent somebody's face – the face of Sting here, let's imagine.

Of course the two different formats in our example will be used with hugely differing lenses, but each will contain the same image, that tight head and shoulders portrait of the singer. And since in photography we create first a negative and then a positive print we shall here consider our football field and its smaller piece of turf as negatives.

You will immediately see that by painting some of the footballs black and leaving others white it will be possible to create an impression of a face; and the entire football field, containing many more footballs, will allow greatly more details to be shown than will the smaller area.

To put it with dubious subtlety, the smaller area just doesn't have sufficient balls to match the quality of the larger!

None of that will affect the popularity of 35mm photography, and nor should it.

For 35mm is an extremely versatile tool. Of course, if you enlarged a 35mm negative to the same size as a 10×8 negative, assuming both to be of the same film emulsion, the quality difference would be substantial. And a negative from a $2\frac{1}{4}$ square camera would show an improvement (but proportionately less) in quality over 35mm too – again if on the same film.

However, the man who does indeed want the ultimate in quality from his 35mm camera can always use a very slow film, in which the silver halide particles are very small (instead of footballs think of cricket balls) and consequently highly capable of recording detail.

What, though, is quality? It is not, emphatically not, the preservation of detail alone: it is as much impression and atmosphere and subtle influence on the mind of the viewer of a picture. And the pure convenience and portability of a 35mm SLR puts those particular quality goals well within the reach of anyone with half an ounce of sensitivity in his soul...

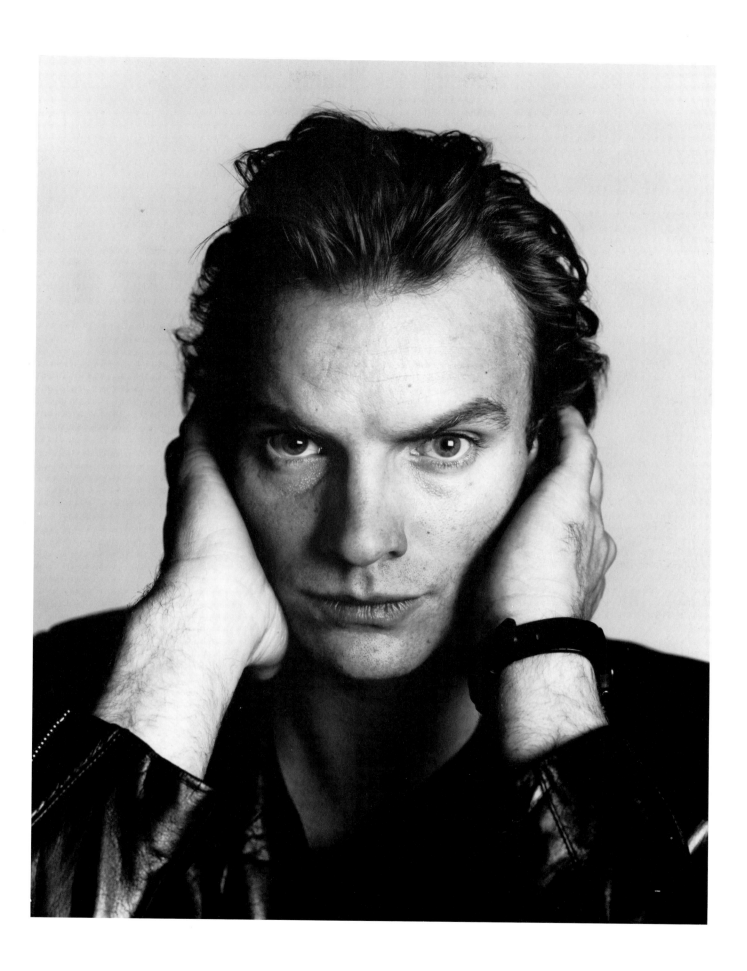

Portraits
large format
lighting

Though this is another 10×8 photograph (it was shot on a Dierdorf studio camera) there's a world of difference between it and the 10×8 portrait of Police singer Sting on page 95.

With Sting, it mattered not a jot that the lens showed his every pore and the overall impression was crisp and hard. The picture was a-dribble with detail – and detail uncompromisingly shown. A male portrait need not be dressed up in the coy approach!

But here, where the subject is Marie Helvin, the intension was that the image should be soft, gentle, romantic, and intensely feminine. The flowers help in all that, of course, and so does Marie's exuberant tumble of hair. But just as important is the delicate lighting, and the strong concentration on the eyes.

This is the very antithesis of that vintage Hollywood glamour lighting in which the model was swathed in mysterious shadow, either to highlight or conceal certain features. Here, the soft light insinuates everywhere – even in beneath Marie's chin, where models usually have to put up with a pool of dense nothing.

You could get this effect by using a very large brolly flash unit, bouncing light all over the subject. But even with the light quite low down you'd be very well advised to use a reflector, as here. The reflector – a large sheet of white card makes a good one – was placed just in front of Marie, and a shade to the left of the camera, so as to bounce light into the right cheek (avoiding a nose shadow) and up under the chin.

A heavy blush tint on a girl's cheeks will prevent her cheekbones being swamped by light so that they lose modelling when treated to soft frontal light.

There is actually not a great deal of depth of field in this picture (that's a pretty normal outcome from 10×8 portrait shooting!) and yet the impression is compulsively of quality in those facial tones. Look close and you'll see great care has been taken to stretch whatever depth of field there was sufficiently far for it to cover both eyes.

It isn't wrong (nothing is ever 'wrong') not to have a portrait model gazing straight into the camera lens; but if you do have her looking anywhere else but at the lens the effect you come up with will be very different from this.

Here is the 'Laughing cavalier' syndrome: in that famous painting the cavalier's smiling eyes, directed straight towards his painter, appear to follow the viewer around the room.

But the directness of a gaze affects the intimacy of a portrait too. If the model's eyes are downcast, or gazing away out of the picture area, the viewer feels a less direct contact with her; in fact, he may very well end up feeling a bit like a peeping Tom!

Eyes should always be in the crispest focus, no matter how disturbing the technical problems involved – or unless there is a very good reason (the girl may be secondary to a product pack in an ad shot) for not having them so.

Mostly, props are a bit of a liability when shooting portraits. In particular, obvious attempts at creating a feminine atmosphere – with soft veils, flowers, cuddly toys – should be treated with great thought. Here the flowers work well enough – but only since they are so unfussy. A tiny little posy of miniature blooms *could* have spelt disaster.

Begin with a plain background, plain surroundings, your model plainly dressed – and you will seldom go wrong. Stick with the simplicity through to your lighting too, and you're halfway home.

The big 10×8 negative positively drips quality, but 35mm photography is full of exceptionally fine-grained films which could offer you that smooth tonal quality of skin. But please remember that in any experiments you carry out along those lines what you should be looking for is quality of tone, and gentle lighting. Sharpness is not the ultimate, though it matters greatly over the eyes. If you spend ages examining your negative through a high-powered magnifying glass to check whether your lens is delivering so many lines per millimetre then you've missed the point.

Portraits
square format
zoom lenses

The simple but very bold graphic shape is what makes this portrait of model Penelope Tree interesting. She is swathed in a cloak of dark material, and topped by a huge hat, also dark.

Those simple elements keep the outline free of fuss – to which end, also, Penelope's hair is carefully arranged.

The large ring can hardly be missed! And it too plays its part in the composition: it and the hat are in harmony of shape.

But most significant of all is the shape of the picture area. It is square – and that, in the handling, is a proposition entirely different from the 1:1 ratio of a 35mm negative.

A powerful advantage often claimed for the 2 inch square negative is that it has so much space, and will readily allow the photographer to crop away huge slabs of it in order to manipulate his picture area to his precise fancy. No idle claim that, and many a studio or wedding photographer has good reason to rely on the biggish format SLRs or TLRs. The big negs can be cropped to quite specific proportions, and pictures of wedding groups supplied in more or less 'conventional' shape. Provided, that is, the composition has in the first place been arranged to allow for cropping.

In a perfect world cropping should never be an afterthought. The composition should be so arranged in the viewfinder that you can see in your mind's eye the finished picture.

Accepted, that is not the easiest trick in the world. To begin with, photographers shooting in black and white must learn to ignore colour, and to see everything in terms of shades of grey, black and white. Half closing your eyes helps; at least it seems to make bold shapes more easily recognisable. But nothing will take the place of real appreciation of how certain colours *and* light levels translate into black and white. Bright light on, for example, a background paper of almost any colour will be rendered white in the print.

For all that concern with colour and tone, most people will automatically think of actual shapes when they consider composition. And they will think in two dimensions. That is, they will begin to visualise the image in its relation to the four edges of a flat piece of paper. But the world is three dimensional – and that is of the most enormous importance in photography...

The human eyes, nicely spaced apart through aeons of evolution, use the three dimensional quality of our surroundings to keep us aware of precisely where we are in relation to everything else – so for humans, 3D is an aid to spatial awareness, you might say. But to a camera two of the three dimensions are for composing in, and the third is for determining scale!

Scale has, of course, much to do with composition, in the sense that by varying the sizes of the elements within your picture you can greatly influence the effect. And scale, relationship of the size of one thing to another is yours to control simply by moving nearer to or further from your subject – or by arranging the elements of your picture nearer to or further from each other. And having done that you then adjust the image size by choice of the right focal length of lens.

Let's suppose the requirement in this picture of Penelope Tree had been massive emphasis on that ring she is wearing. As it is, the ring is prominent, but not intrusive. Had Penelope's hand been outstretched – nearer, that is, to the camera – the ring would become much larger in relation to the rest of the picture. Then, by moving the camera even closer, to within inches of the hand, the ring would be made larger still.

But at that close range it would become necessary to switch to a wide-angle lens if it was still required to show head and shoulders too, as here.

So, first assess the composition, arranging it to convey just the impression you want – and *then* choose the lens focal length to suit. And that, is the greatest single justification for the existence of zoom lenses.

Portraits

Polaroid posing

Here is a Polaroid shot made for Italian *Vogue*, on 195 material, which yields a negative from which conventional prints may then be made. The quality is, as you can see, very high indeed: it's certainly more than adequate for reproduction. In fact some photographers work a great deal with Polaroid negative material, and American landscapist Ansel Adams produces superlative print quality in that way.

Polaroid film is now commonplace in professional studios: it is relied upon to provide an indication of how the lights are balanced, where shadows will appear, so that the photographer may make last minute adjustments before shooting on conventional material with his high powered flash units.

Such Polaroid test shots are done by attaching a special back to the conventional camera, which is loaded with the Polaroid material – usually the peel-apart variety.

You can see that what this adds up to is that, in effect, a series of 'rehearsals' are held before the shot proper is taken.

So, does that make a mockery of the magic moment, the instant when everything is supposed to be just right for a perfect picture to emerge? The answer is simple: no it doesn't – and when shooting pictures which require a spontaneous response from a subject the professional wouldn't go through the 'suck it and see' rigmarole anyway.

Obviously, a photographic exposure of as brief as 1/100sec captures only the tiniest slice of what's going on – and it had better be the right slice otherwise you're in trouble!

Different photographers cope with the problem in different ways. For example, when photographing (on Royal Wedding Day) a family group of around sixty, Patrick Lichfield used a referee's whistle to make absolutely sure everybody was aware – and alert! – precisely when he pressed the button.

Just how you prepare your sitters for that precise moment doesn't actually matter – as long as you do prepare them. Shooting a sequence – a girl parading around in a new fashion design – doesn't require it, but photographing a static model or two, or a group of your friends, will go much easier if everyone is doing just what the photographer wants, when he wants.

That does not mean you have to organise one pose and stick to it, repeating the shot several times in the hope of getting it right once. By all means build up to what you want, persuading your sitter through all the stages. But let them be stages of physical change – a hand raised or lowered, the face turned a little more this way or that.

Don't have long pauses while you rearrange your lighting, or make adjustments to your camera which require fresh exposure readings and general fiddle faddle. A photographer is there to take photographs, not to pretend he's an engineer!

The more portraiture you do the more you will realise that it is the way you arrange your sitter which matters, not the technical surroundings. In particular, lighting can be duplicated time after time without any risk of becoming mundane. Establish early on an arrangement which suits you, and you can then set it up within minutes – and in many pro studios the lights stand in exactly the same position – more or less forever. All that's needed is an occasional adjustment, higher or lower, the placing of a reflector in front of, or to one side of, the sitter.

Essentially, one light – soft, and bounced from a large white brolly – will do the trick. But because of the inherent inability of film to cope with great contrast between shadow and brilliance, most photographers prefer to use another light, as a fill-in. The main light should be the one which models the face, though; it should be slightly to one side of the camera and higher than the sitter's head level.

The fill-in light can be placed further back, on the opposite side of the camera, but should not be allowed to create any shadows of its own (at least not within the camera's field of view). Its job is merely to throw some light into the shadowed areas of the face.

Study portraits carefully: learn to read them, to assess where the lights were. For example, it's easy to see that here the main light was very high, and just to the right of the camera position. That arrangement typically produces a relatively soft effect, but one which highlights cheekbones in an attractive and always flattering fashion.

Portraits

110 cameras
viewfinder

Here, in a straightforward family portrait, is Mrs Bailey, wondering perhaps whatever made her little son David start mixing with the world of fashion photography!

Seriously, this simple portrait is here for a purpose: to make, and resoundingly, the point that you can start shooting successful pictures just the minute you have a mind to. There is no magic in equipment specifications, though a reliable piece of machinery will obviously keep you happier than a dud camera which is forever going back to the repair shop.

The little machine used for this was perfectly reliable: it was a 110 camera. The massive enlargement necessitated by the tiny 110 negative has made the grainy structure of the image quite obvious, but does that seriously matter? Surely not! If you ask any of the old diehards why it is they are so contemptuous of grain, chances are you'll floor them – they won't have an answer.

This was printed from the entire 110 negative; even so it represents a giant blow-up – by about seventeen times.

You can see that straight flash was used: there are the tell-tale shadowed outlines around the head and shoulder.

So what sort of a set-up could be more simple than this? None – for it shows a lady sitting in her own home, and it's so fuss-free it could have been taken while she patiently waited for the kettle to boil.

Where one picture can be taken so can another – especially if the subject isn't about to vanish like a scared gazelle. In fact, this portrait was one of nine shots.

Now here we run into a potential problem, and it will be one to be solved only by you. It is this: to shoot or not to shoot? Put another way, it concerns the balance between your desire to create a successful portrait and your disinclination to use up more film.

This was the seventh of nine exposures, half a dozen of which were very similar, made as the picture began to shape itself almost. Now, nobody but a fool goes on clicking a camera shutter for no reason – each time the film inches through the camera for another exposure that represents a certain sum of money. But why should it be assumed that one single squeeze of the shutter will capture exactly what you want? With such an assumption both you and the subject are keyed up for that single shot – tensed and expectant that something like 1/60sec will encapsulate all the character of, say, your mother...

Portraiture does take time, even with the closest members of your family as subjects. And weighed against one 'just right' picture the cost of a dozen exposures becomes very small beer indeed.

Now a distinction, which should be self-evident: the purpose of portraiture is to produce a satisfying picture (not necessarily an analytic character study), not to get through a roll of film in the shortest possible time. Each exposure should be an advance on the last, a slight tweaking of the arrangement before you, a progressive moving towards what you are after.

And how do you know when you have actually got what you are after? By letting your eye continually roam over the entire viewfinder area and imagining (work at it, and work hard) the scene as if it were an actual print. Then examine the pictures when you do see them in print form, and be quite critical of all the bits which don't please you – the odd bits of furniture intruding, the ugly shadows, the awkwardly placed hands.

At this stage don't go to any 'experts': jot down the points which don't satisfy you, and eliminate them on your next session – and make sure there is a next session, soon. Bit by bit whittle away the errors – until you can recognise instantly what looks cumbersome and what doesn't: *then* you can show your work to the experts – for by then you'll be sufficiently sure of what you are doing not to be confused by prejudices.

Oh, by the way, that *isn't* a very young Bailey hanging on the wall...

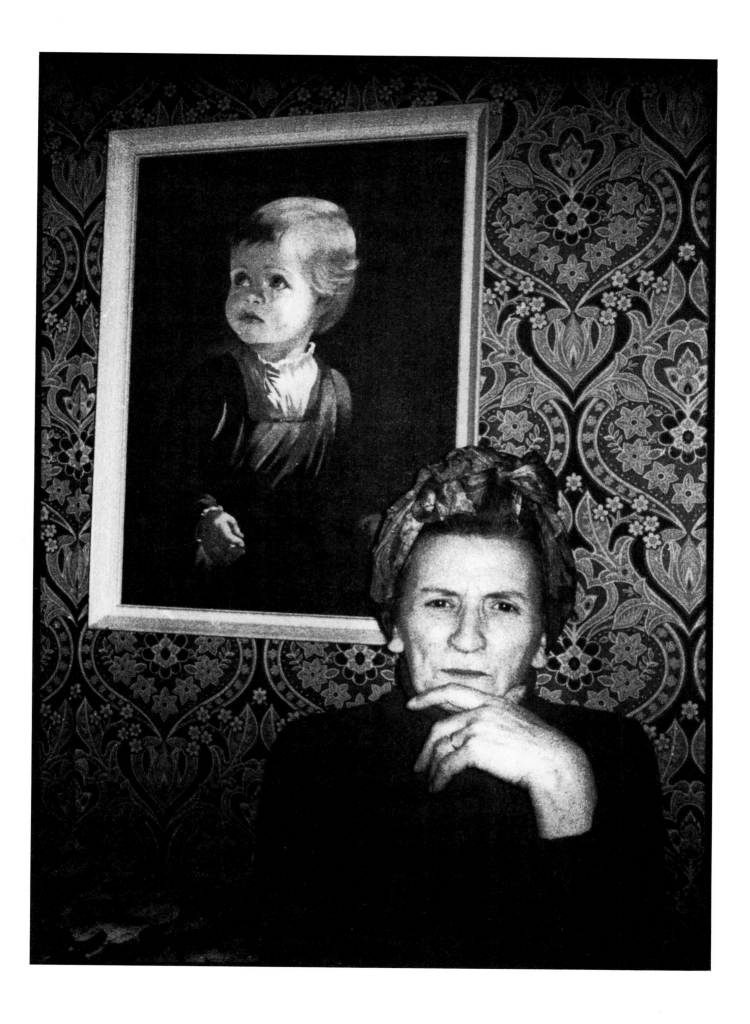

Portraits
enlarging
grain

The extent to which it is possible to alter a negative, or a piece of it, in the darkroom goes far beyond merely making it bigger by use of an enlarger. Of course, to enlarge a picture is the prime purpose of home printing when the negative produced in the camera is as tiny as $1 \times 1\frac{1}{2}$in – it is much too small to be viewed with any satisfaction if converted to a same-sized positive print.

To enlarge a 35mm negative (or transparency, now not only possible but highly popular) by 10 times (close to maximum with most enlargers) produces a photograph of quite giant-sized proportions – 10×15in. And a picture only a quarter that size, $5 \times 7\frac{1}{4}$in, is still respectable – it's about the same size as those wedding prints touted around the reception after the ceremony. Whatever the size, remember *everything* on the negative is enlarged.

In theory, there's no limit to how big you can make an enlargement. But practical factors intervene. Basic limitation is the distance you can arrange between enlarger and paper onto which you are projecting the image.

That distance can be stretched by arranging the projected image to strike the floor instead of the enlarger baseboard. But there is a more important element which will raise its head long before you begin to create such mammoth sized pictures as would result from projecting the image onto your wall: it is the quality of the image, and its progressive deterioration as it is enlarged.

Especially in black and white, the picture will begin to break down as its building bricks, the grain from which it is constructed, become more evident. And eventually that grain will appear as huge chunks which quite obliterate any impression of detail within the picture.

Look at this portrait of Catherine Deneuve: it is a positive sandstorm of grain! And yet all the detail required is there – in the eyes, and in the ear-rings. So, is this a case of image-breakdown, of grain making an unwelcome appearance? It isn't, of course: there is a major difference between a picture in which grain is deliberately used and one in which the grain is a byproduct of over-enlargement.

A picture in which grain is there by mistake will be a puzzling thing. It will be like looking through a rain-streaked window – everything beyond the windows indistinct. The accidental grain obliterates, and particularly is that true of grain caused by enlarging the picture too much: and the 10 times enlargement we spoke of earlier ought to be thought of as the threshold of image quality holding. With care you *can* go much bigger: 15 or 16 times enlargement, and even more, is done every day. But never as an afterthought! Such blowups must be planned for, and great care must be taken in exposing and processing the negative, and in the enlarging technique.

It all revolves around detail. And a picture like this, in which grain is exaggerated, makes that particularly easy to explain.

Had Catherine Deneuve's face been smaller on the negative, thus requiring much more enlargement to bring it to the size opposite, then the detail would not have been held so well. You can clearly see the grain: now, imagine the effect if each square inch of the picture were to be expected to hold, say, twice as much detail as now. It couldn't cope! There wouldn't be sufficient small dots of grain to make up a complex pattern – for in enlargement each individual grain, or clump of grain, becomes bigger, more chunky.

This is an important point, and one we've touched on before. Understanding it is important for appreciation of quality. And the much repeated advice to 'fill the frame with your subject' is aimed as much as anything else at reducing the degree of enlargement required. Let grain be an occasional tool for creativity and effect – never a curse you're forced to cope with...

Photojournalism
subject
picture stories

It's very wrong of course to suggest that any means of communication is more noble or more effective than another. But photographers just can't help it! And you can't avoid the fact that a story told in pictures is a lasting story – images remain long in the mind. The real storytellers of photography are the photojournalists, those who distil the essence of a happening – or even one picture so that the impact is immediate and the understanding easier.

Not surprisingly, photojournalism is thought of as being a particularly professional activity. That is, the results of it are seen most often in newspapers and magazines – though many books have been published which are superb pieces of extended photojournalism. Only rarely does the hobbyist relate his own shooting to what he sees as a long term pursuit.

In fact, photojournalistic stories are not always very lengthy assignments, and nor are they necessarily concerned with events of world shattering importance. They may be one, or both – or they may be neither. It all depends on your definition of what is important, and to whom. A story on the year of a shepherd, or on the life of a Japanese community suffering from the effects of pollution of their water by a local chemical works (and both stories have been done, very powerfully) may be the kind of thing which would engage a professional cameraman full time: and both would be interesting and important, though on different levels. The story on the Japanese community, by Eugene Smith, filled a book and was very influential: the series on the shepherd, shot by Dennis Thorpe of the *Guardian*, made fewer ripples but did much to illustrate the lonely life on the moors.

From the essay to the single picture: here is a man in a park, feeding sparrows. It's a gritty picture, which compels attention onto the hovering bird, about to pluck a crumb from the man's mouth. And the picture has something to say about urban life, and about man's closeness to nature. The point is, as more pictures are added to a picture essay the meaning becomes ever more clear. Add to the picture here another which shows, say, the park keeper sweeping the path and the story begins to focus on park life: add instead a picture of a man walking his dog and the inference changes.

Assembling a picture story requires every bit as much skill as is required in any other area of communications – skill of thought and suggestive power much more than pure photographic skill. But choosing the subject ought not to be a problem: if there is an issue about which you feel strongly, or a subject – no matter how obscure – which interests you passionately, then you have your subject.

There are many freelance photographers who invest quite large sums of money in their photojournalistic work: they stand ready to fly off anywhere, prepare to spend much time and living expenses while they track down the pictures to tell the story. And that is the first requirement: you must invest something – and in the area of hobby photography that will usually be time.

Variety is important too: a series of pictures should build an impression, in glimpses of varied impact. Consider such a mundane thing as, say, a motorway service area...

Having thus begun thinking about your subject the next stage is to appreciate it. And that means convincing yourself that a motorway service area isn't at all mundane. People pass through it, on their way to who knows where; some stop to eat, and gaze out of the cafeteria windows, or even grab a quick nap; lovers may sit in a corner; fast cars roar in, refuel, and roar away again; the police may use the place as a base. All in all, your service area may actually be quite a community.

To picture such a subject you would need to include some portraits – the waitress who sleepily clears the tables at midnight, the girl who takes the cash at the petrol station. And you'd need some general views – but don't stop on the motorway approach to shoot one! Detail shots are important too, and add colour – pictures such as a waste bin overflowing with coffee cups; sausage and eggs, over-priced, sizzling on the hot plate; the jungle of signs which meet the driver entering the area; and so on.

Perhaps most important is the question of response. Every photojournalist has some attitude towards the stories he shoots – though some will argue that you should remain quite free of any bias. But freedom from bias can be boring! Every story, whether in pictures or not, needs a point. And you must have a clear idea of what you set out to show. For example, you could be intent on showing how cosmopolitan is that motorway service area, or how untidy or neat, how busy through the dark hours. Make your point and your viewers will grasp it.

Photojournalism
flash
wide-angle lens

Photojournalism or documentary photography is not for all. Really, it needs a positive purpose, such as shooting specifically for a magazine or newspaper, or even a book. But the techniques which have developed within that discipline may be of value in shooting any subject which offers a once only chance of a picture – a wedding perhaps, or children's sports when the weather is dull.

This picture was taken on Christmas Day, 1981, and shows a lady demonstrating against what is happening in her country – Poland. The picture was taken with flash, and with a wide-angle lens. Two points: the wide-angle lens stopped down to, say, f5.6 or f8 allows the photographer freedom to move around quickly without having to bother too much about focusing for each shot. Depth of field is considerable at that aperture, and renders everything from three or four feet away reasonably sharp. Using flash on every shot helps keep the lens aperture small and guarantees a satisfactory light on the subject, no matter what the weather or time of day.

Newspaper photographers make great use of flash and small lens apertures. In their work the immediate subject is generally of prime importance and the surroundings very much less so – Mrs Thatcher coming out of 10 Downing Street matters more to the picture editor than the texture of the door behind her!

Consequently, keeping the flash units charged up is a very important job, usually under the control of one man in newspaper offices. The photographer can thus pick up his flash and run off to his assignment safe in the knowledge that he can use exactly the same exposure he always uses and his pictures will show the detail his editor requires.

Though this is a very functional technique it does have some interesting spin-offs. For the background is rendered in relation to the brightness of the weather while the main subject always displays a wealth of tone and detail (look at the fur of this lady's coat collar). And when the background is bathed in some particularly dramatic lighting – even the strong clouds of a bold sunset – the effect can be very appealing indeed.

Flash does tend to be underrated. It is a mighty convenient and portable light source, but has a bad name through many somewhat 'precious' documentary photographers insisting it spoils all the atmosphere. Often, without flash, there wouldn't be any atmosphere at all due to poor light, no detail!

Don't run away with the idea that using flash for every shot will guarantee success; of course it won't, for there's nothing like natural light for stimulating effects.

Flash is an accessory, and a valuable one. And any technique based on its use is worth learning and using whenever it will help you get a picture no other technique will allow.

When buying a flash unit make sure it is man enough for outdoor shooting. With 400ASA film in your camera, and shooting at ten feet distant you'd need a guide number of 80 at the very least to get down to f8. Check guide number specifications with care: they tend to be given in all sorts of mixtures, and you must establish that where a guide number is given for film of, say, 100ASA and in metres you understand how it relates to feet and 400ASA.

When all's said and done it's a good idea to run some tests with any new flash unit to establish conclusively that the unit is as powerful as its guide number suggests – and with your particular kind of shooting.

Documentary
composition
SLRs

With this picture we are very firmly in 35mm territory. There is all the evidence of the quickly arranged composition, shot with no disturbance of the subject, though she is very well aware of what's going on. And the image shows that gritty content, that evidence of exposure which is aimed at missing nothing – only in the deepest shadows here is there a void.

The need for detail is not important here, and it matters little that the grain of the film adds its veil of texture.

In documentary photography, as here, the subject comes first. You will, of course, agree: it would be foolish not to, and the sentiment seems so obvious it doesn't require spelling out. And yet, amongst the peculiarities of 35mm photography is one which so powerfully affects subject matter that it can well stand some examination.

The 35mm single lens reflex camera puts the photographer into greater intimacy with his subject. Much more so than does the screen on top of a 2¼sq camera – whether SLR or TLR – and certainly very much more than the direct vision viewfinder of 35mm cameras other than SLRs. And it's the easiest thing in the world to become so seduced by the 35mm SLR screen that you concern yourself only with a small part of it – the moving image, the human being, the portrait face in front of your lens. The screen shows a mini-pageant: it represents life going on – and represents it precisely, with the bits and pieces arranged as your eye would see them.

Question is, what is subject? In the case of the 35mm camera the subject is an area in the proportions one to one and a half – unless, that is, you have predetermined that you will crop the picture when you get around to printing it. Potentially, everything in every corner of that SLR screen is subject matter. And if you ignore or neglect any of it due to preoccupation with something else then you fail to capitalise fully on the instrument in your hands.

Composing in the camera is actually a high speed skill. Polish it up and you can afford to ignore some bits of the viewfinder. In commercial photography the man who calls the tune is, of course, the cameraman's client. Often he is represented by an art director, who stands right at the photographer's elbow while a picture is being taken. And especially when a plate camera is being used, though also when there's something like a Hasselblad in action, the two will confer as to where a picture is to be 'cut'. That means they will allow all sorts of rubbish to appear in certain parts of the image, safe in the knowledge that their predetermined composition will ensure that all extraneous bits are excluded from the final print.

In fact, the proportions of the 35mm negative are somewhat ungainly. Certainly they are outside the size of a standard magazine page. The long side is just a bit too long, and so the image is almost always cropped. But an enprint may also not contain the entire image area. Of course, if you are shooting transparencies to screen at home then the full 35mm format is yours to explore – but make sure you know how closely the area shown in the viewfinder matches that which will appear on the transparency: virtually all 35mm SLRs show your eye more than they allow onto the film.

Now we've considered image proportions, let's assume you have decided exactly what shape your finished picture will be. So now you know into what area of that viewfinder you must assemble the component parts of your subject. Right?

No, not right! Subject is not just some component parts: it is *everything* which appears in the picture – the entire area gives an impression which can vary greatly depending on what you include and what you leave out. This is such an important concept that it bears repetition until it's coming out of the determined beginner's ears...

To put it simply, we ought not to speak of component parts of a picture at all: we should deliberately cultivate the awareness that every square centimetre of a picture counts. If you feel that in this picture the lady in the wheelchair is the subject, and that she would have been better portrayed by fitting a telephoto lens, then you have missed the point. Everything here is subject, and everything adds up to an impression that the unfortunate woman is imprisoned by her disability. She sits there looking out at the world, but access to that world is barred to her for the time being at least. This is less a portrait of a person than an exploration of a set of circumstances.

Suggestion is as important in photography as bludgeoning people across the head with what you are trying to say. But the suggestion should be bold. Make it too subtle and it will float on the wind: allow confusing elements to intrude into the picture area and you will kill your suggestion stone dead.

In a sense, the 35mm SLR camera is the perfect machine for voyeurs! That intimacy we discussed earlier is very real, and the photographer can't avoid feeling closely in touch with what he sees on the camera's screen. But what the person at whom the camera is pointed sees is not another human face – instead there's a head with a big piece of metal and glass obscuring most of it, and hands clamped around the camera obscuring the rest of it.

The intimacy is a bit one-sided: while the photographer is focusing his attention fully upon the person before him that person is concentrating on a machine. And if there is a longish lens on the camera the photographer is able to probe deeply into the eyes, the face, the expression of his subject. And so powerful is that, so hypnotic, that it is then the rest of the picture area is likely to be ignored.

That determined beginner we spoke of earlier will do well to pay great attention to his compositional skills very early: he should consider them more important even than the acquisition of a new lens. But let's make it very plain that the beginner is not alone in being guilty of producing pictures with unsatisfactory backgrounds and surroundings, though he is liable to suffer more from their consequences than the professional. You will often have seen, in newspapers and magazines, pictures which consist only of a cut-out; they show a person doing something, and the background has been removed altogether. The cut-out is achieved by spraying the picture's background with white paint, so that it does not reproduce when the picture is being prepared for publication.

Not every cut-out results from an unsatisfactory background, but the remedy is always there. The snapshot photographer who gives his subjects trees or telegraph poles growing out of their heads, or who includes a confused jumble within the picture area, just has to live with those glaring faults. And that is why the matter is so important as to well deserve repeated airing.

Photography is perhaps the most direct method of communication. In speech, the inflection of voice may vary, and one person may not mean precisely what another means by a certain phrase. But a still picture tells its tale without explanation in so many cases that its tale must be plain as a pikestaff.

When viewing what you are shooting concern yourself not only with the plane on which you are focusing: probe the background, the foreground, the corners. Align and realign, and always be ready to move a little for a better viewpoint. Finally – tell your tale directly: highest compliment is when people view your pictures without asking what they show...

Buildings
perspective lenses

There are in photography several phenomena resulting from fairly straightforward laws of physics, which can't be understood unless we fully consider the difference between the eyes and the lens. Obvious difference first: one lens, two eyes. Hence, a physical difference in the way things are perceived. Less obvious difference next (but only less obvious because ever increasing automation and electronics may lead some to imagine the camera has a brain!): the mind can persuade us to see things the way we believe they *ought* to be seen – and so we introduce an emotional response which the camera doesn't.

Amongst the phenomena most often encountered are differential focus and 'converging verticals'. Here, we are concerned with converging verticals – a phrase you will often come across if your photography goes beyond snapshot level. It is that effect observed when lines we know *should* be parallel – such as the sides of a building – don't appear to be so in a photograph.

You can see a hint of convergence in this arrangement of windows; but in a really bad case the impression is of imbalance. Particularly objectionable is such a degree of convergence (the vertical lines sweeping steeply towards each other at the top of the picture) that buildings appear to be toppling backwards.

The effect intrudes, as sure as eggs is eggs, the minute a camera is tilted in order to include the entire height of a building in the viewfinder. It happens too when the camera is tilted upwards at mountains or trees, though the absence of strictly parallel lines there makes it less evident. However, the excessive convergence of the sides of a mountain would obviously tend to reduce the impression of height – as you can prove for yourself with a pencil and paper and some simple geometry.

Often, convergence *is* accepted; in fact there is a genre of pictures which depend on it for impact. They are the shots which glamorise skyscrapers and city vistas, with tall buildings soaring across the picture at all angles. Yet, the effect is thought so much a problem that it has an ingenious though expensive solution all to itself.

But first, you *can* avoid convergence at no cost at all, just by keeping the back of your camera (and thus the film plane) parallel with what you are photographing. That will mean you must include rather a lot of foreground, so you should move around to find something interesting to fill that foreground – a statue, perhaps a flower bed, or ornamental lake. Just make sure whatever you choose doesn't vie with your main subject (presumably a tall and impressive building) for importance within the picture area.

Having a viewpoint forced upon you in that way is, of course, a diminishing of your choice, And the perspective control lens is the tool which brings that choice back to full stature again.

Professional cameras for large format photography, of 4 × 5 inches and upwards, have a series of swivelling, rising, falling and tilting movements built into them, which allow the lens panel and film plane to be set at virtually any angle to each other: these movements confound the laws of physics (nearly!) – and they certainly affect the path of light rays on their way from the rear of the lens to the film surface. Not only does such a camera allow buildings to be rendered vertical from just about any viewpoint, it can also change the apparent shape of things, and can extend greatly the area of sharp focus in a subject.

Useful indeed: and how nice if something similar could be brought to 35mm photography. Not possible! At least not anything with the same degree of movement: not if you want to keep all the other advantages of the 35mm camera. But one important movement can be introduced; it *is* possible to build a lens for 35mm cameras which can be moved up and down, and perhaps from side to side too. The lens exists – perspective control, usually identified simply as a pc lens. If you slide an ordinary lens around on a table, moving it just a few millimetres, you'll get an idea of how much a pc lens is able to move when on the camera. It's limited, but it does enable those ambitious enough to buy it to introduce a fair degree of control over the planes and verticals of subjects from close-ups to rooftops. And it could also put a bit of the grandeur back into those mountain landscapes...

CHAS. BENABO & SONS

ESTD.
1870

ASSESSORS & SURVEYORS

LAND
AND
ESTATE
AGENTS

Buildings

contrast
grain

Sharpness is something of an illusion. And the more certain influences are introduced, the better the illusion.

There is of course a difference in the degree of sharpness which a very high quality and expensive lens will deliver when compared with what a modest lens will do. But it's a difference likely to be significant only in colour reversal photography, when slides are being produced, or in large format shooting.

For colour enprints, and for modest enlargements in both black and white, actual differences in lens quality have little significance unless the difference is very marked – and a good test report should point out whether there is significant variation over or under what any lens ought to be relied on to produce. Price is a fair guide (the more you pay the higher the quality, that sort of thing) but not much help when the difference is only a fiver or so.

And the simplest fact is that, for modest sized pictures from 35mm negative film, most lenses will deliver more sharpness than the film and paper are able to capitalise upon.

Both film and paper are coated with an emulsion, but the film's emulsion is the more important in determining how sharp the finished picture will appear to be. Within this emulsion are embedded thousands and thousands of light sensitive particles. These minute particles are referred to as grains. Unlike grains of sand they are distributed with a view towards the ideal condition – that they shouldnt' touch each other!

When the film is developed these grains have a tendency to attract each other, to clump together – escpecially in those areas of the negative which have received a good deal of light (from bright areas of the subject).

Clumping is an enemy of sharpness and smoothness of tone – which is why the really enthusiastic hobbyists of yesterday would spend hours inventing new developing solutions in an effort to minimise it. But it certainly still happens in conventional films undergoing conventional development. And the ragged clumps (consisting of light interfering particles, remember) go on making ragged lines out of what were absolute crisp and straight lines in the subject as originally seen.

Don't let's exaggerate this problem, for the ragged effect between adjacent areas of differing tone is only objectionable under really high magnification. And fine grain films display it even less. But it exists – and it takes its toll on sharpness.

The clumping *is* exaggerated, however, by overexposure and, in addition, negative contrast suffers, making the picture flat (washed out in the case of a colour transparency). Which brings us to the photograph you see here. It looks sharp and snappy, the contrast is crisp but not excessive, and the tones are smooth.

But don't you think the building at the left appears sharper than the lamp standard on the right? The contrast – the difference in brightness between dark and light areas – is more noticeable, or higher, on the building. The relatively dull tone of the lamp is laid against the grey of the sky, and there's no huge tonal difference between them.

Important point: great differences in the strengths of adjacent tones lead to a greater impression of sharpness than similarity between adjacent tones. And that 'law' works more or less progressively.

You can aid that effect not only by your choice of subject, but by slight underexposure – which is more easy to achieve with a manual camera than with one which has wholly programmed exposure. All that's needed is about a half stop underexposure; that's a step much favoured by people working with slide film, especially in relatively flat lighting. The slight underexposure aids colour saturation, giving a stronger crisper appearance. And in colour an impression of great sharpness is often achieved simply by contrasting one small area of a bright vivid colour against a larger area of softer colour – such as a dash of red set against green. Again the lesson is obvious: control is in your hands – much more so than it is in your camera.

And talking of hands, are you sure you have camera shake licked! It, more than any other factor, is a destroyer of sharpness. If you suspect your ability to control, treat yourself to a tripod and cable release.

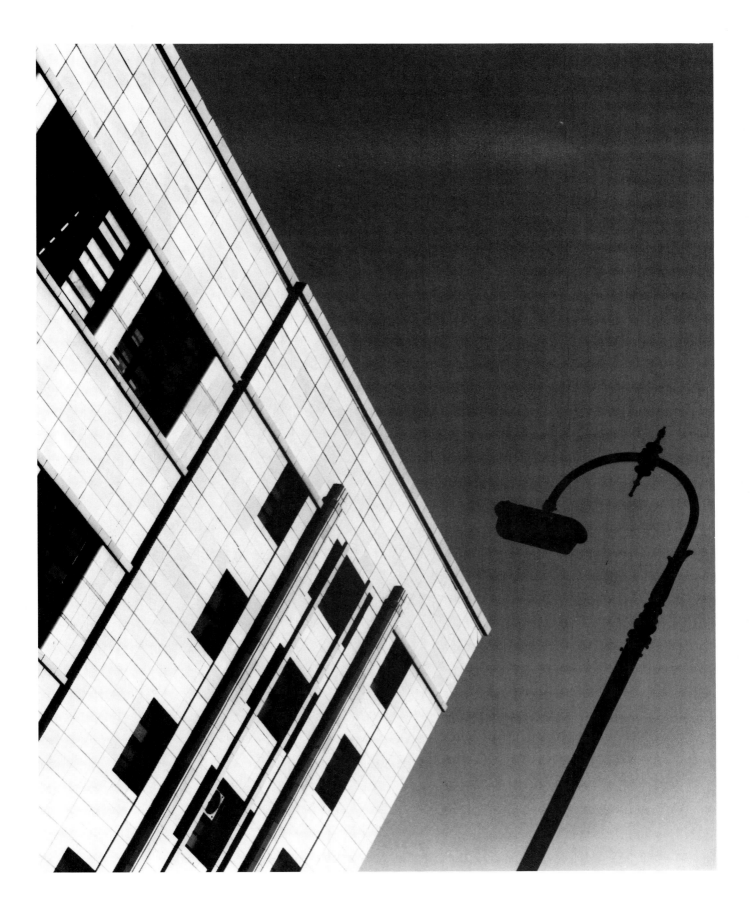

Buildings
shadows
sunlight

This scene, taken in Regent's Park, London, was shot on 120 film with a Plaubel Makina camera, providing a 6 × 7 format. As you can see, the sun was very low in the sky – as it is at dawn and at sunset. The position of shadows is the only way to gauge time of day in black and white photography – unless the picture includes obvious pointers such as, say, the early morning milkman.

In colour photography it is relatively easy to work out the time of day – both by position of shadows, and by the colour of the light. At each end of the day there is an excess of redness, which changes to bright white light in the middle of the day. Dawn and sunset are fairly similar, though the early morning light in summer and winter may be more clear than later in the day, and autumn mornings will often be characterised by mist.

So, what we have here is yet another element which can lead to success or lack of it.

Some years ago it was possible to buy a little cardboard calculator, which when dialled to varying times of the year and the day would quite accurately forecast the positions of shadows. And at around that time there were one or two easy-to-use meters for measuring the colour temperature of light – the idea being that the photographer could then attach appropriate filters to his camera to adjust the sensitivity of his film to the prevailing light.

Today, a very big proportion of hobby photographers work with colour print film, which, in the commercial d & p houses, allows a great deal of more or less automatic correction, bringing the colours of prints to what we expect in the full daylight hours. Measurement of colour temperature is now a matter of importance only for the professional, or for the very dedicated hobbyist looking for ways to control every element of his picture-taking.

Though so much else *can* be done in photography to introduce a degree of control, nothing at all can be done about the position of shadows – short of putting away the camera until the shadows *are* right.

At least, that rather drastic measure is one that is often recommended in 'How to do it' books on camera craft. It is difficult to sympathise with any advice supposedly aimed at improving one's photography which actually recommends not using the camera. The suggestion is made, though, with basically good intentions: the idea behind it is to prevent disappointment caused through pictures which are spoilt by overly harsh shadows. Usually, the advice is not to take pictures during the middle hours of the day, when the sun is high and shadows are harsh – when portrait shots are likely to show people with eyes screwed up against the harsh light.

However, that *is* a bit like taking a sledge hammer to crack a nut. It would be more sensible to advise directly against shooting pictures in conditions which are likely to cause ugly shadows, moving either subject or camera position in order to avoid any such faults.

And this is important; the existence of shadows is a fact of life. They are a product of light – representing those areas marked by relatively lower quantities of light than are evident on the more bright areas of a scene. And even the most harsh shadows may appear photogenic provided the subject is right.

Let us not be too obsessed by shadows and their density, for they have shape too. And that all too evident fact is what gives this Regent's Park scene much of its charm. The outlines of the trees add a great deal to the atmosphere – which would have been lost through waiting until the shadows no longer 'interfered' with the scene. Not only atmosphere but information is carried in those shadows: the scantiness of the foliage tells us that the picture was taken either very late in the year or very early.

There it is. Not only is this a picture of a particular place at a particular time when the shadows were unavoidable, but the shadows are actually a part of the information content *and* of the graphic appeal of the picture. And that is as good an argument as any for not heeding any restrictions at all on time and place of shooting.

The important point to emerge from all this is that this picture is a product of circumstance – of time and place being right. It would be perfectly natural to walk past this fine house on a rainy day, never giving it a second glance – because the flat and full light rendered it unimpressive. And that cat would surely not be there in a downpour either. That is not to say that morning sunlight alone makes the building photogenic; no doubt there are a hundred other circumstances which would here make a picture.

The significant lesson to be learnt is that interesting subjects do not exist only as map references indicating exotic spots on the face of the earth; nor do they appear at quite specific moments, such as, say, Coe or Ovett breaking the finishing tape.

A subject, any subject, is a compound of both space and time – the right spot, the right moment (or the right lighting, if you like). Accept that philosophy and you can view even the mundane in a new light. At which point the mundane will cease being mundane.

Buildings
compacts
subject

In Sri Lanka, they would appear to take their religion with a dash more imagination than we do! But then again, it may be that the shape of the fish means as much to the locals there as the impressive front of St Paul's means to Britons.

Nevertheless, here is a simple but interesting photograph which immediately conveys an impression of one aspect of life in Sri Lanka. Now imagine trying to describe this exotic building to your friends when you launch into an account of your travels. You'd get some way towards recreating the image, but nowhere near as effectively as you would by showing a picture.

Detail seems to take a second place to holiday snaps of people posing in front of known landmarks. But it's the little things which build the flavour of a place – the posters, street signs, shop fronts. And they ought to be photographed in such a way that their 'difference' is emphasised. Mostly, that can be done by means of a straight shot. Pictures such as this are the kind of thing any 35mm compact of reasonable quality will deliver by the dozen. The SLR with its effects, filters and lenses of differing focal length can provide for all sorts of tricks.

This is significant: an SLR, fully equipped with all its image-enhancing accessories, positively encourages you to look for the exciting and the extraordinary. It is just too easy to overlook the ordinary, but telling, details. The 'visual notebook' quality of a 35mm compact *does* encourage the quick decision shot. The Japanese, a few years ago, were to be seen everywhere with little compact cameras – and quite often half frame models, giving 72 pictures per cassette – making thorough use of the shutter release. And look what that willingness to exploit the particular character of the compact has done for Japan!

So, before you go hankering after a second SLR body, think carefully about acquiring a quality compact: it could give you a quite different attitude to shooting.

Buildings

filters
composition

Imagination is, they say, what truly separates man from the animals. In his mind man can hold the concept of a past and a future. And he can relate, through association, otherwise unrelated ideas.

Here is a scene in North London. It shows a wall scarred by the sort of decay you can see in any of the world's cities; and the wall is overlaid with the shadow of a house nearby.

The reaction of most people on seeing this picture is that it has an Egyptian flavour, and that the stained wall appears covered in hieroglyphics. Some see it as a pattern of graffiti, but the main point is that the impression is immediately conveyed that here is some kind of strange writing.

Not only do the stain marks look like hieroglyphics, but the shadow has suggestion of a pyramid shape.

Whatever the impression the picture leaves, it is strong enough to diminish the fact that this is simply the side of a house. The picture elements combine to give the imagination a push; but those elements have been beefed up a bit to give them that power.

The black sky provides the clue. It was caused by use of a red filter on the camera lens, which darkens the sky in black and white photography just as effectively as does a polarising filter in colour photography. But red, orange and yellow filters also increase contrast; and in particular they step up textural appearance and contrast in warm-toned surfaces – wood, stone.

So here you have a quite ordinary scene pushed further towards an unrelated idea by use of a simple photographic technique. And using filters is indeed a simple technique where SLR photography is concerned, for the camera takes care of those compensatory exposure factors which used to cause so many problems.

Making pictures out of odd shapes like this is subject to all the disciplines which are present in other subject areas. Composition is every bit as important. Let's not get over-precious about this, but that dark strip of sky down the left side of this North London scene isn't there by accident; it's there to add balance and weight.

Perhaps, though, the most significant point is that every subject, portrait or slab of wall, should have you thinking about ways to make it more direct and more palatable for those who will see your finished pictures. To go around with your head in the clouds insisting you take pictures for your own pleasure and 'therefore it doesn't matter a damn if nobody understands them!' is as inexplicable as meandering around the streets muttering to yourself. Of course we all enjoy taking pictures, but unless they convey something to somebody they'll have little value.

All of which brings us right back to imagination, that remarkable force within us. And imagination it is, telepathy it isn't!

An example, drawn from the popular pastime of gazing at fluffy white clouds and 'seeing' shapes of reality within them: though you might see within a cloud an image of, say, an old man with a beard, it is quite likely that someone standing beside you will see nothing but cloud.

This great gap between imagined view and the end product shows itself time and again – especially where portraits are involved. It is perfectly natural for you to look through your camera viewfinder and see a vision of loveliness when in reality there's a rather windblown girl, with a tree growing out of her left ear and the sun casting ugly shadows across the face you so often ogle by candlelight!

You must understand that photography concerns itself with the transition from reality to illusion, and that you have to help the illusion on its way.

The popular image of the professional photographer is that he is a man who crouches there firing his shutter like a machine gun, snatching gems of genius with every click. Some might argue that he fires so many shots in order to grasp *one* gem of genius. But neither idea is quite right.

The truth is, success, if it is to be consistent, must be wrung out of every picture-taking opportunity. And you will find that the very best of photographers will actually shoot relatively slowly – though the session time will be taken up by concentrated attention to how the picture may be improved.

Sure, the imagination may run riot, but the eye is every bit as important; and it is important too that you should see each subject through not only your own eyes but also through the eyes of those who will be viewing your finished pictures. Don't work in a sloppy fashion. If contrast really is a little bit low but you think it won't matter that much – you're being sloppy. Step it up, use a filter, push your film – change your film even.

In the same way, view *every* element of your subject with detachment. Imagination is indeed a marvellous thing – but it can play the most evil tricks on you, leaving others wondering what the blazes you're on about!

There are a number of ways in which a historical time might be suggested by no more than a design. Think of heraldry, with all its twirls and shields and curlicues: it brings to mind several things – things to do with status and society of course, but it also suggests the pageantry-filled time of the past.

Somehow, a heraldic design seems not of today – though many a perfectly respected company or individual may sport an exotic crest on note paper, or above the front door.

No doubt about it, heraldry is symbolic. That's the whole reason for its existence. But it is symbolic only of certain things within its 'language'. However, around us there are endless design arrangements which are also symbolic: and to the photographer with ever-open eyes any arrangement of design will mean *something*. Whether that something is thought sufficient to make a photographic subject is another matter – and it depends upon how able the photographer is to read the symbolism of what he sees around him.

Contemporary life is full of symbolism, and of effects and images which convincingly create a sense of period. And the streets through which we walk are particularly stuffed with graphic indicators.

Here's a cinema front, its design evocative of the Odeons and Rialtos which sprang up in the thirties – when that curvy brand of architecture was all the rage. The hint of elaborate design at the very top of the picture sits not too precisely beside the cinema fronting: the sleek car standing outside the darkened entrance is of a period later than both.

The three elements – cinema, elaborate panels, sporty car – all have tales of their own to tell, about period and taste and the minds of the people who created them. But together, as here, they combine to create a more precise composite impression. Just like a piece of heraldry...

While this is a series of different subjects gathered into one, it is also a piece of graphic design. And it is made that way by high contrast, which in its turn is made that way by lighting, and by relatively limited exposure.

It would be wrong to refer to this as underexposure: it is limited exposure – limited to those parts of the subject which matter, while the shadows have been allowed to go black.

The resulting high contrast image is a simplification – a reduction of the scene to those elements which are important to the design.

Too generous an exposure would have brought with it an abundance of texture effects, and considerable detail within that dark void of the cinema entrance.

But there are a couple of other influences at work here, helping to produce just this impression and no other.

They are viewpoint and the focal length of the lens used. For example, look at the extreme right of the picture and you will see part of another car: too much of that would have taken attention away from the central subject. And look at the very top: a shade more cropping and the hint of those twiddly bits would have disappeared. So, the modest wide-angle lens used was just wide enough and no wider, just long enough and no longer. As a matter of fact, for street pictures like this a lens of 28 or 35mm is pretty good, though the slightly longer optics on modern compacts are quite suitable.

Of course, all the elements assembled here were already together: not too many casual cameramen go around shifting buildings and their facades, and parking motorcars just so! But the point is there are always many more elements than any photograph actually includes; and by swinging his camera to right or left or up or down, or by shifting his viewpoint or changing his lens, a photographer can quite alter what he presents within the limits of the borders of his picture. And he can alter effect too by changing the exposure, and also by waiting until the lighting is very different.

All of that considered, it becomes obvious that selection is just as important an element in picture making as any other. Now in that sense, by selection that is, the photographer is actually able to construct his picture almost with as much significance as any heraldic emblem: it can tell a tale with several strands.

In this picture there *could* have been other strands, or elements. Suppose a tramp had slouched past: the contrast between his poverty and the apparent affluence of whoever owns the car whould have substantially altered the story. And yet another slant would have been introduced had there been an exotic woman striding past...

Do not ever underestimate the power of selection. It is more important by far than your camera – as long as your camera may be made to do your bidding.

Landscapes
subject
recurring shapes

The power to evoke dwells in abundance inside every camera ever made. And if only cameras had been in use long before they were, well, what gems of evocation we'd have around us now! Nobody is about to play down Wordsworth's part in shaping the images which fill our awareness, but wouldn't it be something if we could see a beautiful photograph which underscored the poet's famous 'Earth has not anything more fair...', those lines he wrote while intoxicated by the view of London he saw from Westminster Bridge...

Great landscape pictures always evoke: they create in the mind of a sensitive observer much much more than a mere impression of place. A photograph of, say, the Lake District – another inspiration for Wordsworth – may present no more than a graphic representation of the map maker's squiggles, or it may send us careering through our memories and our imaginations.

In the early days of the photographic explosion, when the hobby potential was being vigorously explored by the ordinary man as opposed to the scientists, the chemists, the men of leisure, there was much probing into different styles.

Then, around 1910 to 1940, there was a pictorialist movement: men took pictures for no other reason than that the subjects should be pleasing, and self-contained. But that so often led to pictures with little or no communicative value. Esoteric images they were, which meant nothing to anyone except other photographers who were also in on the rules of composition, members of the almost-secret-society of appreciation which was fostered in the camera clubs of the day.

Great photographers of that period there were, and they towered above the others like giants. The gulf was not one of technical ability, but of thinking.

The obscurity of much of the pictorialists' attitudes is best explained by the way they approached this business of evocation. And their particular delight was in finding a subject which was full of recurring shapes.

An example is needed. The photographer might very well photograph someone in a tall hat – for no better reason than that behind the wearer was a series of shapes mirroring the hat's shape. Could be chimneys! Or fence posts! Common also was subject matter made up of an object and its shadow – just because the shapes more or less matched. Church steps and arches were everywhere too, the curving geometry and the straight lines marching away into the distance. The idea was that the recurring shapes should evoke the original – and even each other! But when the original was already there in the picture anyway the idea lost its charm. It became tied up in itself – a knot of esoteric indecision.

Birds and aeroplanes have similarities, of course. And one plane and a flock of birds are major elements of the picture opposite. Like great flecks of snow the big white birds wing across the surface of a lake. The plane buzzes along in the opposite direction, its shadow darkening the surface.

The picture is not at all a comment that birds have wings and so do planes: we all know that.

Shot in Africa, it speaks of man's intrusion into the territory of wild creatures. The wide open space of the lake is exciting, and tells of natural environments where wildlife *can* still roam free. But the shadow of the plane is a sinister intrusion on that freedom. The picture evokes – and what it evokes is much more than an appreciation of the shapes within it.

It doesn't matter at all that the birds, because of their motion, are streaked into white blurred shapes. This is not an ornithological study – it's a picture which makes us consider our attitudes.

Perhaps the greatest difficulty would-be story-telling photographers come up against is choice of subject. It is vitally important to consider always what it is you want your pictures to transmit to those who will see them. That's a discipline: do not be seduced by mere 'pretty' subject matter which says nothing.

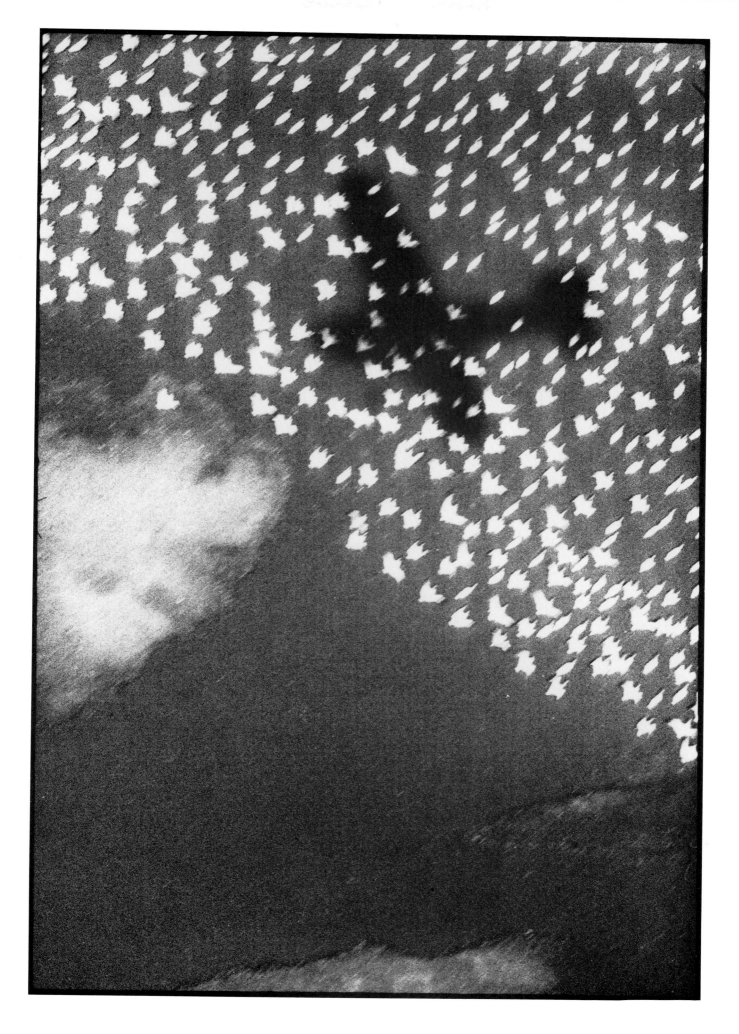

Landscapes
picture planes
infra-red film

Landscapes have played a major part in the history of photography. In the early days they featured regularly because it simply wasn't possible to record images of anything that moved – the exposures were just too long.

But as time went on and photography grew up, the landscape remained popular although it became possible to capture even fast action on film. The reason of course is that the splendour of nature demands our attention: it seems it endlessly throws out challenges to the photographer, to capture this or that incredible effect on film.

The very fact that so many millions of miles of film must have been used up on landscapes over the years creates a further challenge for the modern cameraman, however. No photographer worth his salt would willingly wish to copy the style or approach of another; so he is left with the problem of finding a new way of looking at a subject which is, if you will pardon the expression, as old as the hills.

Now, you may say, there's nothing particularly new about using infra-red film to record a landscape. But you might as well say there's nothing particularly new about using black and white or colour film. Of course there isn't! It's the approach of the individual photographer that counts.

Infra-red film's character can be ideal for landscapes, but it really has to be used sparingly. The picture here has benefited from the tones and grain which are so typical of infra-red material, but there are times when the whole technique would fall flat on its face. The photographer has to decide which situation merits which types of film and unquestionably infra-red performs best when there's an abundance of greenery and strong blue sky.

Apart from film, notice how this photograph has been put together. It consists broadly of three subject planes. In the foreground there is plenty to keep the eye interested, but it's not so busy that you don't feel inclined to look further into the picture. The next plane consists of the middle ground, the field. This is very bare, and invites the eye to go further until it hits the background, and suddenly there's nowhere further it can go. It's a simple composition, but nonetheless effective for that, and it has meant that the viewer has been made to look at the picture in the way intended.

The whole business of planes within pictures is a complex one to explain in words, but most photographers will make use of them at some stage, whether they realise it or not.

Imagine, for example, that you are photographing a football match from a vantage point above the half-way line. There's a linesman running up and down in front of you; there are twenty-two players kicking a ball around in front of him, and beyond them there's a crowd cheering for their side.

Again you've got the three planes, but suppose you want to place more emphasis on a certain aspect of the game.

Imagine you want to make a point about the officials who are in charge of the game. You could stay in your vantage point, focus on the linesman, letting the rest of the picture go a little blurry – and you've got your shot. Alternatively it may be the game itself you want to show, in which case you'd alter the focus to make the middle plane the important one, the rest emerging as merely incidental or as set dressing.

And of course you can emphasise the crowd in the same way, should you want to make some kind of photographic comment about them – perhaps in a picture story concerning leisure activities.

So, planes are important, although per-

haps less so where landscapes are involved. Often you will find that a landscape picture will revolve around just the one plane, the middle-ground. It's not always necessary, desirable, or indeed possible, to compose landscape in any other way.

Although the picture here was taken with a modest wide-angle lens, it's possible to use a long focal length lens to advantage in landscape photography too. The telephoto will, naturally, compress the picture; it will bring the planes together, with the result that everything will appear to be on one flat 'canvas'. For example you might care to cause a distant farmhouse to be dwarfed against a mountain, or maybe make a tree that is some way behind the main subject appear to be much closer, and thus more in harmony, than it actually is. The pattern of a ploughed field on a distant hillside can be made into a stunning image with a telephoto, where it would have been very ordinary with a standard, or any other lens.

Landscapes
receding planes
wide-angle lens

Here's a view from the rugged West Coast of Scotland; it was taken on Skye, the island of that dramatic Cuillin range of mountains. And it illustrates how very well the camera can suggest the grandeur of nature.

This is a large format picture, shot with a Linhof camera; but that only marginally affects the impression, if at all.

The large format has of course held great detail on the rocky shore in the foreground, and also given a satisfactory rendition of the distant Cuillins, at top left: but a 35mm camera would have no trouble with landscape on this scale. A 35mm camera would also capitalise on that sense of distance here induced by the presence of distance haze.

You may have heard photographers talk of receding planes – in relation to landscape pictures. Receding planes are simply different planes of the picture which, because progressively recorded paler (and perhaps bluer, depending on distance) strongly suggest the impression of distance we can see.

Light is much affected by the atmosphere of the earth. When we shoot portraits we are within two or three metres of the subject, and light is perfectly able to force its way through that much atmosphere to give us pictures quite unaffected. But fill a room with smoke or steam and try to shoot through that; very quickly, you're up against degradation of the image!

In landscape shooting it isn't at all unusual for parts of the subject to be many miles away – the Cuillins would be fifty miles or more distant if pictured from the top of Ben Nevis. But even at a mile or two distant, not much for a landscape including mountains, chances are the light rays will, on their way to your camera, pass through a considerable amount of moisture, heat haze, and perhaps dust clouds too. The blue content of the light will suffer from scattering of rays – as it always does to some extent when passing through earth's atmosphere.

The scattering of blue is what gives the greatest emphasis to those distant hills – the blue hills, with detail obliterated because light just bounces all over the place in the atmosphere, the off-course blue rays overwhelming everything else.

It is of course possible to filter out an over-blue distance – by using a strong orange or red filter. But that will give an abnormal effect – though every effect in photography, abnormal or otherwise, has its place now and again. But filtration won't cope with such things as dust clouds and moisture in the air. And with landscapes involving great distances it is even possible that the more far flung parts are actually being viewed through a rain shower or two.

When we view a landscape our eyes have

reference points all round, as well as that distance haze, and perception and comprehension of great distance is no problem. By the same token, pictures taken with standard lenses, which roughly match the angle of view the eye comfortably encompasses, rarely exhibit any curious effects. Wide-angle lenses (which seem to have gathered quite a following as the fashionable optics for landscape shooting, when in fact the lens should be chosen to suit each job) will tend to diminish the effect of distance, since they show so much foreground and middle ground in strong tones.

But mount a telephoto lens on your camera and you immediately begin to play tricks with distance. Certainly in landscapes over great distances you can begin to expect your pictures will be short on detail, strong on great slabs of tone in vary-

ing shades of (black and white photography) grey and (colour shooting) blue and blue-grey.

Then too, a telephoto lens will greatly distort the impression of distance – just because it is a telephoto lens! By considerably narrowing the angle of view it removes (from your pictures) nearby points of reference, so that the small slice of distance picked out by the lens now has to serve as foreground and middle ground too.

Landscapes
lenses
burning-in

Time and again you'll have heard how a photograph is worth a thousand words. It's one of the 20th century clichés. And yet it has within it an abundance of truth, though it can't be said to be the rule. A picture such as the landscape view here does yield a great deal of information, and its component parts are such as to make it almost a contour map. At least, it is a compendium of photo-techniques.

This distant view, with foreground silhouette, was taken in Wales, near the strange little village of Port Meirion. But, rather than any sense of place, it is the impression of distance which makes the effect; and the atmosphere of spaciousness – just distorted by the burning-in – plays sharply on the senses.

At its simplest, this is a picture of a calf on a hill, silhouetted against a distant vista of forested land. The telephoto effect, brought about by concentrating on only a part of what the eye actually encompassed, has piled up the background so that it appears suspended as a curtain beyond the foreground subject.

In theory that 'curtain', in classic telephoto fashion, ought to hang straight down, vertically. For any telephoto view piles up the background in that fashion, flattening perspective and eroding those points of reference which suggest depth. But nothing can prevent light from suggesting shape, and it does so here in such a way that the shape of the distant land is quite plain; the slopes are easy to distinguish, and the lengthy shadows throwing the trees into contour even go some way towards suggesting the time of day.

There is, though, another element which disrupts the flattening effect of the distant perspective, and that is the degree of burning-in which has been used to create a vignetted effect – and which makes the calf stand out the more clearly. The vignetting interrupts the natural tones of the picture.

In nature, the more distant the background the more shrouded in haze it generally is, the consequent pale colouring serving as an effective gauge of space. But here we're faced with curved space. At least, the darkened edges of the picture bring those areas apparently closer, leaving the centre plainly distant – so that the picture appears to curve towards us, like a concave surface.

Control? Yes, it has been exerted here to considerable extent – though remain very aware that shadows and light-fall are such powerful indicators that it takes a vast amount of overriding control and influence to obliterate their effect in any picture. And remember too that the introduction of any control should always have clear purpose – as the purpose here was to focus attention on the silhouetted calf contrasting with the far distant background.

Reading a picture such as this is for photographers, of course. In fact, it's almost automatic that photographers will read *any* picture – and certainly should do if they have any interest in the workings of the medium. But for the viewer – who may have not the slightest inkling of tonal contrast and the effect of distance haze on an emulsion – the reading of a picture is a pure academic exercise. For him, the impression must be all. And it is that requirement which gives to the cameraman the right to bend reality in favour of a degree of fiction.

Choice of lenses does, of course, have a great deal to do with the effect introduced, and that is particularly true when a wide angle is chosen at the outset of shooting. It is always possible, in the darkroom, to trim away a negative taken with a standard lens to such a degree that it equals telephoto impression.

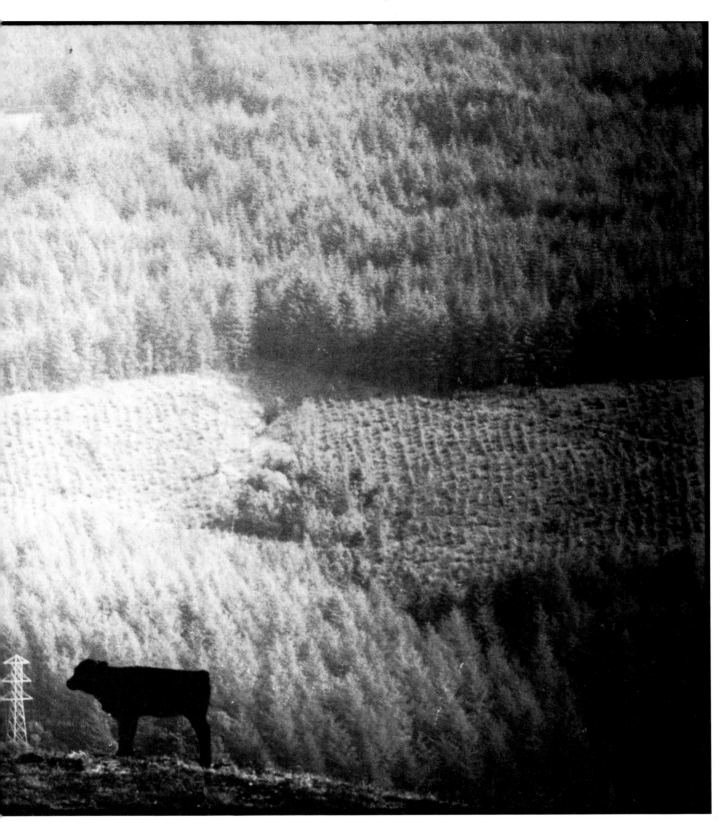

Breakdown of image quality and appearance of grain will eventually make the picture unacceptable; but a thoroughly good standard lens should allow you to work with a quarter of a 35mm negative and still produce a 10 × 8in enlargement of adequate quality. And using only a quarter of the image area means that you have effectively treated your standard lens as though it was 100mm in focal length.

That is perfectly fine to begin with, to gain experience with, to discover just what limits you can go to, but will not continue to act as a satisfactory substitute for a high quality telephoto lens. And when shooting colour transparencies the standard just won't do at all, for enlarging a transparency involves duplicating a part of it, which is a quality-inhibiting process in itself.

Landscapes
vignetting
burning-in

What a strange thing is the vignette. It was with us when photography started, though it was often nothing more than the side effect of using a lens which didn't have sufficient covering power for the size of the plate being used. But since then it has won enthusiasts for its own qualities.

Vignetting is done in camera or in the darkroom: it is a special favourite of High Street wedding photographers, who often present the bridal pair as a romantic image in soft focus, fading away to gentle haze at the outer edges of the print. The trick is frequently performed by simple use of an appropriate attachment in front of the lens – as simple as a card with a ragged hole torn out of the centre (ragged for soft edges).

But darkroom hobbyists who make much use of burning-in and dodging techniques sooner or later try the vignette too – only they do it in reverse! That is, instead of fading away to white paper the image fades into darkness around the edges.

Here is a crofter's cottage on the Isle of Skye: you can see how the vignette effect adds a little touch of mystery, and forces attention onto the central area. In addition, the darkened edges form a strong framework which brings a feeling of solidity.

You will meet with the vignette effect when using some of the modern compact cameras with short focal length lens, and certainly when using a low-powered flash unit with a wide-angle lens – emphatically so when the flash has been designed for use with a standard lens.

Do not automatically condemn the vignette as a fault: it is merely one of hundreds of photographic phenomena – and it is, once you understand it and recognise it, capable of being turned to your aesthetic advantage. Especially, capitalise upon it when shooting landscapes with much open sky – for it then breaks up areas of emptiness.

Glamour
composition
lighting

The existence of beauty in front of your camera's lens is no guarantee that those who see your photographs will appreciate that beauty. Effective translation from reality into photographic print is necessary, and it is entirely your responsibility.

Consider a most stunning landscape, which is bathed in the right light, and has some foreground interest: it *could* still be rendered ordinary by use of a lens of wrong focal length, or by a bad choice of lens apertures and focusing, making the foreground a mess of indistinct blobs due to lack of depth of field.

And consider a beautiful woman before your camera: what an easy subject that should be! In fact, beautiful ladies present a very challenging subject – and the first hurdle you must clear is establishing that your lady really is beautiful.

It is very easy to be dazzled by, say, lovely eyes so much that you quite ignore your subject's unfortunately heavy jaw, or straggly hair. And emotional involvements with any subject will always lead you to rhapsodise about some facets while excusing others. But the camera is entirely unemotional: presented with faults (rather, imperfections that are distinctly unphotogenic) it will without bias transmit those faults to your viewers.

Therefore, effectively photographing beautiful things does not depend alone on having beautiful subjects: your final result should be an amalgam of emphasis on the attractive parts of your subject, of playing down the less than perfect elements, and of designing your picture so that the composition helps build the impression.

In photography it is easy to change things. For example, that heavy jaw could be made less prominent by photographing your model from slightly above her eyeline; and straggly hair could be made less obvious by subdued lighting, or by use of a dark background and low key lighting.

But manipulating the lights and the model will be very much a case of reaction to individual circumstances. Composition is that too, of course, but there are certain tactics which will help you towards success time and time again.

Here is Marie Helvin, sunbathing. She occupies roughly half of the picture area, the remainder being vaguely suggestive of water – which it is, out of focus. The large and relatively empty area introduces a quiet air, in keeping with Marie's relaxed pose.

You can see that the light was quite hazy: there are shadows, but they are not aggressively harsh. Suppose the sun had been bright; how might this picture have been treated?

The upper area could still have been used, and perhaps forced to play a very active role. Using a small lens aperture would have caused sunspots to sparkle off the water. And if Marie's eyes had been open, gazing directly into the camera lens, then a much more 'electric' atmosphere would have been produced. Add sunglasses, light sparkling off them too, and you change the effect yet again. Having Marie's hands clasped across her stomach would also have introduced a subtle change of atmosphere.

The design here is based on two quite conflicting ideas. On the one hand the large area at top tends to introduce a feeling of tranquillity; but the diagonal arrangement of the model is a tactic often employed to step up tension – to bring a feeling of liveliness.

This tilting of the subject within the frame is a dynamic dodge, much used in action photography. But here it is not used in isolation: quite specifically, it has been used to allow emphasis on that other major element of the picture, the large area of water.

How do you decide on the arrangement of various subject elements within the picture frame? First, you should be quite clear about what it is you are photographing. Cover up the top half of this picture and the subject becomes something else. With the top area removed, you now have a somewhat steamy image, which is a celebration of a beautiful body, massive emphasis being placed on the torso. Including the water defuses that eroticism and overlays the relaxed air.

All of that does not mean there is only one way of photographing every subject; what it does mean is that every individual way of photographing a subject will very likely considerably affect the impression your pictures put across.

This is particularly important when your subject is a beautiful girl. For the borders are remarkably shady between unpleasant suggestiveness and a healthy eroticism.

Many a perfectly well-meaning photographer specialises in photographing small areas of a woman's body, in giant close-up. But if in the composition the photographer suggests a comparison between woman and earth and nature (and photographing the female body as a landscape of rolling hills, valleys, sand-dunes, is common) then the picture has a quality of, almost, reverence.

Design makes all the difference – a design in intent, and of composition.

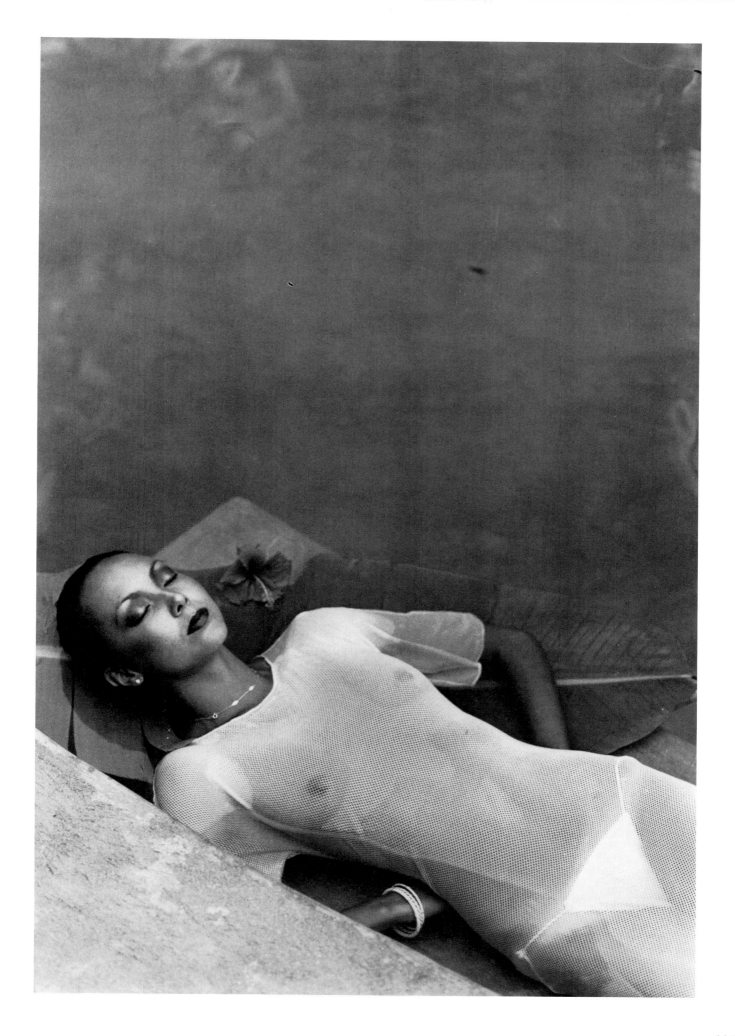

Glamour
posing
lighting

Glamour photographs must have a purpose. All photography *should* have a purpose, of course it should, but glamour is particularly liable to be misunderstood if the purpose is lacking, or obscure. It's no good vaguely mimicking the kind of thing you see in magazines in Soho and persuading yourself you're creating a desirable image of woman; chances are you'll actually degrade the very lady you set out to put on a pedestal!

To anyone with half an ounce of sensitivity glamour is elusive. There are immature louts who will drool over any girl pictured in a revealing way, especially if she measures a metre or so around the top. But no glamour photograph will appeal to *everyone.*

To begin with, the idea of female beauty is not a fixed concept. It has varied in this century alone through several different body shapes, endless dress style, just as endless ways of wearing the hair, and through a bewildering variety of facial make-up. Even eyes and the brows above them have had varying influences: where once the pencil-thin plucked eyebrow was a mark of elegance, and inseparable from sophisticated glamour, now it's bushy eyebrows which set young bloods alight.

And glamour, the idea of it, is as personal an image as it is a fashionable one. Some of us do indeed prefer blondes, and some of us can live content with a lady whose looks are luxuriant and dark. And some will find poetry in the way a girl walks, while another can't take his eyes off her 'pouting' mouth.

Now how can anyone expect to carve a path through all that variety and produce a photograph with impact if he hasn't decided why he's taking his pictures!

A professional owes his living to this ability to turn in what he's asked for, and the purpose of his picture is frequently decided for him. He may, for example, be asked to shoot a series for a calendar, which is to evoke a vintage mood. He'll collect his props; white lacy dress for his model, brass paraffin lamp to glow in the background, everything in muted browns and blues. The wrong girl would destroy the whole thing. He must choose one with long hair, perhaps in ringlets, and with a peach complexion, and certainly without the exotic eye make-up of a contemporary miss. There, he begins with the idea – then finds the girl to suit.

The hobbyist tends to skip this very important stage, and begins instead with the girl – perhaps because she is his wife or girl friend, and he thinks he doesn't need to go through the model casting process of the professional. That's a mistake – at least it is if truly convincing photography is the aim. To succeed, you must enlist the aid of whatever model is suitable for each picture, whether she is a professional or a typist.

It's not just the girl's appearance which has to be thought about; just as important is how you pose her. This picture was taken for *Ritz* magazine, a gossipy publication which is read by people concerned with fashion and its subtle changes of direction. The girl has a wild exotic look, with the thick hair and eyebrows in vogue. And her pose is exaggerated; in these lively times excess is perfectly acceptable, even if it mocks the glossy fashion plates of the past.

But there's more: the picture has a sharpness, a kind of hard edge. The jagged arrangement of girl and shadows creates a restless image, and the tossed-up hair adds to it. The casual arrangement of the coat mirrors the carefree exhibitionism of much of contemporary fashion, and the exposed body doesn't seem at all offensive. For its purpose, the picture is right. It capitalises on the outrageous lighting much used now – even to the point at which shadows cross under the girl's chin. But, the mass of light has been used in another way – to emphasise the cheekbones. Glamour and fashion are often interchangeable – for each influences the other.

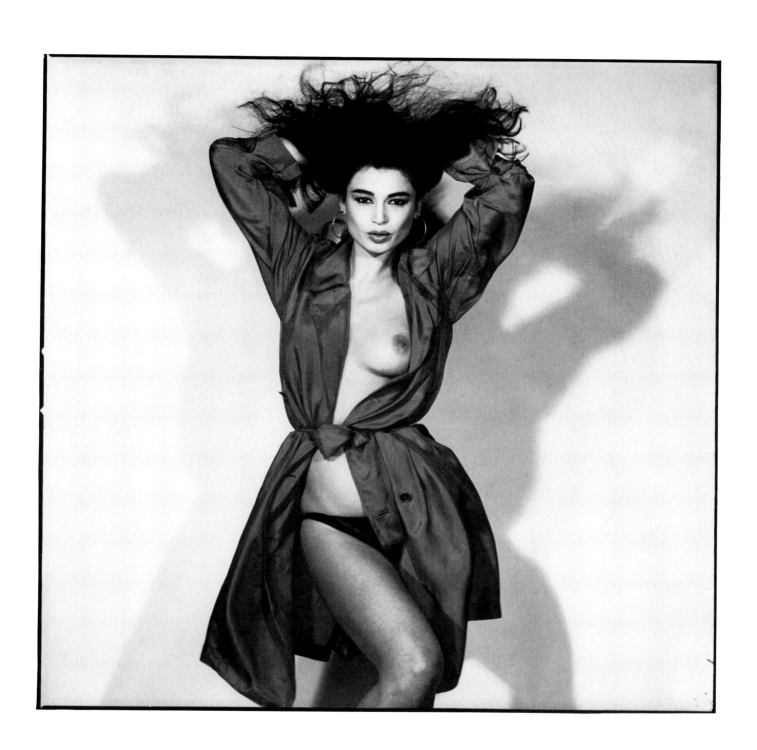

Glamour
water shots
filters

Girls appear in endless variety, and look good in most settings; but dunk 'em in water and something happens – something primaeval. All that aside, water must be just about the most versatile setting there is.

Here, Marie Helvin goes through the unlikely motions of rocking gently in a chair in very shallow water. There's turmoil where the water washes over her body, but look at that beautiful pattern over the rest of the picture; the dancing dazzling ever-changing arrangement of light creates an appealing enough atmosphere in black and white – but imagine the effect in colour.

Water responds to all of photography's tricks and techniques. Those lines of light here could take on a very different guise, depending on how you treated them. Through a long mirror lens light sparkling off water takes on the appearance of a myriad of tiny doughnut shaped flares, which look pretty spectacular in telephoto seascapes, perhaps with a yacht sailing through the light pattern. But put a starburst filter on your lens and the result is even more dramatic: shafts of light streak from every sparkling crest of water, and the effect is of a fairytale lake; it can even make the most mundane subject of them all – swans – look good.

Try a polarising filter when you're shooting on the beach, with a girl as your subject, and you will find the sea takes on a velvety appearance and the colour appears more intense, as the filter subdues a large percentage of the glare normally observed. When a wide-angle lens is also used, this saturated-colour effect is terrific for setting off the bronzed tan of the beach beauties, and is greatly popular with glamour photographers working on calendar shoots.

If you were to photograph a girl in the water at dawn, and again at three in the afternoon, you'd have two entirely different results, though shot perhaps from the same spot. For early morning mist rising from the surface of water lends a quiet but mysterious atmosphere – which so well suits soft focus techniques. But later, with light in abundance, and probably clear as wine, you might capitalise on that by having your model either washed by waves or jumping up and down: either way the motion will throw countless droplets of water into the air, to create a lively impression.

Many a photographer has succeeded in turning in exciting shots of girls actually underwater. But waterproofing is needed! There are some special camera housings, but the Nikonos 35mm camera is designed to operate without any additional protection. The variety of results which can emerge from an underwater session rivals

the variety of light you'll encounter; and the deeper under water you go the more overall blue the effect.

But you don't need the sea for this kind of shooting. An ordinary swimming pool makes a perfect location – and you won't be bothered by background detail.

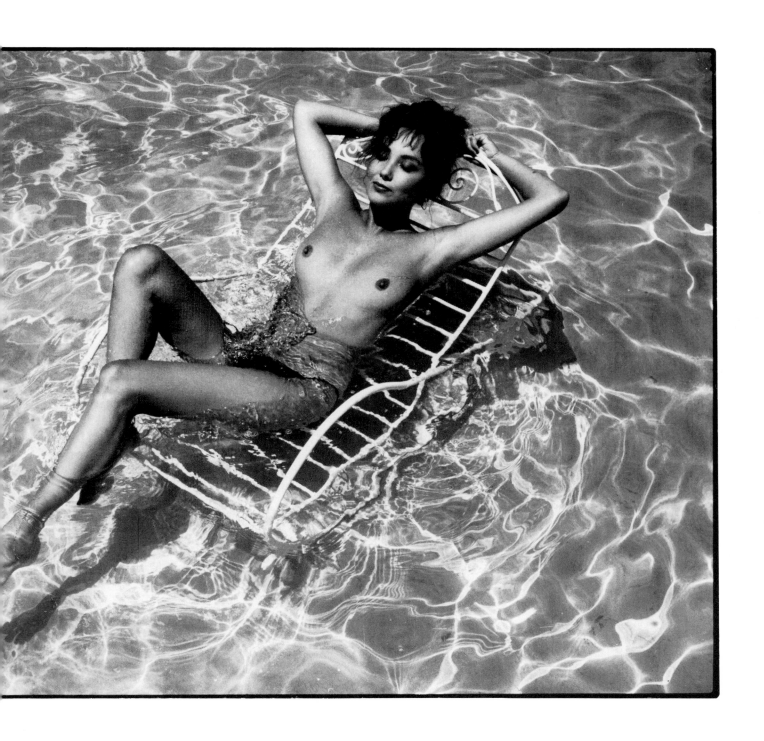

Fashion
background
cropping

Here is Michelle First, pictured during a shoot for Italian *Vogue*. And this is quite an ell-embracing shot, in that it shows a large slab of the location.

There's a sheet behind the model which will eventually become a relatively plain and unobtrusive background. There is the soft effect of a largish light source which is fairly directional but not nearly sufficiently so to be even remotely harsh. And there's the exaggerated make-up which has been applied to the model's face to heighten the appearance of the cheekbones (which in this soft light would not normally be so dramatic).

What is here is what you would see when standing back contemplating such a scene before stepping forward to the camera to begin shooting!

But you wouldn't, or shouldn't, be sweeping with your eyes the entire picture area as outlined in this print: you would be concentrating on the actual area to appear in whatever fashion plate or portrait you had in mind.

Use some strips of paper to crop away the top area and the areas at the sides of this picture: suddenly, attention is greatly concentrated. You have used your strips of paper to isolate an area – an area which you know may eventually be covered either with a lens of longer focal length than has been used here, or by moving the camera.

For the ultimate improvement of your ability to recognise subject matter you must learn to do with your eyes alone what you have just done with those strips of paper.

You must develop blinkers: you must cultivate the art of ignoring – ignoring the bits you know won't be at all relevant to the final picture.

But there's more than recognition involved in the photographer's impression of whether or not a picture will be a success. There's also the business of cause and effect – of imagination, of the projection of certain likely effects if such and such a thing is done.

For example, look at the sheet behind the model. From where we are we can clearly see its folds, and the shadows cast upon it by the way it is draped. All of that could be made to vanish by adopting one of four tactics.

The model could be moved closer to the camera (relative to the way the camera is positioned here); the camera could be moved closer to the model; the lens aperture could be widened; the focal length of the lens could be altered (either by adjusting zoom mechanism or switching lenses entirely).

Those adjustments would all have the effect of limiting that area of sharpness which exists in front of and beyond the subject – the area described by the term depth of field. That means the depth of the field of sharpness – or satisfactory sharpness – which varies, depending on the circumstances of the picture taking.

Very, very roughly, close focusing and large lens apertures add up to limited depth of field; and if you add to those long focal lengths then you might well limit the depth of field to mere inches. Small lens apertures and distant subjects, and wide-angle lenses, add up to extended depth of field: with all three in conjunction you can stretch depth of field from a few inches in front of the lens all the way to the horizon.

The subject is more involved than that paragraph suggests, but the rule of thumb is reasonable. And the existence of the depth of field phenomenon is a mighty boon to the home portraiture enthusiast. Assuming he doesn't wish to shoot against perfectly plain backgrounds he can use limited depth of field to disguise his background. He is then using what's known as differential focus.

As a matter of fact professional photographers who build 'sets' in their studios are frequently taking great advantage of depth of field to keep costs and time well under control while still producing a convincing result. You may be familiar with the sight of a large sheet of hardboard, or a piece of canvas, painted mostly brownish (or greenish), with black and grey smudges all over it: you will possibly have seen such a thing in a wedding photographer's studio, and perhaps in your local high street portraitist's too. At first sight such backgrounds look downright scruffy: subjected to the softening effect of limited depth of field (provided they *are* outside the limit of the field!) they actually look pleasantly smooth, slightly mottled, in the finished picture.

A hardboard background, painted blue, with some daubs of white on it, will produce a very convincing likeness of a summer sky: it matters not that the edges of the painted white 'clouds' are a bit ragged.

Experience will, of course, help you estimate limited depth of field effects. Certainly you will need that experience if you are shooting with anything other than a reflex camera. There are tables published for various focal length and lens aperture combinations at differing subject to camera distances – but for full awareness of, and control of, depth of field insist on a single lens reflex camera which has a preview button, allowing you to view in advance the image exactly as it will appear on your film. Then, you will see precisely the effect of potentially distracting sharpness when it is rendered harmlessly unsharp.

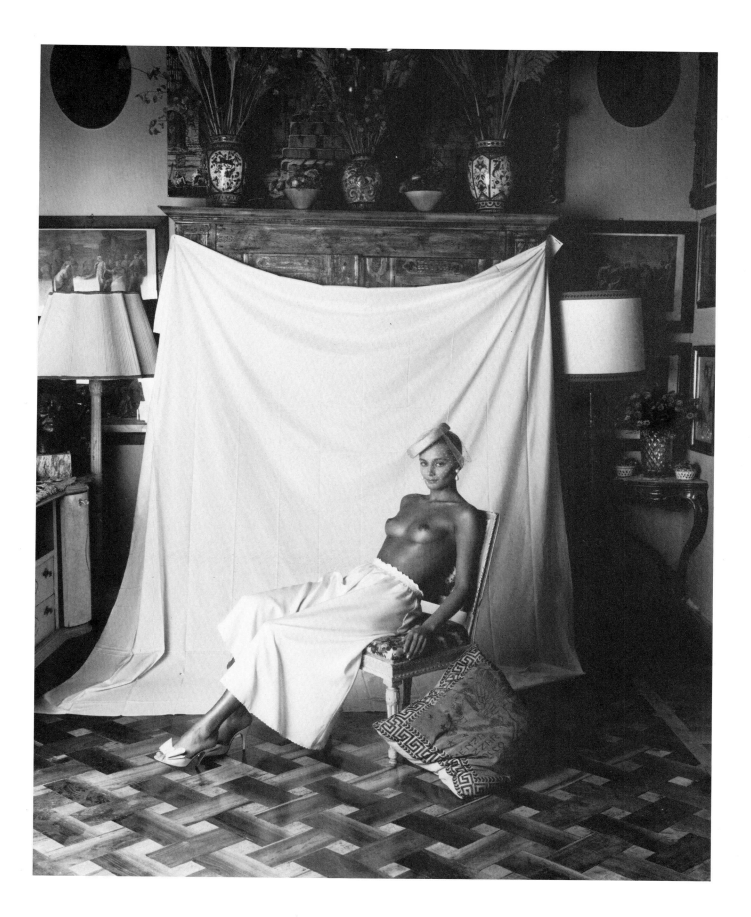

Fashion
studio shots
subject arrangement

There could be nothing in the world more futile than a picture which leaves you cold – one which provokes absolutely no reaction at all. Mind you, it's doubtful if there is any such thing. Even the simplest of images has us looking for points of reference, for meaning, for things familiar. But is the impression we get from certain pictures always the right one – the one the photographer intended to convey, that is?

Here's a shot of young fashion model Lorraine Irish, somewhat dishily attired. But from the fact of Lorraine being a fashion model the picture then takes off in several directions, depending on how you interpret it.

To begin with, the model is obviously modelling! Remove all other elements and she still stands there, quite independent, her pose at once indicating the soft feel of that dress and displaying those alluring stockings.

Plainly, she is in a studio. And at the left of the picture you can see a reflector, of white polystyrene, propped up beside the backing paper. Thus far, nothing at all to suggest oddity. But then you come to the figure in the foreground, with his cuddly lion tucked beneath his arm, his head cocked as he takes in the model's charms.

What's going on? Is he, perhaps, a casting director? Is he master of the house interviewing a new maid? Is he a fetishist, or is he, plainly and simply, a nut?

The important thing is that what you have been looking at is a fashion photograph. And the other elements in it have served to hold your attention: you have been forced to examine the picture carefully, to work out your own response to it. And in that way pictures like this are a long way removed from the photojournalistic image, which tells a tale of something actually going on before the lens, some event unfolding, and which is unlikely to introduce any confusion or leave you with anything other than a very direct impression.

Now and again it is wise to stop and remind yourself that photography is a most powerful language. As a matter of fact a great deal of our day-to-day life is under the influence of picture-language, as when we drive, and obey (or not!) those pictorial road signs, and as when we view television. But once you've embraced that concept of photography as language, you must go on and allow that there will be different ways in which language can be used. You can write a poem, a letter, or a report, using the same words from the English language for all of them, and greatly vary the impression you put across.

Let's face it, that picture of Lorraine Irish has to leave you with a lingering impression of sin! No girl wants to wear a dress which will do nothing more for her than have the vicar raising his hat! She wants to feel deliciously wicked, a bit irresponsible, even a bit at risk. Try this picture on your friends in the office: without explaining anything, ask for their reactions. You will get two quite different kinds from the men and the girls.

The photographer has massive control over the impressions he imparts. Consider, for example, how much more healthy would be your impression of this man in the evening suit had he been holding a bunch of flowers instead of that ridiculous stuffed toy! The power of transmitting certain impressions is also a heavy responsibility.

Particularly in shooting portraits, you have the ability to win sympathy for your sitter, or to have him ridiculed. That is all very well while you remain aware of the power in your hands; the unforgivable thing is to blithely push on with never a thought of the end result. And don't get the idea that your power operates only when you actually step in to arrange or rearrange the subject: it can be equally effective when you take no more active part in the proceedings than pressing the shutter.

It all has to do with what you include in the frame, and how. To use this picture of Lorraine once again as an example, you will see how a viewpoint further to the left would remove the trappings of the studio, and would simplify the picture – while at the same time quite altering the impression. As it is, we have two people in a studio, acting under direction. Take away the emphasis that the picture lays on the studio environment and you make it that much more sinister.

First, before you ever pick up a camera, you should use your eyes. Spend a leisurely moment examining every square centimetre of every subject you approach. Examine all planes of the subject area, right away into the distance. Only when it says what you want it to say should you then fire the shutter...

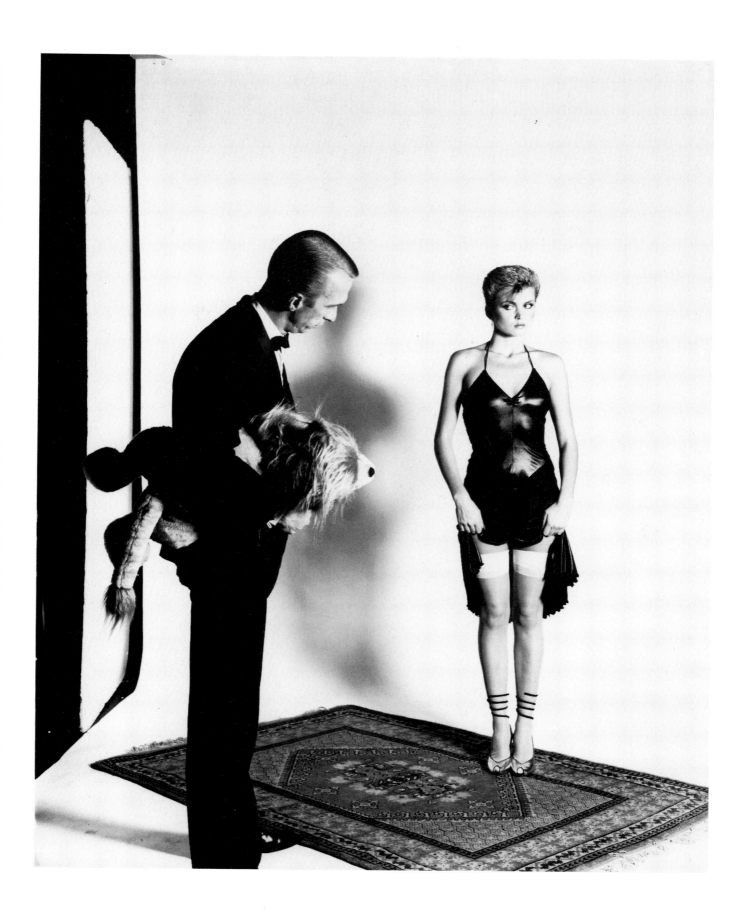

Fashion
lighting
reflected light

Look long and hard at this picture of model Kim Harris, photographed for Italian *Vogue*, and you should spot evidence of the relatively complex lighting set-up used. Clue: look carefully at the coat-hook and shadows on the far wall, and at the shadows cast by the bottom of the bed. Consider also the light spread on Kim's cloak.

Don't be misled by that bright lamp hanging from the ceiling: it is there purely as an element within the picture design, and has no influence beyond that.

Photographers can of course so often spot the building bricks used in the work of other photographers – just as art historians can tell you in which direction Van Gogh laid the paint strokes on his canvas, and can spot quickly the work of a forger.

But good photography isn't about revealing or concealing the building bricks: it is about the effect the end result has upon those for whom the picture has been taken (here readers of Italian *Vogue*).

Stripped to the bare minimum, the building of a picture is concerned with quantity/quality of light, and the shapes which will make up the picture. The two are inseparable, since the quantity of light will determine the apparent shapes within the picture, through causing more or less shadow. Thus, light and the lack of it can actually be shapes themselves.

By using more or less light it would have been possible to have this background beyond the model in virtual darkness or so bright that walls and ceiling appeared glaring white.

The strength of light falling on the subject, or parts of it, dictates much. Trouble is, the strength of light, though an easy affair for an exposure meter, is not so easy for the man in the street to ascertain.

On the face of it, the vivid whiteness of the light globe here suggests great strength of light: yet the obvious lack of effect it is having on the picture makes it plain that there is stronger light coming from elsewhere. Point is, light coming from that globe is flying directly into the camera, unhampered, and thus looking very bright. Kim's face is pictured here courtesy of reflected light, striking her from the front and then bouncing off towards the camera; and some light is always absorbed by whatever surface it strikes, a greater or lesser quantity being bounced off dependent upon the reflectivity of the surface struck.

Probably the best way to understand the behaviour of light is to compare it with something that can actually be observed (we observe the *effects* of light, not light itself), such as raindrops.

Watch raindrops strike a surface – the roofs opposite your house – and see how an intense and heavy stream of drops soaks the roof but also bounces off in all directions. A gentle shower – like low light level – doesn't bounce off nearly as much as a full scale torrent.

Think of light as a real physical presence; think so hard that you can imagine you see the light rays, and think so hard that you imagine you can follow their course all the way from the sun to subject (or lamp to subject). And further, keep on thinking and imagining so effectively that you can begin almost to predict the way the light will bounce off various substances. Sometimes it will glance off a sideboard and go crashing into the wall, expending all its force and energy, and sometimes it will bounce off the rounded edges of that sideboard in such a way that it flies straight towards your lens: when it does that you will have an excess of strength of light – flare in everyday terms.

Light, because it travels at uniform speed and in straight lines, and because it is absorbed by some substances and scattered by others (such as cloud), is actually quite predictable. Get to grips with that and you are more than half way towards complete control of your own picture taking.

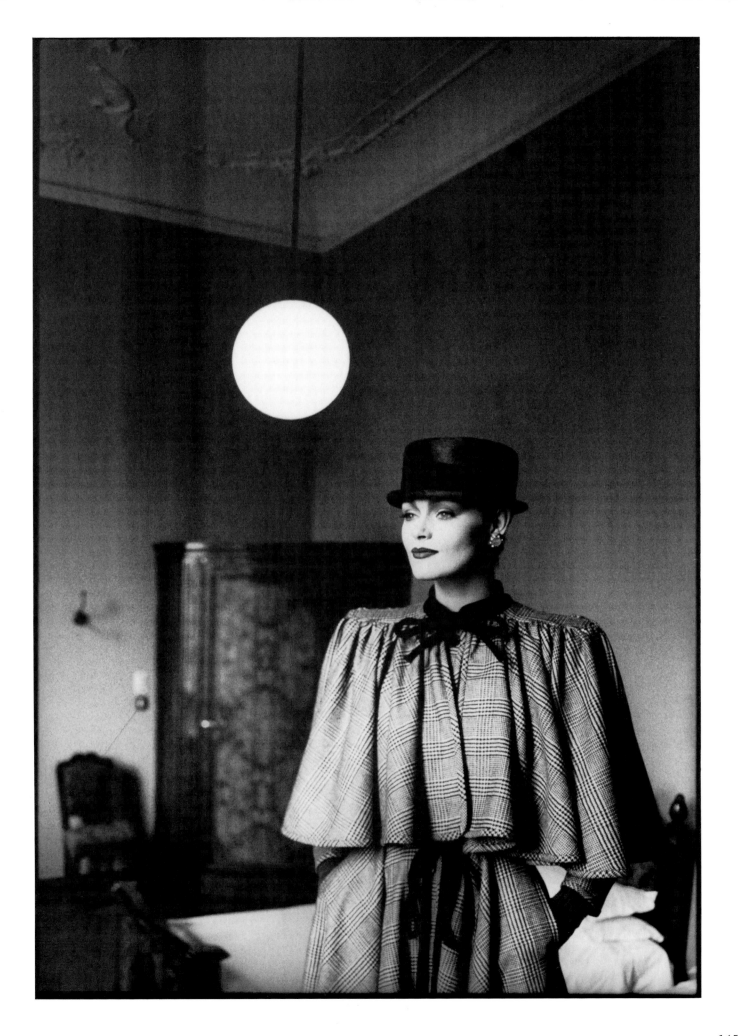

Fashion
action
flash

For a feature in Italian *Vogue*, two models leap in the air; and with their holiday clothes, exuberant air, and dazzling white studio background, they create an airy impression of days by sand and sea.

Studio lighting solves many a problem and helps the photographer create just about any atmosphere he wishes.

But the electronic flash units sold for hobbyists are streets ahead of the cumbersome models of only ten years ago. Now, units with variable light output, computer control of light output, and conveniently tilting and swivelling heads for bounced flash shooting, are not just useful accessories (necessary accessories isn't too strong, even!) – they're the starting point for new fields of picture taking.

Computer units work by sending forth a burst of light when the camera is fired, and measuring the light which returns (bouncing from the subject). When the measured light equals what the computer 'brain' has been programmed to understand is sufficient for a satisfactory picture, the output is automatically switched off. Such units therefore have variable flash duration periods. And it follows that the closer the subject the shorter is that period – the subject intercepting and bouncing back a greater proportion of the output than distant subjects would.

Here, the studio shot shows girls in action, but not actually frozen – there is blur in the hair to suggest the action. Small hobby units with computer control may, however, freeze extremely rapid action when used close-up. Amongst other things, that makes them highly valuable for natural history work – perhaps of restless insects.

Contemporary developments should always be considered in the light of what they actually allow you to do that earlier equipment didn't. It is no good merely drooling over specifications – look beyond the figures to the ultimate effect.

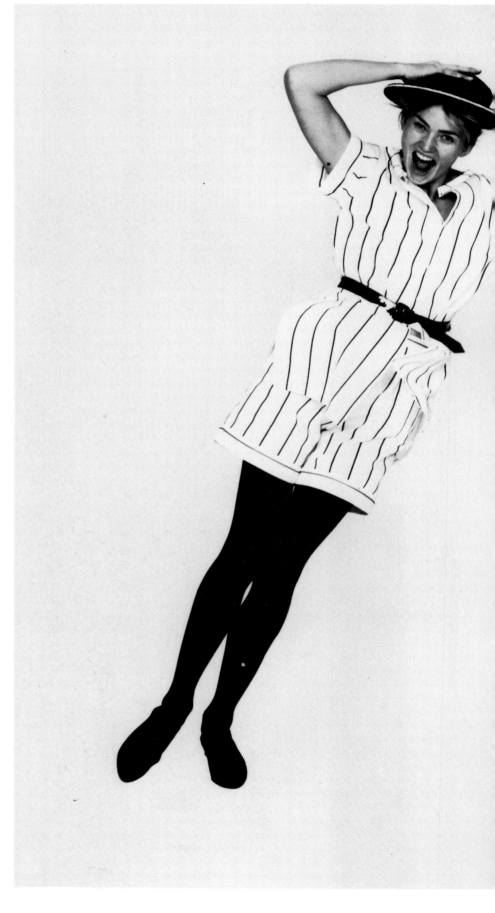

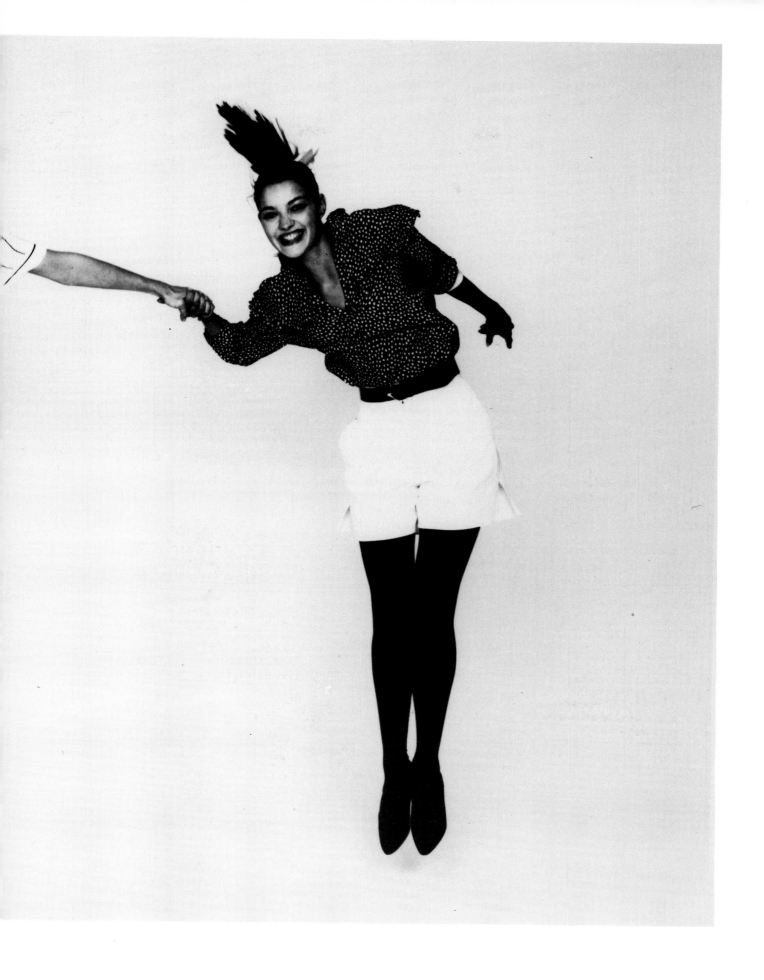

Fashion
special effects
props

Here's a Hollywood type shot, produced for the British edition of *Vogue* magazine. It is obviously a studio creation, but the addition of one or two props has introduced the impression that the lady is off travelling.

Her dress, the solid brass-bound sturdiness of her suitcases, the hefty binoculars, all suggest luxury. She could be about to board the Orient Express!

There's an air of mystery here too. Is the girl shrouded in a sinister dockside mist, or is that really steam from the train which will soon whisk her away to exotic places?

Simple props – but look how effectively they set the scene. And setting the scene is a very important element in the fantasy world of fashion photography. But mist, smoke, and steam are friendly allies for other kinds of picture taking too.

In particular, glamour photographers – and stage and television directors – use dry ice, which gives off a dense blanket of 'fog', though the cloud then lies low, just inches off the ground. As an atmospheric 'accessory' it is tremendously effective and makes something very special – and 'steamy' too – of a glamour set. It is also possible to buy smoke canisters, which give off a more mobile cloud than dry ice.

Such a readily available prop as a cigarette could also be used, its smoke wreathing a mysterious background for a close-up portrait; but don't do it if you or the sitter are allergic to the smell of tobacco.

Of course, any smoke effect can be varied greatly – by stirring the air with a fan, or wafting a piece of cardboard up and down.

In the professional studio there is usually a wind machine, often used to simulate windblown hair, and to make fabrics swirl around a model's body, clinging closely where required. But on a smaller scale it would be possible to use a domestic hair dryer.

Point is, the professional studio photographer has a great array of tricks at his elbow to help him recreate just about any atmosphere he wishes: for him, a downpour is a simple matter and a snowstorm is a piece of cake. Moody lighting is his stock in trade; that, coupled with clever set building can bring even a Rocky Mountain sunset or a moonlit Mediterranean night into a 20 foot long studio.

Obviously, the hobbyist will work on a very much smaller scale, but by no means need his work be any less reliant upon artificial aids to boost impressions. In fact, that is precisely what the very popular creative filter kits do – boost, or at least alter, effects. There is even one to introduce a fog across the entire image!

It is important though to understand clearly the difference between influencing a picture by putting some attachment between lens and subject, and influencing the effect by adjusting the lighting, creating a special atmosphere, using original props. The second way is by far the most creative – and yet it actually has very little, if anything, to do with photographic equipment.

Most special effects – those created by the photographer rather than by a piece of equipment – would actually look quite ridiculous to an observer standing in the studio or the location. For the sole concern is that the square or rectangular area 'seen' by the camera lens should be convincing: whatever is outside that area may be as slapdash as is necessary. After all, think how ridiculous this picture would appear if you could see a smoke canister standing on a wooden box right beside the model!

It is that ability to think abstractedly, to envisage how an effect will appear on film, which marks the truly creative photographer. And in that sense the modern SLR may actually be performing a dis-service. Of course you see right through the lens, more or less exactly the subject *arrangement* you are about to photograph, but you do not see it precisely as the film will record it. Your eye perceives light and shade in a way the film doesn't – and the film's more limited response is quite a tool for effect in itself, since it often means you can ignore certain bits of the scene, confident that they will not register.

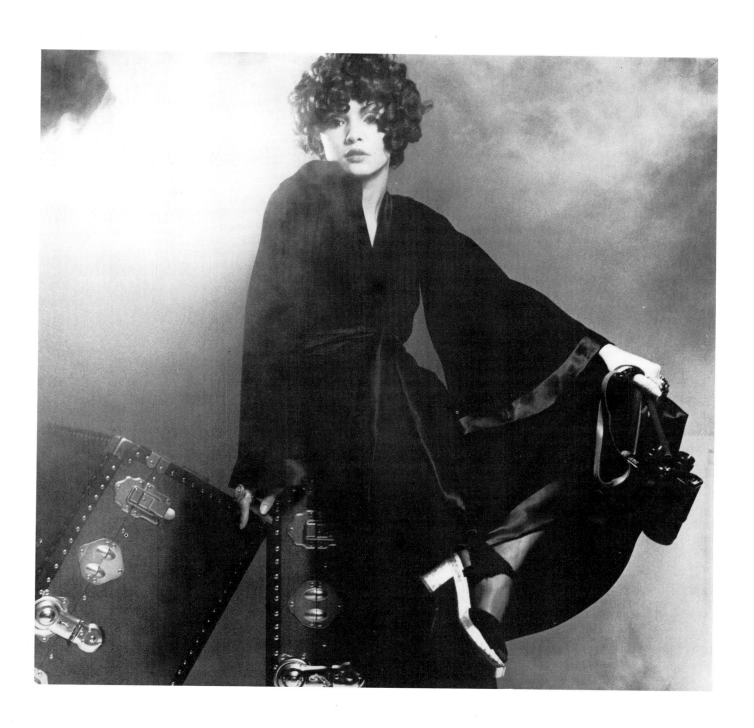

Fashion
blur
shutter speed

Anjelica Huston, seen here lounging in the South of France, looks crisp enough. But the figure at left most certainly isn't! This is a classic case of blur – caused by the subject moving while the camera's shutter was open. But that figure *isn't* the subject – the seated lady is.

What you should get as you examine this picture is an impression that here is a young lady relaxing, watching the world go by. It doesn't matter that the striding figure is unrecognisable, for the aim here is to create an anonymous 'world' going by: the seated lady is the focus of attention, her surroundings being mere support for the picture.

Notice that this picture is sharp all over, except for that figure. The sharpness indicates use of a small lens aperture. And a small aperture suggests use of a slow shutter speed – the recipe for blur. Of course, even at reasonably high shutter speeds you can still end up with blur if your subject covers ground while the shutter is open.

Blur may be an accident (often is!) or a planned element of a picture. But how does it occur? It shows not necessarily when the subject is moving, but when the *image thrown onto the negative* moves in sufficient degree. Blur is a lessening of the density of light beams striking the negative.

Light is reflected from everything – here, from the moving figure, just as surely as it is reflected from the bandstand in the background. But the bandstand remains static, and continues reflecting light towards the camera, sufficient to affect the film. The figure moves, and the space it occupied in one fraction of a second is in the next fraction occupied by background – so that background *and* moving figure record on film to some extent (each sharing the exposure time). Their edges are run together in what we know as blur.

But remember, blur can be counted an error only when you didn't intend it to be there!

Nudes
subject
posing

One of the most interesting ideas in our everyday life is that of specialisation. And while few people actually *do* specialise very strictly, there are many who have been pigeon-holed because one or other aspect of what they do has excited more attention than other aspects. In the fields of creativity – art, writing, cinema, photography too – the disproportionate attention on one aspect is usually the result of high pressure publicity and promotion, to encourage acceptance of a new book, a new painting, a new film, perhaps even a new calendar.

The creator concerned is, for a while, branded as the hottest property in existence, in a certain area of activity.

This leads the interested public to believe that a man can reach the heights of success and aclaim only through specialisation. But how boring that could become. On the other hand, those who dabble in diverse disciplines may very soon find critics winking at each other and muttering 'Jack of all trades, perhaps – but master of none'.

What's a man to do! More important for the moment – what's a photographer to do?

Nothing! Which brings the discussion right to the point...

Subject matter photographed for its own sake is seldom satisfying beyond initial brief impact. And if subject matter is continually treated either to suit someone else's idea of what you should be expected to do, or in a desperate attempt to establish your 'differentness', then what emerges will be an empty image.

It must be made plain that professional photographers working for a client don't always have freedom to do what they like; but pictures taken for personal pleasure and satisfaction should reflect the photographer's tastes, his style, his intellect even. And he will make those goals much more attainable if he treats *every* picture as an individual expression of *his* ideas. If those ideas are of sufficient interest to other people, and if his technical control is impeccable, then our photographer is well on the way to success – without anybody's help but his own.

Let's illustrate that.

Here is a naked lady. Quite often, on page three of the *Sun* you'll find a naked lady too: and they're splashed all over the colour pages of the soft and not-so-soft porn magazines, and they help sell everything from peanuts to brake linings when featured in calendars. There is nude photography, there is glamour photography – and there is the production of smutty pictures. This *is* a naked lady – but she is in none of those categories. The simplicity and directness of the picture could hardly be made more of.

The picture explores the lovely ripeness of pregnancy, and much is made of touches of light just brushing the rounded body. There is eroticism, of course – but only of the healthy kind, sparked off by the contemplation of the magical business of fertility.

One twist this way or that, more of the body included, a change of lighting, the addition of certain props – and here we *could* have had a very different impression.

It is not important that the girl has no opportunity to display any personality: the picture is not about one person – nor even about two, or three. So don't refer to this, please, as a 'David Bailey nude': in doing so you'd be guilty of the most indiscriminate pigeon-holing. And look at the work of other photographers too with a more understanding approach. As you do, some of the thinking will inevitably rub off – just as it did when your first primary school teacher began to draw incomprehensible squiggles on the blackboard, continually insisting that they could be used to write down ideas...

Nudes
posing
surrealism

Finding a pose which is novel seems to be the most difficult part of photographing the nude. And finding novel surroundings isn't all that easy either...

The nude has been pictured endlessly in woodland – particularly common in the pictorial period of the thirties – and endlessly amidst tumbledown window frames and doorways. The beach, the sea, the motor car, all spring quickly to mind as 'props', and it's possible to conjure up in your mind's eye a score of the pictures which might be taken using them.

Indoors, there are two or three obvious approaches, amongst them the somewhat strange effect obtained when photographing a model in an empty room. And simply picturing a nude surrounded by the everyday furniture of a slightly 'arty' home is perhaps the most common of the current styles.

Helmut Newton and like-minded photographers have sparked off another vogue – for pictures in the clinical surroundings of a tiled bathroom or shower cubicle.

Much, so much, has already been explored. And much has been exhausted too: the sort of glamour which features a short-skirted girl perched on a five-barred gate is now as much old hat as, say, a portrait of three little kittens snuggling inside a basket.

Nude photography is no longer alarming or offensive, but it can very readily be boring. To catch the eye it must have something the viewer can think about. And it may well prove very fruitful to move away from reality and try a surreal approach.

The surreal approach has a bad name. Possibly because so many automatically think of Salvador Dali – and then go no further! The consequence is that some very unremarkable surreal stuff has been shot, with the picture area stuffed with unrelated objects dotted around merely because they're unrelated.

Nobody wants to suggest that the only way to succeed in surrealism with a camera is to plunder the works of the painters, but there are styles hugely different from Dali's. What about Magritte, for example? A very unalike kind of approach there.

But there is a quite significant advantage in thinking surreal, an advantage which goes far beyond the inspiration for a one-off picture. It is that surrealism has practically no boundaries, and once you start letting the imgination run free it is quite easy to find yourself with a whole string of picture ideas.

The set-up shown here was conceived as part of a series on wrappings, and was carefully 'constructed'. It was shot on 5 × 4 format, and the model was tucked into the corner between two walls. In the event it didn't get included in the series, but the point is it stemmed from an idea, an abstract idea, not from an existing stimulus in more real terms – as sand and sea would be a real and existing stimulus, and might very often result in the photographer picturing his model splashing in the surf.

You see, one thing leads to another. But if you want to create a set of pictures which are in themselves interesting, rather than merely featuring interesting but familiar subject matter, then you had better begin with an idea which has somewhere original to lead.

The theme in photography is every bit as important, historically, as the individual masterpiece. Some of the great essays published in the reportage magazines such as *Life, Paris Match,* our own *Picture Post,* were great *because* they were essays, constructed from a total shoot of many rolls of film.

The truly great picture stories do of course usually include a couple of shots which are gems in themselves, quite capable of standing alone – but each will also be part of a story progressively told. That is, of course, because there *was* a story to be told. The set of pictures on a theme which makes up an essay differs much in that respect from a thematic set on some abstract idea. If you can come up with a theme which is sufficiently abstract you could find yourself exploring it for the rest of your photographic life!

Nudes
lighting
camera angle

When is a portrait not a portrait, and when is a nude not a nude? Two questions there, so two answers: a portrait isn't a portrait when it's a nude, and a nude is a nude no longer when she starts to put her clothes on!

Nonsense, isn't it! This plainly is a portrait of model Jane Goddard, and in it she is as near to being nude as would be required by the most pedantic of word users. But the nonsense comes in when one begins to try to pigeon-hole various kinds of picture; it's a pastime much practised by judges of club photography, and one they really should abandon forthwith. Indeed, rigid pigeon-holing is an inhibition, in that if a club photographer is faced with the need to submit pictures for quite specific club competition categories he could well spend more time worrying about exactly what he should shoot rather than how.

The world of painting is full of images such as this, and some of them are hugely famous. To a large extent the painters had a very much easier task than ourselves, for they could rely on mythology, and the representation of fabled figures as subjects. And so, Miss Smith, friend (and perhaps even mistress) of the painter, would appear in the altogether as an impression of the goddess of love or hunting or fertility or whatever. The truth is contemporary photography of the nude is bolder than the kind which existed at the dawn of photography, when every cameraman was hell bent on producing something that would pass as a very near relative of a painting. And subject matter today centres around the nude herself, not on some airy fairy idealism. No photographer would now seriously consider dressing up a set and posing his model to recreate, say, the court of Cleopatra – unless for a client.

Sometimes, a photographer will arrange a nude session for the purpose of producing potential cover pictures or feature pictures, and then he will pop off a dozen or so rolls of colour and hope he gets a high proportion of successes amongst the exposures.

Also common in the world of nude photography is the studio session in which a dozen or more hobbyist photographers fire away at some model gently gyrating through her repertoire of poses. Such sessions are a bit difficult to understand. The photographers present will produce a great deal of similarity, of that there's no doubt; but what's the purpose of it all? Much better surely to grab your camera and shoot quickly whenever you find yourself particularly inspired. And that's the snapshot way.

Mind you, snapshot pictures of the nude do smack a little of voyeurism. But in fact most snapshot impressions created by pro-fessionals are the result of careful arrangement.

The genuine snapshot requires that you should have a very photogenic wife or girl friend who is not selfconscious about her body, and who does not mind being photographed. Naturally there are times when she will appear more photogenic than at other times; your simple rule should be to watch out for arrangements and moments which add up to good compositions. You could come close to the ideal by simply hiring a good professional model and suggesting she just goes about her business; ask her to undress, to put on her clothes, to make up in front of a mirror, to arrange some flowers, to make a few telephone calls – anything which will occupy her while giving that necessary casual air. And before you start getting hot under the collar about the idea of a girl undressing remember this: they all do it, perhaps a couple of times a day. Undressing may indeed be an erotic business, but it's also as casual and ordinary a part of everyday life as you're likely to find.

The arrangement of this picture of Jane Goddard is deceptively simple. The elements are few, the lighting uncomplicated. But it's also rather a neat picture, in that there is little to distract the attention away from the central subject, Jane herself. The ceiling and walls and the bed all contribute to the simplicity, while also bringing an assortment of straight lines and angles, which contrast a great deal with the model's curves. Even the bedding is neat; blankets all over the place would have changed the 'story', and would also have brought a rash of textures and tones of grey.

The wide-angle lens used has helped to push all the vertical and horizontal lines into pleasing arrangements, by allowing a very close approach; you can see just how close when you realise the scale of Jane's limbs (and the disproportionately large shoes) means the lens was very much an intruder. But the wide-angle lens really is such a useful weapon for the exaggeration of the female body.

For lighting, one flashgun was used, and it was mounted on the camera. Obviously too powerful a gun at this close range would cause bleaching out of skin tones. But the modern computer models, which deliver an extremely brief burst so as to limit light output when used close to the subject, are ideal for this kind of thing. So too are guns which allow substantial reduction of output by a simple switch to fractional power.

By spending a moment or so examining the shadows here you can easily work out the location of the camera when the picture was taken – and hence the location of the flash unit too. You'll see it was not a low angle shot – had it been, Jane's legs would stretch all the way from here to the North Pole. The wide-angle lens is friendly when controlled, but a monster unleashed...

In fact the picture was taken from a slightly crouched position, though more or less the conventional standing position. And the flash shadows hardly intrude at all. Anything too fancy would have made them much more evident. Flash-on camera is an intriguing technique to work with. Strange, because it seems only yesterday that flash was despised; in particular, photojournalists would shudder and say 'never use it – it destroys atmosphere'. Perhaps the current popularity has much to do with what is going on in flash technology. Not only is accurate exposure now a doddle, but synchronisation is much more positive, there are filters which slip over the flash head and colour the light or diffuse it for softer effects, and the bounced flash technique is made so simple – with swivelling heads and front facing cells for measuring the light actually bouncing back off the subject. In addition, nobody now seems to object to the shadow outlining the subject, which is so characteristic of flash lighting.

One point which you ought to keep in mind when shooting with very wide-angle lenses and flash is the spread of the flash light. There is no guarantee that the unit will cover the same field as the lens! You can see here a certain darkening at the edges of the picture, caused by light cut-off. You either find such varied intensity acceptable, or you don't; it's actually a bit like the deliberate vignetting often employed. If you don't like it, make sure your gun and lens are in harmony – some flash makers provide a special plastic arrangement which fits over the head to spread the beam.

Nudes
subject choice
posing

Taste in matters erotic is a strange and fluctuating animal. And because photography is such a vehicle for realism it tends to get caught up in outrage more than most of the other methods of illustration.

The sharp eye of the camera focuses attention on every hair and every pore of the skin, and every bead of sweat. Muscles and shapely curves are voluptuously seen, perfectly shaped by light and shadow.

Here is model Kelly Lebrock, during a fashion shoot in Haiti. And the gentleman so wrapped up in her (or the other way around...) is pictured in biting detail: though such as he might be seen on any beach, this picture makes the embrace all the more 'animalistic', because of the detail yielded by a close and leisurely scrutiny.

At some indistinct point within the population of Britain the picture will cease to be acceptable, and will become offensive, you can bet your boots on that. And yet the pose held by the pair is as innocuous as two doves billing and cooing!

Erotica has always been a subject for the artist. But very often it was for the interior and exterior decorator too! You have probably heard of, and perhaps even glimpsed, those ancient Indian statues in which couples are shown entwined in togetherness much more explicit than this. You may also have seen any one of several painted versions of the famous old legend in which Leda is seduced by a swan.

The ancients had the skills and the techniques to depict the erotic just as powerfully as it is shown today. But the sexual imagery of the past was often created for private patrons. The big scale demand of today didn't arise because there weren't low cost newspapers and magazines and books, and because cinema hadn't yet begun to titillate the masses, and television and video tapes were nowhere in sight.

Make no mistake, there has always been an interest in erotica, and much of what was produced to satisfy that interest was very beautiful – and very natural too. What, after all, could be more natural than Rodin's famous sculpture, *The Kiss* – with man and woman doing what they ought to do if the race is to get on with sorting out another generation.

The Victorian era seems to have been the time when the system started to break down. There was much disapproval of erotic imagery from the upper layers of society, yet there was almost unparalleled pornography in circulation. Suppression had in fact spawned more than it prevented.

At around that time, photography was finding its feet. That is to say, the craft was becoming available to a very large number of users; it was coming out of the hands of the gentlemen of leisure alone.

Unfortunately, in that Victorian climate, with its great undercurrent of demand for erotic imagery, the camera was all too able to oblige. The artistry mattered little: what counted was the biting penetration of the lens, its ability to show in great detail women – and children too – in sexually explicit poses. And it did it quickly and cheaply. Photography has never recovered from that.

And generations of otherwise genuinely sincere photographers have been smeared with some of the distaste the Victorian Establishment professed. The little man in the dirty mac, his camera empty, is a spectre which still hangs over us – and which almost certainly prevents thousands of photographers daring to ask a girl to be photographed, and just as certainly prevents many thousands of pretty girls saying yes.

Now, in the early eighties, the force of taste is in a turmoil which can only add to all the inhibition!

On the one hand there is a great liberating force which expresses itself in music and in the cinema – and in the words of so many young photographers adventurous enough to carry on, and to advance even, the centuries-old tradition of portraying woman as a beautiful animal. On the other hand there is a sweeping tide which suppresses more violently than the Victorians the picturing of woman in any way which might be thought to suggest she is a sexual creature.

This conflict holds centre stage. In just a few short years it has virtually obliterated what was no doubt a perfectly harmless and enjoyable feature of many a camera club, the portrait night. Those gentle pictures of the pretty young girls next door, posing for a dozen or so gents she has known for years, with spotlights raking her hair from behind, a chiffon scarf draped around her shoulders, are now things of the past.

The modern hobbyist has either given up altogether, in shame, or has moved right into the page three mould. Only a few are steadily working, treating the naked figure as a very beautiful object.

Action
panning
flash

A young boy hurtles along, perched precariously on a tiny set of wheels; a camera shutter fires and a flash unit blasts out a burst of light. And there's the boy, almost as crisp as if he were sitting there posing.

Well, he isn't quite that crisp: take a very close look and you'll see the signs of movement which are such inherent elements of photography.

Especially, there is blur in the background, which tells you immediately that the camera was swinging (to follow the boy in the viewfinder) when the shutter was opened. For this is a picture which incorporates several of the methods of indicating action with a camera.

Children are such versatile subjects! To begin with, when they are small and pink they have everybody drooling – and newspaper picture editors go bananas over them. But later, when the mischief has worn off a bit, they are thoroughly active, and become very mobile camera subjects.

Every craze going is taken up: across the years kids have hula-hooped and skateboarded, skipped, climbed trees, and generally hurtled around their small world in ways sometimes predictable, sometimes less predictable.

When you think of action photography don't get dazzled by the idea that you're concerned only with the Olympics, the Cup Final, and the downhill slalom. Kids in action will offer you just as much of a challenge.

In this picture movement is suggested by the boy himself (he's obviously on a skateboard), by panning technique (swinging the camera, following the subject), by flash used to halt the action, and also by the composition.

With a sufficiently high shutter speed – say, 1/250sec – you could get a reasonably sharp picture of most activities. That means that as long as you catch your subject obviously in motion your picture will have a certain amount of excitement, generated by the action itself. Thus, a more or less sharp picture of a couple of small boys racing down the street could be a real joy *whatever* else you did. Action, good action, is always exciting – and even when only in mediocre pictures, as thousands of newspapers sports pages will testify.

However, as photographers our aim is always to rise above the mediocre, isn't it!

Panning is one of the commonest ways of handling action which takes place across your field of view – athletes running, racing cars, stunt planes, cyclists, anything with a predictable path. All you do is pick up the subject in the camera viewfinder, keep it there, swing your camera to follow, and release the shutter gently while you continue swinging.

The best results come when you prefocus on a spot across which the subject will pass – releasing the shutter just before he reaches that spot. But with practice it is possible to get pleasing results even with a very simple camera (limited shutter speed, no focusing). Real experts can handle the technique at speeds down to 1/15th sec for really spectacular effects, with background drawn out into long streaks, against which the subject stands out crisp and clear.

Particularly in laboratory experiments, ultra high speed flash is often used to freeze action: by this means bullets may be observed in mid-flight. But even smallish electronic units for hobby use have astonishing brief flash duration: for example, the little plug-in A11 unit for the Olympus XA is as brief as 1/40,000th sec. And so flash may help your picture action where no other method is available.

The characteristic of flash/action is a bitingly crisp subject and a dark background, often jet black. Especially, flash is a natural for active children indoors – when, say, they're pillow fighting. But the best bet in that situation would be to bounce the flash – firing it so that the light strikes a ceiling or wall, and bathes the whole room in soft light. Direct flash in an enclosed space invariably results in pictures with harsh shadows.

Flash is often used not as the sole light source, but in a supplementary role, as fill-in. The basic idea is to reduce harsh shadows, but as you can see from this picture outdoor flash may also add some. The balance between natural light and flash light should, for unobtrusive flash, be about 3 : 1.

Both Polaroid and Kodak have instant cameras which provide that flash balance automatically, but it is no disaster to photograph children with *any* flash. The results *may* appear slightly unreal, but quite often the flash will create a crisp image while the slower exposure of the camera will record a softer outline, giving a curious but not unpleasing result – and one which certainly suggests movement.

Finally, the way you compose your picture will affect the impression of action too. Because of the way this picture is arranged within the frame the young boy looks as though he's moving downhill. But cut two pieces of card, in L shapes, and use them to rearrange the borders of the picture. Now, you can alter the effect – even making it appear the lad is travelling uphill.

When actually shooting pictures use your camera's viewfinder just as you have used those L cards. Arrange each composition in the way which best convey the sense of excitement you want to portray.

The world around you does *not* have to be photographed perfectly level, with the subject always slap bang in the middle of the picture.

Movement
blur
shutter speed

When Oskar Barnack publicly introduced his first Leica camera, in 1925, it was the product of several years development. Barnack was a design engineer who hit upon the idea of using off-cuts from the miles of cinematography film then being used, as the movies were growing hugely in popularity.

The film, complete with its sprocket holes, formed the heart around which Barnack designed the system which revolutionised photography – he truly was the father of 'miniature' photography, as 35mm was known for decades.

It's ironic that Barnack should use movie film to establish a system which has so popularised still photography. And it's equally ironic that the photograph here was shot on a large format (6 × 9) camera, yet it provides for us a perfect example of just how well photography of the 35mm kind can suggest the passage of time and movement.

The picture was taken on Scotland's West Coast, using a shutter speed of four seconds. The film has recorded the motion of the waters of a highland stream swirling around the clean stark skull of a long-dead sheep. The moving waters blurred, of course, producing a soft and gentle abstract pattern which contrasts greatly with the crisp detail of the skull, and which suggests the ceaseless and timeless flowing towards the sea.

It is an altogether different effect from that which could have been produced by using a high shutter speed to freeze the water: in any case, such a choice would have forced the photographer to use flash, since the light was very low. With the water crisp there would have been a powerful focus of attention on the sheep and its demise: it could have been gruesome!

In this picture there's a strong impression of the passage of time. Blur is very powerful – at least when intentionally designed into a photograph. When it appears accidentally – as through camera shake – it is nothing more than an obvious mistake. Blur has to be planned. And you can make effective use of it by showing it in the main subject or in supporting elements of the picture – such as the background – and for a variety of purposes.

Racing cars and motor bikes move, and children do so too when playing in the garden: a touch of blur anywhere there can greatly help the effect, but blur needs different treatment for different subjects and effects.

When you watch any action-sport your eye follows the action. You focus on a racing car hurtling around the circuit, and neither your eye nor your mind takes in the background: you are aware only of the car and driver, and because your eyes swivel as you watch them, they are sharply registered. But a camera will record, in detail, everything before it: and if you simply 'point and shoot' at a racing car the chances are you will get a *reasonably* sharp image of it (depending on the shutter speed of your camera – high for sharp, low for a blurred image), but you'll certainly get a sharp image of the *background*.

What your photograph will show is something you'd never normally see: the car will appear as though static, and the picture will look static, and the picture will look *wrong* – at least to the sub-conscious mind, for it's not always easy to put your finger precisely on those disturbing elements which contribute to a basically unsuccessful photograph. Experienced photographers solve this problem by a technique called 'panning'.

As soon as a moving car – or bike, or runner – is clearly framed in the viewfinder they swing the camera to follow the subject, and fire the shutter while still swinging. The result is that the photo shows the subject crisply against a background which blurs in horizontal streaks – and the effect is a very convincing impression of flat-out motion. It's necessary, for successful panning, to keep the subject in the same spot in the viewfinder during the swing, and to press the camera shutter smoothly, carrying on swinging till the shot is well and truly over.

Imagine the opposite effect: the background sharp, the subject blurred. Still, there will be an impression of motion in your picture – but how different now! The motor car, blurred, will attract less attention than the background: a crystal clear rendition of the spectators will make *them* the main subject, so that your picture will then be about them and their reaction rather than about the car and its speed. There is, you see, a grammar in photography just as much as there is in any other language, for that's what photography is – a means of communication.

Blur which is evident in photos concerning motion does, of course, suggest something of the passage of time as well. For it takes time, no matter how little, for a racing car or anything else to move even an inch. But usually a picture deliberately intended to make an observation about time will be concerned with a longish period: for other than fast action, few other circumstances produce sufficiently observable differences between one second and another – which makes a nonsense of those who believe Henri Cartier Bresson's insistence on finding the decisive moment refers to shooting in one specific split second.

It doesn't of course; Cartier Bresson's 'decisive moment' refers more to the *arrangement* of his subject than to the timing.

Time and its passing can be suggested spectacularly in one shot – as in this 'stream and skull' – but there's no need to stop at one. A particularly memorable montage shows, in a whole series of 24 strips, the progress of the sun through the sky: each strip helps build up a picture of how the light striking the landscape varies over a whole day.

Owners of zoom lenses have an interesting way of suggesting motion, but it works effectively only when the subject is head on. All that's necessary is to diminish the focal length as the subject approaches.

Close-ups
detail
zoom lenses

Of all the zoom lenses on the market there isn't one to equal the human eye. No, the eye does not vary the image size of what it rests upon, of course it doesn't: but it does magnify the importance of it, by concentrating the mind and the attention. The eye homes in on a detail, and makes that detail the most burning issue in the world for a moment or two.

And it is the details which make up our image of the whole – the expression on a face, the worn carpet in a hotel lobby, the bitten fingernails of someone we're portraying. We observe the whole scene, but the detail draws the eye and insistently makes its own comment.

Here, two people are out strolling in Japan. The woman wears the traditional kimono, and there is little remarkable in that, other than in the intricacy of the patterning (although kimono wearing does reveal a lady's marital status). But the man is dressed in an outfit owing its origins to Scotland and perhaps Iceland. Well, why shouldn't he? No reason at all, except that the stark difference between that and his companion's distinctly Japanese clothes set in motion a whole train of thought about the changing culture in Japan. There, white hot technology has sprouted cheek by jowl with the continued existence of whole seams of traditional behaviour.

And that is the function of detail in photography – to underscore and illuminate, by excluding anything irrelevant. Naturally, detail is easy to photograph; you just move in close, or twist the ring on your zoom lens to change to a longer focal length. But detail, telling detail that is, may not be so easy to identify.

The point of the detail is that it is an amplification. It is at its best an accompaniment to a picture essay, when the broad outline has been sketched in by other pictures. For example, a photojournalist covering an election may picture the candidates making their speeches, shaking hands, smiling; he may then switch to a close-up of a wilted carnation in one candidate's buttonhole. And that detail will suggest either defeat or exhaustion.

But can a detail shot stand alone? Of course, just as any photograph can. One striking cover of a book which remains in the memory was of nothing more than a lady's eye. And not a few photographers, the much respected Brassai amongst them, have produced a whole series of detail shots of such as tiny areas of colourful torn posters, or small patches of peeling paint and rust. Very graphic subject material they make too.

There is, though, one pitfall to be wary of: occasionally, detail has almost a life of its own. You could suggest opulence simply by shooting in close-up the silver lady mascot on the bonnet of all Rolls-Royce cars. And you could suggest a nervous personality by focusing attention on nicotine-stained fingers – indeed, close-ups of hands feature frequently as detail devices in magazine picture stories. But the suggestion is already inherent in those two examples quoted – and you'd have a job to make them convincingly demonstrate anything else.

Truly effective detail should do its work as conclusively as a steam roller! Robert Burns once demolished the image of a haughty young woman by drawing attention to a flea on her bonnet, but he did it to the great and lasting amusement of the rest of the world.

Close-ups
lenses
extension tubes

Monumental scale is always impressive; excess of size hits us right between the eyes. Even in its original size – about six by nine inches – this print showed a hand larger by far than life sized. But reproduced here, enlarged up to something like twice that, it has truly mountainous proportions.

Of course, sculptors have always appreciated the power of works on the larger scale – and, increasingly, hobby photographers have been able to enjoy the experience too.

Since the popularisation of the single lens reflex camera, and especially since the coming of through the lens exposure metering, it has been relatively easy to show the tiny details of our world in stunning blow up. Thousands of nature photography enthusiasts regularly make monsters of caterpillars, and exotic 'canvases' of colour from perhaps a portion of a butterfly's wing. Sometimes they create the original negative or transparency on a scale as large as 1:1...

That is a ratio. And 1:1 represents 'life-sized'. Which means that the creature or object being photographed is recorded on the film the same size as it is in the flesh. Of course, negatives are enlarged, and transparencies are projected to giant size on a screen: it is thus possible to show, say, a tiny moth an inch across as a big and detailed beauty a couple of feet in wingspan.

Besides telephotography – the business of bringing distant subjects closer – the real close-up stuff deserves exploring. And the equipment required to do so is minimal, as long as you have a single lens reflex camera.

There is a range of special lenses made, known as macro-lenses; they are designed especially for close-up work, and are certainly pretty well standard equipment for the dedicated natural history enthusiast whose interests centre on the tiny flowers beneath his feet and the creatures of the back garden and the local woodlands. Many a zoom lens offers a macro facility too, though the description is occasionally applied rather loosely, and the only way to be sure the zoom will take you as close as you want is to peer through it while it is actually on your camera. A useful thing to have with you when shopping for a zoom-with-macro is an old envelope with a stamp on it: that will give you an instant appreciation of just how close any lens will focus.

But ultra close-up photography can be within your grasp for less outlay than a new lens might require. For only a couple of pounds you can buy a set of extension tubes. They screw onto your camera, between lens and body. Effectively, they simply allow your lens to be extended further away from the film plane than it can be unaided – and the image projected onto the film is thus larger than it would normally be.

Tubes are inexpensive, tough, easily portable, and can take you into the world of insects with an eye-dazzling vengeance: they will also let you get right into details of ornaments, to photograph your stamp collection, and to fill your camera viewfinder screen with all the miniature elegance you can find. For a bit more outlay you can acquire extension bellows, which work on the same simple principle but allow you to focus over a wider range more easily. Marginally more fragile than tubes, bellows may still be carried on outdoor trips, though they are bulky.

For photography as close as 'insect portraits', or tiny flower heads, you need nothing more than bellows or tubes and a steady hand. But camera shake is a real danger in all but very bright conditions, since exposures tend to lengthen (and you really should always work at a small lens aperture). So if you have a desire to make this a more than occasional part of your photography it is a good idea to get yourself a tripod and a small flash unit. The tripod will hold your camera rigid, and will enable you to set up your picture – compose it – more satisfactorily. And the flash will provide a sufficiently bright burst of light to freeze the motions of even the most restless tiny subject.

When working very close your camera viewfinder is enormously important. Not only is it your canvas on which to compose, but it will also show you whether your subject is sharp. Take time to study it carefully: begin by practising on flowers – at least they won't fly away!

Water shots

shutter speed
ASA rating

A wave breaks over a young woman, spray and foam fly, and the sun glances down across the girl's cheek. This is an action picture without doubt – and one shot with a high shutter speed and a relatively small lens aperture, and in backlighting.

The picture tells all those things: depth of field is plainly limited, though that is exaggerated by the apparent increase in speed of the water as it hurtles towards the camera lens. Just look at how much more clearly delineated is the splashing water beyond the model – where, at a further distance from the lens, the impression of motion transferred to the film is lessened.

There are several cameras which would allow you to take pictures like this – ranging from the specially designed Nikonos to waterproofed 110 models by Minolta and Hanimex. And you could of course protect a conventional camera by using a special underwater housing or even a plastic bag entirely covering both body and lens. Maybe you are bold enough to cover just the camera body, securing the plastic bag tightly around the lens barrel and protecting the lens itself with a UV filter!

If you do try photography like this, make sure you wipe your camera as soon as possible, to remove traces of salt water, which is very corrosive.

The so obvious interplay between shutter speed and lens aperture here raises an interesting point – and that is the matter of choice between shutter priority and aperture priority cameras. Once you move beyond fully programmed cameras (in which your only control over exposure is by using fast or slow film) it becomes an important matter indeed – which is why truly versatile machines wil offer both priorities, or at least a form of both, available through automatic *and* manual control.

Quite obviously a high shutter speed was required for this picture: but too high a speed would have frozen all those droplets of water, making for a curiously static impression, such as is seen when high speed flash is used.

In bright sunlight an exposure of around 1/125thsec and f/8 will be right for, say, a 50ASA film – quite average for colour material. And that is what a programmed camera would set. But what if you feel that 1/125 isn't fast enough? There's not much you can do about it, other than loading with a faster film. Switch to 400ASA and you can get the exposure down to 1/250sec at f/22. Speed a bit higher, yes – but the lens aperture has closed down too, whether you like it or not!

Back to the 50ASA film for a moment. With a camera which offers shutter priority auto exposure you could set 1/500sec (about right for this shot) and your camera would adjust the lens aperture to f/4 – perfectly satisfactory.

Shutter priority cameras tend to be favoured by photographers who go in for a great deal of action shooting, as for them precise control over the impression of motion is the aim. But aperture priority cameras have their strengths too. And if you are willing to carry a tripod with you when out shooting landscapes, then an aperture priority SLR will most certainly ensure that you *never* turn in an unsharp picture. All you have to do is set the aperture as small as is necessary to cover the depth of the subject (remembering that depth of field may often be required from only a yard or so distant all the way to infinity). If your camera indicates what shutter speed is selected then you can make your decision whether to use your tripod or not – and for goodness sake do so if the shutter speed indication drops anywhere near 1/30sec. The difference between a sharp landscape and one that is unsharp is very obvious.

Very simple cameras are not to be thought valueless because they don't offer control over exposure: it will always remain true that the most effective tool a photographer has is his own mind. But it is also true that the best modern SLRs are not tricked out in gimmicks just for the sake of it.

Forget for the moment the sharpness figures for lenses and examine instead the specifications of a camera body by any of the big makers. You will see that the very best of the cameras are those which offer the user a number of alternatives and checks, features concerned with introducing control over light – how much of it strikes the film, and for how long, and which part of the subject gets most attention from the camera's nerve centre, its exposure system.

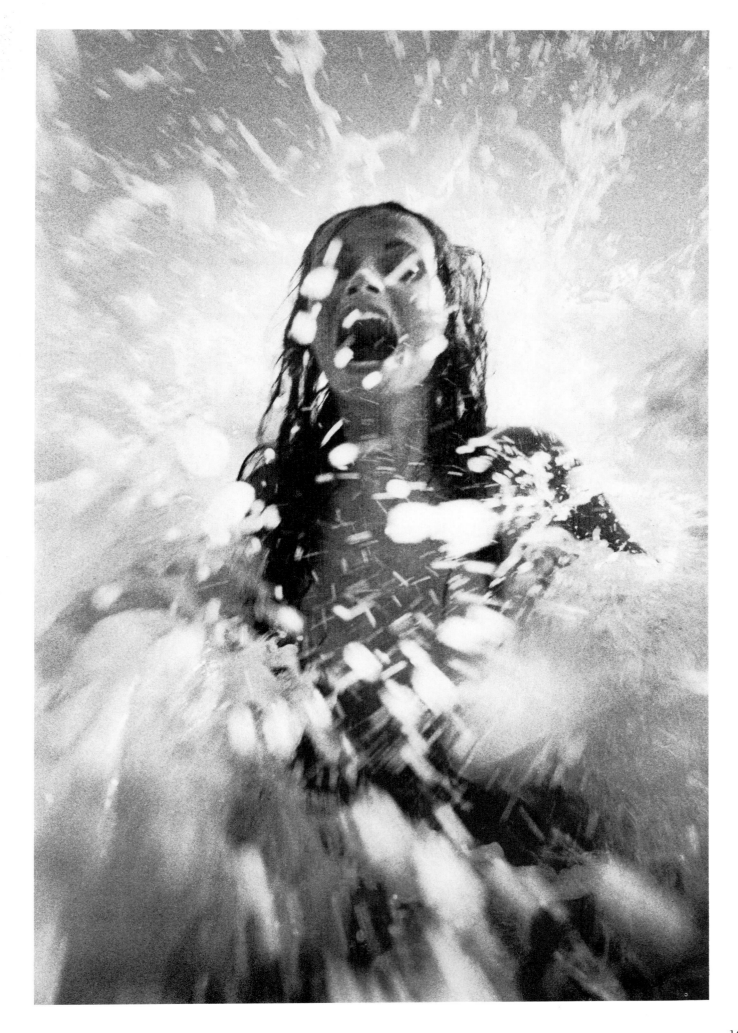

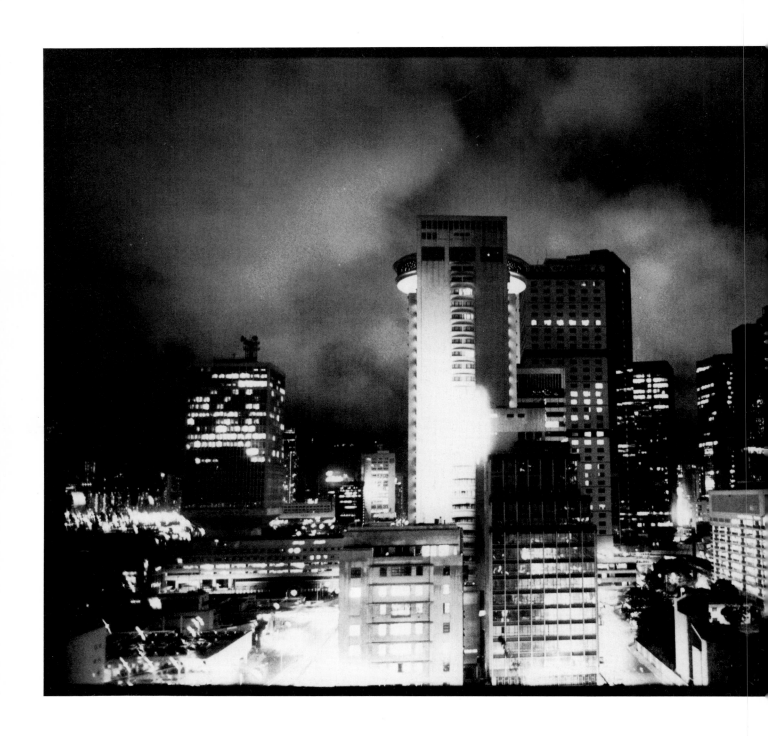

Night shots
bracketing exposures
ASA rating

In colour views of the city by night, different street lights create different colour effects, and stone buildings take on a fine mellow warmth. Rivers look smooth as silk and – if caught at the right time – the sky is capable of appearing as a magnificent 'midnight blue'.

But there is much to be found after dark for the black and white photographer also. Then, contrast between brightly lit buildings and deeply shadowed streets can make a picture sparkle with life and light in a way that perhaps even high summer can't match. And there is scope too for lots of atmosphere in the sky – rightly treated that is a very powerful backdrop to night-time city shooting.

Here is a wide-angle shot of a vividly lit city panorama – such as just might be shot from the bedroom window of a holiday hotel. Strictly, a tripod is necessary for the very best shooting of this kind – if you want crispest detail that is. But here there is just a tiny hint (at lower left and right) of shake which actually does not spoil the picture. That indicates that you *can* get away with resting your camera on something solid, such as a wall or a window ledge. At a pinch you can even get a picture by pressing the camera firmly against a window.

Point is, to make a cracking success of night shooting you really ought to go out with camera, tripod, flash unit (for painting with light), cable release, torch (for checking camera settings), warm coat, fur lined boots – and perhaps even a hip flask of brandy! But, not all successful night pictures are taken while actually out looking for them: some situations may present themselves when you are on the way to or from something quite different, or even just admiring the view from your window. And all good photographers must learn to be opportunists.

So how does the opportunist handle night shooting? He shoots – whatever!

Certainly it is very sensible to bracket exposures – suicidal not to in fact, if the view is sufficiently spectacular, and is one you are unlikely to come across again. Don't think that exposure bracketing is limited to the owners of sophisticated SLRs. You *can* bracket perfectly easily with a simple compact, just by altering the film speed setting: for a good range of shots fire with camera set to ASA values 25, 50, 64, 125, and perhaps 200 as well.

They may seem slow those settings, but they are actually a good substitution for the most effective way of night shooting – which is to make use of the B setting where it is to be found: it holds the shutter open for as long as the release is pressed.

There's hardly an exposure meter in existence which will at night give you anything like an accurate exposure reading – because there is no such thing! Bright lights themselves, bright walls of buildings, bright rainstreaked streets, the surface sheen of a river, the darkened mouths of alleyways, will all require different levels of exposure; and even with a B setting you'd be very wise to bracket widely, giving exposures even as long as a minute, depending upon just how much detail you want to capture.

If going out to shoot nothing but night shots then you would tailor your outfit accordingly, and probably selects a film to suit the brightness of your target (some city streets are actually so bright as to yield snapshots with a 400ASA film). But the occasional spur-of-the-moment shot will no doubt find you already with a film in your camera – a film which might seem all wrong. Don't give a damn, go ahead and shoot!

The point is, night shooting is never going to result in an absolutely accurate rendering of what is before the camera, and might indeed produce something many times more spectacular than the original. The secret really is in the bracketing, and in the composition.

Aim to arrange something balanced in your viewfinder: remember that bracketing may well give you a lighter sky-background than your naked eye perceives, and therefore those dimly outlined spires or skyscrapers at the edges of your picture might end up standing out very clearly indeed.

Don't turn away from night time views because you think you aren't equipped for them: shoot anyway, for just about every film and camera combination is capable of producing something.

Sky
film sensitivity
darkroom techniques

If you were to carefully cut out the sky portion of every photograph you see, and then assemble all the bits like a giant jigsaw puzzle, what would you have? An awful lot of blank white paper, that's what! And that goes for colour pictures as much as black and white. Mind you, since we're not a nation given to spending endless hours contemplating the sky it doesn't seem to matter – people rarely notice.

Yet there is something insipid about a photograph in which the sky area is blank, quite without tone. Cynics may claim we live beneath grey and featureless skies for so much of our time that emptiness above is the natural order of things. But the dramatic impact of a really well detailed, or toned, sky is so remarkable that it can't be missed.

Surely *that* is the more natural – for it's no good saying space is empty. Above us is an incredibly mobile atmosphere, which is sometimes heavy with storm clouds, pregnant with rain, sometimes dotted with shredded 'cotton wool', occasionally as clear as gin, now and again streaked with the stunning beauty of a mackerel sky, frequently blood red, and not infrequently shot with the staggering majesty of lightning.

Blank white paper indeed! A good sky will do more for a photograph than almost anything else: it may, of course, do it almost by accident – but learn to handle the sky by design and you're onto a consistent winner.

What, though, is a 'good' sky? An easy answer is that a good sky is one which adds something to a photograph – one which helps put atmosphere into the picture. But since nobody can control the weather and the drifting clouds, that's not really a satisfactory answer; at least, it isn't a complete answer. But let's consider just what it is that the sky does to a photographic emulsion that it should so often leave so few traces of its existence.

Black and white film is particularly notorious for what's known as bald sky – blank white paper. For the film is very sensitive to blue, and the negative quickly builds up considerable density in the sky area, through which little or no light passes during printing: the result is the printing paper remains unaffected (unexposed) in that area and appears as white. An overcast sky is grey or white anyway, and will also appear more or less blank in a black and white picture – a monotony of unrelieved pale tone. It will also look unimposing in a colour picture, the uniformly pale grey being very insipid.

Frequently, when there's moisture in the air, colour film will record an apparently blue sky as very pale indeed, because the moisture scatters the sun's light rays, being particularly effective on the blue content of light. And distance haze is nothing more than moisture and other particles in the air, scattering sunlight and obliterating light reflecting from distant objects. You can appreciate the destructive effect of light-scatter by looking directly above: there, in the zenith of the heavens, the sky is at its deepest blue – because you are looking through the earth's atmosphere by the shortest route, and scatter is at its least effective.

Much *can* be done with the sky, no matter what the conditions. Reproduced here is a simple view, of few elements. But the heavy tone of the sky immediately conveys an impression. It sets the mood. That sky *was* actually there – the picture is full of the monsoon atmosphere of the Pacific. But tone can be added and exaggerated to any degree, up to jet black, by burning in when printing – allowing more light to fall on the sky area than the rest of the picture, when enlarging. In colour, a polarising filter will strengthen a blue sky enormously, but it wouldn't do a thing for a sky like this. The polarising filter works only on clean, direct, unscattered light rays, when it will effectively darken the sky, and the greenery of a landscape, by preventing some of the light from passing through it.

If a blue sky is made more blue (in a colour picture) when some of its light is absorbed by a filter, then you could get a similar effect merely by underexposing your film. And many photographers do just that: by closing down half a stop they increase colour saturation – they make the colours darker, stronger. That trick works better with transparencies than with colour prints, as automatic printing machinery has no appreciation of your intent and will produce prints adjusted to 'normal' tones – when the effect could then look more than a little muddy. To underexpose by half a stop for increased colour saturation is easier than it sounds. All you do is uprate the ASA value of your film by half.

Black and white photography allows much more flexible treatment of skies than does colour. Flexible? It actually allows conjuring tricks – so that you could transfer the springtime clouds of an English landscape to a winter view of the Siberian plain if you wished. Even the great Bill Brandt has before now pulled a moon out of reserve to add atmosphere in an otherwise empty sky. The technique involves use of two negatives, and is often used to improve a picture in which the sky area is featureless – perhaps because it was overcast, or too pale a blue to record with satisfactory tone on the negative. Here's how to do it...

First collect a number of negatives showing good strong skies: use yellow or orange filters to make clouds bold. Then, when printing any landscape view (or any other) with a bald sky, select one of your strong sky negatives – but make sure any shadows and modelling evident in clouds match the direction of light seen in the picture to which you're adding sky. Put your landscape negative into your enlarger, and size up the image. Next, support a piece of card several inches above the enlarger easel – using books, a shoe box, anything sufficiently stout – so that the skyline of the landscape can be seen, though blurred. Go over this skyline with a pencil, and cut out the resulting shape. Go ahead and make the exposure for your landscape; when you've finished take great care not to move the printing paper, for you must now put the cut out shape back in place, above the paper.

Take the landscape negative out of the enlarger and put in the one featuring strong sky. Now make another exposure. Develop the print: if you've been careful you'll have done a fine job of cloud and sky transplanting, from one picture to another.

Really confident photographers don't bother with the card cut-out, cupping their hands to the skyline shape instead when making the second exposure. If you try it, keep your hands moving back and forward – so as to soften the 'join' between sky and landscape.

Particularly dramatic treatment of skies, especially those streaked with ribbons of cloud, comes with wide-angle lenses and filters – orange for black and white film, polarising for colour. Go for any of these techniques – for the sky is more than just a backdrop.

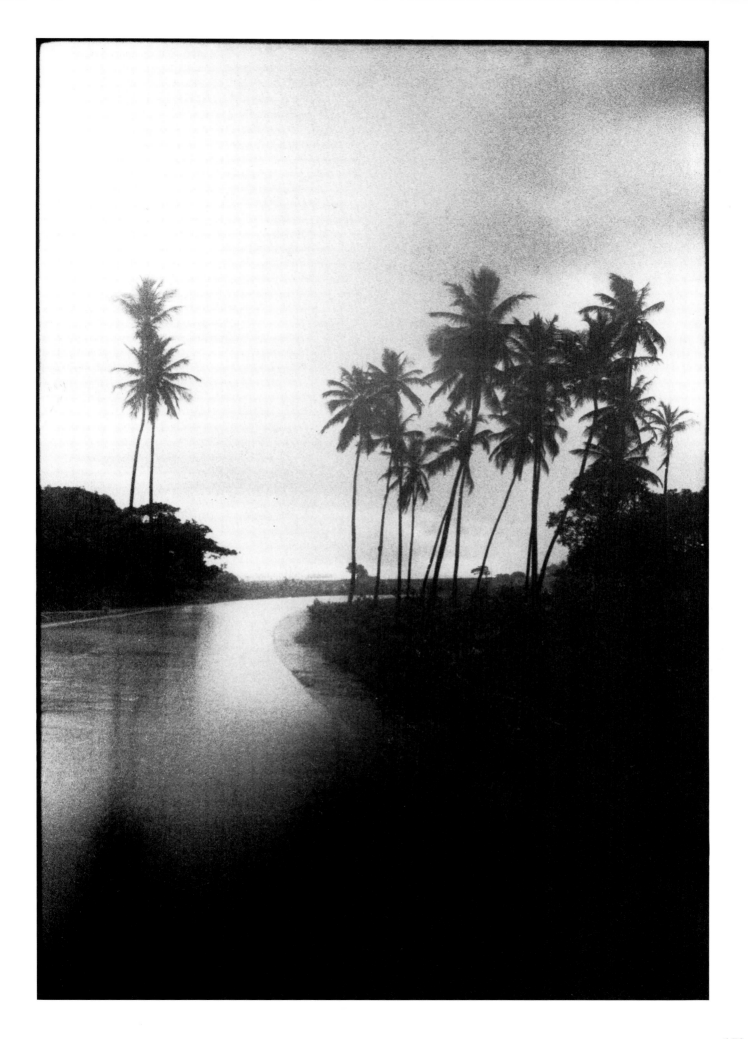

Silhouette

exposure
light lock

There once was a thriving business in making stark black and white impressions of people's profiles. The artists who created these images worked sometimes in ink, and sometimes in lampblack.

What was important was not the materials used, but the effect produced. And a successful profile would capture faithfully a patrician nose, the fall of the hair across the forehead, the fullness or otherwise of the lips of the person portrayed. The silhouette was much in vogue – though it lacked in detail beyond outlining the face.

Creating such a silhouette required a fair degree of draughtsmanship, as with any medium which relies upon accuracy of line. With one exception...

Though it far too often appears by accident the photographic silhouette is as expressive, if not so stylised, as were those simple images of our ancestors. A silhouette made with the camera is one picture in which detail has little part to play: it relies upon instant impact, a broad slab of tone imparting all the necessary information immediately.

The silhouette is a particularly curious photographic phenomenon. It owes its existence to the inherent inability of film to separately record brightness levels over a very wide range. Certainly there are many scenes which, to the human eye, yield up detail right into the shadows and in the brightest highlights, but which look hugely different when photographed.

What happens is that the film records a certain amount of detail – detail within the brightness range it can handle – and leaves everything outside its range to record in uniform tone. Shadows will go entirely black, even though *you* can observe detail, and highlights will record as a mass of white or grey.

The range of brightness which a film can handle is not fixed: it can be adjusted upwards or downwards, depending upon how the film is developed (black and white is particularly versatile here, but not all colour films respond).

With that control it is possible to create silhouette pictures at will. The contrast of the film used to picture this busker was pushed up considerably: by extended development the film's brightness range was reduced.

But it's possible to produce perfectly satisfactory silhouettes by the simple trick of underexposing – and a great many people do that accidentally! Rarely, though, is an accidental silhouette a success: if you are looking for preservation of detail and you fail to get it, through underexposure, then quite plainly you have failed in making your picture convey what you wanted it to.

A planned silhouette, on the other hand, is akin to a huge advertising poster in its delivery of information – wham! You can do it by first identifying the shape which is to be in silhouette, and then arranging the exposure to make sure that happens.

What was wanted here was a plain bright background beyond the busker: any detail, no matter how faint or indistinct and out of focus, would have been just that bit distracting. The profile and a clean outline of the old man's recorder are important. So the exposure reading was based on the blazing splash of light just where that distant figure is leaving the underground passage. That exposure required a small lens aperture and a relatively high shutter speed – and the figure of the busker was consequently underexposed by three or four stops.

Of course, a single lens reflex camera allowing manual control can handle just about anything you care to put to it. But the little 35mm compacts which have a light lock facility (allowing you to take a reading off any subject area, hold that reading, and then reframe your picture) are really very suitable for this kind of thing. Their programmed exposure settings are very conveniently arranged for quick fire shooting of the huge majority of subjects, and their relatively wide-angle lenses bring a pleasing 'airy' atmosphere.

Sure enough, it is that sense of spaciousness which helps tell this story – a sad tale, about what a bad day the busker is having. Beyond him, that single figure hurries unhearingly onwards: a simple picture and a simple story – made so much more powerful by simplification of the image too...

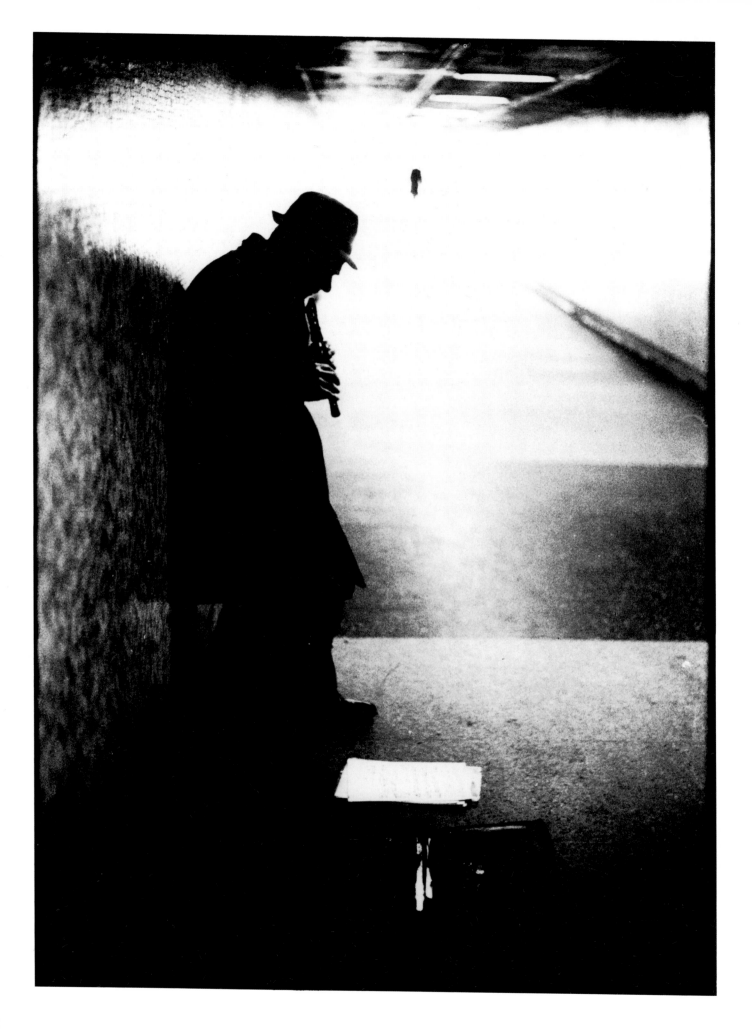

Silhouette
underexposure
starburst filter

It's impossible to be long involved in photography without hearing the words 'seeing eye'. And what a strange phrase that is, for how can there be an eye which doesn't see! Perhaps it's the very oddness of the words which makes them seem so lacking in any direct meaning.

Like all hobbies, all activities, photography has sprouted its own jargon – and the seeing eye is part of it. What the words describe is a rare quality: it is the ability to understand how what the eye sees will emerge when put through the photographic process. For what the eye sees and what the camera shows are most certainly not the same.

That is equally true of black and white and colour photography, but is particularly significant when it comes to black and white. For colour work it's possible at least to recognise that a scene will appear in the picture as overall blue, or green, or rainbow-spattered with colour. In black and white, the translation from what the eye sees to what the print shows must take account of how different colours will merge with each other (by being rendered in similar tone) to form the masses within the picture, and how different levels of light will affect the film, in subduing or pinpointing detail. How, the translator must also ask himself, will each element of the scene leave its record on his film?

Quite an understanding is needed, as you may imagine. But it's an understanding worth pursuing: it is the highest satisfaction photography has to offer, and it is, in those who possess it, a quality which truly brings mastery of the medium.

The little snippet of landscape here shows several aspects of how differently things appear when they've been photographed. It's a simple picture – early morning sun seen piercing through the leaves of a tree in a meadow, with the dawn mist still wisping above the grass. Since we can't, on the printed page, examine a real-life scene and forecast how it would appear on film, we must begin with this landscape and work backwards, taking the effects in the picture and seeing how they came about.

The searing ball of light, sending out rays like a star, is the picture's most striking element. And it's an effect that you can cultivate, one you can with a fair degree of consistency introduce into any landscape which includes the sun. It comes about through using a very small lens aperture, and is exaggerated by underexposure and when the sun is partly obscured – as when it peeps over a mountain or a roof, or through leaves, and light spills everywhere.

In reality, the eye doesn't see the sun quite like this – in fact it's just about impossible to see the sun at all. Look towards it and you'll see a blinding glare which it's not possible to hold in view for more than a fraction of a second – and it's foolish to even try. But the eyes are remarkable light-gathering instruments, and there are two of them. The camera lens is less efficient (it certainly can't by itself take steps to compensate for different levels of brightness) and it views the sun's glare along one axis, not two.

That singular view, through a small lens aperture, causes a spectacular star-like flaring – which is more pronounced if the sun is near the edge of the picture area. Knowing that, you can visualise the effect when preparing to shoot your landscapes. But knowing too that the effect is brought on by underexposure you must at the same time visualise much of your landscape going into silhouette.

We think of a silhouette as a black and detail-less shape, seen against the light. And that's the way it appears in a photograph. But silhouettes actually begin life being quite well equipped with detail.

For example, the leaves on this tree displayed some texture and colour. But it is neither texture nor colour which dictates how a surface will look in a picture; it is the amount of light reflected towards the camera, and the time for which it is allowed to act upon the film, which will influence the appearance. In the right light it is possible for a white shape to appear in black silhouette, simply through absence of light. Apart from the controls on the camera there is no way you can influence light outdoors, but you can get an idea of how subjects will appear by looking at them through half closed eyes: that will help you assess the final print appearance, and is particularly useful in making plain the fact that adjacent heavy tones, even though of different colours, may well merge into one solid dark mass in a black and white print.

The darkness, of sky and silhouette, introduced by underexposure creates a backcloth for that flare effect of sunlight – it couldn't happen if the sky was rendered very bright. And the effect can be created around lights other than the sun, by using one of the star-burst filters so readily available. But their effect is somewhat regular, and lacks the exciting and dynamic appearance of the irregular flare from nothing but a small aperture. Using a wide-angle lens will often exaggerate natural flare too.

Never forget that film is less able to perceive fine detail, or faint detail made visible only by subtle differences in tone, than the eye. The morning mist looks like a dense cloud here, but you will know that you can usually discern ghostly shapes, even through a thick fog. Light spilling into this mist patch, from above and behind, has rendered it even more dense, since the mist has now become a cauldron of bouncing light, the sun's rays being thrown around everywhere by moisture droplets in the air.

You should quickly develop great awareness of this detail-softening quality of photography, for it can make gentle the outlines of even the most rugged object – and that includes a haggard or blotchy face.

The significance? That you should recognise that frequently you can concentrate on shape alone, never fearing that those wrinkles or little creases on your subject's face or dress or hands will scream out of the picture to distract. Of course, if you are shooting in big close-up, with a lens renowned for its phenomenal LPM capacity then you *will* record detail.

Notice that the tree trunk and its shadow merge into one shape here, though again there were obviously differences in texture and colour. To test *your* seeing eye try to visualise this scene as it looked 'in the flesh'. If you can do that, and translate the other way, you're well on the way to real understanding of the language of photography...

Silhouette
lighting
background

Heavy top light and a wide brimmed hat combine here to create a silhouette of the face of Jean Shrimpton. And that highlights a simple point. Which is this: distrust instinctively anything which sounds remotely like an iron-clad rule.

Don't necessarily ignore it; just distrust it – and examine it carefully to see whether it really is so iron-clad, or whether there is another way of achieving what it is you are after in the way of effect.

A beginner, on asking an experienced friend how to shoot a silhouette, will be told 'Shoot against the light, and underexpose'. But here there's both underexposure and overexposure (on the back of the hat), and the light is from directly above, slightly to the rear of Jean.

Don't be misled: shooting against (that is, directly into) the light is of course a pretty good way to produce a silhouette effect – but it isn't the only way.

This picture resoundingly demonstrates that where light doesn't penetrate there will be darkness. An obvious statement, maybe, but one you should engrave in big bold letters upon your brain. And you should add to that: 'Film does not see things in the same way as does the eye.' While detail may be plainly evident in your subject in your own 'studio', if the film isn't exposed to it for sufficiently long there will be darkness. And light does not go on forever: it falls off with considerable rapidity. Perhaps because of our experience with sunlight we are tempted to believe that light goes on and on; but photolamps, and flash too, have only the most minute fraction of the strength, and power, of sunlight.

Look behind Jean, to the background, and you will see evidence of that: the background paper is close to white where it is nearest the light used here – but within a few feet it has failed in strength, and the background paper is now a dark grey.

That failing of light is the greatest argument there is for the new breed of computer flash units, which go on pumping out more light until their receptor cells are 'satisfied' that sufficient has struck the subject for there to be a satisfactory exposure.

But a computer flash needs understanding, just like any other piece of automation. Unless you specifically adjust it (that is, the ASA setting on it) for a special effect, then it will, time after time, deliver sufficient light for what it computes to be a good exposure. Thus, with a subject like this, where there is pretty even balance between light and dark, the flash (if used from above) would very likely do its best to fill in some of those shadows.

Just as you must suspect the iron-clad rules of photography so too should you approach with caution the guarantee that automatic equipment is supposed to give you the guarantee of perfection. Sure, you will get something very close to perfection most of the time. But if you want to try the adventurous, experiment a bit before you commit yourself to shots you can't repeat.

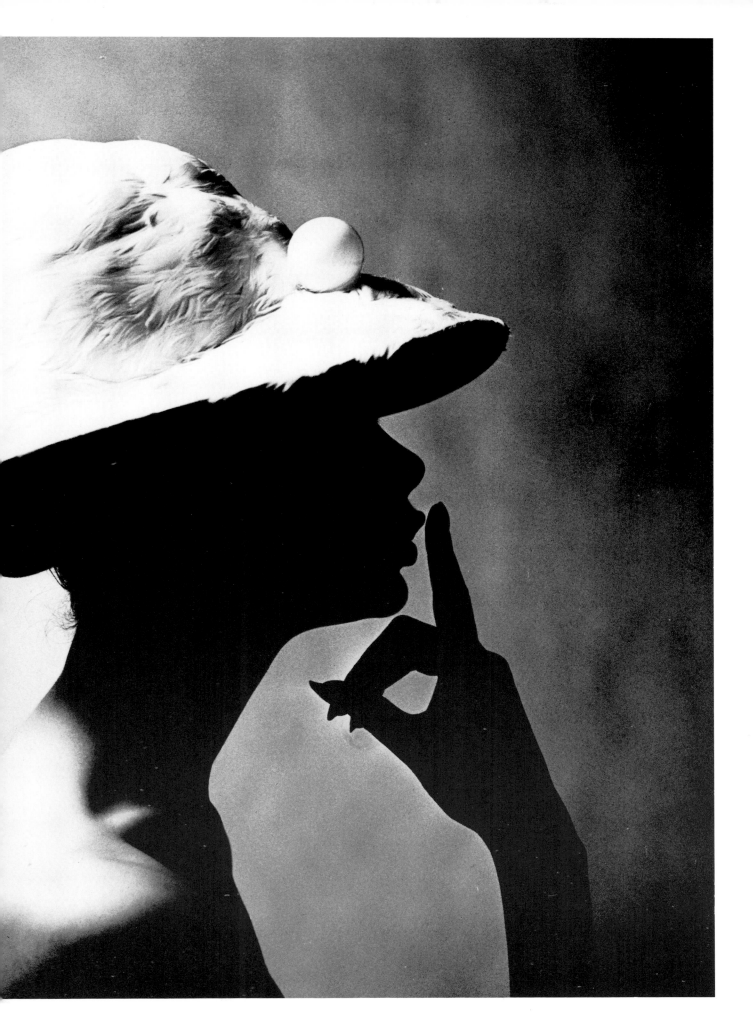

Abstracts
composition
picture frames

There is a school – many schools – of painters who create their images from nothing but design. That is, they have the freedom to abandon natural shapes, and to construct whatever assembly of line and mass suits their tastes.

Of course, any cameraman could do something similar: he could open his shutter on B and wave it around in front of some out-of-focus lights, and he could simply lay a piece of paper on his darkroom easel, flashing all sorts of light splashes upon it. But, essentially, when we talk of abstract imagery in photography we mean exactly that – our pictures are abstracts, slices abstracted from reality, from the natural world. They may of course be taken from a less than usual angle, as is this shot of Lake Rudolph, in Kenya.

It was taken from the air, and shows a sprawling pattern of foam flecked waves and pounding surf. At first glance it is a design and nothing more; but since it is a photograph, a longer examination will cause the picture to yield up a certain amount of detail.

You will have seen those weather report pictures, beamed from satellites, in which huge slabs of land and sea are striated with cloud – the pictures indicating plainly to the weathermen where next there will be a spell of bad weather. The whole point of those is that they should yield not detail but broad pattern: it doesn't matter a bean that you can't see the streets of London as long as it's plain there's a rainstorm heading up from the South coast! But producing satellite pictures is a pretty expensive business, as you may imagine.

There is rarely any commercial or professional need for pattern pictures such as this one, though they do sit very nicely indeed in those exciting travelogue articles in such publications as *National Geographic* magazine. The breed is somewhat odd, though.

Many photographers have explored abstract imagery, though mostly only in short bursts. André Kertész had a spell many years ago of producing distorted nudes, just as Bill Brandt did with his incredible wide-angle camera; but they were not true abstracts, though the resulting sets of pictures were, and are still, much published. More abstract was the set of close-ups of torn posters, by Brassai – again very well received by the folks in photography who appreciate the occasional sortie into the unusual. And nature has often provided the pattern for abstracts, in the form of the delicate design of leaves, the rugged shapes of tree trunk and bark.

The most dramatic territory for the production of true abstracts is reached through the microscope. There, in vivid colour, the photographer may find shapes which will arrest any eye. Crystals and the wings of insects, and even droplets of oil, suddenly mushroom from the tiny into a photograph capable of sustaining interest as a four-foot blow up.

But is the pursuit of the abstract a journey leading into a blind alley? Not at all – no thoughtful and exploratory approach to photography should ever be thought of in that way. It is, however, an approach very different from the soul-stirring search for the perfect landscape, or the great and gregarious pleasure portrait photographers enjoy.

In an abstract it is pattern and colour which attract. And as far as the enthusiast photographer (not the enthusiastic naturalist, note) is concerned, it will matter not at all whether the pattern is of sand dunes or a butterfly's wing. And even peeling paintwork is a rich hunting ground for pattern.

It may seem a bit bizarre to discuss composition of abstracts in the same terms as we might for more conventional subjects, but it requires every bit as much care – that's for sure. It is not a matter of simply finding an extraordinary shape and snapping away. The business of balance must still be taken into account, and there shouldn't be bits of the picture meandering away off the edge of the paper. You may not actually find a self-contained image all that often, one wholly arranged within the picture boundaries, but you should at least aim to include some area which is in itself a sort of focal point of interest. In the Lake Rudolph shot here, the eye tends to dwell on that area at left of centre, and in the white patch at top centre.

Consider photographing a peacock feather in thumping great close up: chances are your attention would immediately be grabbed by the curious eye-like markings on the feather, and you'd concentrate on building your picture around that. Trouble is, for many tastes a peacock's feather might seem too instantly recognisable to be a true abstract – as a picture which might be thought a piece of artistry to hang on the wall.

To hang on the wall? Yes, that's about the most noble place for a really good looking abstract, unless you can find a book publisher you can delight with a whole series of them.

Abstract art is not to everybody's taste, you must accept that right from the beginning. But worse still, plainly recognisable bits of very ordinary objects are likely to be ridiculed too. One French photographer spent ages in the desert, minutely recording the great variety of colours and textures he saw in an old oil drum 'graveyard', only to find he was endlessly having to explain what he was doing photographing old oil drums anyway.

Pattern is, by itself, quite sufficiently appealing to thoroughly justify trying your hand at abstracts. But, and this is important, remain ever aware that you should be trying to produce something which will allow the viewer to 'daydream' over, rather as people will endlessly envisage shapes in the clouds. What you are most certainly not trying to do is offer your viewer picture puzzles (though most people will try to guess what you've photographed anyway).

There once was a vogue for having portrait pictures in ornate little frames dotted around the house. For sure, a really good portrait will always look good, especially if it's even more a fascinating design than it is a recognisable map of someone's face. But contemporary taste demands something bigger, something more grand, more expansive than the half-plate portrait. And an enlarged abstract will look every bit as good as a Kandinsky on your wall – especially in glowing Cibachrome, with your signature scrawled in the right place. Very impressive! Why Cibachrome? In fact the Kodak and Agfa colour print processes are fine too, but for wall hanging Ciba does have a particular edge: it is highly resistant to fading.

Very important to the presentation of any picture – painting or photograph – is the way it is framed. A modern looking abstract would appear absurd in an ornate walnut frame, you'll agree. Something very plain is needed, and the galleries to be found in just about every town these days should provide you with plenty of inspiration.

Don't let the search for abstracts take over your photography – if you do you'll miss a great deal of enjoyment from the wider view of the world. But the genre is very much worth a bit of attention. It has the advantage of being available in the most commonplace locations: there will probably be a dozen examples even in the reflected light gleaming from your car. And colour and black and white are both equally effective – with interesting slabs of tone taking over the interest from hue in monochrome prints.

Still life

mood
exposure

This still-life picture was taken in 1959, by a young man recently demobbed from the RAF, then spending a gruelling but fascinating apprenticeship with John French, one of the most respected photographers of the day...

Still-life photography continues to feature in the Bailey output, of course, for as a subject it is no less capable than any other of yielding satisfying portraits. But it is no coincidence that many a modern college tutor starts his photographic students off on still-life.

He may ask them to photograph eggs, or stones, or fabric; anything which will make them appreciate what are the eventual effects upon lighting and grain and texture of whatever it is they have done with the camera settings, how they have placed their lamps, and how they have processed their film.

And it may also be no coincidence that a number of very famous photographers have continued throughout their lives to take pictures which are more or less in the still-life mould, of the same or similar subjects: certainly André Kertész did, Steichen did (a thousand negatives of a white cup and saucer!). And, endlessly, Steichen continued to photograph an old tree in his garden.

So what's the point of it all, of picturing what may seem like insignificant detail, though it is actually very familiar to the photographer? There's no single overall answer; but a reasonably reliable response might be that one very great advantage of frequently photographing something familiar is that it ought to give every opportunity to see how a number of different equipment/film/technique combinations affect what you produce. On the same subject, comparisons may be very direct indeed, and very easy to analyse.

A still life, even a simple one, can yield much. Take this one for example: in it is sufficient to illustrate grain, rim lighting, flare, silhouette, differential focusing.

Around every home there is surely some little cameo which may be promoted to permanent 'test subject'. And every enthusiastic beginner ought to find himself such a subject right away.

The simple fact is that there is no finer way to understand photography than to look at photographs – and if they are your own you can extract so much more from them.

Consider exposure. If your awareness of it has to be fed by only one quick and chancy snapshot of some subject – with tricky lighting anyway – then how on earth are you ever to begin to assess in advance the results of your shooting! An avalanche of uncertainty builds precious little experience...

And yet how simple it is to take your time and go through your camera's capabilities, lens stop by lens stop, or shutter speed setting by shutter speed setting, and see on the results what is the effect of a twiddle here and there. You'd be bracketing, in fact; trying out the effect of various exposure combinations. Mostly, bracketing requires just one or two stops either side of the theoretical correct exposure, but running through the whole range is going to yield much more information about the conditions of so-called over and underexposure.

And another advantage of a fixed subject, easy of access, is that you can try out differing lighting arrangements on it. How, for example, does your portable flash affect the picture when held high above the subject, and does it change things dramatically when held away out to one side on an extension lead? It ought to be obvious, but a small change in the position of a light can make an enormous difference: and with a print in your hands, you won't need a detailed explanation of just how much.

You could also fire your flash at your still-life subject to see exactly how much light gets to your subject from a variety of firing positions.

There is, too, depth of field. Do you know by how much it varies at each aperture, with each lens, at differing subject-to-camera distances?

Depth of field is a highly visual affair. Looking at it personified in a picture is a million times more explanatory than all the wordy explanations under the sun.

Of course, there remains the simple business of mood. With a fixed subject available to him, a photographer may approach it at any time in any light with any of a score of different intentions. He may simply want to try a new lens, or he may want to see what happens when he breathes condensation onto an old one.

A subject which is always there, with which the photographer becomes increasingly familiar, is a thoroughly valuable reference point. But only if notes are kept, and each shot is made to yield up an alternative – a profile of the effect to be had by doing so and so instead of something else.

Photography is not about theory, but about inspiration, awareness, imagination, and experience. That is, experience insofar as it becomes possible to predict, and to control to a certain extent what will happen under certain conditions.

Special effects
double exposure
cameras

There's no doubt a large number of ghosts owe their existence to a simple camera error – double exposure. And perhaps also to the fact that films once stayed in cameras for months on end, with the user forgetting what had been taken previously, and not being at all sure whether or not the camera had been wound on and the shutter cocked. Double exposure was a *very* common fault.

Nowadays, the camera makers have for the most part dealt with the problem: cameras have built-in locking devices, which prevent a second picture being taken until the camera has been wound on. And yet many a professional will insist on buying a camera which doesn't take away his option to make a double exposure when he wants to.

The fact is, double exposure is a problem only when you do it by accident: done deliberately, it can produce pictures of great beauty, images full of mood. It all depends where within the picture you place the two separate images, and how much prominence you give to each – in terms of strength of tone, or of colour.

Combining two images produces a third image: and that's the term used by the very enthusiastic slide show hobbyists, who use two projectors, dissolving the pictures together on one screen to produce quite dramatic effects.

But the third image can be produced in other ways too – by sandwiching two transparencies together, by sandwiching two negatives together while printing, by printing one negative after another on the same piece of printing paper, by projecting an image onto, say, a nude and photographing the effect, and by that simple business of double exposure.

Simple? Well, though it is essentially simple the people who are good at it will go to great lengths to match the two images in just the right way for the success of the end result. The very best of them will work with 4×5 cameras, composing the picture with much care on the ground glass focusing screen at the back of the camera – with the camera on a very sturdy tripod. Having arranged the first image they will then draw an outline of it on the focusing screen, as a guide to precisely where the second image must be placed. And very often the whole idea will have been sketched out on paper in advance.

A $2\frac{1}{4}$ square camera (preferably an SLR, but a TLR will do, though precise positioning of the images is then more haphazard) will allow you to work in that thoroughly prepared way. But the screen of a 35mm SLR is just too small for that approach, so there you must rely on your memory for alignment of the two images. Don't let this put you off though: if your camera is one of the sophisticated models with double exposure facility, then use it.

Remember this: *how* the two separate parts of the picture are presented is every bit as important as *what* they are. In this picture – shot for a beauty feature in *Vogue*, 1970 – there is a fresh young girl, and there is sea. The two are arranged so that the girl is much the more prominent. Beyond her, the sea is just out of focus.

You should make use of all the facilities of the SLR in this kind of experimental work – even using lenses of different focal length for the two images, so that you arrange the perspective of the third image in a way which will appear convincing, which will add to the unity of the end result.

This third image technique works equally well in black and white or colour – though introducing a variety of colours means you must take care not to have them clash, or else you will destroy the harmony the third image must display.

Just score one or two successes in double exposure shooting and you'll find yourself wanting to try ever more exotic effects. And if you begin to move on to other third image methods you will be able to control very precisely the relative densities of the two parts of your combination picture.

Almost invariably, the technique will work best when one image is dominant; the other softened by diffusion, soft focus, or telephoto lens de-saturation of colour. But just now and again the impossible can be made to appear possible, by really inventive juxtaposition of the two parts which make up the third image. And when you can make miracles you can then go on to adding more than two images together. In photography's early days the old camera wizards would often use a score or more of negatives to build up the most extraordinary effects; and Rejlander used more than thirty to create his controversial masterpiece *The two ways of life*. It worked for him – and Queen Victoria bought the picture for Prince Albert.

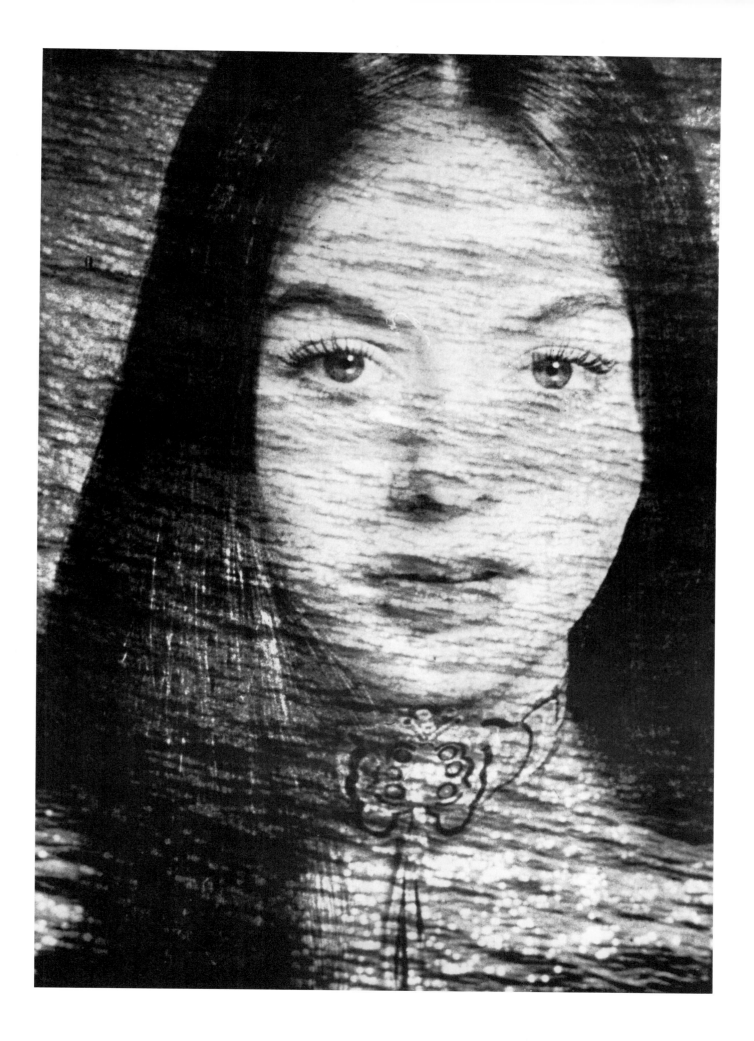

Special effects
double exposure
lens aperture

One very common fault in photography used to be double exposing on one piece of film – caused by forgetting to wind on the film after taking one picture. So disastrous was this for most people, as it wrecked many a never-to-be-repeated scene, that camera manufacturers banished the problem altogether, by designing shutter mechanisms and locks which just wouldn't fire till the film *had* been advanced – that action cocking the shutter ready for the next exposure.

Sophisticated cameras, and studio models, do not always offer this protection – for in reality it is also a restriction. It prevents exploration of a number of techniques.

It's not exactly that certain techniques are trademarks of certain photographers, but it is true that professionals will often resort to favourite tricks, problem-solving methods of working, when faced with a client who wants an impossible image, and, naturally, in the fierce competition of the professional world the exact details of the trickery are so often jealously guarded. So what is written here about this picture of Marie Helvin is not so much a blueprint for duplication of the technique involved, more a suggestion as to how you might produce a *similar* effect.

First, you'll need a camera which allows double exposures. A number of the more advanced 35mm SLRs allow that, but there is rarely any guarantee that you can precisely position both exposures in perfect relationship to each other. Better is a large format camera on which you have to manually cock the shutter.

The camera must be rigidly mounted on a sturdy tripod, and your model placed in front of a suitable background. Place her very close to the background, and arrange bright and flat frontal lighting; try to avoid any shadows behind her, for they will wreck the illusion.

Now you are ready for the first exposure. Don't stop the lens aperture down too much, for you must now mask part of the lens, and a small lens aperture might cause the edge of the mask to appear too sharp (depending on how deeply your lens is recessed into the barrel) thus spoiling the smoothness of the effect.

The mask need only be as simple as a piece of black card. With it, cover up the bottom half of the lens: make the exposure. Now cock the shutter again, but take great care not to move the camera – that's why you need a strong and stout tripod. Next, cover the top half of the lens with your card mask; move your model away, right out of the picture area. Make your second exposure – and that's it.

That simple technique outline will give you a result similar to Marie in the animal skin background. But the real skill is in the arrangement of model and background in precise harmony with each other. Choosing complementary juxtapositions will produce some bizarre and surrealistic effects.

Do notice that this technique differs from superimposition of two slides in that the model is so very plainly entirely part of the upper half of the picture; study Marie's hair outline and you'll see that. But you could, with considerable care and great accuracy in shading and dodging, get a result similar to this by use of double printing – that involves using two separate negatives instead of double exposure.

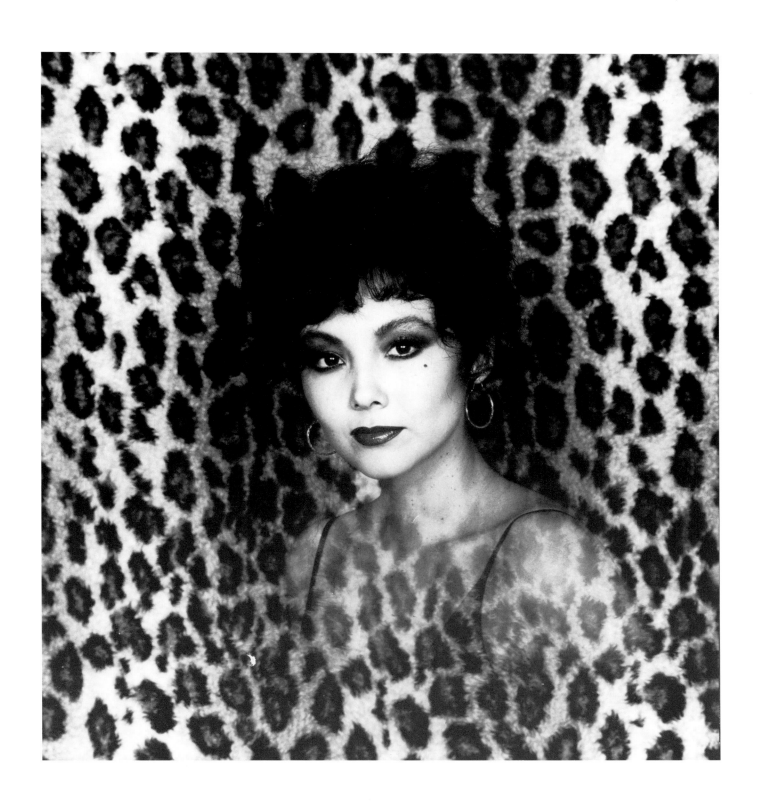

Special effects
double exposure
sandwiched negatives

Two angles on Terence Stamp – in one impossible picture. Impossible, that is, to shoot in one go, precisely as it is here. It is easy enough to use mirrors to duplicate a face in one exposure, and that is often done – particularly when photographing ladies. But for two quite different angles you must make two exposures on one frame, or combine the images from two separate frames.

Either way the secrets of success are absence of a fussy background, and lighting thoroughly under control.

Cameras preferred by professionals almost invariably have some means of allowing two exposures to be made on one frame, but the majority of models on the hobby market are designed to avoid errors – unintentional double exposure is certainly an error! Thus, the shutter release locks when one exposure has been made, and may only be fired again when the film is advanced. That action automatically cocks the shutter, ready for the next exposure. How can a camera featuring such a protective device be persuaded to yield pictures such as this one? With ease! And you don't even need a darkroom, though your scope will obviously be much extended if you are already doing your own processing and printing.

Let's make it clear that there are other ways of producing 'two view' pictures, and some of the ways are a piece of cake with the right equipment: but the simple way described here will work with virtually any camera – even the simplest 110 which has no controls other than a shutter button. It will not work with the instant cameras which eject a self-developing print.

You will need a black background: use a black sheet, black paper or arrange for any dark background to be completely unlit. And you will need a simple light source: a spotlamp, a flash unit, or a window with the curtains partly drawn so that only a slice of light passes into the room. But do make sure that no light is allowed to spill onto the background.

If your camera has a tripod bush then take advantage of it and mount the camera on a tripod: if that's not possible (you have neither tripod nor bush) use a very solid support.

Pose your subject so that he or she will be lit just as Terence Stamp is here. If you use a flashgun it will have to be away to one side of the subject – and, remember, its beam mustn't spill onto the background. Problem? Sure there's a problem, since flash units spread their light in a fan-like burst. But shooting good pictures has more to do with solving problems than with using an expensive camera. To keep the flash off the background mask part of the

beam with a piece of card, or swivel the unit so that its light falls away from the background but doesn't strike the subject. As a last resort you could place the flash unit inside, say, a shoe box: cut a slit in the box which will control the width of the emerging light.

To fire a flash unit away from the camera you will of course need a flash extension lead. And simple cameras which don't allow flash connection will have to be used with a spotlamp or sunlight coming in a window.

Now you can start shooting: you will need to take two pictures. Arrange the first one so that your subject is positioned at the left side of the camera viewfinder, leaving the right-hand side empty, dominated by the black or very dark background. With a standard lens you should be shooting from no more than four feet. This first picture should be a frontal view, like the portrait of Stamp at left here.

Now take the second picture, this time arranging your subject in the right-hand area of the viewfinder. At this stage you are on your own where sense of balance is concerned. You must aim to get the two pictures so positioned that the heads will finally appear close together but not overlapping. Let that serve as yet another emphasis of the fact that picture taking success is more a matter of personal judgement and problem solving than of your camera.

The next job is to have the film processed. And amongst the negatives will be the two portrait heads you shot, both showing big areas of emptiness. In black and white film the empty area will be indicated by more or less clear film; a colour negative will show a cast in blank areas, but that is filtered out in printing and shouldn't affect skin tones. If you do use colour negative film be prepared for a very warm coloration on faces lit by spot lamps, unless you use a filter, or special tungsten film. But don't worry to begin with: you might find the very warm colouring actually adds to the dramatic effect of two-view portraits.

Use a piece of sticky tape along top and bottom edges to stick your two negatives together, making a sandwich from which you can now have a print made. Best bet is to seek out a photodealer or processor offering a hand-printing service. The thickness of the sandwich may cause a loss in sharpness in the final print (stopping down during printing will help diminish the loss) but at least you will have proved to yourself that even simple cameras can produce quite sophisticated pictures – once you know how.

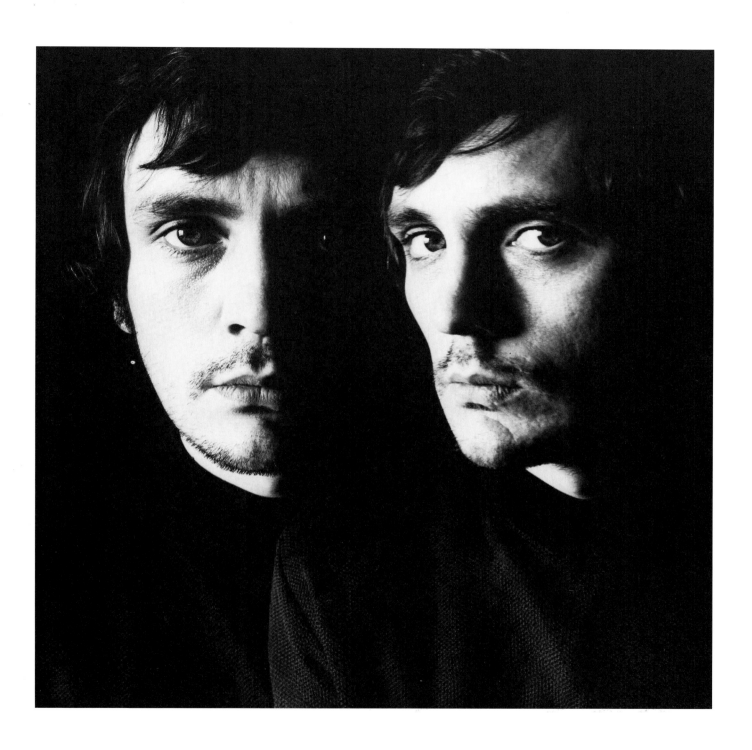

Special effects
reflections
mirrors

Most schoolchildren sooner or later try painting or drawing fantasies – and many a reputable artist never stops drawing fantasies! But both children and artists have a world of images to call upon – weird shapes and half shapes stored up in the mind, requiring only pencil and paper to reveal them to us.

The photographer has that opportunity also, though he must use not pencil and paper, but double exposure or multi-printing techniques, or perhaps scissors and paste montage.

However, there are some extraordinary images to be found which require nothing more than a quick snapshot. They are the bizarre juxtapositions which abound in the world – and surely bizarre is this sheep, pictured in a shopwindow near London's Primrose Hill. But notice another element here – the reflection, in the window, of a car.

Reflections, by themselves, have long been a more than acceptable subject. Many a picture, of reflections in a rain puddle, has thoroughly well conveyed the bustling and glamorous atmosphere of the lights of Piccadilly Circus (though that particular shot is a shade old hat now). But there must be endless tourist pictures of the beautiful Taj Mahal reflected serenely in that long lake which stretches before the building.

The reflection in this picture is in glass: that alone is a rich hunting ground for pictures. Take a look at the soaring 'glass walls' of a modern skyscraper and you will see exciting pictures.

Look at shop windows: you will find endless astonishing subjects – especially when people are reflected in windows full of fashion models, clothed or unclothed. But look too at your mirror: there you can take interesting self-portraits. But remember to focus on the reflection in the mirror, not on the mirror frame itself.

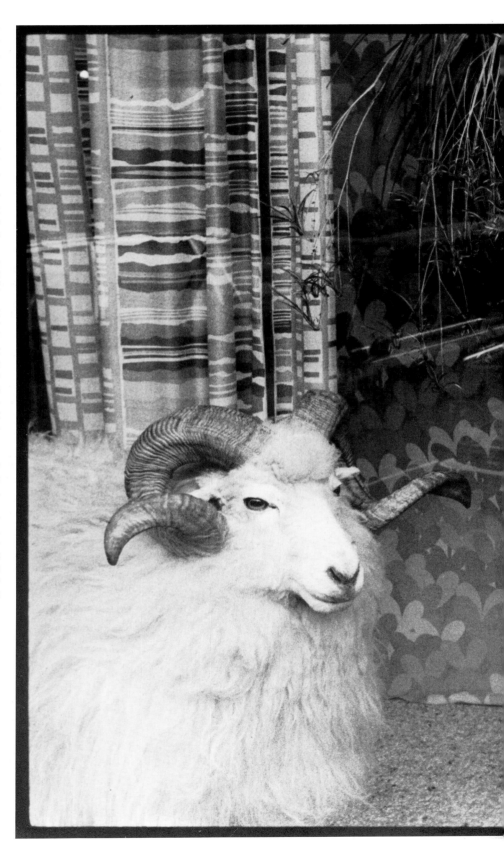

Special effects
vignetting
wide-angle lens

From time to time it is worth getting right back to basics and reminding yourself of the behaviour of light, photography's most essential ingredient. Behaviour, note: not so much nature, since the nature of light is still not entirely understood, and in photography we can discern little more than strength and weakness of light, and its colour temperature.

But behaviour of light is, in any case, more fundamental for the black and white photographer than its nature.

Here are some more or less shiny 'masks', being used to display sunglasses. And the way the display is arranged means that there are equally reflective surfaces all over the picture, but at a great variety of angles to the lens-to-subject axis. Not only that, but those masks at the top of the picture area are evidently less bright than those at bottom and centre.

Why should that be so: are they in less direct light, have they been darkened by shading in the darkroom, or are they dulled by the common enough phenomenon known as vignetting? But let's deal with the more brightly lit (or apparently more brightly lit) areas first.

Particularly in the centre of the picture you can see highlights – areas which immediately catch the eye because of their relative brilliance. What makes them bright? Simply the fact that there the subject planes are so nearly at right angles to the lens-to-subject axis that most of the light bouncing, or reflecting, off them is being directed straight and square towards the lens. And where much light strikes a black and white negative the negative is heavily darkened, thus blocking light when the print is being made, so that you end up with a white area on the final picture.

As the roundness of the masks causes the surfaces to be at more acute angles to the lens-to-subject axis then progressively less light is directed straight into the lens, and the negative areas correspondingly will show a thinner deposit, thus allowing more light to come through when enlarging, with consequent darkening of the printing paper.

Important point: it is the quantity of light reflected directly into the lens from any subject which dictates whether that subject will appear dark or light on the print. It is *not* the colour of the subject which dictates how it will appear: a shiny black wall, or a dark muddy river, may appear blindingly white if sufficient light is bounced *directly* into the lens.

Another important point: any subject area which is potentially bright may be darkened a good deal simply by allowing a disproportionate quantity (that is, more than for any other area in the picture) of light to fall on the printing paper.

So, was that darkened upper part of this picture made that way by burning-in, by allowing more light to pass through the negative? That's possible. But there is another way in which it could have happened – through vignetting.

Of course, it is possible that in this actual picture-taking situation there was less light falling on the upper part of the subject.

But a close look will show that wasn't the case: the shadows thrown on the cheeks of the masks, by the sunglass frames, are similar all over the picture – except that they appear to be thrown in different directions. That is always a phenomenon when a very close approach is made with a wide-angle lens.

And vignetting is a not necessarily unpleasing side effect of certain wide-angle lens designs. Also of some compact cameras, where the lens is designed so as to be uncommonly close to the film plane, for smallness and compactness.

With a very curved surface, such as you might find on a ultra wide-angle lens, there needs to be extremely accurate refraction at the outer edges of the lens in order to direct all the usable light rays to where they should be on the film plane. Creating such accuracy brings with it considerable expense.

Knowing the extent of any vignetting of your camera and lens combination will obviously help you visualise your pictures better: but knowing just where the strongest light is bouncing off your subject, and where is the weakest, will help you even more.

Soft focus
filters
enlargements

Somebody once said that none of us really perceives the world accurately. What we see, the theory goes, is more or less what we want to see. For the way we see what's around us depends on our built-in 'filtering' mechanism. That could very well explain why some ladies are thought outrageously beautiful by one man, less so by another.

Whatever the truth of it, there's no doubt that very often an already beautiful girl can be made to seem even more beautiful, and a little mysterious as well.

Even a relatively inexpensive camera can produce a thoroughly sharp and detailed portrait, one in which the pores are plain, every eyelash is seen, and the wrinkles can be counted. Shoot that kind of picture of any girl with less than porcelain-perfect complexion and you may find you've lost a friend. The simple fact is that we rarely examine any human face in quite such a penetrating way as the camera does: that built-in filtering mechanism is already at work, persuading us the face before us is kindly, beautiful, honest – or perhaps evil! But mostly we don't observe the flaws. The camera does – it's relentless, and presents a wholly unbiased view.

The biting detail of the photographic portrait can very often be used to great effect: just by including, or emphasising, such things as freckles or stubble, or pores, the photographer can produce a very much harsher impression of his subject.

On the other hand, it's often to the photographer's advantage to divert attention away from detail. And this he can do by softening the image, by obscuring the detail in some way. In this picture of the exotically dressed Marie Helvin much detail has been subdued by exaggerating the grain – the structure of the film. But there are simpler methods, and all are straightforward...

The simplest is to make use of the soft focus technique. Let's for a moment be controversial and suggest this technique should really be called 'softening focus', for if it is to work satisfactorily it is important that the subject should actually be focused on with great precision, and bitingly crisp. The word soft in the description of the technique refers to the fact that the photographer is softening, or diffusing, only some of the light rays travelling from his subject through his lens. He intercepts those rays, and by means of some translucent material causes them to scatter, so that they lay a veil of light over his entire subject, a veil which lowers contrast and softens the image. But the crisp details should still suggest its presence: the viewer should look through a veil of light and see a sharp picture, *not a blurred one.*

How do you achieve a soft focus result? Easiest way, though not recommended, is to put a dirty great fingerprint on your camera's lens! Seriously, you achieve the effect by arranging to let some light pass unobstructed, while the remainder passes through translucent material, and is scattered. Special soft focus filters are made, and they vary in the degree of softness they introduce. Some have a pattern engraved on the glass – which effectively turns the engraved area into ground glass, a translucent material. Depending on how much area the marking or engraving covers your pictures will be softer or less soft.

The commercially made filters are very convenient, for they simply screw, or push, onto the camera lens, and require no further effort on your part. But they are far from being the only soft focus inducers. Anything, absolutely anything, which is translucent will give you a certain soft focus effect – but it must of course be just sufficiently transparent to allow shapes and colours to be seen through it.

Vaseline smeared on a plain glass filter – a UV is perfect – is an old favourite, and has the advantage that by rearranging the smears of Vaseline you can control the effect with some precision. Another common dodge is to use a patch cut from old tights or stockings, and stretch that in front of the lens. If you try that one, experiment by burning a cigarette hole in various places on the material: you will soon see how differently placed holes affect the image. And just as easy is crumpled Cellophane, with or without holes cut in it.

What is it that happens when you produce a soft focus effect? Obliteration of very fine detail, yes; but the actual effect is observed only when the technique is exaggerated. Mostly it comes across as nothing more than an impression, which with subtlety alters the picture without intruding upon the viewer's appreciation. On excessively soft focus effects (and they can be striking for very romantic subjects – such as might appear on LP covers) you will notice a kind of halo, a phosphorescent glow, all around the light parts of the subject. This appears because the scattered light – scattered remember by the filter, or Vaseline, or whatever – tends to strike the film all around the subject, and bright light will build up quickly on the negative: a girl's white hat in soft focus would be black on the negative, with a grey halo around it where light has spilled, or scattered, outside the boundaries of the subject. But the effect occurs on colour material too.

It is possible to achieve a sort of soft focus effect as an afterthought – when you have already taken and developed your pictures. All you do is use any of the soft focus techniques, holding whatever type of filter you choose to do the trick, in the enlarger's light beam while printing. That will present an effect different from that achieved when shooting. For now the bright light passing through the filter will be coming from the darkest areas of the subject – those which appear almost clear on a black and white negative. As a result the dark areas on your photographs will tend to spill into whatever light areas border them. A girl's white face against a dark background would appear to have very soft outlines, where the dark area creeps across the border between the two. The effect is unusually liquid: not seen often in an exaggerated form, but used by portraitists who don't want to offend their sitters' vanity!

The technique used for the photograph here was none of those. Look closely and you'll see that very bright areas close together tend to merge into each other, and that a good deal of detail can be seen in the shadow areas of the picture. Those are the clues. For they are the typical products of overexposure. And by giving more exposure than was required for the bright areas – exposing for the shadows in other words – and agitating the film very vigorously in the developing tank, an excess of grain was produced. Like pepper, sprinkled all over the picture. But it effectively breaks up the image, subdues detail, softens the impression. Still, the essential crispness is there – look at the detail in the stitching and pattern of the robe.

Remain aware always that both camera and film are there to do your bidding.

Soft focus
sepia toning
hand tinting

Only a fool would wring his hands and whine about Kodak having 'made it all too easy'. Of course anybody can now produce a pleasing picture *most* of the time, and a great picture *some* of the time – and why shouldn't that be so?

Nobody has a monopoly on producing good pictures, though there's many a skilled craftsman who can be relied on to produce the goods consistently. But surely all photographers who have a genuine love of the medium must welcome the advances which have made it possible for even beginners to meet with modest success straight away.

And yet, it is an inescapable fact that unless skills are practised they will soon evaporate. Thus, while laboratory-processed colour prints justly delight millions, they have also diverted many from sampling the so satisfying world of black and white photography. And since a black and white negative might be thought a starting point rather than an end product, endless avenues of exploration are left untrodden.

Here's a picture of Charlotte Rampling, a gentle portrait designed to end up as a soft sepia print. Sepia is that warm brown tone which characterises vintage pictures, and which inevitably seem to bring with it a hint of the romantic. It's an effect which requires much more participation and control than simply posting your exposed film off to a laboratory.

Sepia is but one form of toning which is laid onto a black and white print; it isn't much different in concept (though miles away in execution) from hand tinting, with coloured inks or dyes, which is at present a bit of a vogue amongst young art college photographers. Sepia suffuses the entire area of a picture, and while highlights will remain gleaming white and shadows dense black, the warmth of the slightly purplish brown pervades all other areas. Coupled with soft focus treatment, as in this picture, the effect is very delicate.

Your photographic dealer or chemist ought to be able to provide you with the needs for making sepia-toned pictures.

It's a technique you can do easily at home – even if you have to have your black and white enlargements made for you by a professional laboratory. The principle is simple enough, and not over-technical.

The best results come with black and white prints showing lots of tone and not too many blank white areas. Here, for example, the white areas are but smallish highlights on Charlotte's face and hand.

The fully toned print is first soaked in a chemical fluid which bleaches away the image; next, it is soaked in another fluid, which brings up the sepia colouring. In fact, it is possible to use toners of other colours – blue is also relatively common – but the warmth of sepia puts it in front as 'most suitable most often'.

Seeing the colour come up in a sepia-toned print is exciting, almost as much so as seeing the image emerge when you are processing black and white prints in your own darkroom. You do not, though, need a darkroom for sepia toning. And while the excitement is one thing – a bonus if you like – the driving force has to be the immense satisfaction at the end of it all, when you end up having created something very much to order, to your precise taste.

Sepia does of course introduce colour; but the effect is worlds apart from straightforward colour shooting – unless, that is, you are a very disciplined colour photographer, and can successfully control every tone in your pictures. But sepia does solidly underline the fact that there's great effect in simple colour: those colour prints which are strident with every shade in the rainbow may boggle your eyes, but nothing beats the very economical use of colour for gentle effect.

Sepia in itself is well worth trying. And if it can also discipline your colour shooting, by inspiring you with the charm of limited colour, then it moves beyond being merely another photographic tool. It will become instead an important turning point in your appreciation of just how much control is yours, how little belongs to the camera.

Once you have sampled the delights of sepia toning you may care to try your hand at using a paintbrush and coloured inks to put other effects into your pictures. Start with small areas of accented colour; in a portrait you could, for example, paint the lips. Or tint a vase of flowers in the background. Orchestrate the effect.

Be assured that really successful pictures never get that way accidentally. Well, very rarely so. And it is important to remain very aware of how the photo process can entirely change not only tones, but colour impressions too.

Lighting
flash
shadows

Here's Marie Helvin, during a modelling session featuring Anthony Price clothes. The outfit is bold and dramatic – and the lighting is ultra-simple, so that textures and strong lines speak for themselves, with no confusing presence of shadows to cloud the issue.

In effect, this is the kind of lighting you'd get from one of those little brolly flash units, the kind which is mounted on a tripod and reflects a wide and diffused spread of light onto the subject.

Basically, the brolly flash outfits are no more than portable bounced flash set-ups. They work by collecting the relatively tight and harsh beam from a flash unit and spreading it out, so that the light bathes the subject from several directions at once and has no corners it can't reach.

In fact, the light unit here was slightly to the left of the camera position, and quite low down: you can see that it had to be low, to send light in under the brim of that cap.

But though the unit was left of the camera it has nevertheless sent light just creeping around Marie's face, just brushing her left cheek.

Important point: if you are going to operate with any bounced flash set-up make sure your bouncing – or reflecting – surface is large enough to provide a spread of light sufficient for what you want. If that surface is too small the light it bounces back will be in a relatively concentrated beam, and will undoubtedly create shadows – though they will be less harsh than they would be from a direct burst of flash light.

The secret of softness lies in working with a light source that is as large as possible. That is why many professional studios are equipped with a massive bank of flood-lights, as much as six or seven feet in each dimension, and perhaps also covered by some sort of muslin: the effect is very bright, very soft.

Tungsten lighting is still very much with us, but it is under great rivalry from the supremely portable and powerful electronic flash units now well within reach of the hobbyist's pocket. And it would be a shame to invest in a really powerful unit and then have your pictures ruined by shadows simply because you have skimped on the means of reflecting your light back onto the subject! If you can't find a large enough brolly as a reflector then use a very large piece of card – or white cloth. If you are prepared to go to the trouble it is not a bad idea to paint one side of the cloth – silver or aluminium paint would do – so as to stiffen it a little and increase its reflectivity. Un-treated cloth will almost certainly lose a large proportion of whatever light is blasted onto it – the light will simply go straight through.

Another important point to consider is the distance between your flash unit and whatever reflecting surface you are using. The closer the flash to the surface, the less light spread you will create and the less soft the effect on your subject. Of course, a very powerful flash unit will allow you to position it further from the reflecting surface than will a very small pocket job.

Never ever forget that shadows are caused by absence of light. Sounds obvious, but when dealing with light it is all too easy to make the mistake of assuming that because it's bright you will light up everything. Think of a laser beam: can you imagine anything brighter! Yet just inches off the arrow-straight axis of a laser beam you could find the deepest shadows. Brightness does not wipe out shadows: wide spread of light does.

Think about it . . . effectively the sun's light reaches us in a straight beam – just like a giant laser, really – because the sun is so distant. And how that can cause shadows! But give us a dullish day, with a huge and wide canopy of clouds bouncing light all over the place, zipping it towards the subject from every angle – and where are the shadows then?

Dealing with light is simply common sense. Leave your meter to look after its strength, trust your film to handle its colour temperature – and yourself concentrate like blazes on its direction. A simple recipe that, but one that could take you forward in leaps and bounds . . .

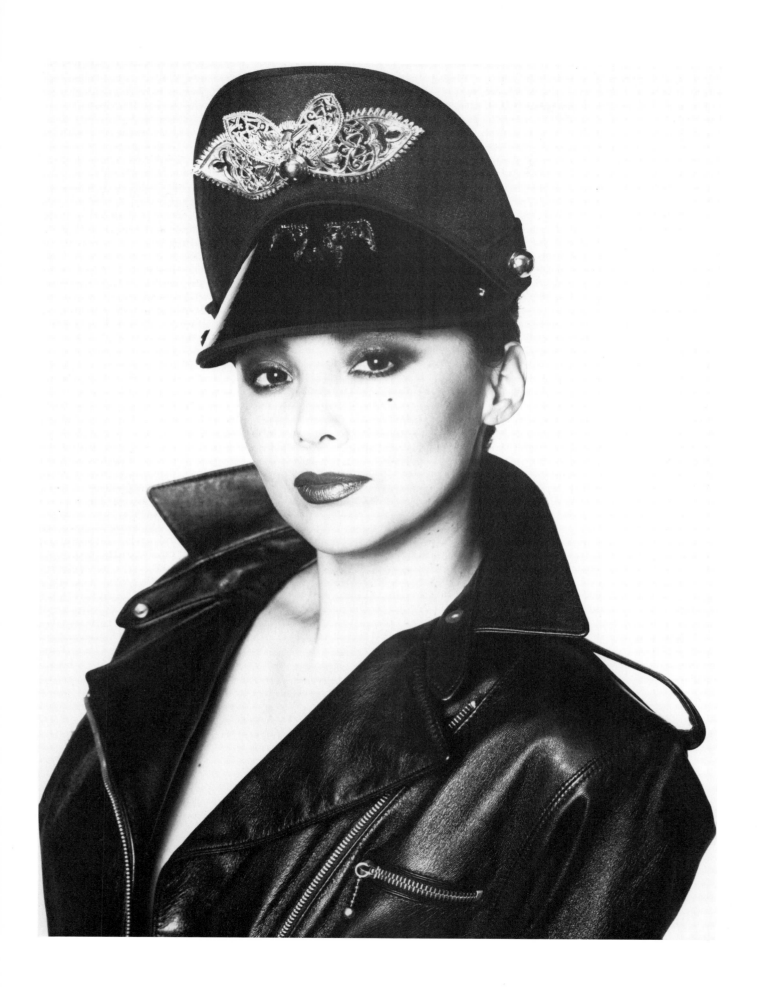

Lighting
groups
soft lighting

Rarely does any group of people end up arranged quite like this in front of a camera. But these are dancers of the group known descriptively as Torso; and they'd have looked out of their element if posed in a straight line with arms folded.

If not exactly with folded arms, wedding groups are almost invariably posed in straight lines, just as football teams appear in two rows, and amateur dramatic societies are 'frozen' in re-creation of some characteristic scene from their favourite production.

Whatever the nature of a group it seems there is a sterotyped pose to suit it. Have we advanced from those distant days when Victorian, and earlier, photographers lined up the family, with father standing behind an ornate chair, mother sat on the chair with the baby on her knee – and any other children of the family sprinkled around more or less aesthetically?

In fact, there is one area in which there has been not an advance, but a distinct backwards slithering.

A century ago, the cameramen setting up in business (or converting a room for his hobby) was likely to look for a studio arrangement such as the painters relished. He would seek a large room with much north-facing glass, preferably high up – perhaps even skylights. And he would arrange blinds so that he could control the daylight entering the studio.

With such a place to work in, the photographer would never be troubled by harsh shadows, and would always be in control of the light, and, to a certain extent, the angle at which it fell upon his subjects. The lighting style of the day was soft and gentle, though sometimes ranging greatly in contrast between shadows and highlights – as much as does the chiaroscuro of Rembrandt.

There had to be a change of direction, of course, though it was a long time in coming.

More than any other influence, it was probably Hollywood which dramatised lighting. At any rate, harsh shadows and distinctly directional fall of light have now been with us for so long as to appear not only the norm but even desirable. And the very clever and often complex lighting used to put impact into pictures of movie stars was bound to be considered something special: sure enough, you will find it being mimicked even today in camera clubs up and down the country.

Two points arise. First, the pre-Victorian worked in his window-lit studio because he didn't have any other sufficiently powerful light source – and taste of the day was in favour of him anyway. Second, the Hollywood photographer used his complex lighting arrangement particularly to dramatise, and taste of *his* day too was in his favour.

To re-state the obvious: every light source will create a shadow. And the more lights you use the more shadows you are likely to end up with – which can be especially irritating when the shadows are sprayed in ungainly fashion over a group of people, some shadows possibly even obliterating important bits.

There are no practices in photography which can't be bent from time to time of course, but 'harsh lights on a group of people' stands less chance than do most arrangements of generating any kind of success. Faced with a group, go soft ...

How? Large diffused floods, or powerful bounced flash. Many a professional uses a big bank of floods, concealed behind some diffusing material such as white cloth, perhaps also with a reflector arrangement behind the cloth, so that what is diffused is not direct but reflected light. Very soft indeed, highly flattering – and shadows well under control.

A group may be as small as two – mother and daughter, perhaps. Then, a hobbyist flash unit would probably have sufficient strength to deliver an adequate light when bounced from a nearby wall or ceiling.

If there is no light-coloured wall or ceiling near enough then a portable reflector is a good substitute – and very acceptable indeed are the folding white umbrellas designed to clamp onto a tripod. In fact, giant-sized versions of them are common in professional studios.

Look closely at the evidence of shadows in this picture. You will see that the light was almost frontal, and placed quite high up. Close to the camera-subject axis, but above it – just right for a group, or any subject of many elements in different planes.

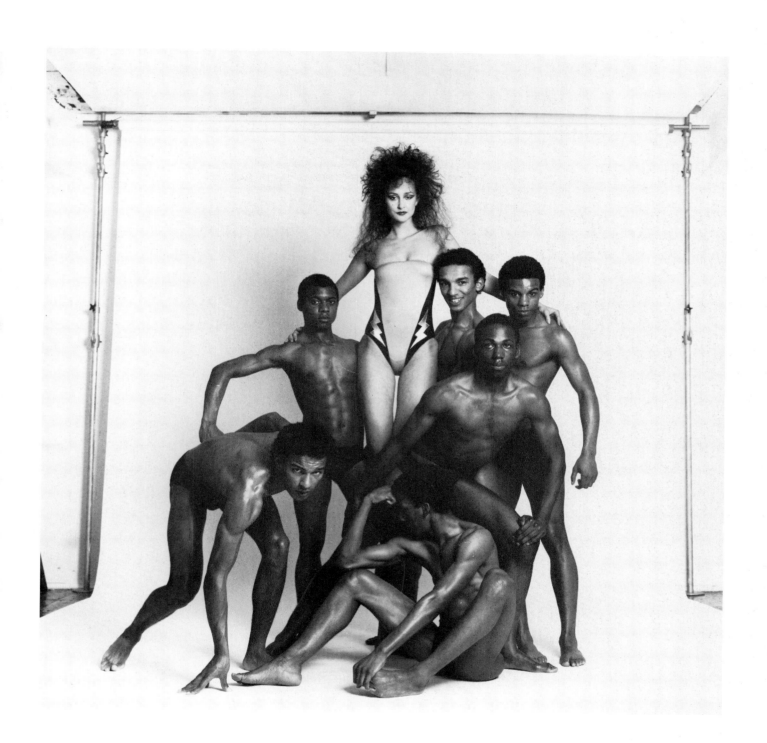

Accessories
camera outfit
compacts

Amidst the tools of his trade, and with a fair number of mementoes around the place, an old man sits in his barber shop in Ceylon. The picture tells much, but not the whole story: for this man was Lord Mountbatten's hairdresser.

You may think a barber's shop an unlikely setting for a portrait, but portraits in the everyday surroundings of a subject have a very particular charm and quality which isn't matched by the big scale studio arrangement. This has a quality that is *different* – not specifically *better* than in the studio.

This kind of thing is typical of what you might get with a small pocketable compact with built-in flash, or with an SLR fitted with a small electronic unit. However, skilled 'readers' of photographs will be able to surmise from the positions of the shadows in the picture that the flash was here very high – as it might be if you were working with the unit connected to the camera by an extension lead, or a flash cable as it is often known.

And the theme which ought to emerge from contemplation of this portrait is that accessories are not at all esoteric bits and pieces to be thought of in the same way you consider all those add-on bits for motor cars.

A gadget bag – or a sturdy carrying case, perhaps of aluminium – may indeed be a treasure house of all the things you imagine you might just possibly need whenever you leave the house; but packed full with lenses and camera bodies it can pretty soon become unwieldy. And very seldom will you actually need to use even a fraction of all that stuff slung around your shoulder (unless, that is, you have selected the kit with a very definite shooting purpose in mind).

Mostly what happens is that the gadget bag becomes a nuisance, and stands an increasingly better chance, as the months go by, of being left at home. Then, suddenly you are confronted with a genuine picture opportunity – but all the gear is at home. Don't risk that one!

Instead, sit down and work out the very minimum you need to cart around with you to ensure a fair crack at *any* subject. It matters little whether your bare minimum includes a lightweight SLR or a well-specified compact: but it does matter which accessories you choose to include.

Flash is a necessity, though more times than not the little built-in units on 35mm compacts will be more than adequate (for portraits – but don't for goodness try shooting landscapes, or anything more distant than around four metres, though the actual limit of flash coverage will often be marked on the unit).

Compacts are fine for daylight landscape shooting, and for low light work too, if they have a sufficiently slow shutter speed. But if low light landscape pictures are likely to appeal to you (or are likely to be forced upon you, because the winter months bring precious few sunshine hours), then you would do well to think about a tripod. Not a bulky job extending to three or four feet, but a very small and pocketable one which

you can stand on the ground, or which may be clamped to a fence. Provided your camera has a delayed shutter release (self-timer) then you don't actually need a cable release.

Compact users will either flounder or learn to live with their fixed focal length lens; but SLR owners have the opportunity to fit a lightweight zoom; something like 35-70mm should suffice for everyday jaunts.

Filters? Possibly, but which ones? On balance it is better not to burden your mini outfit with them, but to leave them for those occasions when you are specifically on the lookout for certain subjects – such as moody landscapes which might benefit from graduated filters, or cityscapes which might sparkle all the more through a starburst.

With such a trimmed down outfit you should rarely miss a picture. But you might like to add a flash cable and separate unit, just for highlight work, or for tricky bounced flash shooting. Do remember, though, that it is very easy to begin expanding an outfit again once you've just spent time limiting it! Trouble is most people go about their photography the wrong way round. What they do is begin to conjure up all the situations which *could* arise – and each imagined situation in turn suggests another piece of equipment.

Much better to develop every confidence you can in all the equipment you have, and learn how to make even a simple compact do your bidding, which it readily will if supported by the right accessories.

In fact, though relatively few accessories have been discussed here, there are many more which can make life easier when you are out and about with a camera. Take for example the humble converter: that and a couple of lenses (say a 50mm and a 135mm) could offer a lightweight outfit – and not too costly – covering some very useful focal lengths.

Finally, one accessory you should never leave behind – spare film! And while you're at it why not make it something other than your usual film: there is such an exciting variety now available that you owe it to yourself to see what different effects you can achieve just by changing film types.

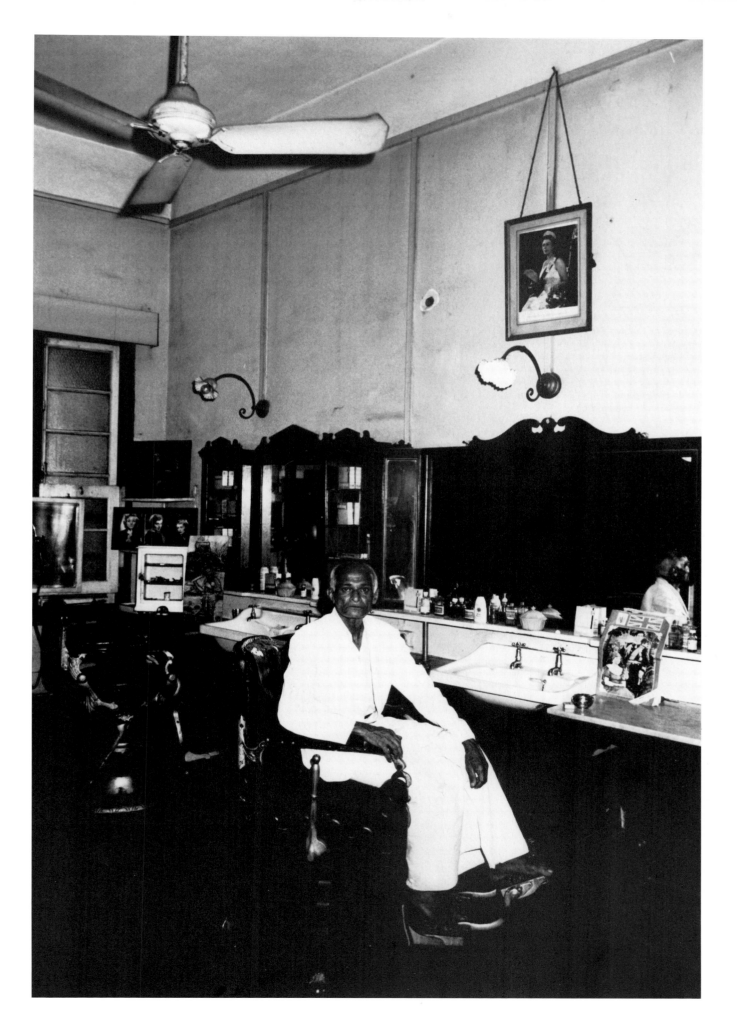

Film
ASA rating
push processing

Things have changed now, of course, but it's not too long ago the average man in the street was convinced that photography required sunlight. And he was sure, too, the sun just had to be behind him.

Many things have conspired to broaden awareness of photography, and to educate everyman in the near-endless field of what can be done with the camera. Television has helped. The manufacturers have helped, making equipment ever more capable of working in conditions once thought impossible. And the film makers have helped – in that high quality pictures are now possible (they always were, but not in snapshot style!) even in a blizzard.

In fact, nothing has changed *so* greatly, other than the layman's awareness. Since photography began, its prime raw material has been light, not hardware and films.

This photograph was produced in the midst of a snowfall, and the lady crossing the slush-laden street has been stopped in her tracks: obviously, a shutter speed of at least 1/30th sec was used, since the figure would have blurred otherwise. And there is quite considerable depth of field which, on the face of it, would point to a small lens aperture of f/8 or smaller. But a wide-angle lens was used, of 35mm, and with such a tool depth of field appears great, so that even f/4 on wide-angle will deliver adequate crispness all over.

The really flexible element in difficult light shooting is the film. All films bear a sensitivity value, measured in ASA (American Standards Association) ratings. The figures are easy to understand: a film of 100 ASA is twice as sensitive to light as one of 50 ASA, and half as sensitive as one of 200 ASA. What that means is that by carefully choosing his films the photographer can decide what range of exposure he wishes to use.

For example, let's suppose you've been used to taking pictures only with colour negative film of 100 ASA: now that would let you use exposure settings of around 1/125th sec and f/8 in the brilliance of a summer afternoon, but faced with a moody landscape late on an autumn day you might find the light low enough to require 1/15th sec at f/2.8 – not greatly satisfactory for landscape shooting. But if you loaded with a film of 200 ASA you'd have twice as much sensitivity available, and could adjust those camera settings to cut that exposure by half – to either 1/30th sec and f/2.8 or 1/15th sec and f/4.

The higher shutter speed will help guard against camera shake, or the smaller stop will stretch depth of field – whichever advantage you prefer. However, load with even faster (more sensitive) film, like 400 ASA, and you can enjoy both advantages.

Film is rated at its ASA figure on the manufacturer's decision: he builds it to a certain level of sensitivity. But photography is nothing if not flexible. And while, say, 400 ASA might be the rating of a film for optimum results, it can be shifted from that rating with the greatest of ease. Be aware that tinkering with the ASA rating will alter the characteristics of a film, but not disastrously so, and certainly not significantly enough to deter you from taking advantage of the benefits it brings.

Often 'pushed' is 400 ASA black and white film. Although it doesn't have to be pushed by a factor of $\times 2$ each time, that is the way most experienced photographers do it: thus, they will often push 400 ASA rated film to 800, 1600, 3200, and even 6400 ASA.

These astonishing increases progressively make more evident the grain of the film pushed, and also make higher its contrast. Indeed, the extra sensitivity is largely gained through stepping up the highlight densities of the negative, whilst the shadow areas receive proportionately less of a boost. And the increase in sensitivity is gained so very simply – by increasing developing time, sometimes in conjunction with a different developer. Manufacturers like Kodak and Ilford do themselves suggest a speed increase in order to produce negatives of somewhat higher contrast for differing types of enlarger illumination.

Consider, for example, Ilford's HP5 film. Rated at 400 ASA, it should be developed in ID-11 for $8\frac{1}{2}$ minutes at 20 degrees C. But Ilford tell you an increase in time to $12\frac{1}{2}$ minutes will increase the contrast, effectively pushing the film to 500 ASA (only a quarter of a lens stop more). However, develop the film in Microphen for 9 minutes and you can rate HP5 at 650 ASA – a half stop (and a bit) increase. All that is fairly unspectacular, merely allowing for minor adjustments of contrast to suit particular printing methods.

Using Microphen developer you can push HP5 to 1600 ASA, by keeping the film in the developer for 12 minutes: leave it there for 18 minutes and Ilford advise you the film can be extended to 3200 ASA – and that's an increase of three stops. In other words you could shoot at 1/30th sec and f/4 in light which actually requires an exposure of 1/4 sec at f/4 for an image on 400 ASA film.

One must admire Ilford for being so bold as to actually offer processing suggestions for pushing film, because it is subject to so many variables it can easily become an inexact science. In fact what you're doing when pushing film speed is simply underexposing, and cameras do vary in the accuracy of their shutter speeds and lens apertures. Also at variance – auto-camera exposure reading systems. And the way you agitate your film, and any significant variance in temperature of the developing solution can influence the exact sensitivity to which you process. Don't worry about all that though – go ahead and try it: establish for yourself just how much extra sensitivity you can squeeze with your *own* processing technique. In fact by diluting your stock

developer (say 1 part developer to 6 parts water), agitating the film in it for two or three minutes, then leaving the tank alone for a few hours (even all night!) you may come up with some astonishing increases.

Experiment, but make notes so that you can repeat your finds. And yes, you can increase the speed of colour films too, by increasing the first development.

You may wonder why anyone should ever want to *reduce* the sensitivity of their film, but there is a very good reason for doing so: it greatly enhances the capability of the film to record detail in both highlight and shadow areas. It reduces the subject contrast when it is transferred onto the negative. And you can produce that frequently valuable effect by overexposing your film and cutting the development time. For example if you rate HP5 at 200 ASA (overexposure by one stop) and process it in Perceptol for 11 minutes you'll be able to hold a great deal of detail right across your subject's contrast range. And many a wedding photographer overexposes Kodak Tri-X, at 300 ASA, to help him record the lacy dress of the bride *and* the dark suit of the groom. He merely reduces the developing time in D76 from 8 minutes to 7 minutes.

You should by now be very much aware that successful photography is created by your own initiative and imagination. The camera really is just a machine – but it's important you find one you're comfortable with: only then can you let it look after the mechanics while you get on with the miracles.

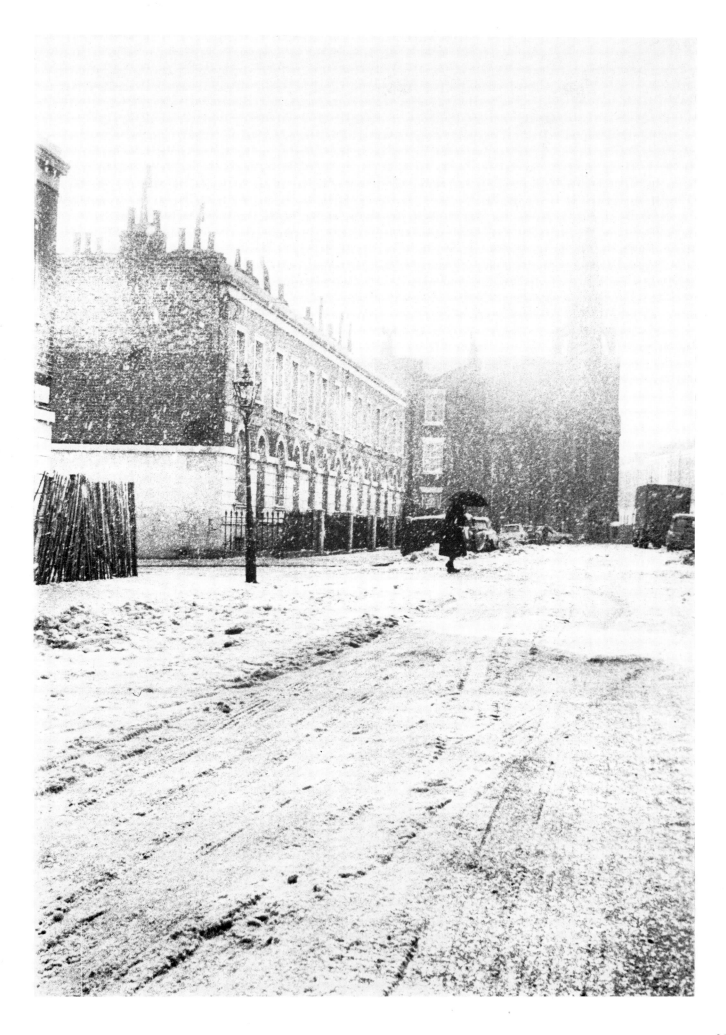

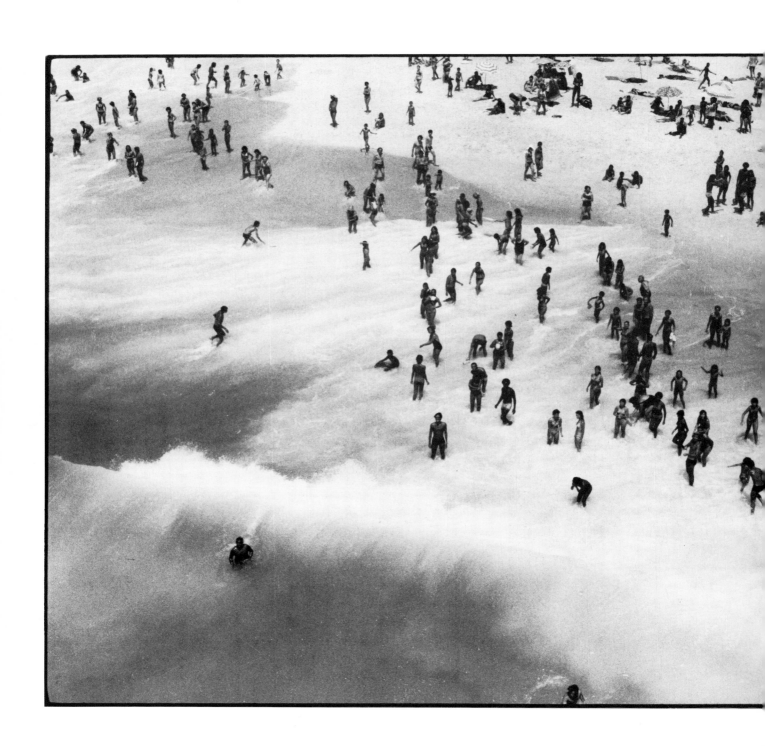

What follows really happened, believe it or not. On a hillside in Surrey, on a clear cold night, a man stood gazing into the star-dotted sky; beside him was a camera, mounted on a tripod; on the camera was a lens, of standard focal length for the 35mm format, which is of course 50mm; the man's reason for being there – he was hoping for a picture of a UFO.

This story is not at all about the likelihood or otherwise of any unidentified objects appearing in the Surrey skies; it's about making decisions.

The moon is quite a large object in the skies, as big, surely, as the majority of reports would suggest a UFO to be; but you try photographing *that* with a standard lens! And our man on the Surrey hillside was way off beam – he would have ended up with nothing, or an unidentified smudge.

If you own an SLR camera then you have at your fingertips a hugely versatile instrument. Its ability to function with lenses of differing focal lengths, and with endless accessories such as bellows and tubes, means that you can picture in crisp detail objects a few inches away, or a mile or two distant. But you reap the benefit of that facility only by choosing the right lens for each job. That is a matter neither of guesswork nor luck. Your eyes view the world across a certain angle of view, normally about 48 degrees. And that's why a standard lens, one of 50mm, provides a view which looks normal.

It's a fair bet that some parts of this beach scene interest you more than others. Just as you'll find some parts of any scene across which you sweep your eyes will particularly interest you. The straightforward function of a telephoto lens is to allow you to isolate that interesting part, to blow it up, to make it alone the subject of your picture. For a moment, compare our people-studded beach with that star-studded sky being scanned by the Surrey UFO watcher: a tiny light (nobody sees, or photographs, UFOs as big as cars it seems!) in the sky would be hardly bigger than the head of one of our bathers. So, in search of detailed pictures of distant and small objects – or big objects so very distant as to appear small – you need to choose your lens to suit.

This is an aerial shot, from a low flying plane; but just suppose for the moment it had been taken with a 24mm wide-angle lens. The very simple rule relating lens focal length and image size on the negative says that doubling the focal length doubles the image size (along one dimension, that is, so it actually quadruples image area), and increasing focal length threefold trebles image size, and so on. You can see on this picture a tiny area, boxed around: it's about one eighth as wide as the whole scene, and it represents the picture you'd get with a 200mm lens (if, that is, a 24mm lens *had* been used for the scene reproduced here). You would of course get any number of such details of the whole scene, depending on where you pointed your 200mm lens. To get just a portrait head of any of the bathers you can easily work out you'd need a lens of around 1000mm focal length.

You can't *measure* every view you see, of course, but you can – and should – begin seeing the world in small rectangles. Imagine an actual frame, covering the area your favourite telephoto lens covers, and you'll be able to 'examine' distant views through it, deciding if there's a picture there or not.

Final point: no, you can't get quality comparable with telephoto results simply by blowing up a tiny section of a negative. The smaller the area on a negative the less information can be crammed into it, and the more the image will break down on enlargement.

To get good telephoto results you must learn to see with 'telephoto vision'. It could bring us a lot more pictures of UFOs!

Instant
Polaroid negative
light variation

As the year moves into September and October the lanes and the lawns become carpeted with leaves. The trees grow bare, but the sun still shines – and so often with a particular light, a mellow golden light that is unique autumn light.

Bonfires burn, consuming the many tons of leaves which have spiralled, crinkled and brown, onto the damp earth. And the bonfires send plumes of blue smoke into the sky across all the shires of England.

It is a magical time, and a poetic time. Then, light is like cheesecake – so thick and so full of presence that you can almost cut yourself a slice of it!

And a slice of it, just about, is what you can see here. You can see, to be more exact, the effects of light – the way it splinters into rays as it pours down through the branches, and the way it shapes and dramatises the rising smoke.

Perhaps in no other way does light make its impact than when it comes into contact with smoke, and with particles in the air (as when sunrays shine into a dusty room, or when theatre lights pierce through a cloud of cigarette or cigar smoke); but every time you begin to consider the effects of light you could actually go on for hours. For example, a rainbow, sun sparkling on the water, low level sunlight striking the hill tops, are just a few more of the ways in which light itself shapes landscape photography.

It must be particularly baffling for those seekers after 'photographic truth' to be told endlessly that light is what it's all about – not cameras and lines per millimetre and what brew you develop the film in and whether you set the camera on automatic or manual! But that's the simple truth.

Here, of course, the effect of light is very plain to see, and none but a blind man would deny this picture is 'made' by the presence of those beams illuminating the smoke. It wasn't even necessary here to be concerned with contrast levels to any great extent.

Perhaps it is the almost universal popularity of colour print film which has led to lack of appreciation of light; for the colour photographer is very easily seduced by a colourful arrangement of subject, whatever the lighting upon it. And he seems seldom to be aware that his eye will make certain corrections for poor light (or light of low or high colour temperature), corrections which his film cannot make by itself – which fact thus leads to a disappointing picture, either because it isn't bright enough or the colours are all wrong. Everything gets the blame except the photographer's own lack of awareness of light!

The matter of contrast, the difference between the brightest and the darkest parts of a scene, is also likely to escape the attention of the colour print snapshot photographer – and if he misses it, and his processing laboratory goes out of its way (by machine printing) to level out all excesses of brilliance, and sometimes even of colour, then what chance has he of ever understanding how it translates from real life into photography!

No, the suggestion here is *not* that black and white film is the only material for worthwhile picture taking. But without doubt the young beginner aspiring to eventual mastery of the medium ought to begin there.

And the suggestion which follows is aimed at the determined sort of person who is willing to go to some trouble to understand the nature of what he is dealing with...

Get hold of a secondhand Polaroid camera, one of the oldies designed for use with black and white films. Packs of films are readily available – though you may have to cancel a night at the pub to find your costs!

Shoot as many pictures as you can afford to, concentrating on subjects which show interesting light variations – scenes in, say, woodland, with sun dappling through the trees. Then examine your pictures there, on the spot, and compare the actual scene with the way it has translated onto film.

The object is to *explore light*, and how it affects film. Open landscape, say, may be fine for one trial, to show you how distance haze appears – but having found that, then get on and shoot something of high contrast, or even of excessively low contrast. Try portraits, try textures, try evening light, try shooting indoors – try everything.

Remember the point is not to persuade you to abandon your conventional 35mm photography, merely to help you understand it better. But you can actually get Polaroid instant black and white film which also delivers a negative; so, depending on your own seriousness of approach to learning this way, you could merely have a brief flirtation with exploring light, or you could go on to another exploration – one in which you seek the perfect negative.

American landscape photographer (and master printer) Ansel Adams has turned out work of very high tonal quality from Polaroid negatives. If the experiment helps you step up the quality of your own black and white or colour work then it will have been well worth the few pounds invested.

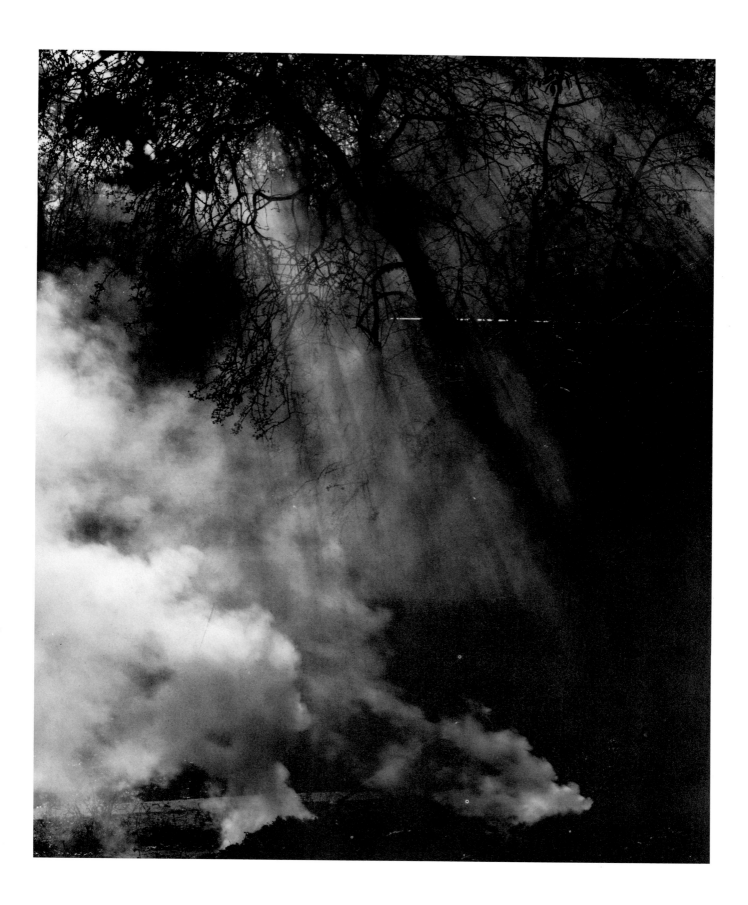

Most professionals and dedicated hobbyists rarely allow themselves the luxury of shooting just for fun; every shot has to be taken to a client's instructions, or must be pursued to satisfy some artistic drive. That's fine, for photography does need ideals and professionalism and the search for perfection; but it's easy to let our love affair with the camera become precious.

Give a camera to a child and watch what he does with it. He will be a caricature of an adult. Sure, he'll picture his pals and his pets, but he will spend ages getting them to pose – because he has seen the adults do it that way and that's the 'proper way' to do it! He might, of course, produce something really pleasing, for youngsters and animals *are* fine subject matter. But now watch what he does when he is out without the camera. He will dawdle along, stopping to examine this and that, and sometimes he'll linger for ages, nose pressed hard against some shop window. Or he will shuffle along backwards, eyeing those two lads playing across the street.

Endlessly, his attention will be grabbed, and by things which might at first glance seem trivial, but which are just odd enough to spark the imagination. We too can be as absorbed as a child; trouble is, our concentration becomes overlaid with other matters which fog straightforward observation – and how particularly prone to that are photographers!

If you are on the prowl for pictures it is a certainty you are going to examine each potential subject from a strictly photographic point of view: you'll consider which lens you should use, and you'll worry about whether the light is just right; and will the depth of field available to you be sufficient; there's black and white in the camera – but this subject *demands* colour. The subject, for its own value, never gets a look in!

And yet there is available to us today an incredible array of little cameras which thoroughly deserve the label 'visual notebooks'. This is not the time or place to consider why half frame as a format never took off (there's only one model in regular production now). No matter how compact a 35mm camera body is made, it must still accommodate that cassette of film, and a modern 35mm compact camera not only packs in a full sized negative, but often has flash built in as well, and accurate rangefinder, or even automatic, focussing.

The compact is capable of high quality results. And it is capable of delivering those results often without any attention from its user! Point and shoot photography is a reality. And with a little compact in your pocket you can snap those vital notes any time, any place.

So, what shall we do, abandon the relatively bulky SLR and invest in a pocketable 35mm? No, merely add a compact to the outfit, for no compact is to be considered a replacement for the versatility an SLR offers. But using a little point and shoot camera, or even one with rangefinder focusing but a relatively short focal length lens which can be used as a fixed focus lens, does involve a different approach.

It's a more leisurely approach, a less technical approach, one that should be as enjoyable as whatever occupation it accompanies – whether walking in the country or going to a party.

This collection of Japanese masks was hanging in a shop: not a subject which could be arranged, lighting changed, and generally subjected to all the control at the fingertips of the SLR user. *But that's the point:* uncontrolled photography, snapshot photography – and it's practised by millions who've no desire to own sophisticated gear – is something you must enjoy on the run. That's not to say you must not take *any* part in the picture-making process; it is still as vital as ever to examine every corner of that viewfinder, to quickly check that you are shooting the best available composition of the subject.

Two things in particular make the modern compact reliable for pleasing results. One is the relatively wide-angle lens invariably fitted, the other is the ease with which flash can be used – and without those harsh black shadows once so much a part of flash.

Commonly, the lens is of 38mm focal length, occasionally 35, sometimes 40mm.

While it's true that the very crispest results come from focusing accurately on your subject, it's equally true that many subjects are extensive in depth, and there is not then *one* plane on which to focus. The wide-angle lenses of the compacts, once stopped down beyond f/4 or f/5.6, which most will do automatically in anything like reasonable lighting, do offer considerable depth of field – sufficient to give the user confidence that whatever he shoots beyond four or five feet away will be satisfactorily sharp. In practice, he can use his lens as if it were fixed focus, by putting it onto a setting of 10ft – and that's a dodge the professional reportage photographer using a wide-angle lens on a highly sophisticated 35mm camera will often adopt too.

Second advantage of the compacts: all give pleasing results with the latest breed of tiny, and often automatic, flashguns – and the trend of building the flash units into the cameras (though they are of low power) is doing much to obliterate harsh shadows, bringing the flash tube closer to the subject-to-lens axis.

Filters
filter factor
red filter

Years ago, mothers used to tell their children that at the end of each rainbow was a pot of gold. At school, you may remember laboriously learning all the colours of the rainbow – the same colours as in the visible spectrum. ROYGBIV was the strange sounding word the teachers pounded into young minds, as an aid to recalling red, orange, yellow, green, blue, indigo, violet.

The rainbow is far more ordinary (or perhaps far more wonderful) than the fairy tales suggest. It's the structure of white light laid bare: it is the creation of a spectrum by nothing more than droplets of water acting like prisms.

But the rainbow is, or should be, a very valuable practical lesson in one aspect of photography – using filters.

On this vast beach lies model Ingrid Bolton. She's asleep, or seems so: the whole thing looks a bit dreamlike, and is suggestive of moonlight. The sky is dark – it's black. No sky was ever like that on this earth, at least never while it still had the capacity to throw the shadows you can see around Ingrid's body. The effect has been achieved very simply indeed – just by attaching a filter to the lens of the camera.

Think of the rainbow again. Light is made up of those seven colours of the spectrum, and it follows, doesn't it, that if you take away one of those colours you'll change the effect of light...

In this case the blue content of light has been removed, and also the green. But we're talking about a black and white photograph, so what has colour got to do with that? Well, light doesn't change according to whatever film is in your camera: what changes is the way film reacts to the light. And black and white film will record all the colours of nature as slightly differing shades of grey, darker or lighter depending upon the quality of light reflected from the subject.

Where no light is reflected, none can record on film. And what a filter does is stop some light passing through it, leaving other light unobstructed. In this beach picture the obviously blazing bright sky appears black because all the blue light has been blocked by a deep red filter, and is unable to pass through the lens and onto the film. For the same reason, the green foliage appears black.

There's a simple rule to remember when using filters for black and white photography: a filter will pass light of its own colour, but will block light of a complementary colour. Here's how it works...

A blue filter passes blue, but blocks yellow; a green filter passes green, but blocks purple; a red filter passes red, but blocks blue and green; a yellow filter passes yellow, but blocks blue.

Whatever you do, don't forget we're discussing the effects of filters on black and white films, for their use with colour materials will lead to pictures drenched overall in the same colour as the filter. Remain very aware that black and white film works by reacting to different levels of brightness.

If reflecting the same quantity of light (and thus equally bright), certain colours will record on black and white film in pretty well the same shades of grey. Green and red show up as very similar, and so will blue and yellow. A bit of a nuisance that; at least it is if you want to emphasise a subject placed against a background colour which is going to turn out as a very similar shade of grey in your picture – the two might even be so similar as to be almost indistinguishable, though the presence of shadows helps separate subject planes.

However, by making use of the filter's ability to distinguish, and to stop some light while passing other colours, you can very effectively separate the greys, pushing one further towards black and the other further towards white in comparison.

A very simple example of effective use of filters is in lending tone to a very bright blue sky. This beach scene shows a great deal of tone – black even – but a weaker filter will whittle that down a bit, to a less dramatic grey. By using a yellow or orange filter you can bring a pleasing grey to the sky which will make white clouds stand out much more boldly than they would in an unfiltered picture. But you can do all sorts of things with filters of varying strength. Try blue on your lens when picturing a girl and you can make blue eyes appear strikingly pale while flushed cheeks look bolder. And use a green when photographing a summer landscape to bring you a fine bright and feathery appearance.

Back briefly to that rainbow. Seven colours there: if your filter stops some of those colours passing through, it is obvious that a lesser quantity of light will reach your film. There's no problem if you're using a single lens reflex camera with through the lens metering, for the light measured will be what's left after passing through the filter. But other camera users needn't feel deprived. Every filter sold has a filter factor stamped on it or on its container. The factor will be $1\frac{1}{2}\times$, or $2\times$ or $3\times$, and so on. That means you must increase the exposure by that factor. And to increase by $2\times$ you simply open up by one stop – or slow down by one shutter speed adjustment. $1\frac{1}{2}\times$ needs an aperture opening halfway towards the next wider one, and $3\times$ needs one aperture wider plus a half stop towards the next one.

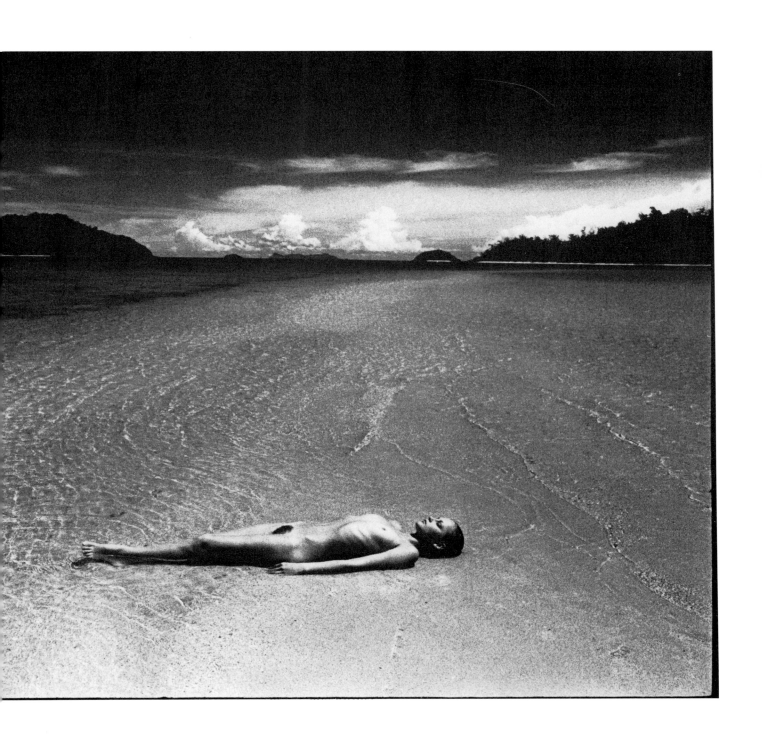

Developing
film types
ASA rating

There probably will always be illustrators, people who can pick up pen or pencil or brush and create images to order – fantasies, if necessary, the likes of which would never actually be observed on the face of the earth. And there will probably always be photographers who prefer colour film – the numbers who do so are increasing every day it sometimes seems. But nothing, nothing at all, can diminish the quite staggering flexibility of black and white photography.

Black and white begins with the film: one emulsion only (except for the chromogenic films, which have two) whereas colour has three. That relative simplicity of black and white makes it many times easier to control.

Let's just dwell on basics, and go through the steps involved in processing a conventional black and white film. We'll consider Kodak Tri-X Pan, a popular emulsion amongst enthusiasts of the black and white image. Tri-X is rated at 400ASA, and Kodak Eastman (parent company of our own Kodak here in the UK) say: 'This is a high speed panchromatic film with fine grain and excellent sharpness. Its high speed makes it especially useful for photographing dimly lit subjects and fast action, for extending the distance range for flash pictures, and for photographing subjects requiring good depth of field and high shutter speeds.'

That 400ASA speed rating is no longer so spectacular, of course, since recent advances have made that level of sensitivity available in colour films for even the simplest of snap shot cameras; and chromogenic films, such as Ilford's spectacular XP1, offer much higher speed as a matter of course. But Tri-X is very flexible, and lends itself readily to push-processing; it is regularly pushed as high as 1,600ASA by photographers working night clubs and music acts. Claims have been made for higher rating still, even up to 6,400ASA.

The point is that ASA rating is merely a convenient way of indicating the sensitivity of a film: in fact, Tri-X could be exposed at anything between, say, 100ASA and that elevated 1,600ASA depending on what effect you were after. When suggesting typical exposure settings, Kodak say that in bright or hazy sun, with distinct shadows, an average subject (not someone in glaring white dress or jet black robes) could require you to set your camera at 1/500sec and f/22. But they quickly point out that with a backlit subject photographed close up you may have to open up the lens aperture to f/11 – which is the same as saying that the film would then be functioning at 100ASA for some parts of the picture.

Processing a black and white film at home is simplicity. There is no magic, and precious little inconvenience. You need a tank, a measuring jug, a thermometer, and some chemicals – and some place which can be made very dark for a minute or so. Most of the process is carried out in full light, as the tank used is lightproof.

Tanks are easily come by: the cheapest, perfectly satisfactory, will cost little over a fiver. First task is to learn the trick of feeding a long length of film into the spiral of the tank: this must be done in total darkness, but the knack is not elusive, so don't despair. Next stage is to pour in the correct volume of developing liquid – thermometer checked to be at 68F – and to agitate (swish around) the liquid every minute for the duration of the processing time indicated on the leaflet which comes with the developer.

It is that developing time, and the temperature too, which brings you such control. Suggested standard time for Tri-X is 11 minutes, in D76 developer mixed 1:1 with water. But vary that time and you will vary the film's reaction. A longer time will increase sensitivity; as little as a couple of minutes will send the ASA rating up considerably, and a similar period of reduction of processing time will reduce ASA rating slightly.

But why reduce or extend the ASA rating? One answer is to allow you to shoot in duller lighting conditions – late in the evening or indoors. But results are inclined to be a bit hit and miss.

A more sound reason is that differing processing times, while certainly acting on the density of the image (thus giving an appearance of higher ASA rating), work in a proportionate fashion, continuously affecting the contrast of the image. Thus, a reduced developing time, working efficiently enough on the shadowed areas of the film, but having insufficient time to build the denser parts of the negative to even higher density, will effectively lower the contrast over the entire image. And extending the developing time will allow the developer to work for longer on the shadow areas, forcing out maximum detail there: the penalty is that the longer developing time will also be affecting the dense areas, making them even more solid – so that the final negative may well display excessive contrast.

High contrast, translated into a print, looks like the picture here. In practical terms it has been used to isolate the lady, by suppressing detail (texture, tone) in those areas immediately surrounding her. In consequence she stands out boldly, and the picture capitalises fully on the graphic shape of her and her dog. It's a simple image.

Differences in temperature of the developing liquid affect the negative too. A higher temperature has an effect similar to extended developing time, while lower temperature slows down the entire process – and may even result in inadequate development of the image.

Certain manipulations of the negative image may be introduced by using a developer other than the standard D76. Some brands will work slowly, some more quickly, and some will speedily make the image both high in contrast and very bold indeed on grain – that gritty broken up effect. Mind you, it is perfectly possible to produce a very chunky grainy image while at the same time retaining a low contrast effect: all you need do is to enlarge greatly from a tiny portion of a low contrast negative.

Just to finish off that developing procedure, since we got only so far as the developing liquid. After the developing time is up, the next stage is either fixing or washing the film in a stop bath. The stop bath is not necessary, but some photographers insist it halts the developing action quicker, and it certainly prolongs the life of the fixing liquid. Whatever you use, the method is straightforward. You simply pour the developer back into its container, and pour in what's next. Fixing takes relatively little time, and requires no attention from you. Last stage is washing: after fixing you may remove the film and wash it in the sink, or leave it in the tank and circulate running water around it. Wash for half an hour to make sure you remove all traces of chemical or your film will eventually stain. Let the film dry naturally, but well away from any area in which there is dust.

Printing
darkroom
dodging and burning

It is to the great benefit of millions that the camera makers and the film companies ever got involved in automation in the first place. Automation, that is, of camera controls and of the various processes that make up photography.

Had they not done so, photography would still be something of a black art – understood by only the few who studied it for years.

As a matter of fact, looked at realistically, photography *is* still something of a black art (or a colourful art?); though, fortunately, the man and the woman in the street can enjoy it, and can produce good pictures without ever knowing a jot about the chemistry and the time-and-temperature-fiddling that used to constitute (still may) making a picture. Thanks to automation.

Now, automation is moving beyond the camera and on into the darkroom: at least, on into the actual print-making process – for the latest clutch of technical developments actually allow most of the print-making process to be done not in a darkroom but in a room bathed in ordinary household lighting.

Consider that the children of today can seemingly work miracles with their micro-computers and their sophisticated electronic toys, and you will readily see that they will, within a year or two, have absolutely no trouble at all in pressing the right two or three buttons and levers in order to first take a picture, and then produce a print of what they have taken.

And it is right that the magic of picture making should become so accessible – for photographs can smash down barriers of language and of understanding. However, it is right too that each hobbyist should be thoroughly aware of just what is possible with the magical medium that he entrusts to automation.

We shall not here get into the argument about whether automatic cameras are less flexible than manual models, for given a reasonable degree of knowledge it is possible to impose your own will on an automatic camera – and in a number of ways. Instead, the point will be made here through black and white prints.

Here are two pictures of Helmut Newton, well known for his very raunchy and erotic pictures of ladies. In fact this is one picture (shot on a 10 × 8 camera), manifested in two rather different prints. In one there is an emphasis on the heavy and juicy tones, while the other is printed much lighter: in one picture Newton has been given a more than healthy suntan, in the other he is a paleface.

Differences such as this are not unduly dramatic – they are simply the result of timing variations, and just possibly of temperature variations too. By giving the picture more exposure under the enlarger, or more time in the developer, the darker effect results.

Significantly, this example focuses on skin tones: and you can readily see that if such a difference as this is possible in black and white photography how much more marked it may appear in colour! Unfortunately, variations from the original *do* often crop up in colour when the prints are processed in professional d & p laboratories; but the labs primarily adjust their machinery to give reasonably accurate skin tones.

While we still have two step photography (that is, a negative or a transparency from which a positive print is made) then it will remain possible, with some darkroom experience, to change the effect. And the importance of that is in the opportunity it brings for producing an end result which is very precisely to your liking.

The most impressive alterations to a print (black and white, that is) are done by hand, in a process known as burning and dodging: the first allows more light from the enlarger onto the print, the second reduces light – the hand being moved to control exactly where the light falls or is prevented from falling. In colour, a certain amount of this can be done too, while filters may be used to adjust the actual colours of your print.

For the time being, the actual enlarging remains pretty much as it always has been – though sophisticated electronic measuring machinery is now available to help the hobbyist decide on precise enlarger exposure, and which filters to use when printing in colour. And it is in the act of enlarging, of interfering in some way with that light beam which shines onto the printing paper, that most control may be exerted. For that reason, darkroom work will for a long time remain the very pinnacle of the satisfaction to be got from photography.

For you will truly be able to glean the very best from your negatives and, more importantly, exercise your creative muscle just that little bit more. As good as printers may be, somewhere up there in your head is a mini-vision of how you ideally see that picture being finished.

Presentation
sequences
half-frame

Photography, like language, provides more ways than one to skin a cat. To say 'He ran along the road' is little different from saying 'He sped along the road' – yet there *could* be a difference, in that the speeding can be done in a car, or on a bike.

When a photographer sets out to put an idea across in his pictures he must first choose his method – though he may do that in the final seconds before pressing the camera's firing button. The effect of speed? Show an athlete blurred, or blur the background, or do neither and catch the runner with his feet off the ground and his face contorted with the effort of pushing his body along. All say the same thing – and all say different things.

Here's a triptych – at least that's what the art critics would call it. In fact it's three frames from a film exposed on a young woman modelling a dress. The pictures are in half frame format, taken some time ago. The camera had a clockwork film advance, and was quite suitable for this particular assignment.

Isolate any one of these three pictures and look closely at it. It tells you here's a girl, in a wild location, wearing a loose dress which is being whipped by the wind.

Each of the three tells you that. But the last of them adds something; the girl's pose suggests she is revelling in the wind, almost dancing. If nothing else that should stress one of the advantages of shooting many exposures on an assignment.

If you now shift your attention from one picture and view all three as a unit, what's the result? They continue to tell of a girl in a dress blown by the wind. But something very important is added: now it's plain she has *not* just been snapped in the act of walking through this weird place. She is either posing, or being buffeted by the wind so much she can't stand still. She is not advancing towards the camera. But now you know the circumstances and you are aware she was indeed posing. So the triptych is no longer a piece of contemporary art (and you'd be surprised at what is passing for art in photographic salerooms these days!); plainly it's a portion of a contact sheet from a photographer's working day. So, where do we go from here?

This particular set of pictures will serve very well to underline the nature of a sequence. Primarily, a sequence should do something a single picture doesn't: otherwise what you're producing is repetition!

A sequence, which may consist of anything from two pictures upwards, is usually shot in one location, during one session: there is then a uniformity. Sports photographers have been known to point a camera straight down an athletics track, firing every second or so, and reproducing all

pictures in a strip to chart the progress of a 100 metre sprint. And even the much respected Ilford once produced a sequence, to promote film, which showed the gently erotic spectacle of a girl peeling off layer after layer of her Victorian era clothes. Frequently published are sequences showing some disaster; sometimes a motor racing crash, shot on 35mm film with a motor drive camera, and sometimes such as an air crash, the individual frames being perhaps blow-ups from an 8mm movie film, snatched by a traveller involved in the incident.

For some reason the sequence is particularly popular amongst the young breed of American photographers, who tend to produce somewhat morbid metaphors in se-

quences of four or so frames. They like to shoot with a person in the frame and then absent, suggesting death or departure; another favourite is to progressively underexpose a figure, so as to make it appear to dematerialise, suggesting things spiritual.

There's no denying the sense of unity a same-location same-session sequence presents, but the most important linking element should be unity of idea; the pictures do *not* have to be shot one after the other in one concentrated burst. In fact a particularly fine essay can be made of a developing pregnancy, by photographing the expectant mother month by month, ending with her and the new baby. One photographer who did that pictured the

mother-to-be standing on tiptoe, peering out of the same window in each picture – as if waiting for someone to arrive. And she was, of course.

The idea is to tell some sort of story, or make some observation, in your sequences. But that shouldn't put *anyone* off trying. Everybody has access to some sort of subject, and one famous Japanese photographer recently published a sequence showing his daughter growing up.

The sequence, you see, is not at all some obscure and arty angle on photography. It is simply a more detailed presentation of an idea than a single picture allows. And talking of presentation – good sequences look good when framed.

Index